RENEWALS 458-457 ⁻

DATE DUE

GAYLORD			PRINTED IN U.S.A.

Hidden in the Shadow of the Master

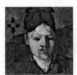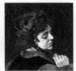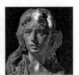

RUTH BUTLER

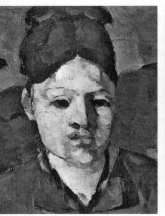
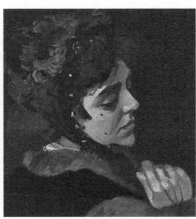
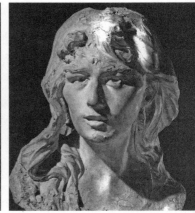

Hidden in the Shadow of the Master
The Model-Wives of Cézanne, Monet, and Rodin

YALE UNIVERSITY PRESS
New Haven & London

Designed by Sonia Shannon.

Set in Monotype Bulmer by Duke & Company, Devon, Pennsylvania.

Printed in the United States of America.

Library of Congress Cataloging-in-Publication Data
Butler, Ruth, 1931–
Hidden in the shadow of the master : the model-wives of Cézanne, Monet, and Rodin / Ruth Butler.
p. cm.
Includes bibliographical references and index.
ISBN 978-0-300-12624-2 (hardcover : alk. paper)
1. Artists' spouses—France—Biography. 2. Artists' models—France—Biography. 3. Artists—France—
History—19th century. 4. Cézanne, Paul, 1839–1906—Relations with women. 5. Monet, Claude,
1840–1926—Relations with women. 6. Rodin, Auguste, 1840–1917—Relations with women. I. Title.
N6847.B87 2008
759.4—dc22
[B]
2008004984

pp. i, iii, and xv (l–r): *Mme Cézanne in a Red Armchair* (detail, p. 43); *Camille* (detail, p. 115);
Mignon (detail, p. 227)
pp. ix and 13: *Mme Cézanne with Hortensias* (detail, p. 54)
pp. x and 93: *Claude and Camille Monet in His Studio Boat* (detail, p. 169)
pp. xi and 205: *Bellone* (detail, p. 265)

A catalogue record for this book is available from the British Library.

The paper in this book meets the guidelines for permanence and durability of the Committee
on Production Guidelines for Book Longevity of the Council on Library Resources.

10 9 8 7 6 5 4 3 2 1

PREFACE

The most authoritative source about the life and work of Claude Monet is Daniel Wildenstein's multivolume catalogue. In the first volume we read about the death of the painter's great model, his first wife Camille Doncieux, in 1879. Further, we are told that "all the letters written and received by Camille and the photos in which she appeared were destroyed at the behest of the jealous Alice [Alice Hoschedé, Monet's second wife] who now reigned supreme in Monet's life." In a later volume we read of Monet's behavior in 1911 after Alice died. Monet's step-daughter, Marthe Hoschedé, reported that she "frequently found Monet bent over the letters of his departed wife and painfully re-reading them before he burned them."[1] The second description makes me wonder about the first. Camille's letters belonged to Claude Monet, and I believe that he destroyed them. Letters were the most intimate remains of the two women he loved. They were private, his property, his memories, and, besides, who would be interested in the thoughts and experiences of these ordinary women? There was no reason to preserve them.

As I began this project, I thought about Alain Corbin's wonderful book *Le monde retrouvé de Louis-François Pinagot: sur les traces d'un inconnu, 1798–1876* (*The Rediscovered World of Louis-François Pinagot: Retracing the Footsteps of an Unknown Person, 1798–1876*, 1998), in which he sought to bring a dead peasant back from oblivion in order to give new life to an ordinary man by considering such factors as his geographical origins and the historical events through which he lived, as well as searching for evidence of his life in the French archives. I had such goals in mind when I considered three women born in the French provinces between 1844 and 1850, about whom we have little firsthand written material, but they were women who became less ordinary when each joined her life to a future giant of late nineteenth-century French art. And the three unions took place just at the moment when artists everywhere were trying to replace the older, more traditional conventions of the art schools with fresh new approaches based on the sensations of their own lives as they were living them everyday.

Other interests drew me to the subject of this book, including my previous work on the sculpture and the life of Auguste Rodin. The work gave me an opportunity to put Rodin into the mix with contemporary painters. In the nineteenth century the separation between the professional lives of sculptors and painters was quite real. Rodin's life was different from that of Claude Monet and Paul Cézanne, not only by the materials with which he worked, the conditions of his workshop, and by the different kinds of patronage to which painters and sculptors had access, but also in terms of class. That separation extended to his peasant wife, Rose Beuret, especially when we think of her beside Camille Doncieux, an educated daughter of a bourgeois family. But primarily my goal was to think of these three women in terms of what they had in common—the contemporary situations they shared: struggles with poverty as wives of young artists whose work had few buyers, distance from their provincial origins, the railroads, the changing face of Paris, inner-city transportation, the political upheavals of 1870–71, and, especially, the burden of having thrown in their lot with someone who has set his sights on becoming a genius.

When I finished writing the book, and looked back on all the works I had examined, I was amazed to find that the images of these women weren't just representations of their physical presences on canvas or in clay, but a view of three relationships: the cool distance between the Cézannes; the wariness, sadness, and anger of Rose Beuret during her life with Rodin; and the pleasure Claude Monet and Camille Doncieux were able to find in many of their days working together. These women weren't just models; they brought a whole spectrum of feelings with them, giving their husbands' art emotional texture and substance, contributing elements for art as important as the light in which a scene is bathed, the space where an object sits, or movements that provide real character in a scene or to a figure. It is this quality that I most want my readers to discover.

To Nan in Paris
&
to Carl in Cambridge

Model, living:
One whose profession it is to pose
to an artist. Many female models, possessed
of great beauty of face and form, have gained
celebrity from sitting to distinguished artists.

JULES ADELINE,
The Adeline Art Dictionary, 1866

The model is for the artist what the
human document is for the novelist:
he doesn't want the conventional;
he will take whatever he finds.

RANIERO PAULUCCI DI CALIBOLI,
"Les Modèles Italiens," 1901

CONTENTS

Part II:
Camille Doncieux

Part III:
Rose Beuret

Recognizing the Model and Her Work

La femme qui partageait sa vie avec un don d'elle-même

RAINER MARIA RILKE

I visited the Musée Rodin in Paris for the first time many years ago. I still re-
member the pleasure I felt in the gallery devoted to Rodin's early works when
I spied one particular portrait in plaster. It was of a young woman whose full
lips were slightly apart. She appeared breathless, eager, totally alive, her long
hair a-tangle, giving the illusion of being windblown, although the transforma-
tion from plaster into hair had not fully taken place. She had high cheekbones,
and there was a penetrating quality in her direct gaze, her lowered eyebrows,
and the way she turned her head. This girl was intense, and she was beautiful.
Without question it was the most engaging work in the room.

The museum catalogue told me that Rodin had executed it around 1870,
and that "this bust is the first known portrait of young Rose Beuret, otherwise
known as Mme Auguste Rodin, at twenty-four years of age. Born into a modest
family in the Champagne region, she was the great sculptor's companion all
his life. Her role was totally hidden in the shadow of the master."[1]

The gallery walls were hung with drawings, paintings, and photographs,
all of them early works—some were student productions. There were like-
nesses of family and friends. I didn't pay much attention to them. One was a
broadly brushed oil of a woman with short brown hair, wearing a dark dress
with a white scarf tied firmly around her neck. The intensity of her large eyes
under lowered eyebrows made you stop, but just for a moment. She turns ap-
prehensively to her left as a shadow passes over part of her face. Something
about her tightly closed lips suggests a woman who has decided not to cry.
The work bore the label *Portrait de Mme Rodin mère*. The catalogue noted

1

that this was the only portrait of Rodin's mother in existence and that little is known about her except that she was extremely pious.

Years later I wrote a biography of Rodin, and I looked at this painting again. The label had not changed, but it could not have been clearer: the woman with the tightly closed lips and frantic eyes was not Rodin's mother. It was Rose Beuret, and she was still "hidden in the shadow of the master."

"There is the girl behind the counter—I would as soon have her true history as the hundred and fiftieth life of Napoleon or seventieth study of Keats." That's how Virginia Woolf explained her sense of subject matter when giving advice to young novelists on what was best to write about.[2] This suggests something of the spirit in which I set off to learn more about Rose Beuret. By definition, the days of a woman who wished to share her life with a man totally committed to creating art—and, even worse, to becoming great and famous—cannot be easy ones. Further, it comes as no surprise that once "the master" is gone, such a woman is most likely to be lost from view. This is not an unusual story; rather, it is a common one. But what really made me stop and think was the realization that this was the first generation in which a large number of artists identified their chosen model and their chosen woman as one and the same. By the twentieth century such a circumstance had become so common among Western artists, we hardly stopped to think about it. It is simply what artists do.

I thought about the wives of Rodin's contemporaries, especially those who, like him, achieved remarkable fame. I wondered about Camille Doncieux, Claude Monet's first wife, who, until her death in 1879, was his great model. Monet's first public success was an over-life-size portrait of her, a work he entered into the Paris Salon simply as *Camille.* Yet somewhere along the way "Camille" dropped from view and the work became known as *La femme à la robe verte* (*Woman in a Green Dress*). In an interview in 1900, Monet himself referred to the painting as "The Woman in Green," without mentioning his first wife's name. It was only in studies of Monet's work published in the second half of the twentieth century that we began to find changes in the names of many of Monet's early works.

And then there was Hortense Fiquet, the model Cézanne depended upon more than any other, and the woman he married fourteen years after the

birth of their son. Who knew anything about her? There are many books about Cézanne that hardly mention her name save in picture captions. One of the early important books on Cézanne was *Le maître Paul Cézanne,* by Georges Rivière, published in 1923, a year after Hortense's death. In Rivière's chapter on "La femme dans l'oeuvre de Cézanne" ("The Woman in the Work of Cézanne") her name does not appear. When I learned that Rivière's daughter, Renée, was married to Hortense's son, Paul, I knew that there was a story here, probably one that would be difficult to understand. That feeling was reinforced when I had the occasion to speak with Philippe Cézanne. Upon asking him where his great-grandmother was buried, I was told that he did not know.

This book is about three women who met and modeled for three young artists, men who later emerged as giants among the creative figures of late nineteenth- and early twentieth-century art. Each woman gave birth to a son relatively soon after the initial meeting. All three couples ultimately married. A further similarity is the burden of poverty these couples experienced during the early periods of their lives together. The men all encountered their mates somewhere in the streets of Paris, where they glimpsed that unique face and form of a girl willing to come to his studio in order to pose for him.

Though these stories make a particular unity, there were other artists with model-wives working in France in the second half of the nineteenth century. Edouard Manet, the quintessential prototype in manner and art for the Impressionist generation, is best known for the work he did with a professional model, Victorine Meurent, but his wife, Suzanne Leenhoff, posed for him many times, especially before their marriage, when she was his mistress. It was said that Manet was so demanding of his models it was critical for them to have a personal commitment to his work in order to put up with the difficulties of posing for him. The sculptor Jules Dalou produced an image of modern femininity that served him all his life as he re-created his wife, Irma, in clay and in bronze. Like Rose Beuret, Irma was a simple seamstress. Aline Charigot faithfully modeled before and after her marriage to Auguste Renoir, continuing to do so until she was too old and too fat to go on posing.

The emergence of these model-wives in the second half of the nineteenth century coincided with the growing interest artists had in scenes from everyday life—in both the city and the country—in preference to subjects drawn from mythology, historical events, and the Bible. As the shift came about, professional

models who had learned the conventions of standard poses became less desirable than women who had never posed at all, but who had a unique look or an inherent body language of particular interest to a painter or a sculptor. Many French artists who initiated their careers during the Second Empire (1852–1870), and who arrived at maturity in the Third Republic (1871–1940), made this shift. As they began their careers, the human model was critical for each artist. Rodin was particularly clear about this when he spoke of a model being "more than a means whereby the artist expresses a sentiment, thought, or experience, it is a correlative inspiration to him. They work together as a productive force."

That a number of artists found mates—women willing to model and who, in the end, became their wives—is not a fact, however, that we should take for granted or think of as inevitable in the context of the nineteenth-century French art world. Far from it—popular propaganda was firmly set against an artist getting married. Most men thought such a move would inhibit inspiration, alienate friends, and curtail liberty. This had been the view of some of the most admired artists of the previous generation. Shortly after Eugène Delacroix's death in 1863, the writer Charles Baudelaire noted, "He made painting his only muse, his only mistress, his sole and sufficient passion.... He looked upon woman as an object of art, delightful and made to excite the mind, but an unruly and disturbing object if we allow her to cross the threshold of our hearths, devouring greedily our time and strength." The great realist painter Gustave Courbet had numerous affairs, often with his models. We hardly know their names. In a letter to his close friend Max Buchon Courbet wrote, "Rose wants to come with me to Switzerland, telling me that I can leave her where I wish. My love does not go so far as a trip with a woman, knowing that there are women everywhere in the world" (September 13, 1854).

The question—should an artist marry—was widely debated in cafés on both banks of the Seine. Novelist Alphonse Daudet addressed the problem directly in *Femmes d'artistes* (1874). He introduced the problem in terms of a discussion between two friends: a poet about to marry, and thus in favor of the institution, and a painter who is married—actually not unhappily, although, as he points out, such a situation is not typical. And he feels impelled to warn his friend about the risk he is about to take: "The first and biggest thing is the loss of one's talent or at least a severe weakening of it." Daudet's painter speaks

4

for his own profession when he makes the point that most wives cannot put up with having a husband spend long hours alone with a model, especially if she has no clothes on. And a marriage contract usually gives a woman the idea that she has the right to make demands. She might try to lead a man into a fashionable life he does not want, or she will become overbearing and totally frustrate the development of his creative life.

A book illustrating many of the fears of Daudet's painter had been published a few years before Daudet brought out his own treatment of the subject. Edmond and Jules de Goncourt's *Manette Salomon* (1867), which provides rich descriptions of a painter's day-to-day routine, is often seen as the first realistic novel about an artist's life. Early in the narrative we find the hero, Coriolus, traveling across Paris on an omnibus, on which he catches sight of Manette. In the flickering light he examines her face, taking in as many aspects of her form as he can between the shifting bodies of other passengers. In the days that follow, he cannot get her out of his mind, so he sets about to search the city until he finds her. Would she be his model? In time they become lovers. The birth of their son is a transforming event in Manette's life. She now envisions herself as a wife, as a lady in society, and she no longer wishes to pose. By the end of the book, Manette has coerced Coriolus into forgetting his dream of becoming the great innovative leader among contemporary artists—in other words, a genius—and instead has gotten him to make easy, readily acceptable pictures, the kind of work for which there is a waiting clientele, cash in hand.

The consummate atelier novel of the nineteenth century, however, the one that has attracted the widest range of critical probing, is Emile Zola's *L'Oeuvre,* published in 1886.[3] Zola, born in 1840, was a contemporary of the artists in this book. In his youth he was Paul Cézanne's best friend, and he came to know Monet well. When he published *L'Oeuvre,* he may or may not have known Rodin personally, but he certainly knew about him and his work, which, by 1886, was beginning to command a place in avant-garde circles.

Zola drew upon the situations, the places, the events, and the people in his own life. The novel was on my mind because much of its drama results from circumstances quite similar to those of the men and women about whom I write. They were part of Zola's world in the 1860s and 1870s, the time period of the novel, and some of his descriptions are about episodes and individuals that overlap the stories told here.

One of the major events in *L'Oeuvre* invokes the Salon des Refusés of 1863, that extraordinary exhibition signaling the arrival of a new generation of artists in France. The Paris Salon, a venerable institution dating back to Louis XIV, was the only way artists could exhibit their work in France. Thus it operated as an overcrowded starting gate through which they had to pass in order to have any career at all. The keys to this imposing portal rested in the hands of the Salon jury, and the biggest struggle to loosen the tight control of that very conservative body took place during the Second Empire when Monet, Cézanne, and Rodin were trying to place their works in that all-important show.

Zola, writing art criticism in the 1860s, plunged into the thick of the fight for Salon reform. His memory of that struggle was central to the novel he wrote two decades later. He focused on the Salon of 1863, when 70 percent of the works presented were rejected. This quasi-annihilation of the younger generation of artists, as well as many who weren't so young, provoked a protest and pushed Emperor Napoleon III to declare that artists who had not been accepted should be allowed to have their own exhibition, thus giving birth to the "Salon des Refusés."

The most notorious painting in the exhibition was Manet's *Le Bain* (*The Bath*), later called *Le Déjeuner sur l'herbe* (*The Picnic*). Manet posed four young Parisians as if in a rural setting. Two men, wearing "horrible modern French clothing," according to a critic, and recognized as students, engage in animated conversation, while their closest female companion, totally disrobed and paying no attention to the men, stares bemusedly at the viewer. Clothed and unclothed simply did not belong together, and the majority of the visitors to the "annex" of the regular Salon reacted with shock and anger. Critics found that even the way in which the work had been painted was all wrong. For example, when Jules Antoine Castagnary looked, all he could see were "boneless fingers and heads without skulls . . . side whiskers made of two strips of black cloth that could have been glued to the cheeks." But when Zola walked into the exhibition hall with his friend Cézanne, they were struck with admiration. Art historian Wayne Andersen describes the exhibition itself as the best thing that could have happened to the two young men from Provence. It helped position them within the world of art: "They needed something to fight for, or against, some context into which their energy could be transformed from dream to

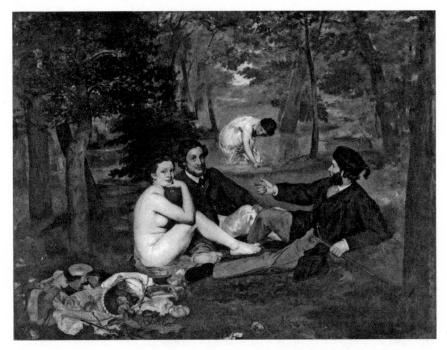

Edouard Manet, *Le Déjeuner sur l'herbe (Le Bain)*, 1863. Paris, Musée d'Orsay
Réunion des Musées Nationaux/Art Resource, NY.

action."[4] Years later, in *L'Oeuvre*, Zola recreated the unbelievable tumult and power he felt standing before *Le Bain* in the middle of a jeering crowd. He would transform *Le Bain* into Claude Lantier's *Plein air (Out-of-doors)* and portray his hero entering the gallery at the Salon des Refusés to find his painting being ridiculed and laughed at by a "confused mass of humanity."[5]

A second aspect of Zola's novel that reflected something of the lives of creative young men in contemporary France in the nineteenth century was a craving for genius. Zola's characters included three painters, a sculptor, and a writer, Sandoz, the character who most resembles Zola himself. The men talk endlessly about art-making and wonder who among them will become truly great. Early in the book, Zola describes these youths strolling down the boulevard and how, when "they squared their broad young shoulders, these twenty-year-olds took possession of the entire pavement. Whenever they were together, fanfares cleared the way before them and they picked up Paris in one

hand and put it calmly in their pocket. Victory was theirs for certain, so what did they care about down-at-the-heel boots and threadbare jackets when they could be conquerors at will?"

This passage in *L'Oeuvre* brings to mind a letter that Léon Fourquet, Rodin's best friend, wrote to him when they were students. Fourquet reminisced about their youth: "Do you remember a few years ago when, on those delicious evenings, we walked under the trees of the Luxembourg, how you, always with a stern look on your brow, and I, a little more careless, would talk about our glorious future? We were sixteen and without care, you were already covered with laurels in school and we spoke about art with an enthusiasm that transported me. Michelangelo and Raphael—the great names. In our delusion we were able to approach them, we saw the way open up and crowns tumble to our feet."

But these young men needed something else besides models from the great historical past. They needed flesh and blood models in the here and now, that right person to provide the inspiration as they began to translate the materials in their hands into form. The theme is central to *L'Oeuvre,* which is why Zola placed the discovery of the painter's model at the opening of his tale. It is late at night in a driving rain when Claude Lantier arrives at his door on the rue de la Femme-sans-Tête. In the entrance huddles a girl. She is a stranger in the city—alone and lost, so there was nothing to do but to give her shelter for the night. In the morning, Claude wakes and peeks behind the screen he has set in place to separate them. He cannot believe his eyes: "Here it was, the very thing, the model he'd tried in vain to find for his picture—and what's more, posed nearly as he wanted her! . . . He begins to sketch her face, studying it closely." Her name is Christine Hallegrain. Claude also needs her to pose for the body and in the next couple of chapters he is continually wondering, "How can I get her to pose for the whole figure?" All the while she resists the way he undresses her with every look.

After several years together Claude and Christine become parents. They have a son. They are ambivalent about the child, and in this Zola has created a situation that is extraordinarily parallel to the one we will see in the Rodin/Beuret household. Christine admits that she is "twenty times fonder of the father than of his child," a sentence that could have come right out of the mouth of Rose Beuret. In a few more years the idea of marriage comes

up, mostly through the influence of the Sandoz/Zola character. Zola himself was intensely pro-marriage. In July 1885, when Zola was finishing *L'Oeuvre,* Cézanne spent several days with him at his country home near Paris in Médan. They must have talked about the novel, which touched on so many facets of their shared lives. The following spring, Cézanne married Hortense Fiquet, mother of his fourteen-year old son. We have to wonder if, during Cézanne's visit, Zola didn't speak about marriage, advising his old friend that it was an essential condition for the production of "good, solid, regular work," just as Sandoz counseled Lantier.

Descriptions of the wedding that took place in Aix-en-Provence in 1886 sound almost as depressing for the bride as the one Zola wrote about in *L'Oeuvre.* Like Christine, who had no choice in identifying the witnesses for her wedding because she "had no friends at all," Hortense was also unable to express any element of choice in this regard, for she, having come to the home of Cézanne's family in Aix to be married, found herself in a friendless environment. Zola described Claude and Christine's three-hour wedding luncheon, at which the only subject of conversation was an intense discussion of Mahoudeau's most recent work, for the sculptor's statue had broken apart a few hours before the wedding, a loss which Claude had witnessed. As for Hortense, she was not included in the party when Cézanne went off to lunch with the men who had been witnesses at her wedding. Instead she accompanied Cézanne's parents to their home, the Jas de Bouffan, a place where she had never been made to feel welcome.

In *L'Oeuvre,* when Claude and Christine return home from the wedding celebration, Claude immediately goes back to work. At this point Christine begins to face the realization that her life has not become better, but worse. She now understands it to be one of endless solitude. From a woman's point of view, this is the major theme of the novel: the terrible psychological drama played out when a woman joins her life to that of a man who yearns for the great prize, that of being recognized as a genius. Her lot is loneliness and neglect. Nothing could have been more familiar to Hortense Fiquet, Camille Doncieux, and Rose Beuret.

L'Oeuvre matters because it introduces a relationship and a household that parallel the three I describe in this book, and in writing it Zola was committed to reproducing the world in which he and his friends lived. Zola gives

9

us a glimpse of what a model-wife might have thought or said, and the truth is that we know almost nothing of these things in a direct way from Hortense, Camille, or Rose. Our primary information about them is their look. We know what people said about them, but next to nothing in their own voices. I have assumed that Monet burned Camille's letters after her death in 1879. Two letters exist in the hand of Hortense Fiquet, one saved by Cézanne's dealer, Ambroise Vollard, and the other by the wife of a collector of the artist's work. In a sense we are better off with Rose Beuret because of the existence of the Musée Rodin, founded before Rodin's death, and dedicated to keeping everything that was in his possession. Thanks to the museum we have eleven of Rose's letters to Rodin. But Rose, unlike Camille and Hortense, was unschooled, nearly illiterate, so her brief, undated letters contribute in only a modest way to our knowledge of her.

The story I tell depends both on fact and on imagination. Thus it seems worthwhile to turn to Zola's story of Christine Hallegrain and pay attention to the way she experiences the conflict between her day-to-day domestic activities and her self-abnegating devotion to her man's great goal by serving as his model. It helps to shine light on the mysteries of the model-wives who really lived but who, in the absence of their own words, remain so silent. We learn of the difficulties of modeling, especially how painful it is to stand for long periods of time. Christine wonders if she will ever grow used to it. And we learn how jealous she is of Claude's involvement in a wider world, while she lives in an isolated place with a son she does not love. But she is even more jealous of the life Claude is putting on canvas. At a certain point he has almost stopped talking to her; she begins to fear that in his eyes she is more "thing" than woman. As the novel develops, however, she becomes less passive, her voice becomes sharper, stronger, more courageous, and in the end hers is the voice of a woman speaking for life and against art.

None of the women in this book are quite like Christine. In contrast to the scholarly studies of *L'Oeuvre* in which there is endless speculation about which contemporary painter, or combination of painters, served to inspire Zola's creation of Claude Lantier, the majority of writers do not believe Christine is based on any living person, and there is little speculation about her beyond the pages of the novel. But she is the fictional sister of the women in this book, and the problems she faced were the ones that they too had to confront.

In the end, as Claude levies ever greater demands on Christine, she finally explodes: "*Your* painting! It's killing me, poisoning my whole life." None of the model-wives depicted here would have said that. I think Camille Doncieux and Rose Beuret both loved the work they helped to create, but both of them suffered, Camille from her husband's longing for great success, and Rose from that success when it came. Hortense Fiquet probably suffered less than her two model sisters, perhaps because it seems there were limitations in the degree to which she understood Cézanne's work. Further, he was less involved with her than Monet was with Camille, or Rodin with Rose. Hortense had a certain amount of freedom to be her own person. But basically these are all tales about pain and adversity in a time when most women had little power to determine their own lives. And then, for a woman to enter into an alliance with a man who hoped to be a genius was to establish a household in collaboration with a human being wedded to his own self-interest. For all three men, art always came first.

What were the women's feelings about the contributions they were making to the new art they saw coming into being all around them? Did they understand the power of their presence on those canvases or in that clay? The Goncourt brothers implied that Manette Salomon had a strong sense of her value in this regard, but they ridiculed her idea of herself when they described Coriolus telling his best friend, Anatole, that Manette is "actually persuaded it is her body that has made the paintings." Henri Matisse's model Lydia Delectorskaya described the way Matisse got the best out of a model by "eliciting from her a passion for his work. He knew how to take possession of people and make them believe they were indispensable. It was like that for me, and it was like that for Mme Matisse."[5] Rare in the history of art is there one who exalted her work as a model in the way that Gwen John, the British painter who modeled for Rodin and who was briefly his mistress, did. She wrote: "The statues made of me by *mon Maître* are our children, mine as much as his. And we are married through a love much closer than those who have living children, because our children are more beautiful and thus immortal."

Nevertheless, to this day the contribution of the model's work is frequently not understood. During the 1990s, Elizabeth Hollander—then working as a model—remembered receiving a compliment for a particular pose from the students in a life class. She responded: "Yes, that one's usually a winner." Upon

hearing this, the students were "startled—even offended at the notion that the model is taking credit for her work, or even that it is work."[6] A similar spirit inspired a question April Masten received as she began working on an article about biographies of nineteenth-century women who had worked as models. A friend was startled when she learned about the project and asked: "Biographies of artists' models? Why not do biographies of bowls of fruit?"[7]

The three lives chronicled here, as we shall see, were difficult and lonely—more unhappy than not. But I'll leave it to the reader to decide: Would Hortense Fiquet have preferred to settle down with someone who owned a floral shop and always stayed put? Would Camille Doncieux have preferred a department store manager who could have given her ready access to the pick of the most recent arrivals in the world of fashion? Would Rose Beuret have been more happy with a man who worked for the *chemin de fer* and returned home in the evening to eat the dinner she had prepared?

Something else to wonder about: could these women have imagined that their faces would shine forth from works that are a key to some of the most extraordinary moments in the history of art, and that paintings and sculptures for which their presences were central would be sold for fabulous sums of money in a century not yet born? Could they possibly have imagined that the work they did would be so celebrated and that it would live forever?

PART I

Hortense Fiquet

Hortense Fiquet and Paul Cézanne

"My wife likes only Switzerland and lemonade": this was a joking—and de-meaning—remark tossed off by Paul Cézanne when speaking about his wife, Hortense. Somebody repeated it. It was repeated again, and it has ended up in book after book about the painter ever since. "Cézanne was shy and intellectual, while she was superficial and drawn to the gay life of Paris," writes the author of the catalogue description for *Madame Cézanne in a Red Armchair* in the Boston Museum of Fine Arts. This doesn't quite match the image of a woman with a small child and a small allowance frequently left alone in Paris while Cézanne spent months at a time in Aix-en-Provence with his family—who did not know such a person as Hortense Fiquet existed. What we know for sure is that Cézanne painted Hortense Fiquet's portrait at least twenty-seven times, and he drew her face over and over again. He spent more time studying her form and face than that of any other human being—with the exception of his own face—yet it's easier to write about Paul Cézanne and Mont Sainte-Victoire than it is to write about Paul Cézanne and Hortense Fiquet.

Hortense Fiquet's past is obscure. Some books designate Lantenne, a village in the department of Doubs, as the place of her birth, but the majority says it was Saligney in the Jura. When I asked the mayor of Saligney (population 157) if people knew that the wife of the great Cézanne was born in their village, he hesitated before saying "maybe 10 percent," while his assistant, surely having just learned the fact herself, rolled her eyes in disbelief, and whispered, "*Moins* [Fewer]."

When Hortense was born in 1850, forty-three-year-old Claude-Antoine Fiquet and his twenty-nine-year-old wife, Catherine Déprez, were living in

Saligney in the home of Antoine's parents. Sometime after Hortense's birth, they moved to Lantenne, residence of the Déprez family, in the neighboring department of Doubs. Lantenne, a village of some four hundred inhabitants, is situated among low hills on the road to Besançon. There, in April 1855, Catherine gave birth to a second daughter, Marie Eugénie. In the archives of both departments we learn that Antoine Fiquet was a farmer.

By the time of the 1861 census, however, the Fiquet family no longer resided in Lantenne. They had joined the great migration to the capital, presumably in search of a better life. Even before the railroad—that giant facilitator of the migration—had arrived in Besançon, the Fiquets took leave of the countryside. If they had had enough money to secure places in a diligence drawn by a team of trotting horses, the trip would have taken four days. But probably they didn't, and, like the majority of people, they would have sought places in a coach pulled by a pair of horses able to make about 30 miles a day of the 250-mile journey. When they arrived in the capital, they found themselves to be among the approximately 750,000 people—out of a total population of 1,696,141—who had been born in the provinces.

Like thousands of others, the Fiquets were eager to participate in the opportunities to be had in the capital. But it wasn't easy. Newcomers daily faced myriad hardships and prejudices aimed especially at those who spoke in regional patois, as surely the Fiquets did. Catherine Fiquet had less than a decade to settle into her new life in Paris; records establish that she died in the capital in July 1867 at age forty-six. Her will, recorded in the department of Doubs, makes two things clear: Antoine Fiquet had an office in Paris, and Hortense was their only surviving child.

Claude-Antoine Fiquet was back in Lantenne for the 1872 census, now identified as a sixty-five-year-old widower. That was the year in which his only daughter became a mother.

The house to which M. Fiquet returned is still owned by a descendant of his landlord, Mme Michelle Petitrichard. When she invited me to look at the two-room house (plus the cow shed), which is attached to her own, she indicated that the only difference from the way it was when M. Fiquet lived there is the tile covering the old dirt floor. Mme Petitrichard spoke of her grandfather, Claude-François Guignaud, for it was he who went to the *mairie* in 1889 to declare the death of Hortense's father. Family tradition has it that

Hortense brought Paul Cézanne to Lantenne to visit her father three times. Mme Petitrichard remembers a search or two in the cellar in the hope of finding a discarded canvas or a drawing.

Hortense was sixteen when her mother died; she had come to Paris with her parents sometime between her sixth and her eleventh birthday and thus was educated primarily in Paris. From the evidence of the two letters in her hand, both carefully written and in no way crude or simple, we can see that she did have basic schooling. It also seems clear she remained in Paris after her father's departure. But we don't know how she made her living. Some authors say she sewed handmade books. A likely surmise, since the majority of women and girls who were alone in Paris made their living through some kind of work with a needle, an employment that generally meant bad pay and long hours. In 1866 Julie-Victoire Daubié analyzed the situation at a glove manufacturer where half of the two thousand employees were women. The men earned three to ten francs a day, while women received one to four francs for the same work.[1] Jules Simon made it clear in *L'Ouvrière,* his classic book on workers living in Paris during the Second Empire, that "if a woman counts on making a living with her needle, she will either die of hunger or go into the street."[2] We have no idea what Hortense's situation was, but it could not have been easy.

Paul Cézanne was born in Aix-en-Provence. His father, Louis-Auguste, a forty-year-old hatter, was not married to his young employee Anne-Elizabeth-Honorine Aubert when Paul was born in 1839. Nevertheless, Louis-Auguste recognized the boy who became his legitimate child when the couple married five years later, as did their daughter Marie, born in 1841. Paul had a lasting devotion to his mother and to his sister, who was so close to him in age.

The other strong emotional tie in young Paul Cézanne's life was to a fellow student he met at the Collège Bourbon in Aix: Emile Zola. He was one year younger than Paul. They became singularly attached both to each other and to the pleasures they shared roving the countryside together under the warm sun of Provence. Zola later remembered how they "followed paths that were lost at the bottoms of ravines," taking possession of them "as if we were conquerors." Neither could have imagined being anywhere else but in the *pays d'Aix.* But at a certain point, eighteen-year-old Emile had no other choice but to join his mother, Emilie, in Paris where, following the death of her husband,

she had gone in order to save the family from penury. In the company of his grandfather, Emile took the train for Paris, arriving in the capital on a bleak February day in 1858.

For both boys the experience of separation was excruciating: "Since you left Aix, a great sadness has engulfed me. . . . I am not myself; I am heavy, stupid, and slow," wrote Paul (April 9, 1858). Emile would write back after having "dipped his body into the waters of the Seine. But there is no worldly pine tree there, no fresh spring in which to cool the bottle, no Cézanne with his immense imagination, his lively and prickling conversation! So to hell with the Seine" (June 14, 1858).[3]

It would be more than three years before Paul joined Emile in Paris. These were the years when he was trying to understand if he should become an artist, or if he should accede to his father's wishes and study law. And what sort of a person would he be, how would he relate to others, and what was he to do with the new feelings he felt within his own body? He wrote erotic poems and languished in the daydreams he concocted about girls. One night, relaxing with a cigar Emile had sent from Paris, he watched the smoke swirl and curl upward as suddenly a vision appeared: "*Tien, la voilà*, it's her, how she glides and sways, yes, it's my little one, she laughs at me, she floats in the whirlwind of smoke, . . . she rises, she descends, she frolics, she turns, but she is laughing at me" (June 20, 1859). From the intense exchange of letters between Paul and Emile (primarily those written by Zola, but he often quotes Cézanne) we know how consumed these young men were with the notion of "virile conquest," whether it was of an imagined girl in a puff of smoke or a victory over a baccalaureate examiner.

Paul's father and Aix tugged in one direction, Emile and Paris in the other. Finally, Paris won—at least for the moment. In the spring of 1861, Paul's sister and his father—who had now found his way up the economic and social ladder from hatter to money-lender to successful banker and landowner— accompanied him on the thirty-hour journey by train to the capital. They intended to make sure Paul found a suitable place to live. Emile did not know he was coming, as we learn from his letter to Baptistin Baille, the third member of the *trios inséperables* of the old Aix gang: "*J'ai vu Paul!!!* I saw Paul, do you understand what melody resides in those three words?" (April 22, 1861). It was a moment of light for Emile Zola in a period of excessive darkness (*une*

vie de misère): poverty, debt, trips to the pawnshop, the end of his first real affair (chronicled in *La Confession de Claude*, Zola's 1865 novel dedicated to Cézanne and Baille). Emile was living in a furnished room—he called his *chambarette* a "real jewel"—in the attic of a building near Saint-Etienne-du-Mont. Paul took a room on nearby rue des Feuillantines, later moving to the rue d'Enfer, but always staying in the neighborhood around the Panthéon. When Paul was settled, M. Cézanne and Marie returned to Aix, leaving him with the promise of a one-hundred-and-twenty-five-franc-per-month allowance.[4]

Paul signed on at the Académie Suisse—from which Claude Monet had recently departed—where he could draw from models, both male and female. They were professionals trained to assume standard poses. With Emile he went to the Salon, and, as he wrote to Joseph Huot in Aix, the experience allowed him to see "what is really the best, because there all tastes and styles meet and clash." He visited "the Louvre, the Luxembourg and Versailles—you know those boring places that contain those admirable works." But it didn't feel right. Paris was too full of agitation. Paris was probably a mistake: "I thought that by leaving Aix I should leave behind the problems that pursue me. Actually I have done nothing but change my abode and they have followed me" (June 4, 1861). By summer's end, Paul was packing his bags. He had been working on a portrait of Emile, who explained in a letter to Baille that when he got to Paul's place for a sitting, he learned the painting no longer existed: "I wanted to retouch it this morning, but it got worse and worse. I destroyed it, and I'm leaving." He finished packing and went back to Aix and took a job in his father's bank.

Paul spent the 1860s unsure of where he should be—Aix or Paris? By the fall of 1862, he was back in the capital and again at the Académie Suisse. There he became close to a slightly younger artist, Armand Guillaumin, and through Armand met Camille Pissarro. This proved to be an important introduction, for some years later the two men would be painting side by side during one of the most critical periods in Cézanne's career. But in 1862 he was floundering. He entered the competition to gain the right to study at the Ecole des Beaux-Arts—it's what his father wanted. He failed.

In 1863, when fellow students at Suisse submitted to the Salon, Paul went along with them, a decision that led to his first exhibition. There it was—a tiny little still life placed almost out of view in the Salon des Refusés. He may have

considered it a good beginning—having his painting in the "Salon of the Out-laws," as the exhibition was frequently called. Like many of his contemporaries, Paul thought the finest thing to be seen in those packed galleries was Manet's masterpiece. He and Emile spent hours together looking at *Le Bain.* It wasn't just the subject they talked about, but all sorts of painterly issues, things like the formidable "interrelationships of tones." Their comments and reflections found their way into print three years later when Emile made his debut as a journalist using the pseudonym "Claude." He saluted Manet for having taken "nature in his grasp and planting it before us, just as he sees it."[5] A few years later, Paul would find his own way to respond to the work as he, too, created a *Déjeuner sur l'herbe,* a dark and mysterious painting in which he himself is the central figure in a drama no one has ever quite understood.

By 1866 Cézanne had met Manet; he had even visited his studio. But as much as he admired his work, he didn't take to the artist: he found this bourgeois Parisian too polished, too quick of wit, too elegant. Manet, in turn, considered the young artist from Aix, with his heavy Provençal accent, as an overly nervous, irascible boor from the country. Monet liked to tell the story about Cézanne arriving at the Café Guerbois on the Grand rue des Batignolles, that select gathering spot for artists—a congregation Cézanne liked to refer to as *les sallauds* (the bastards)—where conversations were dominated by much urbane banter. Cézanne turned to Manet, bowing low and declaring: "I won't give you my hand, Monsieur Manet, I haven't washed for eight days." Another *bon mot* that circulated was Cézanne's answer to Manet when the older artist asked him about what he was submitting to the Salon: "*Un pot de merde* [a pot of shit]" was the quick response.

Cézanne spent the summer and fall of 1868 in Aix. Letters suggest that joylessness ruled over these months. In July he wrote to Numa Coste, another painter from Aix, who was now in Paris: "I have no distractions, except the family, some issues of *Le Siècle* are good for picking up a few new insignificant things. Being alone I find it difficult to venture to the café." Fortuné Marion confirmed the feeling we find in Cézanne's letter when he wrote to their mutual friend Heinrich Morstatt, a German musician: "I spend evenings at Paul's in the country. . . . We dine. We take a little walk. We don't get drunk. All that is very sad." By the end of the year Paul was back in Paris. It was the seventh time he had made the journey.

Sometime after Paul's return to Paris, an encounter took place—we know neither where nor how—that must have altered the course of his usual flirtation with despair. He wrote to Marie in 1869 that he had met a *jeune fille,* and he was in love.

History has no knowledge of her name until it appears on a document in the *mairie* of the Fifth Arrondissement in Paris in January 1872, when a child was born "of masculine sex on the fourth of the month at two o'clock in the morning at 45, rue de Jussieu and has been presented to us, son of Paul Cézanne, thirty-three-year-old painter and of Hortense Amélie Fiquet, twenty-two years old, without profession, not married."

From the portraits Cézanne painted of Hortense Fiquet we know her as a sometimes handsome, sometimes plain, brunette with large dark eyes. Her stature, the steadiness of her gaze, her perfect oval face, and a simple slow determined grace must have been among the initial qualities that attracted Cézanne's eye, but there had to be more than that. Without doubt he was glad that she was not one of those terrible Parisians. She was young, and perhaps she didn't have too many ideas contradicting those which he held so strongly. We do know, however, that she was fond of talk and quick to enter into conversation. Whatever it was about Hortense Fiquet, she did not excite Cézanne's innate hesitancy about women (even if he did think about them a great deal).

And what did she see in him—this blunt, graceless, balding fellow with a thick, dark beard? We have a good idea of the physical man who stood before her, not only from his self-portraits and from photographs, but from Zola, who, in the notes he made in preparation for writing *Le Ventre de Paris* (1873), indicated that his painter, Claude Lantier, was based on Paul: "a slim young man, with big bones and a big head. His face was bearded, and he had a very delicate nose and narrow sparkling eyes. He wore on his head a rusty, battered, black felt hat, and was buttoned up in an immense overcoat, which had once been a soft chestnut hue, but which rain had discolored and streaked with long greenish stains. Somewhat bent, and quivering with a nervous restlessness which was doubtless habitual with him, he stood there in a pair of heavy laced shoes, and the shortness of his trousers allowed a glimpse of his coarse blue hose."[6] In other words, he was one of the most inelegant men about town. Cézanne dressed badly, was sloppy, didn't keep his beard and hair trimmed.

When Auguste Renoir met Cézanne in the 1870s, he thought he "looked like a porcupine." Hortense probably found his strong Aixois accent a little odd. His rough language was something Renoir took note of, commenting that it contrasted sharply to the rather exaggerated polite manners that Cézanne seemed to effect. Hortense would have understood right away that Cézanne was well educated. Given the eleven-year difference in their ages, perhaps it was the quality of an older man's strength that made the liaison desirable for a young woman alone in Paris. How soon was it before she understood his strange combination of enormous self-reliance and terrible insecurity? She must have also seen the tender side of Paul's character. And certainly she wondered why he lived on the fringe of society, even somewhat at a distance from the artistic community of which he was supposedly a part. And it can't have escaped her that he was not having much success. But somehow Hortense, a provincial girl without means, semi-adrift in the nervous, sophisticated, fast-paced world of Second Empire Paris, recognized that this man was powerfully drawn to her. That counted for a lot.

Paul's willingness to take a girl into his life may have been stimulated by Emile who had set up housekeeping with a girl called Gabrielle. Paul liked her, and when he wrote from Aix he never failed to include a warm greeting for Gabrielle. On May 31, 1870, Emile and Gabrielle, who had now taken back her birth name—Alexandrine—were married. The ceremony took place in the *mairie* of the Seventeenth Arrondissement. Zola called on his four best friends—all comrades from Aix—to serve as their witnesses: Cézanne; the sculptor Philippe Solari; and two writers, Paul Alexis and Marius Roux. After the ceremony there was a simple lunch with close friends. Hortense is never mentioned, but she was almost certainly there.

How was it for Hortense to be in the company of an artist? She surely was no more attracted to Paul's work than Christine Hallegrain had been to Claude Lantier's canvases. Just before the couple met, Cézanne had painted *The Rape, The Murder, The Orgy,* and *The Abduction,* works in which we discover a deep preoccupation with the perennial antagonism between men and women. These paintings are shot through with sexual violence of a kind distinctly different from the refined eroticism the public was used to seeing in the annual Salons.

Examples of one kind of painting Cézanne was doing in the period when

he met Hortense can be seen in three small works: *The Temptation of Saint Anthony, Pastoral* (also called *Idyll*), and *Déjeuner sur l'herbe.* They give form to Paul's personal struggle with his sexuality. In *Temptation of Saint Anthony* the balding saint is pushed into the far left corner of the canvas as he fends off the invitation of a naked woman, her bosom thrust forward, her long dark tresses falling back. The central section of the painting contains a triumvirate of nudes—buttocks, breasts, bellies, thighs galore. At least one authority on Cézanne's early works has indicated that she sees an affinity between the standing nude in the center and portraits of Hortense, and she interprets the work as related to the momentous change that had come about in Cézanne's life: his physical involvement with a woman.[7]

In *Pastoral* we are introduced to a dark scene by a river, the setting for three men, all clothed, and three women, all naked. Our thoughts turn to Manet's *Le Bain* that so provoked Salon goers in 1863, of which this work is a mocking echo. The women—to whom the men pay no attention—are depicted on a slightly larger scale than the men. It has frequently been pointed out that the three men bring to mind the triumvirate—Cézanne, Zola, and Baille—the three friends who spent their youth luxuriating on the banks of the river Arc. The most prominent of the three is the bearded man in black who spreads his body out on the edge of the hillside and who looks very much like Cézanne himself. And Cézanne the painter has molded the vegetation along the riverside into one phallic shape after the next, thrusting here, thrusting there. The British painter and art historian Lawrence Gowing viewed this as a "new genre of triumphant emotional allegory at the very moment that Hortense Fiquet enters his life."[8]

Again in a pastoral mode, Cézanne portrayed a real picnic, complete with four persons gathered around a white tablecloth. It's called *Le Déjeuner sur l'herbe.* Was it Cézanne's title? We can't be sure, but we do know that when Manet mounted his one-man show in 1867, he hung *Le Bain* as *Le Déjeuner sur l'herbe,* and we know that competition with that illustrious trailblazer whom he admired and resented at the same time was very much on Cézanne's mind. Under a steel blue sky, four characters gather around a picnic cloth, while a dog and a man look on. Three oranges are the only food in sight, and one of them is in the hand of a large-breasted woman with a mournful face and a mop of golden hair falling down her back. She is dressed in a blue gown, tied in the

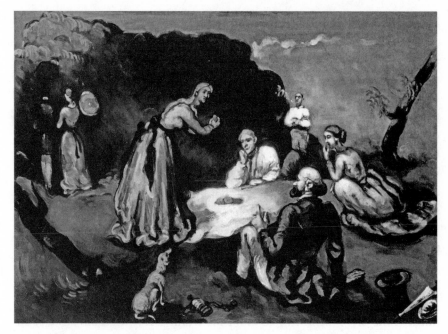

Cézanne, *Le Déjeuner sur l'herbe,* c. 1869–70. Private Collection

back with a long black sash. She looks directly at the man seated somewhat precariously on our side of the picnic cloth. He wears a black frock coat and light pants, and his top hat has fallen on the ground behind him. The balding head and thick dark beard again betray the presence of the artist himself. An intense exchange of gazes is taking place between the artist and the girl with the golden hair holding the orange. She hesitates. Should she give him the fruit or will she keep it for herself? He raises his left hand, index finger extended. The onlookers—including the dog—focus on the exchange being negotiated before their eyes. We find the outcome of the encounter taking place in a second scene in the far left corner of the picture as the frock-coated figure, top hat now firmly on his head, leaves the garden with the temptress as the couple enters a dark and unknown place. Cézanne has not painted a scene that brings to mind the pleasures of enjoying a pastoral setting. Rather it is haunted by the intimation of sexual curiosity, desire, expectations, and fear under a cold sky, with onlookers acting as witnesses to the principal player's conundrum.

Sometime in June, after the Zola wedding, Paul and Hortense left for

Provence. Paul surely stopped in Aix by himself, but the couple was headed for l'Estaque, a village on the Mediterranean coast, some twenty miles south of Aix. They were in l'Estaque by July 18, the day on which Napoleon III issued the orders for France to mobilize, orders followed by a declaration of war against Prussia. As the boulevards of Paris were echoing with cries of "Vive la France!" and "à Berlin!," Cézanne and Hortense settled into a fisherman's cottage on the place de l'Eglise. They seemed to be placing themselves at as much emotional distance as they could from the catastrophic adventure presently altering the course of French history. The cottage was available thanks to Paul's mother. She paid the rent. And she knew about Hortense, and surely shared her son's belief that it was important to keep Louis-Auguste Cézanne from finding out that that his son was now living with some girl he had met in Paris.

On September 1, 1870, the Emperor was defeated at Sedan, a small city on the Meuse River in the Ardennes. Rumors about the disastrous finale of this ill-begotten war reached Paris over the next couple of days as the Empire crumbled away. By September 4, its demise was total. A mob invaded the Palais Bourbon, stopped the Corps Législatif from holding a session, and, in a carnival-like atmosphere, marched across the river to the Hôtel de Ville, where the populace proclaimed the Republic.

In a quick note, Zola wrote to Edmond de Goncourt: "My wife is so frightened I have decided she must leave. I shall accompany her." On September 8, the three Zolas—the newlyweds plus Emile's mother, Emilie—left for l'Estaque, having succeeded in getting out of Paris just days before the Germans began their siege. Cézanne arranged for a place where the Zolas could stay, but in no time at all Emile came to the realization that the quaint village of l'Estaque held no charm for him. Further, his bride was not enthusiastic about the company of Hortense and Paul. Within a matter of days the Zolas moved to Marseille.

Paul was dividing his time between painting scenes of the village and the harbor and working in the little studio he had established for himself. He also spent days at a time in Aix. Friends spoke of Cézanne and Hortense in 1870–71 as "hiding out." In January, Marius Roux wrote Zola that Paul was now considered a draft dodger—the authorities had been looking for him at his mother's house. Paul Alexis wrote to Zola for news of Cézanne, in particular he wanted to know, "What has he done with his wife?" (February 9, 1871).

By September the Prussian troops had surrounded Paris. During the hard winter that followed, starving Parisians could think of little but their stomachs. They discovered that rats could be eaten. Butchers turned their sights on the zoo. The armistice—many called it the capitulation—was signed in January 1871, but the provisional government did not return from Bordeaux until March, and when they returned to the north it was not to Paris, which was full of mobs capable of revolt against the government, but to the safety of Versailles. Their fears of the Left were given validity on March 18 when government troops tried, but failed, to remove the cannons set up in Montmartre by left-leaning Parisians in the National Guard. It was the spark. The next move was taken by the citizens of Paris. They proclaimed their own municipal government, calling it "the Commune."

Once the government was set to return, Zola felt it safe to bring his wife and mother back to Paris. They arrived on March 14, making their way on foot from the Gare de Lyon to their house on the rue de la Condamine in Batignolles, which had been inhabited by refugees in their absence. Four days later, along with every other Parisian, they would experience the drama that took place when government troops stormed Montmartre in order to take back their cannons from the National Guard. In the process of doing so, the troops set off a bloody revolution in Paris that was to last until May 28. When it was all over, Emile wrote a long letter to Paul describing something of what he had been through: "For two months I lived in a furnace, cannons going off night and day; toward the end shells whistled over my head in the garden. Finally, on May 10, I was threatened with being taken as a hostage. I fled with the help of a Prussian passport (the Prussians still controlled the outskirts of Paris to the north), and I left for Bonnières where I passed the worst days. Today I find myself peacefully in Batignolles; it is as if coming out of a bad dream." Emile's letter was emphatically positive: "Never did I have more hope or a greater longing for work. Paris comes back to life. It is, as I have often told you, our reign that now arrives" (July 4, 1871).

As Emile gloried in the return of life to Paris, looking forward to the coming of "our reign," Paul and Hortense, still in L'Estaque, were dealing with a very different kind of promise for the future: Hortense was three months pregnant.

Perhaps Paul and Hortense felt they had more friends in Paris to call

upon should their new situation put them in need. In any event, they did not want his parents know about what was taking place in their lives. Sometime in the fall, they returned to the capital. Philippe Solari wrote to Zola in the middle of December that the Cézannes were with them in his apartment near the Jardin du Luxembourg. But by the New Year, Hortense and Paul were settled in rooms of their own on the rue Jussieu in the familiar Fifth Arrondissement, across the street from the *Halle aux vins.* We might imagine the couple in these last months of Hortense's pregnancy, walking the streets of Paris, heading for the center around the river and contemplating the buildings they knew so well: the Hôtel de Ville, the Palace of the Tuileries, the Cour de Comptes, the Vêndome Column, so many treasures of the beautiful city, all in ruins from the destruction caused by the Commune.

Not surprisingly, Paul was doing very little work, but he did paint the view from their window on the rue Jussieu. Presumably he worked on a Sunday morning, for there's not a soul in sight—just a wall, a ramp leading up to the storage area, a shed, a row of trees, and dozens of wine kegs. The scene, with the exception of a few red kegs, is uniformly brown and gray, its leaden sky speaking to the dreariness of a winter morning, and perhaps the somberness of Paul's spirits in this uncertain time.

The child was born on January 4, 1872. Paul went immediately to the mairie to declare the birth and to acknowledge the child as his, exactly as his own father had done when he was born. He too would be "Paul Cézanne." It's generally agreed that the letter Paul sent to Achille Emperaire, painter and old friend in Aix, in which he asked Achille to take an enclosed letter to his mother, was to let her know of the birth, while keeping the fact a secret from his father.

Achille, a dwarf with a wizened body, was someone to whom Paul felt very close. The artist immortalized his friend in a remarkable portrait that he had submitted to the last Salon of the Empire. It had been, as usual, rejected. Later in January, Paul wrote a second letter to Achille, to give him news of a recent visit from Emile—surely to have a look at the new baby—during which Emile spoke of finding a way to enable the destitute Emperaire to come to Paris. Paul said he could stay with him on the rue Jussieu, although he pointed out that Achille would not find it very comfortable. Paul planned to meet him at the train with a cart, after which together they would make their way on foot to "my cubbyhole."

We know nothing of either the physical or mental condition of Hortense in these months. Did she come through the birth alright? Was she as happy as Paul was with their baby? They were now three living on Paul's allowance, which had been meant for one. Further, there was the prospect of another adult staying with them. Whatever hospitality Hortense provided, it was not appreciated. In letters to friends back in Aix, Achille wrote: "Paul is badly set up, and besides that there is so much noise [from the Halle aux vins or from the baby?] it could wake the dead." By the end of the month the whole thing was too much for him: "I'm leaving Cézanne—it's necessary. . . . I find him abandoned by everyone. He hasn't a single affectionate or intelligent friend left—the Zolas, the Solaris and others. They're not there anymore."

There is reason to doubt the accuracy of the ungrateful guest's last sentence. For one thing, January 1872 is the month in which Zola began writing *Le Ventre de Paris,* in which he fashioned his painter Claude Lantier—one of the novel's most sympathetic characters—after Paul.

Nevertheless, the situation for the new parents was bleak. Their rooms were too small for a claustrophobic man like Paul Cézanne. And it was impossible for him to work. Further, as a father, he was plagued by intense feelings of responsibility. To add to his distress, he was terrified that his father would find out about Hortense and the baby. Such a discovery he was sure would result in the end of his allowance, since, after all, a head of a household ought to be able to support himself, as well as his dependents.

TWO

Single Mother

Camille Pissarro, Paul's friend from the Académie Suisse, was the person who rescued the little family. Pissarro, an artist rejected at the annual Salons almost as frequently as Cézanne, had taken his wife and children to London when war broke out. Upon returning to their home in Louveciennes after the war, they found that their house, having been used by the Germans as a barracks, was now a wreck. An extraordinarily generous homeopathic doctor and a passionate art collector, Dr. Paul Gachet, now came to their aid by finding them a place to live in Pontoise, a town to the north of Louveciennes and somewhat farther out from Paris. Pissarro now urged Cézanne that he, too, should bring his family to Pontoise.

In the summer of 1872, six months after the birth of their child, Paul and Hortense made the move. They settled into a room in the Hôtel du Grand Cerf in Saint-Ouen-l'Aumône across the river Oise from Pontoise. The hotel owner was Edouard Béliard, a painter and a good friend of Zola's. Cézanne and Béliard would occasionally paint in each other's company, and they looked forward to visits from Zola and his wife.

In the fall, Dr. Gachet proposed that Paul bring his family to Auvers-sur-Oise, about five miles up the Oise from Pontoise, where the doctor, his wife, and their sons had been living since the previous spring. Unlike Pontoise —which was a real town—Auvers was a simple village of unpaved country lanes and thatched cottages. At a cost of only a hundred francs a year Cézanne rented a tiny place in an alleyway two steps from Dr. Gachet's house. In spite of its restrictive size the dwelling sufficed for his intention was to spend most of his time painting out of doors. He set up a regular working schedule with

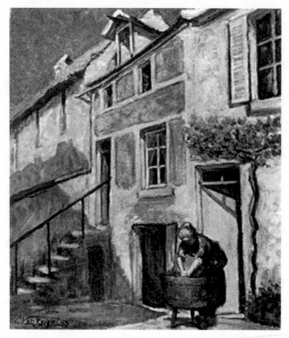

Louis Van Ryssel (Paul Gachet), *Cézanne's House
in Auvers-sur-Oise,* 1906. Private Collection

Pissarro—"en plein air—d'après la nature," a new experience for the younger
artist. Cézanne listened and watched his patient friend, and found in the pro-
cess alternate ways to put paint on canvas. As he discovered he could live
without blacks he lightened his palette and explored putting large masses of
color on the canvas. And he learned to paint slower. The picturesque cot-
tages of Auvers, the chimneys, roof edges, trees, hills, and dusty paths were
perfect subjects. His new canvases were about *place,* and they did not include
people.

Pissarro's oldest child, Lucien, was nine years old when Cézanne entered
their lives. Later he would write about the strange figure who arrived each day
to work with "Papa," a man in "a vizored cap, with long black hair straggling
down his back, yet bald in front. He had large black eyes that rolled in their
sockets at the least excitement. He used to walk armed with a long pikestaff
that frightened the peasants a little."[1]

Cézanne enjoyed his new life in Auvers. When not painting with Pissarro, he might be found at the Gachets. Paul Gachet fils described these visits in the book he wrote about his father and the people who surrounded him in Auvers.[2] He remembered Cézanne's evenings at their house, how the artist loved listening to Mme Cachet play the piano, but most of all how he liked sharing confidences with the doctor, with whom he was able to speak about his anxieties, and "his projects, his hopes and worries." Gachet's only reference to Hortense was that "she seldom appeared." Paul Cézanne was now happier and calmer than he had been in years, but for Hortense it must have been becoming increasingly clear that an aspect of this partnership was how much time she would spend alone with her child.

It wasn't only Pissarro and Gachet who provided newfound companionship for Cézanne. Pissarro was surrounded by several other younger artists who were blossoming under his tutelage. Among them was Armand Guillaumin, with whom Cézanne had felt a sympathetic kinship ever since meeting him at the Académie Suisse. Paul was almost at ease in this company. It reminded him of his youth at the College Bourbon in Aix, the excitement of new discoveries in the company of like-minded fellows. One of the most frequent subjects of conversation when these men got together was the problem of how to get their work into the public eye. Early in 1872, around the time Paul and Hortense arrived in town, Pissarro was putting together a petition asking the new government to hold another Salon des Refusés. Twenty-six artists signed, Manet's name being the most prominent. Cézanne happily appended his name. Their effort went nowhere.

The following year, a group met at the home of Claude Monet in Argenteuil. Pissarro and several others from Pontoise were present, although Paul did not accompany them that day. The discussion went in a new direction. Again, Pissarro's ideas held great weight; he got them to consider the notion of a democratic society along the lines of the baker's union in Pontoise. Membership would be open to anyone ready to pay sixty francs a year, and each man (or woman) had equal rights. The goal: an exhibition of independent artists. Having never seen one of his own works in a public space, save the still life that no one looked at in the Salon des Refusés, Paul was eager to be a part of the new society.

We can feel something of the penury of Paul and Hortense's lives in a

note Paul wrote to their grocer: "In a few days I shall be leaving Auvers in order to settle in Paris." They owed M. Rondès a considerable sum of money, and the grocer had began to doubt he would ever be paid, so Gachet gave him some advice: "If he proposes to pay you with a painting, accept. If he doesn't propose, ask for it," which apparently is what the grocer did, for the note continues: "If you want me to sign the painting of which you spoke to me, would you leave it with Pissarro and I shall add my name."

By January 1874, Paul, Hortense, and their two-year-old son were back on the Left Bank in a small two-story house at 120, rue de Vaugirard, in the Seventh Arrondissement. It may have been the anticipated exhibition of independent artists that lured Cézanne back to Paris. Thirty artists had signed on, including Monet, Pissarro, Degas, Berthe Morisot, and Renoir. The group's biggest disappointment was Manet's decision not to participate. Publicly he stated that he believed professional artists should exhibit "only in the Salon." Monet circulated the idea that his refusal might have been his reluctance to hang his works in the company of Cézanne, for the sophisticated Parisian considered the work by the painter from Provence to be as repugnant as his manner and his appearance.

Plans proceeded to hold the exhibition right in the heart of the most active part of the commercial district on the Right Bank. The artists rented a studio formerly occupied by the photographer Nadar. They would open two weeks before the Salon and run the show an additional two weeks, so that it would still be on view during the first weeks of the government exhibition. By late January, notices that such an exhibition was in preparation were appearing in newspapers and in art journals.

At exactly this moment, a letter came from Paul's parents. The letter no longer exists, but a draft of Paul's reply lets us know in no uncertain terms what it was about: Paul—who had been away for almost three years—should come home. In his letter he was at pains to explain why he hesitated to do what they wished: "Once I am in Aix, I am no longer free and when I wish to return to Paris, it means a struggle, and although your opposition to my return is not absolute, I am very troubled by the resistance I feel from you." He then offered to make a deal: were "Papa" to raise his allowance to two hundred francs a month, he could then consider a longer stay in Aix. We know why he needed more money, but his father did not. Paul would continue paying rent

for the house on the rue de Vaugirard and sending small sums to Hortense and their son.

The exhibition opened its doors on April 15 and lasted for one month. Cézanne entered three paintings: a landscape simply called *Auvers,* plus *The House of the Hanged Man, in Auvers-sur-Oise* and *A Modern Olympia.* A painting showing a cluster of houses grouped within an intensely green landscape, or one of a steeply pitched dirt lane with thatched-roofed cottages on either side (*The House of the Hanged Man*), was not so unusual, although both the composition and the way Cézanne had used his palette knife to plaster the paint onto the canvases in thick layers must have seemed exaggerated or sloppy. People certainly wondered about the strange and gloomy title for his second submission.[3] But what really set people's teeth on edge was the small painting called *A Modern Olympia.* The reference to Manet's *Olympia,* seen in the Salon of 1865 and cause of even greater scandal than *Le Bain* (*Le Déjeuner sur l'herbe*) in 1863, was all too clear. It had all the same elements: a naked courtesan, a Negro servant, flowers, and a four-legged black creature (here a dog, not a cat). But there were major additions. We are presented with a complete setting for an upper-class courtesan's boudoir. A client is seated on an overstuffed couch, his top hat tossed on the seat behind him, his cane still in his hand. His gaze is fixed on the blond charmer before him as her servant removes the white cloth from her mistress's body, her pink flesh suddenly appearing in all its radiance. She brings her knees to her chest as if surprised to be so suddenly revealed to the visitor who peers at her with such intensity. The little dog, too, is riveted by the appearance of the naked lady and stands at attention, his tail erect, wagging like an active phallus. Of course, *we* recognize the heavily bearded client with a bald pate—although few who saw the exhibition would have been able to—as the painter himself. It's the same figure we saw in the painting of the picnic (*Le Déjeuner sur l'herbe*) of a few years earlier, again with his dark frock coat, his top hat, and his dog. There is none of Manet's cool here. This is about the sweaty anxieties accompanying the temptations of the flesh.

The little painting—it measures less than two feet across—was a recent work. Dr. Gachet had already purchased it, and it pleased him to lend it to the exhibition. The work brings Cézanne's mixed feelings about Manet ever more clearly into view. It pays homage to the formidable leader of the younger

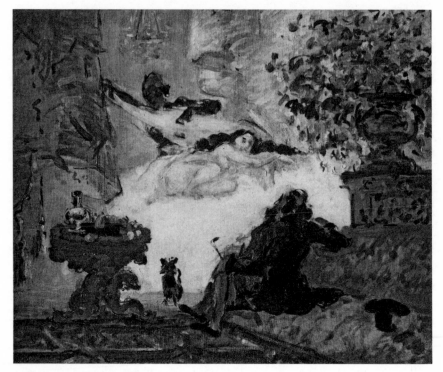

Cézanne, *A Modern Olympia*, 1873–74. Paris, Musée d'Orsay

artists working in the new style at the same time that it presents a critique of the absent Manet, as it shows an alternative view of what the new style might be. Cézanne explored an altered sense of scale, space, and color, placing vibrant and luminous hues over the canvas with lively impressionist brushstrokes.

Hortense surely hated the painting. Here was the father of her child presenting himself as a voyeur. He is contemplating the idea of "a woman" in a strange bordello-like dream. His presence in the place is for looking, not for touching. He is fascinated, but also unsure, thus he sits and stares while the dog does the tail-wagging. What could Hortense have thought when she recognized what the scene was about? As for myself, *A Modern Olympia* makes me think about Cézanne's sad confession many years later to the young painter Emile Bernard about his inability to suffer the touch of another human being —"I cannot bear being fondled or having physical contact with anyone."[4]

And he emphasized that it was an old story with him. Hortense knew this story too.

Nearly two hundred people showed up for the exhibition on opening day. The attendance was small compared to the thousands of visitors who struggled to find space in the galleries of the Salon two weeks later. Nevertheless, from April 15 until it closed, the show was never empty. Some fifty notices appeared in the press, and even critics most opposed to the new tendencies usually were able to find some work that they thought worth writing about in a positive fashion. Such was not the case, however, when they got to Cézanne's submissions, and especially to *A Modern Olympia.* Cézanne would bear the brunt of the most hostile reviews that anyone wrote about the exhibition:

"No known jury has ever, even in its dreams, imagined the possibility of accepting a single work by this painter, who used to present himself at the Salon carrying his canvases on his back, like Jesus Christ carrying his cross." (*Le Rappel,* April 20, 1874)

"Do you remember the *Olympia* of M. Manet: Well, that was a masterpiece of drawing and accuracy, compared to the one by M. Cézanne." (Louis Leroy, *Le Charivari,* April 20, 1874)

"On Sunday the public saw fit to sneer at a fantastic figure revealed under an opium sky to a drug addict. This apparition of a little pink and nude flesh being pushed in the empyrean cloud by a kind of demon or incubus [is] like a voluptuous vision. This corner of an artificial paradise has suffocated the most courageous viewers. M. Cézanne gives the impression of being a sort of madman who paints in delirium tremens." (Marc de Montifaud *L'Artiste,* May 1874)[5]

Zola did make a small attempt to bring solace to his friend by *at least* mentioning him in his review for *Le Sémaphore de Marseille* (April 18). He made reference to "a remarkable landscape by M. Paul Cézanne, one of your compatriots, an Aixois who has been provided with great originality and who has struggled for a long time."

It was Cézanne's first real public appearance—the small still life in the Salon des Refusés hardly counted. Although there are various indications that

in Paris he occasionally adapted to the role of artist-provocateur marching in the footsteps of Courbet and Manet, he was profoundly affected by the negative response to his work in the first exhibition of the independent artists. When the show closed, without a word to any of his friends—even to Pissarro—he left for his parents' home in Aix. Hortense remained in Paris with their son. This would begin what was to become a major part of her life, that of single mother.

Sixty Francs for Hortense

The dean of Cézanne studies, John Rewald, believed that Hortense Fiquet's entrance into Cézanne's life did "not appear to have influenced either his art or his relationship to his friends."[1] Writers often imply that once a son was born to Paul Cézanne, his romance with Hortense was over. Certainly during the period when the couple lived in Auvers, Cézanne was fully focused on how to advance in his chosen way, setting about to create as many works as possible. It was a period of acquiring new technical skills, of investing his energies in landscape and the world around him, especially when in the fields or on country roads with Pissarro. Further, he loved his exchanges with other artists about what it meant to be a painter working in the new style and fighting to get their work into the public eye.

Hortense was in the background, but she was there. The most interesting visual evidence of this comes to us in the form of a tiny oil painting (approximately eight square inches). It's an unusually tender portrayal showing a mother in a pink nightgown which has been pushed down to her waist, thus exposing her breasts. Her lower body is covered with a brown blanket as she nestles, half asleep, into a white pillow and nurses her son. Hortense's presence in this painting is not so much about Hortense in her role as model as it is about the new life of a family.

She becomes "the model" in two other paintings, also probably done in Auvers. In both she arranged herself in a chair resting an elbow on a table, holding her perfect oval head erect, hair parted in the middle, as she quietly glances downward. She wears a high-necked, long-sleeved fashionable bourgeois dress and sits stiffly in a manner we associate with sittings for early

Cézanne, *Hortense Nursing*, 1872

photographic portraits. These paintings are the modest beginnings of the new partnership. More interesting is a single sheet of drawings, also done around this time, containing four little Pauls, from back and front, left and right, and two Hortenses. These images are our first glimpse of her face in any real way. We encounter the directness of her dark-eyed gaze under cleanly shaped eyebrows, the quiet serious expression that seems to have almost never left the face of Hortense as captured by Cézanne. Here, too, is her basic hair style with its central part, the rest of her long dark tresses pulled to the back of her head and knotted in a bun.

What did this couple think they had embarked upon? Certainly their thoughts on the matter were profoundly different. Since the birth of their child, did Hortense feel more secure that now he would not abandon her? We know that Cézanne was thrilled to have a son, but was Hortense? We know nothing of that. If we look back on some of the ideas Cézanne expressed when he was younger—in the period when he and Emile were both reading books by Michelet such as *L'Amour* (1858) and *La Femme* (1859)—we find a contrast between Emile's endorsement of the historian's sense of woman as goddess to be humbly worshipped by a man and Paul's more dubious notion that pure

and noble love "may exist but it is rare" (Zola quoting Cézanne in a letter to Baille, January 14, 1860). But Paul had plenty of fantasies. He dreamt of having a studio in Paris, a woman at his side to aid him as his creative energies were awakening. Once he wrote to Emile about a particular girl: "Should she not detest me, we would go to Paris together. There I would make myself into an artist. We would be happy together" (June 20, 1859). By the following month, his fantasy had altered—the girl was no longer a local but instead had become a Paris girl: "I dreamt that I held my Lorette[2] in my arms, my Grisette,[3] my darling, my saucy imp, that I patted her buttocks, and a few other things besides" (July 1859). Hortense Fiquet was not Paul Cézanne's "Lorette."[4] By the time he was thirty or thirty-one—Paul's age when he met Hortense—his ideas were no longer quite so bohemian, and the images he made of Hortense portray a discretely dressed bourgeois woman.

Cézanne spent the summer of 1874 at the Jas de Bouffan, his father's beautiful thirty-seven acre estate outside of Aix. It wasn't just family that had drawn him there; the place itself had a profound hold on him. Presumably Hortense and young Paul remained in the house on the rue de Vaugirard. Late in June, Cézanne wrote to Pissarro: "I've been weeks without news of my little one and that makes me very worried." It's clear he had not left them. He would return, he would always return for his son, but also he would return for the face and figure of Hortense Fiquet.

Cézanne was fascinated by the problems of portraiture. In his lifetime he painted about one hundred and eight of them, including thirty-six self-portraits. When he was not looking in the mirror, his favorite sitter was Hortense. We know at least twenty-seven paintings for which she served as model. Even more frequently he drew her face. We might expect that such a large number of paintings of one particular French woman in the last quarter of the nineteenth century would supply a certain amount of information about the individual depicted. But such is not the case, for none are dated, and there is basically no narrative content in any of them. They are first and foremost paintings betraying subtleties of style that lead us to analyze forms, colors, and compositional organization. It's very easy to engage with these aspects of Cézanne's creativity and to think very little about the sitter. But after looking at many of the originals and at all of the portraits in reproduction, I find I have a powerful feeling for Hortense, for her calm grace, her lack of

exaggeration, her consistency, and especially for her patient willingness to be there.

To sit for a portrait for Paul Cézanne was not something anyone ought to have wished for. Think of how Zola felt in the summer of 1861 when he showed up to take his seat in the model's chair for the portrait Paul was painting of him, only to learn that the work had been smashed and that Paul was getting ready to leave town: "I wanted to retouch it . . . it got worse and worse. I rubbed it all out, and I'm leaving."

It's the first such story we know, but far from the last. After Gustave Geffroy treated Cézanne's work kindly in a review, the painter proposed that he do a portrait of the critic: "He came to my place in Belleville almost every day for almost three months," wrote Geffroy, who regarded the result as one of Cézanne's best. When Cézanne had reached the point when only the face remained to be finished, "one morning he sent for his easel, his brushes, and his paints, writing me that the undertaking was beyond his strength and that he had been mistaken to take it on."[5]

Ambroise Vollard, Cézanne's dealer at the end of the century, was very eager to have a Cézanne portrait of himself. When he spoke to the painter about this possibility, "He consented at once, and arranged a sitting at his studio in rue Hégésippe for the following day. Upon arriving, I saw a chair in the middle of the studio, arranged on a packing case, which was in turn supported by four rickety legs. I surveyed this platform with misgiving. Cézanne divined my apprehension. 'I prepared the model stand with my own hands. Oh, you won't run the least risk of falling, Monsieur Vollard, if you just keep your balance. Anyway, you mustn't budge an inch when you pose!'" Their sessions began promptly each morning at eight. Vollard frequently found that after a while he would become drowsy and his head would drop. When that happened Cézanne would pounce, shouting, "You wretch! You've spoiled the pose. Do I have to tell you again you must sit like an apple?" And Vollard tells us it wasn't just his shortcomings as a model that might spoil a day's work: the weather had to be just right—that perfect "clear gray" sky—and there should be no untoward noises in the street like barking dogs or the mechanical sounds of pile drivers. "After a hundred and fifteen sittings [surely Vollard exaggerates], Cézanne abandoned my portrait to return to Aix. 'The front of the shirt is not bad'—such were his parting words."[6] The younger painter Maurice Denis

noted in his journal, following a conversation with Vollard, that whenever Vollard moved, Cézanne would complain "that he makes him lose his *ligne de concentration*" (entry of October 21, 1899).

There are no records of the hours Hortense put in over three decades of work as Cézanne's model. Did he shout at her? Probably. Did she hurl back abuses, or just grumble? She was his best model. He loved that perfect oval face with its big eyes. He called her "la boule" (as in "ball and chain")—or was it Zola who first came up with that unpleasant moniker?—but he came back to her, over and over again. Hers were the body and face he wanted, and he wanted her sitting in a chair, hour upon hour, making not a single move.

Without dates on paintings, without documents concerning the time or circumstances of their creation, and with few clues within the paintings themselves, what are we to do with this mass of material? Scholars, especially Lionello Venturi and John Rewald, struggled to interpret Cézanne's stylistic development, thereby assigning dates to the works in their catalogues raisonnés.

Also interesting is the work of Anne van Buren. As a graduate student at the University of Texas in the 1960s, she examined the portraits of Hortense as a group—something no one had done before—and realized the one element that was in constant change (besides that of Hortense's face, which actually didn't change that much) was what Hortense wore. It became clear to Van Buren that, like most French women, Hortense did not want to be out of fashion. Thus the dresses we see in the paintings give some clue as to when they were done. Van Buren shows how Hortense's dresses echo, albeit in simplified fashion, those that could be seen in magazines such as *La Mode illustrée*. We know this journal was around the studio, as Paul used the back of one of the *La Mode* illustrations as a drawing surface. If, as has been suggested, Hortense worked as a book binder, she might have had the skills to make her own dresses—a good thing, since she was in no position to take herself to one of the new department stores in Paris to select fabrics, and then to instruct a *modéliste* on the kind of dress she wished to have made.

The two earliest portraits mentioned above show Hortense seated and centered in the picture frame, each representation cut off at approximately the level of her knees. The dresses are perhaps the most notable elements in the paintings. Van Buren calls them *robes de promenade*, that is, dresses with simple

overskirts that fall loosely when worn around the house, but which could be pulled up and fastened into a bustle upon stepping out into the street. They have slightly puffed sleeves, tight at the wrists, and are pulled in at the waist. The paintings, however—particularly the earlier of the two (present whereabouts unknown)—are not very interesting, nor do they depict the Hortense we have come to know.

That Hortense shows up for the first time in a small group of portraits generally dated around 1877. In the fall of 1876, Cézanne moved his family into an apartment in the Fourteenth Arrondissement of Paris at 67, rue de l'Ouest. It was a new area of the city, just south of the Cemetery of Montparnasse. The cadastre describes their fourth-floor walk-up as having an entrance, a kitchen, a living room, and a second room *avec feu,* that is, with a stove. It was listed at 270 francs annually, but Cézanne managed to get it for 230 francs, and they stayed there through the spring of 1879. Lawrence Gowing has estimated that Cézanne painted as many as twenty-two pictures in this apartment.[7] Gowing based his estimate on the appearance in these works of their distinctive apartment wall, which was covered with an olive-yellow wallpaper with a blue lozenge pattern.

For an artist of Cézanne's temperament, living and working in such a small space, with a woman and a child constantly present and capable of creating every sort of distraction and disturbance, was difficult at best. It couldn't have been any better for Hortense. Yet, in this less than ideal situation, Cézanne painted one of his most beautiful portraits of her: *Madame Cézanne in a Red Armchair.* He had Hortense assume a frontal pose, and at first you hardly think about her face because her body—the bulk and placement of it—is so commanding. One hand slips into the other—not exactly in her lap, but suspended above it—and then he drew red pigments across her fingers, strengthening the hands as a focal point at the center of the painting. Yet it's not the center, for Hortense has shifted her body to the right side of the chair, giving the large area of red to her left enormous power and creating a tension within the canvas which is almost completely filled by figure and chair. The thick, rounded curve of the chair's back and the curve of Hortense's jacket swelling over her puffed-out, striped skirt echo each other and, along with her hands, control the composition. To Hortense's right, Cézanne allowed enough space between chair and picture frame that we know that this is their living

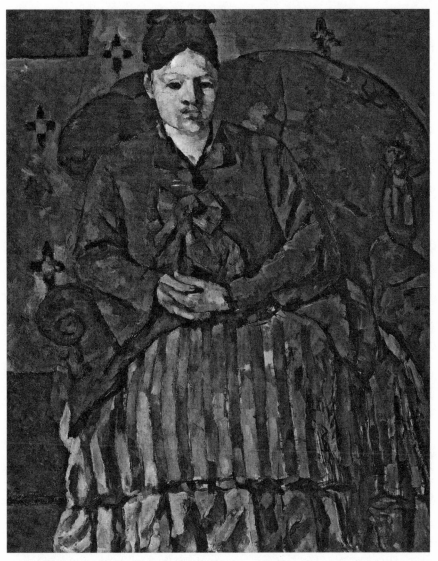

Cézanne, *Mme Cézanne in a Red Armchair*, c. 1877. Oil on canvas, 72.4 × 55.9 cm.
Boston, Museum of Fine Arts, Bequest of Robert Treat Paine 2nd

room with its olive-yellow wallpaper and pattern of blue lozenges. Hortense's jacket, blue with a big bow—also blue, but lighter and more saturated—falls over her turquoise striped skirt, which is ruffled at the bottom. Cézanne rapidly disposed an array of thick, squarish, fractured brushstrokes—many blues and turquoises—so that we find ourselves searching among the colors one by one as if they were jewels (the poet Rainer Maria Rilke wrote of them as "an affair of colors among themselves"). Hortense wears a dark blue necklace that sets off a triangle of flesh over which we see the perfect oval of her head and, atop that, her hair, its center part making a triangle and echoing the shape of the neck below. It's a shape that Cézanne adored. In her face he counterbalanced warm and cool through the use of vivid pinks and strong turquoise pigments which he used to create shadows. The resulting figure is one of both grace and power. Hortense appears to keep her thoughts to herself, her eyes focusing neither on the painter nor on us, but resting in some hidden inner space. She is the image of dignity, and the painting one of extraordinarily monumentality. You see it reproduced in a book and imagine it large; you step into the gallery and are astonished to find it less than two feet wide.

Cézanne had created at least thirty-five portraits before he started to work on this canvas—images of men, mostly friends and family (ten of his Uncle Dominique), six self-portraits, seven paintings of women, including those of his mother and his sister, and the three of Hortense already mentioned. The majority are modest efforts. This painting is on a totally different scale—not of size but of ambition. Hortense is a regal presence on her great red throne. She is not beautiful in the ordinary sense, but Cézanne was not interested in ordinary beauty. The painting is a tribute to Hortense and to the place she held in his life.

Rilke thought so, too. He saw the painting in the Salon d'Automne in 1907, the year following Cézanne's death. After seeing the show, he returned to his room and wrote a letter to his wife about his feeling that "the consciousness of her presence has grown into an exaltation which I perceive even in my sleep; my blood describes her to me."

A recent Zola biographer has sought to describe the place that he believes Hortense Fiquet occupied in Cézanne's life: "In Hortense, tenacity was indistinguishable from inertia. Neither passionate enough to demand Cézanne's ardor nor venal enough to calculate his prospects nor inquisitive enough to

ponder his conundrum, she drifted after him aimlessly, more his indentured servant than his companion."[8] The art historian Susan Sidlauskas, who has made a study of the Hortense paintings, finds that many authors consider Hortense to have been a " 'counter-muse,' an uncooperative helpmate who not only failed to provide sufficient inspiration for the artist, but who acted as a positive hindrance to achievement."[9] This is not what Rilke saw, nor is it what my eyes have discovered as I have lingered these past years over the portraits Paul Cézanne fashioned with Hortense Fiquet as his model.

The year 1878 was the year in which Paul Cézanne panicked. He had taken Hortense and Paul south in the spring, finding a place for them in Marseille. He intended to shuttle back and forth between his two families. Then something happened. It had to do with Victor Chocquet, a customs official with a passion for collecting. In 1875 Chocquet actually purchased three works by Cézanne—it was the first time such a thing had happened.[10] Renoir then introduced Cézanne to the collector himself. They became friends, in fact good enough friends that Cézanne asked to paint Chocquet's portrait, a work he placed in the impressionist exhibition of 1877, where it attracted the kind of attention now familiar to Cézanne: "A worker in a blue smock whose face—long, long, as if passed through a wringer, and yellow, yellow like that of a dyer who specialized in ocher—is framed by blue hair bristling from the top of his head." The mocking criticism did not deter Chocquet from continuing his interest in his newly discovered artist. In the spring of 1878 he wrote Cézanne a letter, addressing it to the artist at his home in Aix, and in it he made reference to "Madame Cézanne et petit Paul." The first person to lay hands on the letter was Louis-Auguste Cézanne. He opened it.

When Paul learned what had happened, he assumed his father would cut off his allowance. Immediately he wrote Emile: "I am on the verge of having to provide entirely for myself, if, indeed, I am capable of it" (March 23, 1878). Emile's letter by return post—now lost—seemed to have had a calming effect. Paul then wrote: "I think as you do that I should not renounce my father's allowance too hastily. But judging by the traps that have been set for me and which I have thus far managed to escape, I foresee a great debate about money. . . . It is more than probable that I will only receive 100 francs even though my father promised 200 when I was in Paris. I shall, therefore, have recourse to your kindness since *le petit* has been sick for the past two weeks with an attack

of typhoid fever. I am taking every precaution to prevent my father from gaining absolute proof" (March 28, 1878).

By April, the new regime for the thirty-nine-year-old boy was in place: one hundred francs, and not another *sou!* Paul turned again to Emile, to "Please send 60 francs to Hortense at the following address: Madame Cézanne, 183, rue de Rome, Marseille. . . . He has heard from various people that I have a child, and he is trying to surprise me by every possible means. He says he wants to rid me of it.—I can't add anything to that. It would be too long to explain this man to you. . . . I am going to try to go to Marseille. I slipped away Tuesday, a week ago, to see my boy who is better, and then I had to return to Aix on foot, as there was a mistake in my timetable. I arrived an hour late for dinner" (April 4, 1878).

From that moment on Paul and Hortense depended on Emile. Each month the request was went off: "Since you have offered to come to my assistance once again, I'm asking you to send 60 francs to Hortense at the same address . . ." (May); "I'm asking you to be kind enough to send 60 francs to Hortense . . ." (June); "Please send, if you are still willing to do so, 60 francs to Hortense. She has moved and her new address is 12 Vieux Chemin de Rome . . ." (July).

In July the situation became even more complicated. It was the summer of the great Universal Exhibition, the one during which France intended to show the world she had recovered from the terrible events of 1870–71. Under a dazzling array of electrical lights, the inauguration of the Festival of Peace took place on June 30. During the first week some two hundred thousand people poured through the gates of the Champs des Mars. Paul and Hortense had left the key to their apartment with Antoine Guillaume, the shoemaker next door. He then gave the key to out-of-town friends visiting the fair. But the landlord, M. Laligand, got wind of this unauthorized use of his property, and he was not happy. He wrote to Cézanne in Aix. Paul then recounted to Emile what took place next: "My father read the aforesaid letter and came to the conclusion that I was keeping women in Paris. It's beginning to feel like a vaudeville act at Clairville" (July 29, 1878).

As if that weren't enough, in September Hortense's father sent a letter addressed to "Madame Cézanne, rue de l'Ouest, Paris." As Paul told Emile: "My landlord immediately forwarded the letter to the Jas de Bouffan. My father

opened it and read it . . . you can picture the result. I made violent denials, and since, very fortunately, Hortense's name didn't occur in the letter, I swore it was addressed to some other woman" (September 14, 1878). Paul wrote this letter from L'Estaque, where he was staying with his mother. This was now his circuit: mother in L'Estaque, father and sister at the Jas de Bouffan, Hortense and Paul in Marseilles. When his mother left the following week, he remained alone in L'Estaque, but, as he told Emile, "I go to Marseilles in the evening to sleep and come back the next morning" (September 24, 1878).

In November Hortense went to Paris by herself. Paul wrote to Emile that "she had a small misadventure . . . but in the end nothing much." He would tell him more when they saw each other; in the meantime, "I beg you to send her 100 francs." With Hortense absent, Paul took care of his six-year-old son in L'Estaque. His relief could not have been greater when Hortense returned to Marseille, because, as he explained, "my father could have caught us out" (Cézanne to Zola, December 19, 1878).

Paul Cézanne's fear of his father's authority and of his anger was immeasurable. Clearly it went well beyond his inability to contemplate life without an income. But that, too, was enormous. He did not believe himself capable of earning a living, neither for himself nor for his two dependents. He was stuck in a no man's land of anxiety, uncertainty, and dread.

One thing becomes clear in this sequence of events: the adored son and the mother of the son were a package. If Paul Cézanne didn't love Hortense Fiquet, it didn't make any difference. She was there for keeps. Was it in the summer of 1878 that Paul's pious, unmarried thirty-six-year-old sister Marie, started to ask: "Marry her, why don't you marry her?"

47

Hortense at Thirty

In the Salon, in the Garden, in Bed

"My wife, who is in charge of providing our daily bread, knows the difficulty and cares that that entails. So she shares these worries with Madame Chocquet and sends her, as does your servant, her most respectful greetings. As for the child, he is a terror in every way and promises worse to come."

These sentiments are included in a letter Paul Cézanne wrote to Victor Chocquet in February 1879. At the time, Cézanne, Hortense, and Paul fils were staying in L'Estaque. You might think that this was a nice ordinary little family.

Cézanne did not date his paintings. Thus our understanding of their chronology is thanks to the work of scholars who have used the conventional tools of art history: the composition, spatial considerations, color harmonies, the manner in which paint has been put on the canvas, and the use of line. Lionello Venturi published *Cézanne, son art, son oeuvre* in 1936, establishing the first comprehensive chronology of Cézanne's work. In her master's thesis at the University of Texas, Anne Van Buren reexamined Venturi's dating for the Hortense paintings, making some adjustments based on her study of the dresses Hortense wore and their reference to contemporary changes in style. John Rewald then initiated work on a catalogue raisonné grounded in his life-long study of Cézanne's work. Walter Feilchenfeldt and Jayne Warman finally brought this project to completion in 1996, two years after Rewald's death.

What I want to do here is to think more about the way in which Hortense's face and figure appear in these paintings and to see if it's possible to fit them into her life. What did Hortense look like when she was thirty? Most scholars

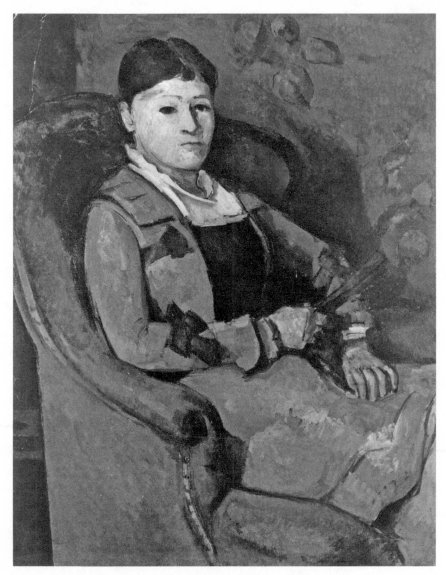

Cézanne, *Madame Cézanne with a Fan*, begun 1878. Zurich, Foundation E. G. Bürhle

believe that *Madame Cézanne with a Fan* (Foundation E. G. Bürhle, Zurich) was begun slightly before 1880, the year in which Hortense turned thirty, and that Cézanne reworked and finished it a few years later.

This portrait is larger, more somber, and more serious than *Madame Cézanne in a Red Armchair,* in the Boston Museum of Fine Arts. Again Hortense is seated in a plush armchair—this one of a rosy-purplish hue—and once again she took up her pose in a room that had been wallpapered, one with large pale-blue flowers. Cézanne placed the chair in a position so that he would create a three-quarter view of Hortense. She wears a stylish blue-green tunic with black velvet bows on both the lapels and the sleeves, and a black bib over her chest, which is set off by a white scalloped under-blouse. Her left hand, a little crude and not quite finished, rests in her lap, while the black fan in her right hand falls lightly across the sleeve of her left arm, the whole area brushed into place with thin patches of paint. The beautiful oval of Hortense's head becomes distinct through a strong dark line moving over the cheekbone down to Hortense's chin and back up again. As in the Boston painting, pinkish flesh tones are set off by turquoise shadows. Hortense's almond-shaped eyes are almost completely filled in with black pigment, prompting some to refer to them as "sightless" or "expressionless." But actually there is enough white in her left eye that, at least for me, Hortense appears to gaze serenely out of the picture. In Cézanne's self-portraits from the same period he depicted himself with an extremely self-assertive gaze strongly penetrating the spectator's space. Hortense's "look" is not charged with such power; nevertheless, her gaze—her exchange with the viewer—is quite real.

In the Boston portrait, the enormous bright red chair, Hortense's frontal pose filling the canvas, hair piled high on her head, the large bow, the jewel on her chest—all give her the appearance of a young goddess. Here she is more mature, quietly elegant, and certainly bourgeois. We might see her as a digni-fied matron in full possession of her own affairs, in no way the real Hortense who moved from place to place, never having a home of her own.

This image of an assured Hortense residing within her comfortable sit-ting room was once owned by Gertrude and Leo Stein. In *The Autobiography of Alice B. Toklas* (Stein's memoirs written under the name of her partner, Alice B. Toklas), Stein mentioned how she and her brother struggled to put it in a cab after purchasing it from Ambroise Vollard, pointing out what an important

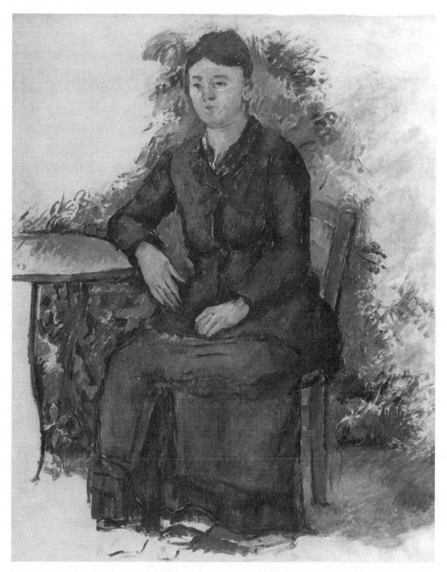

Cézanne, *Madame Cézanne in the Garden*, 1879–80. Paris, Musée de l'Orangerie

purchase it was "because in looking and looking at this picture Gertrude wrote Three Lives" (Stein's first book). It's never been clear whether, at the time, Stein knew or cared who the sitter was, but, nevertheless, Hortense became her personal muse. After Picasso came to the Stein's apartment in 1905 and agreed to paint Gertrude's portrait, he, too, couldn't get the Hortense on the wall of the apartment in the rue de Fleurus out of his mind: "She seems to 'hover' over Picasso's image of Gertrude, and there are definite analogies between the two paintings."[1]

Painted at about the same time as the Zurich painting, and almost as large, but far more experimental, is *Madame Cézanne in the Garden* (Musée de l'Orangerie, Paris). Cézanne was not in the habit of doing portraits *en plein air,* but it was an attractive idea, and during one of those summers—in 1879, 1880, or 1881—he tried it. For the first time he depicted Hortense head to toe, again organizing the pose in a three-quarter view. Here she is seated in a simple wooden chair next to a garden table, leaning her right elbow on the table, thus providing the same balance of resting hand and raised hand that he used for the more formally placed figure of *Madame Cézanne with a Fan.* It's a pose she could hold for a solid stretch of time without much trouble. In the garden she wears a simple unadorned dark blue jacket over a straight skirt of a slightly lighter shade of blue that has a cut up the front revealing another dark underskirt. Van Buren sees the costume as "late 1870's." Though it was hastily done, we have a good idea of Cézanne's intentions. The blue and green foliage forming a hemicycle around Hortense's figure provides the suggestion of a fresh summer's day. The paint is thin, the entire work apparently unfinished; yet here is Hortense, solid and real: the shape of her head, her dark hair pulled back with its simple central part, intense dark eyes gazing into the distance, tiny mouth, lips tight, turquoise shadows by the nose and underneath the chin, which seems tightly set, giving her something of a look of long-suffering, which was, in fact, becoming a way of life. Whether the painting was finished or unfinished, we begin to know the firm, strong image of Hortense.

There is a good chance these two paintings were done in Melun, a medieval town on the river Seine, about thirty miles southeast of Paris. Between June 3, 1879, and February 25, 1880, Paul wrote Emile a total of ten letters from Melun, where he, Hortense, and Paul fils were living in a second-floor apartment on the place de la Préfecture. They were close enough to Paris so that

Paul could make regular trips to the capital. He was also able to make solitary visits to the Zolas at their country home west of Paris, in Médan.

In September he wrote to Emile expressing an intense desire "to see *L'Assommoir.* Could I ask you for three places?" Zola's most popular novel to date had just been transformed into a dramatized version. Paul had a specific date in mind—October 6—and worried that asking for this might be causing Emile too much trouble. We can only wonder who the two extra seats were for—surely not Hortense and seven-year-old Paul. In any event, Paul's report about the evening was his alone. He was so moved by the play that "I didn't fall asleep at all even though usually I'm in bed a little after eight."

In the same letter in which he asked for theater tickets, Cézanne made a couple of intense, honest, and very humble remarks about the direction of his work. He spoke of "nature" almost as if nature were a person—a person who was giving him "great difficulties." Nevertheless, "I am doing my utmost to find my pictorial way." A change had taken place in the tone of this correspondence, for Paul was now writing to a rich and famous Emile Zola. Though the letters remained personal and affectionate, a certain obsequiousness has begun to enter—too many hesitations, too many thank-yous. In one letter Paul addressed Emile as "Oh you Provençal of great heart"; in another he signed himself, "with gratitude I am your former comrade in school in 1854." And he hastened to send his "respects to Madame Zola," whom he no longer addressed by her first name. In the return letters, Emile never greeted Hortense, but if Paul happened to be in Provence, there were always warm wishes for "ta mère."

Sometime in the early 1880s Cézanne made a drawing that is simply his most beautiful facial rendering of Hortense. The drawing, known as *Madame Cézanne with Hortensias,* shows Hortense's face pressed into the upper right-hand corner of a 12 in. × 18 in. sheet of paper. Her head rests on a pillow, and she appears to have just woken up. Her mouth is soft and vulnerable, and her eyes are under lids coming out of sleep, but these are eyes with a greater degree of confidence and directness than we have ever seen. Her uncombed hair falls in wisps across her brow, as the soft rolling curves of the coverlet caress her chin, cheek, and forehead. There is a delicacy and gentleness here seldom seen in Cézanne's work. And then to make clear how truly personal this drawing is, on the larger portion of the sheet he rendered a beautiful hydrangea blossom

Cézanne, *Madame Cézanne with Hortensias,* c. 1885. Private Collection

—the *hortensia*—touching its leaves with delicate green washes. It was a bouquet for his wife, for the only person he could draw in the state of waking up. And he did so again, many, many times.

We wonder if at some point Paul didn't show the drawing to Emile, for it is easy to imagine that it might have inspired the scene in *L'Oeuvre* when Claude Lantier gazes at Christine for the first time and in that moment understands that it is this woman he needs to be his model: "Her sleepy head lay back upon the pillow, her right arm folded under it, thus displaying her bosom in a line of trusting, delicious abandon clothed only in the dark mantle of her loose black hair."

In 1911, this exceptional work made its way to America for a show at Alfred Steiglitz's 291 Gallery. A critic for the *New York Evening Mail* was shocked when he came upon Cézanne's watercolors in this exhibition. He found them to be "artistic embryos—unborn, unshaped, almost unconceived things, which yield little fruit for either the eye or the soul." How our eyes have changed!

In the fall of 1882, Cézanne was in Provence. He was staying at the Jas de Bouffan with his parents and his sister Marie. In the usual way, Hortense

and Paul fils had remained in Paris. Cézanne's younger sister, Rose, had just given birth to a daughter. She and her husband, Maxime Conil, a local lawyer, were living with their baby in the Cézanne family residence in the city of Aix. The arrival of the "first" grandchild was a great event in the family, one that moved Louis-Auguste Cézanne to articulate the division of his fortune among his three children. With this action of his father, Paul came to realize that he himself would one day be in control of a considerable amount of money, and it prompted him to think along the same lines as his father. He needed to make a will. At the end of November, he wrote to Emile for advice: "Could you tell me the formula for drawing up such a document? I want, in case I should die, to leave half of my income to my mother and the other half to the child."

No, this was not exactly a nice, ordinary family. And we have no idea when Hortense understood that she was completely left out of *this* picture.

A Dark Blue Wedding Dress?

In the spring of 1885 Paul Cézanne wrote out a draft for a letter:

> I saw you, and you allowed me to kiss you; from that moment, I've been agitated by a profound unrest. You will forgive the liberty of writing you taken by a friend tormented by anxiety. I don't know how to excuse this liberty, which you may consider an enormous one, but could I remain in this depression? Isn't it better to show a feeling than to hide it?
>
> Why, said I to myself, keep silent as to the source of your torment? Isn't it a solace of suffering to allow it to find expression? And since physical pain seems to find some relief in the cries of the victim, is it not natural, Madame, that mental griefs seek some assuagement in confession to an adored being?
>
> I know that this letter, whose foolhardy and premature posting may seem indiscreet, has nothing to recommend me to you save the goodness of . . .[1]

Is this possible? Could this be the man whom Emile Zola described as having *un comportement amoureux plûtot passif que conquérant* (in love a passive rather than a conquering man), a man whose fear of women was a frequent subject of conversation among his contemporaries—could this man have written such a letter? Were it not for the fact that it is in *his* handwriting on the back of one of *his* drawings in the Albertina in Vienna, we might know nothing about it. In the letter Cézanne does, however, expose the self-

doubting part of himself and his lack of confidence. We also see a rather odd kind of romanticism, a quality he had tried so hard to suppress in his art. It's important to notice how the letter begins: "I saw you . . . ," not, "You spoke and I heard you," reminding us that, as I believe was the case with Hortense, it was a woman's "look" that initiated attraction.

And who was this woman who allowed Paul Cézanne to kiss her? In the 1940s, a Belgian writer, Jean de Beucken, living in Saint-Rémy-de-Provence, began doing research on Cézanne with the help of Paul Cézanne fils. De Beucken focused on this letter, which had been published by Rewald in 1939. He interpreted it as an important document enabling him to look into the soul of the forty-six-year-old artist who has suddenly realized "that he had never loved, because [now] he had fallen in love. He understood it was no longer sufficient simply to paint. There were other things in life and the physical attraction he felt for a servant girl at the Jas de Bouffan called Fanny overwhelmed him."[2] This may well have been a story shared within the Cézanne family and told to de Beucken, but when Rewald published Cézanne's correspondence in 1978, he pointed to some reasons why we should doubt this narrative: the tone of the letter is not one such as Cézanne would have written to a servant. Nor could Cézanne have expected a servant—surely illiterate—to have answered. Furthermore, Rewald believed that Fanny, the maid in question, left Aix in 1884. Nevertheless, the draft was not simply a pipe dream. It was transformed into a finished epistle and placed in a letter box. What followed made a shambles of Cézanne's life, as well as that of Hortense's and the rest of the Cézannes for the next six months. We can follow the developing drama with the help of eleven letters Cézanne wrote to Zola over the course of that spring and summer. The first was written at the Jas de Bouffan in May. In it Paul asked Emile if he would be willing to receive letters for him and then forward them to an as-yet undetermined address. He followed his request by quoting from Virgil's *Eclogues: "Trahit sua quemque voluptas!"* ("Each is prey to his own passions"). It's interesting how, whenever sex was involved, Cézanne's immediate recourse was to secrecy and conspiracy.

In June Paul took Hortense and their son north. Auguste Renoir had rented a house in La Roche-Guyon on the banks of the Seine, halfway between Paris and Rouen. The two artists planned to spend the summer painting together *en plein air*. The minute they arrived at the Renoirs', Paul dashed off a

note to Emile in Paris with instructions that letters to him should be forwarded in care of General Delivery in La Roche-Guyon. Ten days later, he wrote asking when Emile would arrive at his country place in Médan, implying that he would like to come for a visit: "I really feel the need for a change." And, "thank you in advance for your services with regard to my letters from Aix" (June 27). Emile wrote back on July 2: there had been an "invasion" of visitors. No possibility of receiving Paul until they left. P.S.: "I haven't received anything for you in some time." This is the only remark indicating that Paul had received at least one letter from the lady in question. The very next day Paul wrote again: "Owing to unforeseen circumstances, my life here is becoming rather difficult. Would you let me know when I can come to you?" Emile by return mail: "Your letter has considerably upset me. What's going on? Can't you wait a few days? In any event, keep me informed and let me know if you have to leave La Roche, since I want to know where I can write to you when my house is finally available. Be philosophical, nothing goes as one would like. I too am very much upset at the moment. So until soon? As soon as I can, I'll write to you. Affectionately, Emile Zola."

Not surprisingly, when we think about the difference between the lives of the two friends, Emile was somewhat annoyed, but it's also clear there is warmth and care in his letter. On the one hand we have Paul totally on tenterhooks due to a fantasy about a woman he hardly knew. His erratic behavior and extreme agitation certainly must have put him on the outs with Hortense. We can also guess how the situation with Renoir got on his nerves. Renoir had been living with his favorite model, Aline Charigot, for six years. She recently gave birth to their first child, Pierre, only three months old when Paul and Hortense arrived with their thirteen-year-old in tow. Renoir had just finished a wonderful painting of the voluptuous Aline nursing their baby. Aline, a lively, vibrant, and strong woman, was known for her inclination to be a matchmaker (in the far distant future she would find a wife for Paul fils), and she was a force for familial harmony. If, indeed, she tried to smooth things over between Hortense and Paul we might begin to imagine the basis for his view of life in La Roche-Guyon as "becoming rather difficult."

Nor is it hard to understand Zola's dismay at Cézanne's impatience, for he was inundated with worries and obligations that summer. To begin with, his wife was not well. And, as he explained to Paul, the house was full of

guests (plus their servants). He remained deeply involved with his latest work, *Germinal,* a novel based on the terrible conditions of the coal miners in the north of France. Although it was a triumph, there had been much criticism in the press, and Zola felt obliged to respond. Further, he was transforming it into a theater piece at the same time that he was finishing his next novel: *L'Oeuvre.* On top of this, his old friend was acting like a teenager over some woman he hardly knew—what was he to think?

By July 11—Paul and Hortense had been at La Roche for almost a month—Paul could bear it no longer: "I'm leaving today for Villennes (within walking distance of Médan). I'm going to the inn. I'll come to see you for a moment as soon as I arrive." But Paul never showed up. He had forgotten about the national holiday on July 14. The inns were full. So he got back on a boat that was headed downriver, sailing past La Roche-Guyon, past his wife and his son, to finally land in Vernon, where he was able to locate a room. He spent the holiday by himself. Then he changed his plans again: he would leave immediately for Aix, after a brief stop in Médan. Emile must have put him off again because Paul did not arrive in Médan until July 22. The last important guest had finally left.

Paul settled in for a week, and they were briefly joined by their old schoolmate Paul Alexis. We wonder about their days. Was Emile in his study working on *L'Oeuvre* while Paul painted in the fields? We know Cézanne did some views of the house at Médan. Did they talk about old times and the battle for public acceptance of impressionism? Since that was the subject of Emile's novel, it could not help but have been a part of the conversation. Authors speculate about Emile reading passages from the draft to his friends. Cézanne had known that such a book was in the making ever since Paul Alexis had sent him a copy of his own book, *Emile Zola: Notes d'un ami,* in 1882, a book in which he described Zola's plans for a future work featuring Claude Lantier, the artist in *Le Ventre de Paris.* He would be "a man of genius, a sublime dreamer whose production is paralyzed by a flaw in his nature." Surely they discussed that subject. The three old friends then talked about getting together in Aix in the fall after Emile went with his wife to visit the thermal baths in Mont-Dore, where Alexandrine hoped to find relief from her asthma attacks.

Paul and Emile continued to exchange letters in August, though we have only Paul's side of the correspondence carefully saved by Emile. From them

we learn that Hortense and Paul fils had returned to the south and were now living in Gardanne, six miles from Aix. Paul himself was at the Jas de Bouffan, but he walked out to Gardanne every day. He complained of having "*grume-leaux*³ under my feet which are like mountains and which distract me." A few days later he told Emile he had written to La Roche-Guyon—evidently to see if letters had been forwarded there—but "I've had no news at all, I seem to be totally cut off." He then continues with another astonishing statement: "The bordello in town or some such thing, but nothing more. I pay, it's a dirty word, but I need relaxation and even at this price I must have it." This revelation, like the letter of the previous spring to an unknown woman, reveals a side of Paul Cézanne about which little is known. Presumably it was an act of desperation resulting from his longing for an unfulfilled romance. Hortense may have been a factor as well. We can imagine her anger over his infatuation, her ability to turn a cold shoulder and draw away. This too would have been an aspect of Cézanne's sense of isolation in 1885.

Then there is a break in the correspondence: seven months of silence, only to be followed by the *big* silence.

> Gardanne, 4 April 1886
> Mon cher Émile,
> I have received *L'Oeuvre* which you were kind enough to send me. I thank the author of the *Rougon-Macquart* for this fine memorial and ask his permission to allow me to shake his hand, remembering years gone by.
> Ever yours for old time's sake.
> Paul Cézanne

It was a cool and dignified letter of farewell. To our knowledge, the two friends of more than thirty years never wrote or spoke again. Presumably Cézanne saw too much of himself in the doomed painter Claude Lantier, portrayed in such strong contrast to the wise, steady, and productive figure of Sandoz. The sense of affliction was heightened for it came at a low period in Paul's life, at exactly the moment when Zola became a hero to every worker in France, for *Germinal* had penetrated the national psyche. It also put more than 85,000 francs into Zola's pocket.

When Cézanne received the news of Zola's death in September 1902, he locked himself in his studio and wept. Nevertheless, he was still bitter about *L'Oeuvre.* In 1904, he told Emile Bernard that Zola had been a "detestable friend," that he was "totally self-centered and that's why *L'Oeuvre,* in which he allegedly portrayed me, is nothing but a hideous distortion, a fiction he created to glorify himself."[4]

After Paul's experience of unrequited "love" during the summer of 1885, and after the publication of *L'Oeuvre* in 1886, something unexpected took place. There is an undated draft in Paul Cézanne's hand addressed to the Prefect of the Seine requesting the "legalization of the signature of the Mayor of the Fourth Arrondissement" on his birth certificate. It is generally agreed that this request was made in preparation for an event that came as a surprise to almost everyone who knew Paul Cézanne, perhaps even to Hortense. They were to be married. The civil ceremony took place in the *mairie* in Aix on April 28. Paul's parents acted as witnesses. After the ceremony Madame and Monsieur Cézanne took Hortense and young Paul back to the Jas de Bouffan, while Paul invited his brother-in-law, Maxime Conil, and another male friend to go out to lunch. The following morning, Marie Cézanne and Maxime Conil stood beside Hortense and Paul in the lovely Baroque church of Saint-Jean-Baptiste, the parish church of the Jas de Bouffan. There were two other, unrelated witnesses who signed the registry signifying Paul and Hortense as "man and wife" in the eyes of Holy Mother Church.

How did it come about—this union to which Louis-Auguste was so opposed? It seems clear that in spite of Paul having made arrangements to hide his correspondence with the mysterious lady, she was no secret. And there was the fact of Paul fils—we're not sure when his existence became known to Louis-Auguste, but he was, after all, a Cézanne. We can imagine the various forces working toward the final resolution of a family problem that took place that April day in the church of Saint-Jean-Baptiste: a pious Marie who saw the family being disgraced, and a benevolent Madame Cézanne who loved her only grandson, looking forward to having easier access to him, and favoring the notion of his becoming legitimate. This mattered for Paul Cézanne, too. Even when he called him "the brat," he adored his son. And what of Hortense? She must have been both hurt and angry after what she had been through in the past year. Was the marriage an offering, and did it mollify her spirits?

Based on the limited correspondence remaining to us, it appears that Victor Chocquet and his wife, Marie-Sophie, the daughter of an aristocratic Norman family and heiress to a sizable fortune, were the only people among Paul's friends who are known to have welcomed Hortense, though in all probability there were others. The long letter that Paul wrote to Victor Chocquet in May 1886 was clearly in response to a congratulatory greeting received from the Chocquets. Paul wrote, as he often did, with deep and searching honesty. The letter he wrote is not exactly a message from a contented bridegroom. Rather it is from a man full of misgivings. He had to acknowledge that he did not have that quality of equilibrium that he saw in his patron: "Your fine letter, along with that of Madame Chocquet, is evidence of a fine equilibrium in your way of life. I am so struck by the serenity I see in you. Fate did not provide me with a similar lot; it's my only regret concerning the things of this earth." He appended a P.S.: "The little one is in school and his mother is in good health."

Louis-Auguste Cézanne had little time to adjust to the legalization of the union he had hoped would never take place. Six months after the wedding, the eighty-eight-year-old banker was dead. John Rewald took note of the fact that, from this moment on, Cézanne never budged from a newfound and hearty admiration for his father, frequently telling people that he "was a man of genius; he left me an income of twenty-five thousand francs."

Their lives didn't change much. Paul went on living with his adored mother and his austere sister at the Jas de Bouffan; Hortense and young Paul remained in Gardanne, where he attended school. There was more money, which held little interest for the artist, but he was generous with Hortense and their son. This certainly took a strain off them and added pleasure to their lives. Hortense might have hoped she would no longer have to move from house to house, but surely she was not happy with the prospect of settling in a provincial backwater with almost no friends other than her new in-laws, who had little affection for her. So she continued to journey back and forth to Paris whenever possible. Paris remained the closest thing she could think of as "home."

Hortense and Paul's wedding had been a private affair. Nevertheless, when it became known, it was an item of gossip. One of Cézanne's great admirers was the Dutch artist Vincent van Gogh. The two men had never met,

yet Van Gogh felt free to comment on the older artist's marriage. As he wrote to Emile Bernard: "Cézanne has become a respectable married man just like one of those old Dutchmen; if there is plenty of male potency in his work, it's because it didn't evaporate on his wedding night." Everyone was sure they knew how little Hortense counted in this relationship.

Several portraits of Hortense have been dated to the mid-1880s, but only two have been considered by all to be from the period 1885–87. One (a work formerly owned by Matisse) is now in the Philadelphia Museum of Art; the other is in the Berggruen Collection in Berlin. They are small and identical in size (18½ in. × 15 in.). Hortense wears the same dark blue-gray dress in both. With its high neck and dark color the dress is severe, yet its richly embroidered fabric and finely detailed opening with small buttons down the front convey a sense of style and elegance. In both paintings Hortense is seated in a chair that is barely visible. Her shoulders and head come out in full volume against plain backgrounds in cool blues, lavenders, and turquoise tints. The difference between them is the position of Hortense's body—a three-quarter view in one, a full frontal view in the other—and in the treatment of her face.

We don't usually think of Hortense as pretty, but in the Berggruen painting she is almost pretty, and she is incredibly present. Her frontal gaze lets us encounter her as never before. There is a focus, a concentration, an inner power projected, but there is also a kind of serene sadness, one that will last forever. Again we encounter the perfect oval head, though more elongated than it was ten years ago. Cézanne outlined Hortense's right cheek and chin with a thick blue line, that of the other side softened by the blue shadows caressing the whole left side of her face. As usual, she has piled her hair on the back of her head, which Cézanne depicted in three distinct volumes, with the central part dividing the dark masses into two symmetrical areas over her forehead. But the part at the top of her head is not quite symmetrical with the rest of her face, nor with the opening at the top of her dress, the shape of which is almost a mirror image of the parted hair, the absence of symmetry resulting in a distinct visual tension. Cézanne's use of color—the pinks and reds on the cheeks, the lips, the nose, and forehead against the blue-green shadows and the luminous robin's-egg blue of the background—results in a transparency and a delicacy seen in no other portrait of Hortense. It is a work of great restraint,

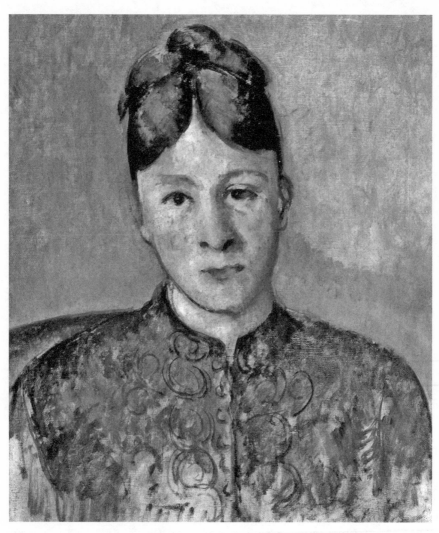

Cézanne, *Madame Cézanne*, 1886–87. Staatliche Museen zu Berlin, Neue Nationalgalerie, Museum Berggruen

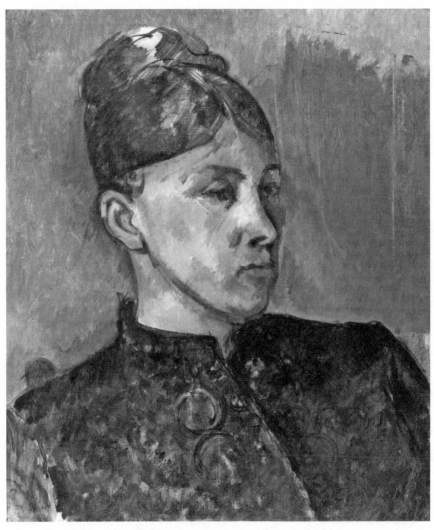

Cézanne, *Portrait of Madame Cézanne*, 1886–87. Philadelphia Museum of Art,
The Samuel S. White 3rd and Vera White Collection, 1967

sensitivity, and directness, one that portrays a soft, susceptible face, a face still young, but one that is distinctly not happy.

The expression in the Philadelphia painting is quite different. In this three-quarter view with Hortense facing left, Cézanne emphasized her heavy eyebrows and shadowed eyes looking off into the distance. The bold line edging her nose is strong, and its shape projects powerfully, while the shadows beneath and beside the mouth give it a rigid, pinched, angry appearance. The paintings are variations on a theme. Further they give us views of the differing emotions that must have bubbled up in Hortense as she lived through a complicated period, one that was to be a turning point in her life, as she stepped into a new situation established by decisions made within the Cézanne family.

There is a third work to consider here—a drawing in the Boymans-van Beuningen Museum in Rotterdam. It's a quick pencil sketch showing Hortense in the same brocaded dress and wearing a hat with some kind of ornament right in the middle of the front brim. When the drawing was shown in the Cézanne exhibition of 1995–96, Joseph Rishel wondered if she was not "dressed for a special occasion," and he found himself tempted "to speculate that the unhappy expression on her face was prompted by her husband's having prevailed upon her—yet again—to pose."[5] A special occasion like a wedding? Was this Cézanne's memento of the occasion? We haven't the faintest idea. It's enough to say that Hortense's emotions about the change that came into her life in 1886 were, without doubt, complicated in the extreme. The clarification may have brought relief, but surely it did not bring joy into the life of Hortense Fiquet Cézanne.

Fifteen Hectares of Fallow Land

When eighty-two-year-old Claude-Antoine Fiquet died in Lantenne on December 14, 1889, Hortense was in Paris. It would be June before she was able to travel to the province in order to settle his will. Fiquet died alone. His passing was declared at the *mairie* by his landlord. He left but a single meager plot of land to his only child. Hortense's inheritance amounted to fifteen hectares of fallow land, worth about forty francs. The title was turned over to her husband, who signed the *declarations des mutations.* This document in the departmental archives of Le Doubs in Besançon also records the Cézannes' new address in Paris: 69, avenue d'Orléans.

Finding themselves in the hilly countryside of Haute Savoy, the Cézannes decided to stay on. They located a place to rent in Emagny, some 5 miles northeast of Lantenne. Emagny was not far from the Swiss border, which may have been a deciding factor in their choice to spend the summer in the region, as the Cézannes were planning a visit to Switzerland, or at least that's what was on Hortense's mind. Initially just Hortense and eighteen-year-old Paul undertook the excursion. We know this thanks to a letter Hortense wrote on August 1 from Emagny—a precious document, one of only two letters preserved for us—to Madame Chocquet, in order to tell her friend about the trip from which they had just returned. Hortense marveled at the beauty of the country. After this brief taste, she knew that there was nothing to do but return to Switzerland as soon as possible. The whole family would be leaving soon. Hortense was particularly taken with Vevey, "where Courbet made that lovely painting which you own." She understood how busy her friend must be since the Chocquets had recently purchased a mansion near the Opéra, and

she expressed her concern about how much work it must take to restore the place, including the installation of the Chocquet's art collection.

Her own news was good. They were all well. She particularly emphasized that she herself was "better than when I left," and she counted on being completely restored in the course of the coming vacation. They would look for a house in Switzerland and stay there for the rest of the summer. She said that her husband was working well, and she knew that he would continue "to surrender himself to the landscape with a tenacity that deserves a better outcome" ("de se rendre au paysage avec une ténacité digne d'un meilleur sort"). Was Hortense trying to say something diplomatic to the wife of her husband's best client about his work when she herself did not quite understand what he was doing? Hortense hoped that the next year would be a better one for the Chocquets, "when you don't have all these worries," and she was imagining that one day they would all meet in Switzerland, for "you will find the country magnificent; I have never seen anything so beautiful; it's so cool in the woods and on the lakes." She closed her letter with considerable fondness: "je vous embrasse de tout mon coeur et je suis bien votre affectionnée. . . . Hortense Cézanne"—then she added a P.S.—"My mother-in-law and my sister-in-law Marie are reconciled. I'm walking on air." Clearly Hortense was close enough to Marie-Sophie Chocquet to have shared some information about the family's problems, and here she makes it clear that she herself was not the only source of those difficulties.

Finally, we hear Hortense's voice! It's a forthright and confident letter. The person who never smiled in a portrait was a woman able to make friends, a woman who loved nature, who looked forward to trips, and generally who knew how to organize herself to taste life's pleasures.

The three Cézannes remained in Switzerland for more than two months, visiting Neuchâtel, Bern, Fribourg, Vevey, Lausanne, and Geneva. When they returned to France in November, Hortense and Paul fils headed for Paris, presumably with a store of pleasant memories of their first experience of traveling in another country.

Cézanne went back to Aix-en-Provence. His memories were of a different sort, as we learn from a letter Paul Alexis wrote to Zola, who continued to seek news of his old friend through the good offices of mutual friends in Aix. Alexis described Cézanne as "furious with *la Boule*" because she dragged

him all over Switzerland, lodging them in innumerable *tables d'hôte*. To make matters worse, "escorted by her bourgeois son, [she has] made off for Paris, but by cutting her allowance in half, he has brought her back to Aix." The two wrongdoers had just arrived as Alexis wrote (February 1891), so he was able to describe all the troubles Cézanne was having with "le crapeau de fils."[1] He indicated that Paul had rented a place for Hortense and young Paul on the rue de la Monnaie—a nice house just off the Cours Mirabeau, a place where they could also take their meals *en pension*. He paid four hundred francs to have their furniture sent from Paris, for he was expecting them to put down roots in Aix. *If* they could do that, he saw no reason why they couldn't visit Paris from time to time. " 'Vive le beau soleil et la liberté' is his cry."

Paul himself would continue living with his mother and his sister, "where he feels very comfortable and which he clearly prefers to living with his wife." Alexis made it clear that Cézanne was extremely correct when it came to financial arrangements, dividing his annual income evenly into three parts: "*pour la Boule! pour le Boulet!*[2] *Et pour lui!* Only *la Boule* is not satisfied and continually overspends her personal share. Backed up by his mother and his sister—who detest the lady in question—he feels strong enough to stand up to her." This is the first contemporary source that brings into view one of the family's big concerns about Hortense: she wanted to get her hands on Paul's money.

Alexis describes Paul as spending his days painting at the Jas de Bouffan. Another interesting part of his report is news that Paul "has converted, he believes, and he goes to mass." Further he tells Emile that Paul had been diagnosed with diabetes. This may have influenced both his return to his boyhood religion and his increasing concern with death.

Numa Coste, another boyhood friend of Zola and Cézanne's, was also a source of news, and he, too, was concerned about Paul, whom he saw as becoming "timid and simple, younger than ever. He is living out at the Jas de Bouffan with his mother who has quarreled with *La Boule,* who also does not get on with her sisters-in-law, nor they among themselves! This is what has happened—Paul now lives on one side and his wife on the other. It's one of the saddest things I know, to see this fine fellow still preserving a childlike naiveté."

The sympathies of Coste and Alexis were all addressed to Cézanne's situation. We have no evidence that anyone gave a moment's thought to the

difficulties Hortense experienced living in a closed provincial southern city, apparently with no friends save the Cézanne family—whose members did not care for her—and with a husband almost exclusively consumed by his creative life. It was a lonely life indeed.

Searching for an image of Hortense during this period of separate residences in Aix, I turn to *Madame Cézanne with Loosened Hair*.[3] It's slightly larger than the beautiful Berggruen *Madame Cézanne* of a few years earlier. Her fuller face gives her the appearance of a woman in her forties. As always, Cézanne has focused on the pure oval of her face, but it's like no other portrait of Hortense that he ever created. Her dark hair falls heavily onto her back as her head descends toward her right shoulder; and, owing to the way Cézanne has placed some emphatic brushstrokes on the background to her left, there is the suggestion of motion. The rapid blue strokes of paint appear to push her, while a vertical band intersecting the other side of her head would seem to hold her in check. This unusual treatment of the background plane establishes a tension which is mirrored in Hortense's face with its fixed gaze and sullen lips.

The dress is dark blue, perhaps a velvet fabric, with wide gray stripes. In Hortense's usual style it has a high neck, but the dress is unusually broad, giving her body a bulky aspect, while the slightly waving vertical stripes push up, insisting that our eyes focus on her face. Here Cézanne created Hortense's face not through light and shadow, but by alternating warm and cool colors. The face that results is replete with sadness. Meyer Schapiro described the droop of her head as being a "pathetic inclination." And in the composition he recognized "an axis of weakness, submission and self-concern, such as we find in old images of praying and penitent saints—an expression which is completed by the extreme closure of the body."[4]

Madame Cézanne with Loosened Hair is a deeply personal work. We are invited to see Hortense in a particular mood, one which may reflect her isolation and her feelings of being caught in a place not of her choosing. Far removed from the emotions of that work, but probably of the same period, is *Madame Cézanne in the Conservatory*. Paul fils remembered watching his father working on it in the greenhouse of the Jas de Bouffan, and on the back of a photograph of it he wrote "1891." Though unfinished, this is a show piece; indeed, it was among the paintings Ambroise Vollard selected for the

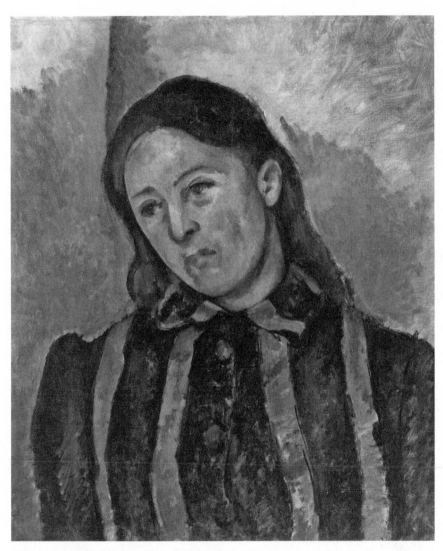

Cézanne, *Madame Cézanne with Loosened Hair,* c. 1890–92. Philadelphia Museum of Art, The Henry P. McIlhenny Collection, 1968

exhibition he mounted in his gallery in 1895, when he gave Cézanne his first one-man show.

Though Cézanne returned to an idea he had a decade earlier—Hortense wearing a dark dress, seated in a simple wooden chair placed in a garden—he reformulated it in a more elegant fashion when he placed her in the conservatory of the Jas de Bouffan. Here he developed the power and solidity of Hortense's form, its rounded shapes under the dark blue dress, and then dealt with it in terms of the rich complexity of the ochre wall, the multibranched tree, the luscious red begonias, and the potted plant in the upper right. The rough paint strokes that create the diagonal line of pale yellow on top of the wall are like a streak of sunlight cutting through the painting behind Hortense's head and focusing all our attention on her. The presence of Hortense dominates the vibrant scene. Within the familiar perfect oval, Cézanne established soft volumes and gave shape to her eyebrows, nose, and mouth through the use of straight lines that fall into schematic sections, especially evident in the ninety-degree angle containing Hortense's right eye. The colors used for the face are all warm—terra-cotta, peach, and red intensified through the use of green shadows under her nose and chin. And, as in *Madame Cézanne with Loosened Hair,* Cézanne has piled on thick strokes of paint that have no other meaning except to intensify the place of Hortense's head within the picture. Her look is cool and impassive, but even in her remoteness in this sunlit painting, filled with the warmth of the south, she assumes her place with great dignity. As is so often true of Cézanne's paintings, this one is unfinished, betrayed most starkly when we look at Hortense's hands. She wears fingerless gloves, and on those fingers there is no paint at all—just a few hastily drawn pencil marks on raw canvas.

We don't know when Hortense and Paul fils—they seemed to always move as a pair—gave up on the experiment of living in Aix, but by 1894 they were living in Paris on the rue des Lions-Saint-Paul on the Right Bank. It was probably here that Cézanne created a series of four paintings, called *Madame Cézanne in a Yellow Chair,* or *Madame Cézanne in Red.* Earlier scholars placed the works circa 1888–90—that is, before the move to Aix—believing they were painted in an apartment on the quai d'Anjou. But on stylistic grounds, more recently, scholars have been inclined to place them in the mid-1890s.[5]

In all four paintings the first thing we notice is Hortense's red dress—not just any red—but a vivid crimson red. It's the color that counts, not the style

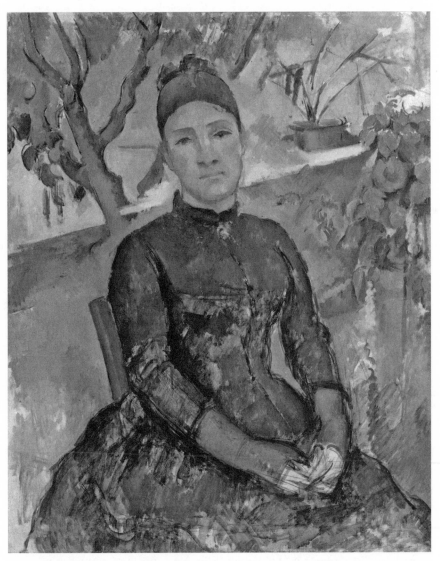

Cézanne, *Madame Cézanne in the Conservatory,* c. 1891–92. New York,
The Metropolitan Museum of Art, Bequest of Stephen C. Clark, 1960.

of the dress, which is homely and ordinary: sleeves almost to the wrists, a bathrobe-like tie at the waist, a shawl collar pulled in a loop around the neck and falling in heavy folds down the front of the bodice. We can't be sure who chose all those other dresses. Since we know that Hortense had a passionate interest in fashion, I have been inclined to think the dresses were her choice, but maybe that's not the case here. Pissarro once told his son, Lucien, about Cézanne bragging: "I, only I, know how to paint a real red!" (letter of January 20, 1896). So maybe this was his choice.

In the simplest of the four, Hortense, in her red dress, seated on a barely visible bench, and holding a flower between her hands, is seen against a mottled rose-and-gray-tinted ground. Her position is frontal and she is isolated against the background. The painting has a strange muted quality about it. In the versions in Chicago and in Basel, she is in a three-quarter position and seated in a seventeenth-century-style chair covered in a richly patterned yellow fabric. Her hands—which are not quite finished—sit restlessly in her lap. The background in both—various shades of pale blue-green—is broken horizontally by the lines of a mahogany-colored wainscoting just below the top of the high-back chair. These paintings are very still; Hortense's face is masklike and strangely bloated in appearance. What draws us to them are the powerful volumes and the way Cézanne has constructed them through color. Never before, when working with Hortense, had he created anything that was at once so monumental and so remote. Hortense is barely Hortense.

Cézanne took this arrangement a step further and created the most ambitious, the largest, the most complex painting he ever did with Hortense as his model: *Madame Cézanne in a Red Dress.* He changed her position in the chair, placing her frontally so we see more of her body or, should we say, more of the red dress. Her hands, which in the other yellow-chair paintings seemed to fidget uneasily in her lap, hold a rose, which adds a certain formality to the painting. This quality is heightened by a heavy flowered curtain pulled back in a swag, as you would find it in a Baroque portrait, falling in a long diagonal to the bottom of the canvas and casting a shadow upon the wall. The curtain is balanced on the left by the edge of a fireplace with a mantel from which hang iron tongs and on which rests the edge of a mirror with a gold frame. The framing elements—mirror, curtain, fireplace—are all in tones of black and gold, again elements which give a formal dignity to the work.

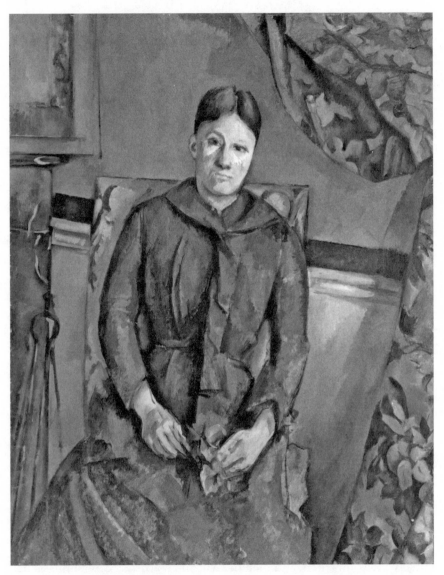

Cézanne, *Madame Cézanne in a Red Dress*, c. 1893–95. New York,
The Metropolitan Museum of Art, The Mr. and Mrs. Henry Ittleson Jr.
Purchase Fund, 1962.

The most surprising element, however, is the relationship between Hortense, her chair, and the wainscoting of the wall. Cézanne gave up any normal sense of perspective, placing these elements on a tilt, thus introducing a destabilizing element into the picture. Hortense doesn't sit anymore. Rather, her big red figure is placed against the chair—not in it—and chair, Hortense, and the wainscoting all appear to be in free fall toward the right. It's the curtain and the gold-framed mirror that hold the scene in place.

Cézanne's treatment of Hortense's face has changed too. Of course we recognize her—the familiar oval face, dark hair, central part—but part of her face is in deep shadow, and her eyes—right eye larger than the left and placed under a big green eyebrow that serves as the top of a triangle of light—stare out blankly. The right side of her face is in a blue-gray-green shadow to which is attached a red ear—no ear on the other side. Her hands, bigger and more angular than we've seen, are dabbed in with green, ochre, and peach pigments. A bright blue brushstroke, a rich hue between the fingers of her left hand, gives off a special brilliance. What mattered now for Cézanne was the composition, the interaction of space and colors, the miracle that takes place due to little touches of paint, an interactive harmony that points the way toward a new kind of dynamic tension and pictorial geometry which were becoming central to Cézanne's late style, a time of creation in which Hortense would no longer play a role.

Apparently these works are the last portraits Cézanne painted of Hortense. It is a complicated series and appears to have been done over a short period of time, during which Hortense must have put in long hours of posing. I want to imagine that once the series was done, she declared an end to these endless sittings. Everyone who knew Hortense spoke of her gregarious nature, her love of conversation. If so, once she had taken her place in the chair, forced herself into silence, willed herself to accept Cézanne's stricture not to move a single muscle, she became someone she was not. It seems that Hortense, initially the companion, and then the wife of an artist, accepted this as her duty. It was her "work"; it was what she did. Now she retired.

Having invested so much of herself in these images, it's worthwhile wondering how Hortense saw them. From what little we know, she did not see them very well. But then, there was only a small coterie of people who could really "see" Cézanne's work in the nineteenth century—mostly other artists

and a small group of connoisseurs and a dealer like Vollard who opened his tiny art gallery in 1893. Hortense did not share their insights. Rewald reported that "when she occasionally attempted to participate in discussions on art which Cézanne had with his friends, her husband would say to her in a quiet, reproachful voice: 'Hortense, be still, my dear, you are only talking nonsense.'"[6]

A good friend of Henri Matisse's, Father Marie-Alain Couturier, remembered Matisse telling him the story of dining in the home of Renoir's children a few years after Cézanne's death in 1906. He was seated next to Hortense, and during dinner she offered her views of her husband's work: "You know Cézanne did not really know what he was doing. He didn't know how to finish his paintings. Renoir, Monet, they really knew their *métier* as painters."[7] Another such reference comes from Matisse directly. In a moment of discouragement he remembered a downbeat remark he once heard Hortense make about Cézanne's work, and he, when writing to his friend André Rouveyre, called himself "an old fool; I'm like what Madame Paul Cézanne said about her husband. I've been told that Madame Pissarro said the same thing about her husband. These women of simple background served their husbands with their modest means and then judged their heroes as one might judge a simple carpenter who has taken it into his head to construct tables with legs in the air" (June 3, 1947). This is the Hortense who lives on in history.

For or Against Hortense?

In 1925, while the English art critic Roger Fry was in Paris trying to understand Cézanne's landscapes, he wrote to a friend: "To get really into such a nature is difficult. It's very complicated to begin with and life changed him enormously—perhaps that sour-looking bitch of a Mme counts for something in the tremendous repression that took place" (letter to Helen Anrep, May 1, 1925).

In November 1960, Paule Conil, one of Cézanne's four nieces, published some personal memories of her uncle in the *Gazette des beaux arts.* Among other things, she indicated that "no one ever speaks about the painter's wife." To make up for the omission she included a brief paragraph about Hortense. She pointed to Hortense's fine sense of humor and commended her for her extraordinary patience, a quality so exceptional that even Hortense's mother-in-law, "who had no special affection for her," recognized its strength. She told her readers that she knew there were nights when her uncle could not sleep, and in these times Hortense would read to him, sometimes for hours. And we mustn't forget Hortense's great gift to the Cézannes: she provided the only male heir in the family.

This image of Cézanne the insomniac, with ever-patient Hortense seeing him through the long nights, is corroborated by Ambroise Vollard. The painter once described to his dealer how he had the habit of getting up during the night to check on the weather. "Then, once decided on this important matter and before going back to bed, carrying a candle he would go and review the work in process. If he felt good about it, he would go at once to share his satisfaction with his wife. He would awaken her and afterward, to make up for

having disturbed her, he would invite her to play a game of checkers before going back to bed."[1]

In spite of Paule Conil's testimony about some of Hortense's positive virtues, as well as glimpses of affectionate moments in the life of the Cézannes, with the exception of the Chocquets most of Cézanne's friends did not speak well of Hortense. The Zolas went to great pains to avoid her, always making plans to see Cézanne by himself. When Numa Coste wrote Zola from Aix in 1897, he said that he found Paul extremely depressed, and that the fault lay with Hortense, "who has forced him to do a lot of stupid things. He is obliged to go to Paris or to come back again according to her desires. In order to have peace he has felt compelled to cast off some of his inheritance. From the few confidences he has let drop, it appears his monthly income now is only about a hundred francs."[2]

But surely it wasn't Hortense who caused Cézanne's depression in 1897. Rather it was his eighty-three-year-old mother—his lifelong caretaker, the guiding force of his life—whose physical and mental capacities were rapidly slipping away. Now it was the son who was obliged to care for her. Anne-Elizabeth Cézanne died in October of that year.

Coste's report echoes Paul Alexis's description of the situation several years earlier. Alexis, too, reported to Zola that "only *la Boule*" takes more than her share of the three-way split of Cézanne's annual income. Alexis also said that if it weren't for his mother and his sister, who enabled him to stand up to Hortense, Paul would be lost. Now the bulwark of that support was gone.

The assertion that Cézanne was reduced to living on a hundred francs a month is surely an exaggeration. But there's no doubting the fact that Hortense Fiquet liked to spend money. We might see the fault in a slightly more sympathetic light if we take a moment to think about the girl who grew up in semi-poverty, who was forced to make a life for herself in Paris at a young age, and who went on to endure a meager existence as partner of an artist who frequently left her alone with their child, and with extremely limited means. Given these facts and that of the hostility of his family to their marriage—the *misalliance* which made Hortense forever an outsider in their home and their society—well, we can't be too surprised by Hortense's apparent "greediness." Once she found herself married to a man of means, how could she not want to spend money? But, apparently, acquaintances and family in the provincial

southern city knew no reason why they should give her their sympathy. Nor did they give her credit for her long hours as the artist's principle model. And she not only assisted his work in her role as model, but she also helped out with Cézanne exhibitions once they got under way in the twentieth century. In September 1905 she wrote to Emile Bernard, noting that "for November still two [more] exhibitions they're asking me for. I only had two months of rest this summer which I really needed because I was worn out!!"[3]

There is evidence that Hortense understood the injustice of her life and that she was capable of making her displeasure known in no uncertain terms. In the winter of 1900–1901, the young symbolist artist Maurice Denis—who had not yet met Cézanne—was working on his painting *Homage to Cézanne.* In that period he had a conversation with André Gide, the man who eventually purchased Denis's *Homage,* and Gide told him a story, which Denis entered into his journal: "Having lost his mother whom he greatly loved, Cézanne decided to consecrate a room in his apartment to her memory. He brought together various ornaments and objects that reminded him of her. . . . One day, in a fit of jealousy, his wife destroyed all these souvenirs. Accustomed to his wife's foolishness, Cézanne came home, found everything gone, left the house, and stayed away in the country for several days. His wife told a friend: 'Do you know what! I burnt everything.' The friend then asked 'What did he say?' 'He just wandered in the country—he's an eccentric'" (journal entry for 1901, published 1957, vol. 1).

"The room" was a direct result of another tragedy to affect Cézanne as a result of his mother's death: the loss of the Jas de Bouffan. His brother-in-law, Maxime Conil, insisted the only way to make a fair division between the three heirs was to sell the "Jas." With this sale in the fall of 1899, Cézanne lost not only his studio, but the memories of his youth. Thus, we understand the need for the special room in the apartment which the Cézannes now rented on the rue Boulegon. (The apartment was only a few doors away from the building in which Louis-Auguste had established his bank.) We can still walk the rue Boulegon and look up at number 23 to see the studio Cézanne had build under the eaves of the house.

In spite of the studio, the space was insufficient for the artist, his painting, and his housekeeper Mme Brémond, as well as Hortense and Paul fils when they were in residence. Toward the end of 1901, following the incident

described by Denis, Cézanne purchased a small property studded with olive, apple, cherry, and almond trees, located on a hill north of Aix near Les Lauves. Cézanne entered the deed of purchase not only under his own name, but also under that of Hortense. It was here that he would build his new atelier.

The shared ownership of the land on the Lauves road might appear to indicate a greater sense of communality between husband and wife. But the following year Cézanne went to M. Mouravit, the notary who had purchased Les Lauves for him, and he registered a new will, written in his own hand and identifying his son as his sole heir. It stated clearly that "my wife, should she survive me, will have no legal claim on the property that will constitute my estate on the day of my death." This would seem to be Cézanne's final repudiation of Hortense Fiquet. But perhaps this is not the right interpretation of the situation. Cézanne's love and respect for his son had grown with every passing year. Often he would exclaim: "Son, you're a man of genius, for you have a practical sense of life." All of Cézanne's contacts with Vollard—and any business dealing he might have in Paris—went through the hands of young Paul. And since he was fully cognizant of Hortense's acquisitive impulses, and her lack of wisdom about money, why would he not have told his son that he must take responsibility for his mother? This is exactly what happened, and, as far as we know, the two remained devoted to each other until the time of Hortense's death.

There must have been a voluminous correspondence between Cézanne and his son. Unfortunately only seventeen letters have survived, all from the last three months of Cézanne's life. Cézanne addressed them to Paul, still living with Hortense in Paris. The letters were clearly meant for both mother and son, the closings typically being: "I embrace you and *maman* with all my heart." In the summer of 1906, when Cézanne heard Hortense was sick, he wrote by return mail, "I deplore the state in which your mother finds herself. Give her every possible care, try to make her feel comfortable, keep her cool and find any appropriate entertainment" (July 25).

Such facts are universally ignored in most of the books and catalogues on the work of Paul Cézanne. From these you would think that all Hortense Fiquet ever did for the artist was to produce a son and to sit endlessly like an apple for a large number of portraits. There is no way to come away from this vast literature without the impression that, whatever the couple shared,

it certainly could not be called a real marriage. The poet Léo Larguier, who knew the Cézannes in the last years of the painter's life, referred to Hortense as a "good person"; nevertheless, he didn't believe she ever "counted for much."[4] Most publications give the impression that Cézanne and Hortense barely saw each other once she stopped posing for him in the mid-nineties. But there is documentation that the three Cézannes were together in Paris every year between 1895 and 1905 except for 1900, and probably that year was no exception—we just don't have proof. Cézanne usually spent the spring and the fall in the capital. In 1896, Hortense and Paul fils talked him into going to Talloires on Lac d'Annecy for the summer, after which the three of them went back to Paris together. In May 1899, when Cézanne's niece, Marthe Conil, invited them to attend her First Communion, he wrote from Paris: "Aunt Hortense, your cousin Paul, and myself are all very touched by your nice invitation. But, to our enormous regret, the great distance between us and Marseille will keep us from being present at this beautiful ceremony."

Though fairly unsocial in these years, Cézanne managed to make friends with several young men doing their military service in Aix. One of these was Larguier. Following Larguier's discharge from the army in 1902, he invited all three Cézannes to come for a visit to his family home in the beautiful mountain range of Cévennes, northwest of Aix. This is also the year in which Vollard decided to make Cézanne a gift of a floral watercolor by Delacroix that the painter had previously admired. When Cézanne sent his thank-you note from Aix, he included "Paul and my wife" as being pleased with the "magnificent gift." In March 1905, when Bernard, Cézanne's fervent admirer, showed up in Aix, Cézanne sent him a note: "Paul and my wife are here, you'll come to lunch with them, won't you?" Of this occasion Bernard reported: "I was presented to Paul Cézanne fils and to Mme Cézanne. The meal was very lively, Cézanne being extremely talkative."[5] The Cézannes may not have been an "ordinary" family, but they were a family.

It's also true, however, that in the last years of his life Cézanne drew more and more into himself. In 1899 he turned sixty, but he looked seventy. He was diabetic, his health was failing, especially his eyesight, and his phobias about being touched became ever more acute—Mme Brémond was under firm instructions that when she passed him she must not touch him, "not even with my skirt." And he was increasingly consumed with anxieties about death. If

he had coerced Hortense and Paul to move to Aix in 1890 in issuing the threat to cut off their allowance, by the last years of the century he was just as happy they weren't there too much of the time. He gradually withdrew from friends and often made angry references to people who once gave him support, even love, including old colleagues like Camille Pissarro. He shared some of his bitterness with Joachim Gasquet, a young poet and son of one of his oldest friends from his schooldays: "I curse the Geffroys and other scoundrels who, to earn 50 francs for an article, draw me to the public's attention" (April 30, 1896). And a few years later he told Gasquet: "I have contempt for all living painters except Monet and Renoir" (July 8, 1902). Only work seemed to give him a measure of sanity and direction.

Bernard had published an essay on Cézanne even before he met him, but it was only in 1904 that he took himself off to Aix to meet the great man face to face. The day after their first meeting he wrote to his mother describing this encounter: "He's an old man, unpretentious, a bit of a misanthrope, and strange. He was going off to work so I went along with him. He spoke to me familiarly, and kept saying at least a hundred times, 'Life is terrifying!'"[6]

But the most moving letters are those from Cézanne to his son in which he spoke directly about two things: being alone and the central role that painting had in his life. "I live a bit as in a void. Painting is what matters most to me" (August 26, 1906). He complained to Paul about the people of Aix: "those pretentious intellectuals, the ignoramuses, cretins and rascals." Though he was alone, he felt as a painter he was becoming "more clear-sighted before nature, although with me the realization of my sensations is always painful" (September 8, 1906).

On the morning of October 15, Cézanne got a letter off to Paul in Paris: "I continue to work but with difficulty, nevertheless, something is coming. . . . Everything happens so quickly, but I'm not too bad. I take care of myself. I eat well." Then he left his apartment in town to resume work outdoors on a landscape motif near his studio at Les Lauves. A storm came up; after hours in the rain Cézanne collapsed near a road. Sometime later he was discovered by two passersby, who brought him home in a laundry cart. But he got right up the next day and went into his little garden to work on a portrait. Five days later Marie Cézanne wrote to her nephew: "Your father has been sick since Monday," but she assured him that the doctor thought he was in no danger.

Nevertheless she wanted Paul to come as soon as possible because Mme Brémond was unable to take care of him, and his father considered the idea of a male nurse in the house out of the question. "I believe your presence is necessary so that he can get well as soon as possible. . . . Mme Brémond especially wanted me to tell you that your father has set up an atelier in your mother's *cabinet de toilette*." Paul should tell his mother "this detail" and recommend that she put off her own visit until Cézanne could move his paint materials elsewhere (October 20, 1906). Hortense must have recognized a familiar sentiment: "*your* presence is not necessary." Two days later a telegram from Mme Brémond arrived in Paris: "Venez desuite tous deux père mal." There was not enough time. Paul Cézanne died in Aix-en-Provence on October 23, 1906. His wife and son were not at his bedside.

This fact has given rise to the final attack on Hortense Fiquet's reputation. A characteristic description—this one in the words of Françoise Cachin, one of the curators of the 1996 Cézanne exhibition—of Hortense's role at the end of Cézanne's life reads: "Having been recalled from Paris when Cézanne's health took a turn for the worse . . . [Hortense] arrived in Aix too late to see her husband alive because an appointment with her dressmaker had caused her to miss the next train."[7] The first time this aspersion on Hortense's character appeared in the Cézanne literature was in 1955 in *Un Portrait de Cézanne*, by the novelist-biographer Jean de Beucken: "It was Hortense who received it [the telegram], but, not wanting to postpone a fitting at her dressmaker's, she hid it in a drawer—where probably her son discovered it." John Rewald, repeats this story in the final version of his Cézanne biography, published in 1986 (it is not included in his earlier books), but he calls it "gossip." I thought it just that—a juicy detail born in the brain of a novelist. That is, I thought so, until Philippe Cézanne, great-grandson of the painter, told me that, in the 1940s, when de Beucken was working on his Cézanne book and living in Saint-Rémy-de-Provence, he was a constant presence in his grandfather's home. If anyone knew the truth, it was Paul fils. But then, Beucken does say that "probably" Paul discovered the telegram. He didn't state it as a fact.

Léo Larguier saw things differently. He believed there had been premeditated action to keep Hortense away at the time of Cézanne's death, and he spoke of Marie's letter as "inhuman." He felt that, for Marie, "the wife of her brother remained the stranger, the enemy . . . an adventuress who had

gotten her hooks into the son of the family" ("qui a mis *le grappin* sur un fils de famille" [emphasis in original]). He also believed that Mme Brémond had always been "with the Cézannes against Hortense."[8]

Hortense Fiquet remains a puzzle. What was she really like? Was she that gregarious, talkative person that is sometimes described? Did she have "*aventures,*" as Philippe Cézanne assured me she did? But more than anything else we would like to know her real place in the life of the most significant painter of the early twentieth century. What was the nature of her affection for her husband? Could she really have sat for him hour upon hour, year after year, without possessing strong feelings for him? Could he have wanted her face and figure so much and yet have had so little sense of her as a woman? To my knowledge only one author has considered these questions and arrived at views similar to my own: that even if Hortense Fiquet and Paul Cézanne did not have thoughts and emotions approximating those of more "normal" couples, these two people counted for each other. In 1975 Sidney Geist wrote: "Cézanne could not have painted Hortense some twenty-seven times and drawn her at least fifty times without having strong personal feelings about her. And she could not have posed for him that often without having strong feelings about him."[9]

Let us hope that "Switzerland and lemonade," *la Boule,* the dressmaker and the missed train do not forever remain the staples to color an art lover's view of the person who played such an authentic role in the creation of some of the truly great portraits painted in Europe as the nineteenth century neared its end.

After October 1906

Six weeks before Cézanne died, he wrote a letter to his son in Paris. He wanted him to know of his enormous confidence in the "direction in which you are taking our affairs." Paul fils had been and remained the principal person to oversee the sales of his father's pictures, and he did so by working in concert with Ambroise Vollard. What had convinced the Cézannes that Vollard was to be their exclusive dealer was the energy he had put into mounting the Cézanne exhibition in 1895. At that time Cézanne was barely known in Paris, thus the project was a daring one. Vollard tried to work with Cézanne himself but did not succeed; instead he found himself dealing with his twenty-three-year-old son. According to Vollard's account, in 1895 he placed 150 works on view (probably an exaggeration), many of them from Cézanne's atelier in Paris, made available through Paul fils. This show put both artist and dealer on the map of modern art, and it initiated Cézanne's son into the family business. Sales from the show were modest; only twenty-four works found buyers, and many of these sales were watercolors. The average price was two hundred francs, although Degas showed up with six hundred francs in his hand in order that he might take home *Le Déjeuner sur l'herbe*.

Cézanne did not attend this landmark exhibition. But surely Hortense did, and probably several times. Three of her portraits were among the works exhibited, including the beautiful *Madame Cézanne in the Conservatory*. Was she there on opening day, standing beside her son with a sense of pride? More likely it was a sense of wonder that this was happening at all.

Eleven years later, Paul Cézanne was dead, and Paul Cézanne fils, now in his thirties, was a very rich man. His mother was also financially secure.

In the days that followed Cézanne's death, Paul and his mother cleaned out the studio at Les Lauves, the property in which Hortense held a life interest. She promptly signed it over to her son for a purchase price of two thousand francs. On November 28, an inventory of furniture and paintings in the apartment on the rue Boulegon was drawn up. Assisting in the work was Henri Pontier, director of the local museum, a man without a drop of sympathy for Cézanne's work. He assigned monetary values to the paintings, making the judgment that no work was worth more than five hundred francs. Their list consisted of seventeen paintings, including the *Large Bathers*, which is now in London, and which Pontier valued at three hundred francs.

Even before Cézanne's death, and even before the inventory had been taken, Vollard went into an agreement with Bernheim-Jeune, which had become the leading gallery for modern art in Paris. Together the two dealers would purchase a large number of Cézannes. This transaction went through in either January or February 1907, when they acquired twenty-nine "studies" for 213,000 francs, and 187 watercolors for 62,000 francs.[1] Many of these were shown in the first large-scale exhibition of Cézanne watercolors held at Bernheim-Jeune in June 1907. These sales, agreed to by the Cézannes, led John Rewald to wonder "why Cézanne's heirs were in such a hurry to dispose of his works, especially if one considers that they also inherited the artist's share of his father's and mother's fortunes, roughly half a million francs, as well as his share from the sale of the Jas de Bouffan. . . . It is not impossible that the artist's widow and son feared that the relatively 'high' prices they obtained for his works would not prevail and therefore decided to take advantage of the artist's modest posthumous vogue."[2]

The next step for the Cézannes in terms of legal matters was assisting at the *Partage des biens,* a document that details an individual's possessions. This took place on December 8 at the registry in Aix-en-Provence. It opens with reference to a handwritten will made by Cézanne in 1902, stating that his son was the unique and sole inheritor of all his goods and possessions, and that his "wife, should she survive him, will have no right to usufruct on the goods that could depend on the succession." But at the end of this very long document, we find that, although Hortense had no right to the *biens*—the paintings, the rents, the furniture, the railroad stock,—"Madame Veuve Cézanne was to receive the sum of 219,675.56 francs."[3]

Once they had packed up their belongings in the rue Boulegon and in the atelier at Les Lauves, Hortense and her son left Aix with little sense that they would return to this city that held so little attraction for either of them.[4] As far as we know, after Cézanne's death, mother and son continued to live together in Paris. When Paul wrote to Vollard (correspondence in Musée d'Orsay), he would usually include a "bonjour de ma mère." In 1912 Paul wrote urgently to Vollard: "I need 1,000 francs." The letter was posted in Monaco, which brings into view another shared trait of mother and son. They both loved playing cards, especially if the stakes were interesting. Rewald called Hortense an "inveterate gambler." In September 1995, as the centennial exhibition of the first Cézanne show was about to open at the Grand Palais in Paris, Hortense's granddaughter, Aline Cézanne, gave an interview to *Madame Figaro* (September 23, 1995). She did not mince words about this aspect of her father's and her grandmother's lives: "She made a rush for the casinos. I always saw her playing at cards. At home, more wisely, she played only solitaire . . . heredity, heredity . . . Paul Cézanne, le fils, he, too, liked to play—worse—he was a big-time gambler. For him it was the stock market, ideal activity for someone interested in exhausting his income." Rewald estimated that Paul fils basically took the fortune amassed by Louis-Auguste Cézanne, enlarged by the sale of his father's work, and reduced it to nothing. This was made easier by Vollard's approach to business. When Robert Jensen had studied the dealer's accounts in great detail, he arrived at the conclusion that Vollard was "less-than-scrupulous," and that the Cézannes were there to be exploited.[5]

After his father's death, Paul Cézanne fils was increasingly drawn into the company of the Renoirs, who became a second family for him. In 1907, the Renoirs purchased Les Collettes, a country manor in Cagnes-sur-Mer, an attractive and comfortable vacation spot—far more desirable than Aix. When the Renoirs weren't on the Mediterranean, they were in Essoyes in Champagne, home of Renoir's wife, Aline Charigot. This warm family, consisting of the painter, his wife, and their three sons, was ready to open its doors with great ease to a large circle of friends. To be in their presence represented an enormous change for Paul. He formed a special bond with Jean Renoir, although there was a twenty-year difference in their ages. In the film director's biography of his father, Jean described this friendship: "I liked to be with Paul simply for the mental and physical pleasure of being with him, just as a dog likes the

company of another dog. And I know he felt the same way about me." Jean Renoir admired the fact that "nothing of human interest escaped his heavy-lidded eyes," making note also that "this son of a genius was handicapped by a paralyzing modesty." Renoir observed that basically "Paul did nothing . . . when I say that Paul did nothing, I mean that he did not practice any known profession. Actually he had an occupation of a kind superior to that of an artist, a lawyer or a manufacturer: he lived!'"

Another important person in the orbit of the Renoir family was Georges Rivière. As one of the first historians of the new school of painting, Rivière got to know Auguste Renoir in the 1870s. Together they launched the journal *L'Impressionniste* in 1874. After Rivière's wife died, his daughter Renée lived more or less with the Renoirs. In time Aline Renoir began to imagine that her two young friends, Renée and Paul, might make a happy couple. Jean remembered how his mother "hoped that he [Paul] would settle down and give up spending his nights in cafés, standing his friends drinks and discussing boxing, for which he had a weakness." In spite of the fact that Paul seems to have imagined himself "too old, too bald and too short-sighted to be worthy of Renée,"[6] the two were married. Vollard marked it down in his journal: "January 6 [1913] marriage of Cézanne fils and Renée Rivère." Renée gave birth to four children, one after the other. Two lived into their adult years: Aline, born in 1914, named after the woman who inspired her parents' union, and Jean-Pierre, born in 1918. Like his grandfather, Jean-Pierre would become a painter.

Did Hortense continue to live with her son and his wife? It's unlikely. The Cézanne's first child, Aline, was born in Nice—Vollard was her godfather —and the young family stayed in the south until 1916, when Paul was called up to serve in the army. Being myopic, he never went to the front. It is impossible to ignore the fact that Hortense had been married to a man who was incredibly close to his mother, and now, she, a devoted mother whose son had spent far more time with her than with his father, had the power to reproduce the situation from the other side of the equation. Did she become an unwelcoming mother-in-law—or was she herself once again unwelcome? In the summer of 2004, I met Philippe Cézanne and asked him about the relationship between Hortense and his grandmother Renée. "Extremely tense," was his response. One particular image of family tensions is provided by Aline Cézanne in her

1995 interview. She remembered a terrible scene when her father pounded the table, shouting at Hortense after he had discovered that she had sold a painting she owned to Bernheim-Jeune. Paul insisted the family remain faithful to Vollard. There may have been more to his fury that simply the choice of dealer since the painting in the transaction must have been a portrait of Paul himself in his teens, wearing his father's bowler hat, a painting now hanging in the National Gallery in Washington.

According to Aline Cézanne, Hortense spent much of her life as a widow in Switzerland in the company of a paid female companion. But she also had an apartment on the rue Ballu in Paris. Léo Larguier remembered being invited there for dinner, an evening in which Vollard was also present. Larguier spoke of looking at the Cézannes adorning the apartment walls. So she hadn't sold everything. And what did Hortense think as her portraits began to leave the country? Vollard must have told her in 1909 that the painting her husband had made of her in the conservatory at the Jas de Bouffan was now on its way to Russia, but perhaps he did not mention that he got fifty thousand francs for it! He later sold two of her portraits to an American who had made a fortune in pharmaceuticals, Albert Barnes, of Philadelphia. For these he got forty thousand francs apiece.[7]

Photos have been published of Hortense in the early 1920s with the Conils, as well as at the wedding of Claude Renoir in Cagnes in 1922, a few months before her death. We know that at the very end of her life she was with her son and his wife in their apartment at 30, rue de Miromesnil, for that is where she died, on May 3, 1922, at the age of seventy-two. Hortense Fiquet Cézanne was buried in Père Lachaise cemetery. Twenty-five years later her son was laid to rest beside her.

During the last years of Hortense's life, Georges Rivière was in the process of writing a book on Cézanne, often viewed as the first serous art historical publication devoted to the painter's work.[8] He was able to study many of the paintings in his daughter Renée's home, as Paul still owned a number of his father's works. In his book, with the exception of two illustrations labeled "Portrait of Mme Cézanne," there is not a single mention of Hortense, even in the chapter called "La Femme dans l'oeuvre de Cézanne."

The chapter begins: "Paul Cézanne's life was not disturbed by amorous adventures. If the spirit of the artist was in constant torment, his heart remained

Jacqueline Picasso, *D. D. Duncan,*
Pablo Picasso and Jean Planque Looking at
a Portrait of Madame Cézanne, July 1960.
Lausanne, Foundation Jean and Suzanne Planque

quiet; love did not hold a place in this reclusive life uniquely devoted to art."
Rivière makes various observations on what Cézanne thought about women
and how this thinking affected his art: "Cézanne saw *la femme* as the tradi-
tional enemy of man: Eve, author of all our evils." Thus, "it's not because he
ignored or misunderstood feminine beauty, but because he thought of it as
harmful and dangerous that he kept it at a distance from his work." In his only
sentence about Cézanne's portraits of women, Rivière writes: "Besides that of
Mme Emile Zola, of Mme L Guillaume, and that of a young Italian . . . one finds
only portraits of women in his family: his mother, his sisters, his wife, the latter
being represented in a large number of paintings done in various periods."

When I met Philippe Cézanne, I read that sentence to him and pointed
out that Georges Rivière must have seen Hortense frequently while writing his
book, and he must have known several of her portraits intimately, yet he did
not once mention her name. I was curious to know what he thought about this
omission. He pondered the question for a few minutes, then laughed, saying,
"I've read that book, but I never noticed he made no mention of 'la Boule.'"

Camille Doncieux

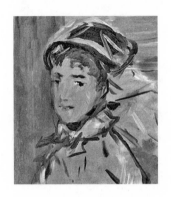

Camille Doncieux and Claude Monet

"Assez convenable"—"quite suitable." These words appear in a letter that Frédéric Bazille wrote to his mother on April 5, 1869. He was describing the family of Camille Doncieux, soon to be married to Claude Monet.[1]

The two men, now best friends, had come to Paris from the provinces earlier in the decade, Monet in the hope of establishing himself as an artist, Bazille honoring his family's desire that he become a doctor, while quietly carrying the germ of an artist in his heart. They met in the spring of 1863 in the painting studio of Charles Gleyre, just in time to visit the Salon des Refusés together. A joint visit has not been recorded for history, yet we imagine them standing side by side, just as Cézanne and Zola did, staring long and hard at Edouard Manet's amazing painting *Le Bain*. It made as big an impression on them as it did on those other two provincials.

A devoted son, Frédéric wrote his parents in Montpellier as often as he could, describing in detail his activities and his friends in the capital. So when Claude was about to get married, Frédéric mentioned the coming event to his mother, making a point of his dismay at the stinginess of Claude's father, who refused to help his son financially. Frédéric had come to Claude's rescue more than once when his friend was in pecuniary straits. "And yet [in spite of the senior Monet's stinginess] he is going to marry his mistress." Frédéric emphasized that "cette femme"—which is the way he referred to Camille—"comes from parents who are quite suitable and who have consented to receive her and to help her if she marries." Frédéric knew how important such facts would be for his parents.

What Frédéric did not mention was that the couple already had a child,

95

a child for whom he, Frédéric, was godfather. His remark about the bride's family was his way of indicating that they were a bourgeois family—as were the Bazilles and the Monets. The Bazille family was prominent among the bourgeois Huguenot community of Montpellier. Monet's family lived in Le Havre, and, though not of such high bourgeois stock, they were related by marriage to one of the foremost families of the port city, the Lecadres, who owned a wholesale grocery business and supplied provisions for ships that sailed in and out of the harbor.

Camille Doncieux, Monet's mistress and later his wife, was born in January 1847 in La Guillotière, on the outskirts of Lyons, a town later incorporated into the city proper. Her father, Charles-Claude Doncieux, was a merchant, presumably earning his living in the textile trades that dominated the Lyons workforce. Early in the Second Empire, however, M. Doncieux brought his wife and young daughter to Paris, where they lived on rue Neuve-des Poirées, a tiny street on the Left Bank within the precinct of the Sorbonne. There, in 1857, Charles-Claude's wife, Léonie-Françoise Manéchalles, gave birth to a second daughter, Geneviève-Françoise.

A few years later M. Doncieux moved his family to the village of Batignolles, a community on the northwest edge of the city that had recently become part of Paris proper. Until 1860, it had been outside the wall of the Fermiers Géneraux, the barrier built in 1785 for the purpose of installing more than sixty tax-collecting gates through which all had to pass in order to enter the city. On January 1, 1860, by imperial decree, the wall, which had defined the edge of Paris for three generations, was ordered demolished. The city's boundaries would now included eighteen independent towns that had previously been outside the wall, Batignolles among them. Within weeks workmen were tearing down the wall, and overnight Paris's twelve arrondissements became twenty.

When the Doncieux family moved there, Batignolles was sparsely inhabited, but now the newly incorporated town was ripe for development. It was exactly the kind of place that Napoleon III's Prefect, Baron Haussmann, focused upon. Here he was presented with ample opportunity for constructing new blocks of middle-class housing. Sometime after 1860 we find the Doncieux family moving into such a block, renting an apartment at 14, rue Truffaut.[2]

Our knowledge of this second Parisian address for the Doncieux comes to us by way of an unexpected, mysterious, and rather odd document. In 1866

a certain Antoine-François de Pritelly, widower, former tax collector, officer in the Legion of Honor, and a man of property, made out a new will favoring nine-year-old Geneviève Doncieux, apparently disinheriting his two sons.[3] This leads to obvious questions about relationships within the Doncieux family and suggests that Camille and Geneviève-Françoise, born ten years apart, were most probably half-sisters.

The flavor of Batignolles in the 1860s was that of a small village quickly turning into part of the city. In the process of the transition it attracted a fair number of artists. In 1867 Bazille found a place on rue de la Paix, Batignolles (Paris had three other streets called rue de la Paix in the 1860s), and he wrote to his mother of his pleasure at being able to live in such a tranquil neighborhood where the "living expenses are less than in Paris." In addition there were new cabarets, cafés, and brasseries. Furthermore, the area was located near the Gare Saint-Lazare, facilitating railroad trips to the country for the growing number of painters now focusing on landscape as subject.

The primary thoroughfare was the Grande rue des Batignolles (today avenue de Clichy). Here artists found the best supply shops in the area, as well as Père Lathuile's popular restaurant and, most celebrated of all, the Café Guerbois, which, according to the writer Edmond Duranty, took on a decidedly Parisian air once the village was annexed. In 1864 Manet rented an apartment on the boulevard des Batignolles, and on Fridays he planted himself at a table to the left of the doorway at Guerbois, soon to be joined by various members of the new generation of artists. Guerbois was the site of the story about Cézanne counseling Manet not to shake his unwashed hand, and it was a place from which Cézanne fled when opinions contradictory to his own became dominate in the loud debates. Monet was far more positive about the Café Guerbois. For him it was a place where "your mind was held in suspense all the time . . . you laid in a stock of enthusiasm that kept you going for weeks."

From 14, rue Truffaut it was only a short walk to the Café Guerbois: stroll to the end of the block, turn left onto the rue des Dames, and three blocks later you would be standing in front of the café. It would seem that this neighborhood, so attractive to young and revolutionary artists, might be the connecting link between a teenager from a home where we suspect there was considerable tension, and an ambitious young painter from Le Havre. It's not hard to imagine the slender, dark-haired Camille Doncieux doing her errands

in these streets, catching the eye of Claude Monet on one of his forays to the café. He would surely have noted her bearing, the way she walked, the way she made every item of dress look stylish and fine.

The idea is pure conjecture. We don't know where Claude Monet first laid eyes on Camille Doncieux or how he met her, but that neighborhood is the only connection we know between the girl and the artist.

Monet had long been associated with the northern edge of Paris, now the Ninth Arrondissement, and slightly to the southeast of Batignolles. There, in May 1841, at six months of age, he was baptized Oscar-Claude Monet in Notre-Dame de Lorette. His parents had an apartment just in front of the church. But Oscar—as he was called in the family—did not grow up Parisian. By his fifth birthday, father, mother, older brother Léon, and Oscar had moved from the capital to Le Havre, home of Adolphe Monet's half-sister, Marie-Jeanne, who was married to Jacques Lecadre, founder of a successful chandlery business. Adolphe now worked for his brother-in-law.

We have known little of Monet's family. So when I read *The Unknown Monet, Pastels and Drawings,* the catalogue for an exhibition curated by James A. Ganz and Richard Kendall at the Sterling and Francine Clark Art Institute in 2007, I was surprised to find that they had located an unpublished journal by one Comte Théophile Beguin Billecocq, who knew the Monet family well and who included in his journal vivid descriptions of Claude Monet's early life.

In 1853, Beguin Billecocq, a rich aristocratic minister, thirty years of age, met twelve-year-old Oscar and the rest of the Monets in the course of a summer holiday in Le Havre. He found them appealing enough to enter descriptions of each member of the family into his journal. He was completely charmed by Louise Monet, the painter's mother. She was beautiful and always smiling. He admired her drawings and watercolors, and this talent was surpassed only by her musical gifts, as both a singer and a pianist. In general he considered her the perfect hostess and commented on the way she received the best people of the *haute-bourgeoisie* of Le Havre into her grand salon. He also called her an excellent *"mère de famille."* The thing that particularly struck Beguin Billecocq about the hard-working Claude-Adolphe Monet was that he was impeccably well dressed. He believed him to be "merciless in commercial negotiations, but honest and fair." It was clear to the visitor that Adolphe favored his older son,

this "*garçon sage*" who, like his father, was disciplined and studious. In contrast M. Monet saw his younger son as a "*sauvage d'Amérique,*" likely to bring out the worse among his contemporaries. According to his father, "he likes to sow disorder, does not listen to his professors, does not do his homework, instead fills his notebooks with grotesque caricatures." But Théophile saw Oscar quite differently: "loyal, gifted with a happy temperament, and capable of being the life and soul of the party." He liked the fact that Oscar was inclined to be a *fantaisiste*—sometimes extreme and scatty, but always full of fantasy. Oscar got along very well with Théophile's young cousin and future brother-in-law, Théodore Beguin Billecocq. The two boys—only two years apart in age— became good friends, spending weeks, even months, together in the summer in whatever spot Théophile located as his choice for his annual vacation.

By 1858 things in the Monet family had changed drastically, for both Oscar's mother and his uncle Jacques had died. After Louise Monet's death in 1857, Adolphe took his sons to live with the Lecadres. Then Jacques Lecadre died, and Adolphe became the director of the firm. His sister, Marie-Jeanne Lecadre, now a childless widow, moved into the role of the guiding feminine presence in Oscar's life. As a woman totally devoted to the arts—one who had even tried her own hand at painting—she took this on with a great sense of purpose. She would put much of her time, her money, and her energy into thinking about her nephew.

Aunt Lecadre's nephew considered school a "prison." He dropped out without even getting a baccalaureate. On the other hand, he had found he could make money—twenty francs per piece—for caricatures that a local frame maker, M. Gravier, was willing to place in his shop window. It was here that young Monet met Eugène Boudin, a local artist who also placed work in Gravier's window. Oscar didn't much like the older man's work, but, when they finally met, Boudin was ready to overlook the "conceited boy's" manner and invited him to come along for out-of-doors sketching trips. Many years later Monet told Gustave Geffroy that watching Boudin work was an illumination comparable to the one Saint Paul experienced on his way to Damascus.

In 1858, both men showed work in the summer art exhibition in Le Havre, Monet's entry clearly revealing the influence of Boudin. The following year he felt ready to apply for a state-supported scholarship to study in Paris, a move supported by Adolph Monet, who probably imagined his son

at the Ecole des Beaux-Arts, followed by successes in various state competitions. Nothing of that sort took place; Oscar was rejected. But in the spring of 1859, in time to see the Salon, young Monet packed up some paintings, took recommendations provided by his aunt to meet painters who could give him advice—Armand Gautier and Constant Troyon were high on the list—and boarded a train to make the six-hour trip to Paris. He would never have to contend with those thirty-hour journeys that separated Paul Cézanne from the capital. Adolphe Monet approved, and he agreed to provide his son with 125 francs a month as an allowance.

Oscar was soon established in the neighborhood of his birth at the northern edge of the city. After several changes of address, he ended up in a furnished room on the seventh floor of a building at 18, rue Pigalle. An advantage of this address was its proximity to one of the great beer houses of Second Empire Paris, the Brasserie des Martyrs. There he could see—if not mingle with—such eminent bohemians as Baudelaire, Théodore de Banville, Henri Muger, the photographer Carjat, and, sometimes, when the great man was in Paris, Gustave Courbet. But as he later confessed to Geffroy with regard to the Brasserie: "I wasted a lot of time; it did me the greatest harm."

More important than choosing a local beer hall was the question of an atelier. Oscar ended up at the Académie Suisse—Beguin Billecocq wrote that he had talked to Camille Corot about the question of an atelier and that the Académie Suisse on the quai des Orfèvres was Corot's recommendation. Delacroix and Courbet both put in time in this well-known studio on the Ile de la Cité. In the winter Oscar wrote to Boudin that he was getting along well and he bragged a bit about his steady hand when drawing figures. Among the friends he made at Suisse was Camille Pissarro. If he had stayed a few months longer, he would have met Paul Cézanne.

In this period, which lasted a little more than a year, we might imagine a fairly disorganized teenager learning to be on his own, some days as a dandy, others as a student, coming to understand Paris as the center of the art world, and discovering what kind of art spoke most directly to him. Further, he had to figure out how to live on a small budget. His allowance was diminished after January 1860, when his father's out-of-wedlock child was born. Presumably Oscar did not know that the reason behind this reduction of his income was the birth of a baby girl, a girl who was his half-sister.

Oscar's time in the capital—complicated and no doubt enjoyable—suddenly came to an end. In November 1860 he turned twenty, putting him in the cohort of men obliged to participate in the lottery that determined who was to be drafted into the army for seven years of service. Oscar drew a bad number. But men who immediately agreed to join up were given the privilege of selecting the regiment in which they would serve. Oscar chose *les chasseurs d'Afrique,* later telling friends he was drawn to their elegant uniforms. Adolphe and a local grocer accompanied him to the ministry office in Le Havre to make his declaration. Of course, Adolphe Monet might have supplied the two thousand francs, the option commonly used among the bourgeoisie to purchase substitutes to free their sons from the lengthy commitment. We wonder why Adolphe Monet withheld his support. Was it is judgment that his son was not making a serious career choice? A desire not to spend the money? A wish to keep his son at a distance from the changes in his own home life? All three?

If Monet was unlucky in the draft lottery, he was fortunate in being sent to Algeria, for it was there that he contracted typhoid and so he returned home to recuperate at his aunt's house in Le Havre. In October 1862 Marie-Jeanne Lecadre wrote to Armand Gautier in Paris that she had decided to buy out the remaining time—five and a half years—of her nephew's service obligation. She explained she wasn't doing it just to please him, but because she couldn't bear to think that, in not doing so, she might be "standing in the way of his artistic career." But she knew he needed strong guidance: "his studies are still sketches, and when he wants to finish—to make a picture—it turns into the most terrible daubs in which he takes a complacent delight and finds some idiot willing to compliment him." Her commitment to Monet's career came at a steep price: three thousand francs. Now he prepared once again to leave for Paris, with a stern warning from his father: "Get it into your head that you are going to work, seriously this time. I want to see you in a studio, under the discipline of a reputable master. If you decide to be independent again, I shall cut off your allowance without a word. Am I making myself clear?"[4]

By winter, Oscar was back in Paris. In his absence much had changed, in particular the destruction of the wall of the Farmers-General, making possible the incorporation of many suburban communities and thereby increasing the population of Paris to over 1.6 million people. The development along

the boulevard des Batignolles gave considerable impetus to building up the neighborhood around the church of Sainte-Marie des Batignolles. Also there was a spectacular new quarter coming alive just to the south in the vicinity of the new Opéra, the cornerstone of which had been laid a few months before Oscar's arrival.

In March, Oscar signed himself in at the Louvre on the artists' register to copy paintings. He gave his residence as 19 passage des Masson, a tiny way found in another of the newly incorporated villages, Montmartre, north of the city, and next to Batignolles. But after the street address he wrote "Sorbonne," which would indicate the Left Bank, far away from *la butte Montmartre.* It's true he was now enrolled in the atelier of Charles Gleyre on rue Notre-Dame-des-Champs, which was quite close to the student quarter and the university. But this document is mysterious, for, in the space for "Nom du Maitre" he wrote "Gautier," not "Gleyre," and he gave his name as "Oscar," while we know he was introducing himself to his new friends as "Claude." The name change is recounted in Théophile Beguin Billecocq's journal: "Henceforth, my name is Claude Monet, which has a must softer sound to the ear . . . Goodbye Oscar, long live Claude!" Théophile felt that, since returning from Algeria, young Claude had become a *véritable homme,* and, though still a bon vivant, he was no longer an adolescent.

The studio he chose—as a result of family advice—did not have much to do with his redefinition or his sense of where he was headed as an artist. Fifty-six-year-old Gleyre was a traditional master who had developed under the influence of David and Ingres; from them he had learned to emphasize line over color and to give primacy to classical subjects. He once counseled Monet to remember that "when you do a figure study, always have the antique in mind." Such guidance had little meaning for Monet, but, as a teacher, Gleyre did have one strong point—he gave his students a great deal of freedom.

The most important consequence of Monet's experience in Gleyre's atelier was his friendship with Frédéric Bazille. Even though it had been the wish of the Bazille family that their son would become a doctor, Frédéric discovered that he loved more than anything else his days in that large drafty studio where the wind blew in between the cracks in the walls. He was intense about learning to draw, and he took real pleasure in an occasional compliment from the master. What did not please him were the other students, most of

whom he found to be loud and vulgar. So his father took note when his son mentioned in a positive way one from Le Havre "by the name of Monet." By Easter the two men were on vacation together in the forest of Fontainebleau. Bazille also mentioned "two or three pals from the atelier." He probably was referring to Auguste Renoir and the English painter Alfred Sisley. In the end, the four young artists were to become a solid band of "independents," but the essential meeting for both Monet and Bazille in the atelier of Charles Gleyre was with each other. Bazille wrote to his mother: "I'm with my friend Monet who is very strong in landscape and who has given me advice that has helped me a great deal" (April 2, 1863).

By March 1864, they were renting rooms near one another on the Left Bank and, undoubtedly, together found their way to Batignolles, the new Mecca for artists. There they could buy supplies and on occasion slip into the Café Guerbois in the Grande rue des Batignolles to participate in some of the lively conversations for which that establishment had become famous.

When the weather was warm Monet was usually out of Paris. Again he went to Fontainebleau for the Easter holiday; the following year he and Bazille were there together, at a country inn on the edge of the forest in the village of Chailly-en-Bière. The royal domain of Fontainebleau had once been a playground for aristocrats; now it was a holiday resort for the bourgeoisie and a magnet for outdoor painters. So clearly was this the case that when the Goncourt brothers arrived to do research for *Manette Salomon,* they found every tree "treated like an artist's model," and each trunk "surrounded by a circle of paint-boxes." One of the paint boxes might well have belonged to Monet. His sense of landscape was deep and instinctive. He was drawn to these sites full of copses and thickets; he loved the woods plentiful in chestnuts, sessile oaks, Norway pines, birches, and acacia trees. And of course, like everyone else, he painted the famous "Bodmer Oak" (named after a painter of the previous generation), the single most loved tree among the artists who trolled the forest.

By 1865, Monet had a number of canvases ready for the Salon. Some seascapes, done the previous year in Normandy, were accepted. And they were noticed by a few critics: "We are interested in following the fortunes of this sincere seascape painter" (Paul Mantz). As works were hung alphabetically in the Salon, Monet found his works near those of Manet, and Manet soon found

himself in a state of confusion when he was complimented for his seascapes. "Who is this Monet whose name sounds like mine and who is taking advantage of my celebrity?" That was fine with Monet. He wanted Manet's celebrity and he wanted it desperately, but he knew it would not come to him by way of the beaches and the choppy waters of the Normandy coast.

Hanging in the same room with Monet's seascapes was Manet's canvas of a nude courtesan reclining on a daybed while a black servant brings her a bouquet, and a black cat raises his stretched back near her feet. Like *Le Bain* it mocked another great tradition, this time that of the classical nude. The label said "Olympia," a title apparently supplied by Manet's friend Zacharie Astruc, who had written a poem in her honor, a few lines being excerpted in the Salon catalogue celebrating the *auguste jeune fille* named "Olympia." It was an outrageous image—a woman's body, not sumptuously beautiful in the great tradition of art history, but a naked lady of the night, or—as the critic Jules Claretie put it—an "Odalisque with a yellow stomach, a base model picked up I know not where."[5] And her impertinent face stared directly at the viewer as she waited for her evening's visitor. It was so beyond the limits of what should have been acceptable for a work in the Salon that it drove both critics and the public into virulent attack mode. One thing was clear to Monet—this would not be his approach, but he had to conceive of something original, something that would turn Paris upside down, a truly great painting that would enter his name into history.

Monet continued to think about *Le Bain,* the Manet painting that had caused such a scandal two years earlier—that strangest of Parisian picnics.[6] There had been thousands of paintings in the Salon des Refusés, but for Monet, as for Zola and Cézanne, this was the one that demanded attention.

Manet wasn't the only avant-garde artist whom Monet had firmly in his sights. His esteem for Gustave Courbet was enormous. Courbet had fought the art establishment with such gusto that, when he found he could not bear the way he was to be represented at France's first universal exhibition (1855), he went out and raised the money to create a pavilion of his own. The center-piece of that show had been a gigantic twenty-foot painting, a self-portrait of Courbet in his studio, working on a landscape while a nude model and a little boy watch, and a vast assemblage of every kind of individual imaginable—some known and some unknown to the painter—gathers round. It was his world,

the world of the artist. In some not-quite-articulated fashion, these two men were the competition against which the twenty-five-year-old Claude Monet wanted to measure himself.

Monet then laid out a strategy by which he might stand up against his idols. Like Courbet's *Atelier,* he would make a painting that was twenty feet wide. And the subject would be young Parisians taking the pleasure of the out-of-doors just as Manet had done in *Le Bain.* But as much as possible he would work in situ, avoiding making his work a studio painting in the manner of his predecessors. Nor would there be references to the past or to mythology. Unlike the paintings Cézanne did under Manet's inspiration a few years later—*Idyll* and his *Déjeuner sur l'herbe*—there would be nothing mysterious in Monet's approach, and certainly none of the highly personal sexual content that emerged in Cézanne's paintings. Nor would there be nudity—no vulgarity, no ambiguity, none of the qualities that had provoked viewers at the Salon des Refusés. This *Déjeuner* would include people of Monet's own age and class. And it would show the life that he imagined as his own: beautiful young people enjoying a day in the country. Even more important, however, it would be a "natural" painting, "pure *plein-air,*" as he put it. Zola was soon to pick up on this idea, insisting that placing life-size figures in a landscape was "the dream of every painter."

By early spring 1865, Monet had settled in Chailly and had embarked on his search for a site. In May he wrote to Bazille: "I really wish you were here to give me your thoughts about my choice of the landscape for my figures." He settled on an area dominated by a single gigantic beech tree, and began making sketches to determine the distribution of figures around a large picnic cloth: five young women, six gentlemen, plus a servant half-hidden behind the tree. Monet had painted portraits before—family and friends—but this was the first time he planned on working with models to be placed within a scene. Of course he never had a plan for assembling a twelve-person chorus, posed stagelike in the woods. No one did that. He would work with individual models, making drawings, getting their poses and positions right in preparation for the large composition which, in fact, he would probably have to work out in his studio.

But who should model? As historian Marianne Alphant points out, Chailly and Barbizon were full of potential models—artists' friends, camp followers of "la Bohème," mistress-models.[7] There were no end of choices,

but Monet wanted particular people. Just as Manet and Courbet worked with friends and family in their paintings, he wanted people who meant something in his life. Besides, he couldn't afford to pay anyone. He especially wanted Bazille: "You were to come to pose for several figures, and without that I will not be able to do my picture . . . I beg of you, my dear friend, do not leave me in such difficulties" (summer 1865). When Bazille didn't come in time: "I am in despair. I feel that you will be the cause of my picture's failure" (August 16, 1865). Finally, Bazille came, which necessitated postponement of his own trip home. We recognize him in four of the seven male figures: his lanky six-foot, two-inch frame lying prone at the picture's base, kneeling to join a female companion on the picnic cloth, advancing from the left to escort two elegantly dressed women who have just arrived—all depicted with Bazille's dark mutton-chop beard. He may also have modeled for the man with the russet-colored beard at the rear of the scene, a man looking attentively at the woman by his side as she adjusts her hat. Some authors have suggested Courbet as the model for the man with the russet beard, but a change of hair color is an easy feat for a painter and it is not likely the young artist would have invited the great man to pose.

But what about the female figures? There is no contemporary documentation save a brief reference to "la jeune Gabrielle" in Monet's letter to Bazille on May 4: "Young Gabrielle arrives Monday during the day."

For a long time it didn't occur to anyone writing about this painting that Monet's future wife, Camille Doncieux, might have been involved in the big enterprise that got under way that summer on the road to Chailly, mostly because no one ever talked about the painting. This was Monet's fault: he never finished it. He rolled it up, left it in a landlord's basement, and, when he finally retrieved it, he cut it up, storing two sections in his studio in Giverny. They were added to the Louvre collection in 1952 (now in the Musée d'Orsay). The American collector Alisa Mellon Bruce purchased the only surviving oil sketch of individual figures from Monet's son, Michel, and in 1970 she gave it to the National Gallery in Washington. Early in his career, when Monet was in desperate financial straits, he himself sold the only sketch of the entire composition, a four-by-six-foot oil, to a private collector. This eventually found its way to Moscow and now hangs in the Pushkin Museum. Thus *Le Déjeuner* didn't really enter Monet studies until after World War II.

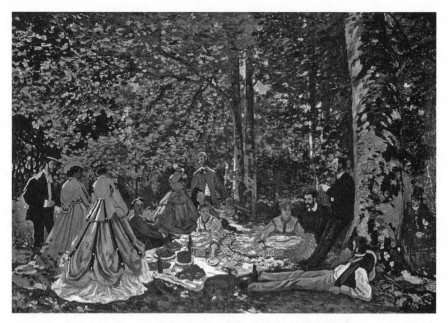

Monet, Sketch for *Le Déjeuner sur l'herbe,* 1865. @ Pushkin Museum,
Moscow, Russia/The Bridgeman Art Library.

What finally brought Camille's name into the picture was a discovery by
Bazille's nephew. In 1947, a maid in his home came across some long-forgotten
boxes of drawings, prints, and photographs. Among them were several draw-
ings by Monet, one a sketch of Camille wearing one of the dresses and taking
the pose of the figure in white seen on the left side of the Moscow study, as
well as in the National Gallery sketch. Every modern author writing about this
painting now takes Camille Doncieux's presence in the forest of Fontainebleau
in the summer of 1865 for granted (with one curious exception: the authors of
the Wildenstein catalogue raisonné). Whatever disagreement there is concerns
only how many of the female figures she posed for—some say all five, or three,
or only two. For me three is the right number, because three of the women,
like Camille, are brunettes; the other two are blondes, which might suggest
that *la jeune Gabrielle* was a blond. Further, the two blondes, both in beautiful
white dresses and seated on the picnic cloth, are seen full face, whereas the
brunettes, entering the picture at the left, have their backs to us, and the woman

in profile, standing deeper in the picture space, raises her arms as if to adjust her hat, thus concealing her face. Could it be that Claude Monet, as he imagined the painting taking its place before the eyes of *le tout Paris,* was not ready to reveal the face of the girl who was now beginning to occupy such an important place in his life?

As Hortense Fiquet brought solidity and patience to Paul Cézanne's art, young Camille Doncieux brought a sense of style and an instinctive taste for feminine elegance to the painting of Claude Monet. These were great gifts for an impoverished young artist dependent upon an unreliable allowance from a father who did not always support the choices his son was making. Claude could not possibly have hired a model like Camille, nor availed himself of such elegant finery.

Camille's father, Charles-Claude Doncieux, is identified as *négociant* in various documents from Lyons. He was in his late forties and still working when he brought his family to the capital. At this time in the Second Empire, Paris was just coming into focus as the fashion capital of a new ready-to-wear world, made possible by the establishment of *les grands magasins*—the department stores. In *Au Bonheur des dames,* Emile Zola's novel about the new department stores, he described how, upon entering a store, women approached a display of fabrics, only to be overcome by a "new bodily desire . . . the damasks, the brocades, the beaded and lamé silks, amidst a deep bed of velvet . . . women, pale with desire, lean over as if to see themselves . . . secretly fearing they might be captivated by such overwhelming luxury and, unable to resist the longing, to throw themselves in and be lost forever." One suspects that the Doncieux emigration to Paris resulted from some kind of connection between the fabrics of Lyons and the new fashion industry of Paris. I suggest that Camille came to her sense of fashion through lessons learned at home. Further, having been brought up in a bourgeois environment—in contrast to Hortense Fiquet—Camille most likely had been taught the importance of bringing pleasure to the eye of a man. How else would she find a husband?

Even if she hadn't learned her fashion lessons at home, Camille could have become fluent in the intricacies of *la mode* and entered these fantasy worlds all on her own. By 1865 there were four major department stores in Paris. The Bon Marché (1852) on the Left Bank was the model for them all,

but, by 1865, Le Printemps had opened its doors on the Right Bank. It was the nearest store to Batignolles and its displays and merchandise attracted young women of the petty and middle bourgeoisie. We can imagine this to have been Camille's kind of place, and, thanks to the new retail approach—*entrée libre,* "no obligation to buy"—she could treat it like a museum, coming and going, looking and dreaming. It was a *démocratization du luxe,* allowing bourgeois girls to aspire to that aristocratic look. Night and day, the store windows were there to teach her exactly how she might achieve it. In addition, there were plenty of magazines publishing fashion plates. Camille may even have introduced Monet to the world of the published fashion plate. Both the clothes she wore and the poses she assumed were inspired by what we see in those plates.

The dresses featured in the *Déjeuner* were of the moment—not those old circular crinolines of 1860, but the new ovoid form, flattened in front, and spreading out majestically in the rear. The two ladies entering from the left, still with their hats on—round-brimmed and modest in size as fashion dictated —wear jackets over their voluminous skirts. One wears a gold dress with black ribbons gathering the overskirt into loops, revealing the white underskirt, with white buttons attaching the ribbons to the skirt, the jacket and sleeves. The woman behind her is in a white dress, but it is painted mostly with a pale gray pigment so that we read the image as being in a shadow cast by the full-leafed trees above. This dress features an embroidered design in black braid following the edge of the jacket and down the close-fitting sleeves to the wrist. It is the dress Camille wears in the sketch found in Bazille's trunk. The center of the painting is full of light, merging the picnic cloth and the expansive white dresses worn by the two blond women. One wears a dress created from a striped fabric with a green puckered design stitched in place at the shoulders, wrists, down the front and circling the folds of the immense display of soft floating fabric. Her dress flows lightly over her neighbor's gown, in a style closely resembling her own, but in a sheerer, gauzy white fabric with tiny black dots and an edging design made possible by the intricate manipulation of black ribbons.

This scene is related to what Charles Baudelaire had in mind when he wrote about "Modernity" in his review of the Salon of 1859. He recommended that artists look carefully at the costumes, the coiffures, and the gestures of

contemporary women. They should observe the cut of a skirt and a bodice, "how the pleats are arranged according to a new system," and finally the artist must see how "through gesture and bearing a contemporary woman is able to give to her dress a life and a special character which are not those of the women of the past." This was "Modernity," and it's what Monet wanted to capture in his *Déjeuner sur l'herbe*.

What we can never know is how it all happened. How did these dresses get to the woods of Fontainebleau? It's hard to imagine Claude writing to Camille, as he did to Frédéric: "Catch the train that leaves Paris at 3, the Bourbonnais line. It connects with a carriage" (April 9, 1865). There were six trains a day from Paris. The trip to Chailly took about two hours. But it would seem Camille's ground-sweeping dresses needed a carriage, door-to-door. And even getting into them—the pantaloons, the chemise, the corset and crinoline, buttons and hooks—could a girl do this on her own? And we don't know how Camille came to have such magnificent dresses, though it's not impossible that they were rented garments. One thing is certain—she never stayed overnight. The inns in the villages of Chailly and Barbizon were rough-and-tumble places. Men slept several to a room, dormitory style; they ate and drank communally, and their boisterous pleasures kept them going into the night even when they hoped to greet the day at dawn.

The notion of these elegant Parisians transported to the woods of Fontainebleau is in itself odd. Most artists and writers who worked around Barbizon have left us with a view of real country life—simple, rough, being one with nature. But Monet was fixed on his idea of being "modern." And he had fallen in love with Parisian chic, which was on display during the Second Empire as it had not been since before the Great Revolution.

We are left with an idea, with a concept—and some fragments—of a work that was to have been Monet's big statement about the new art—a work that was to have made the reputation of a twenty-five-year-old painter from Normandy who looked forward to facing a hypercritical Parisian crowd at the Salon of 1866. In his dream this was the only arena where he might make his reputation. His idea had been to throw out the studio practices of the Romantics along with nude models, exotic references, and literary stories. He would replace them with the exquisite beauty of the triumphant Parisian bourgeoisie here revealed on the very grounds of the old aristocracy, and *en*

plein air! It was a dream as seductive as anything the world had ever seen. And *it was* seductive. Pierre Giffard, in his book about the commercial world of modern Paris, put it this way: "Eve's daughters enter this hell of temptation like a mouse into a trap."[8] And so did an eighteen-year-old girl find her way into a new life that summer of 1865.

Camille—Or—The Green Dress

Autumn arrived. Bazille had remained in Montpellier with his family. Monet was back and forth between Chailly and the Paris studio the two painters now shared at 6, rue de Furstenberg in the *quartier* Saint-Germain des Près. Not only was it a fine and ample space where they could both live and work, it overlooked the studio and garden where Delacroix had worked until his death two years earlier. It gave the place a certain cachet. Monet established his twenty-foot canvas and began preparing for the final composition. In the middle of October he wrote urgently to Bazille: "You must immediately send me 125 francs for the rent." He said he was about ready to "dive into his painting," and reminded Bazille to bring back the same clothes he had been wearing in Fontainebleau.

When Bazille returned to the city in November, he had his own Salon ambitions. He wanted to create a canvas showing a young woman playing the piano. The two men worked side by side, occasionally taking time off to entertain friends who were particularly keen to inspect the progress of Monet's big painting. Rumors were about that he would triumph at the next Salon. The most memorable among various interruptions was the December visit of Gustave Courbet. How they enjoyed that day—welcoming the great man for whom they both had such admiration, then to watch him walk around the studio and study their work. With some excitement Frédéric wrote to his brother, Marc, of Courbet's complimentary remarks about his new work. And when the older painter gazed upon Monet's *Déjeuner*, "he was enchanted." Years later Monet described this visit to the critic Felix Fénéon.[1] He told him about Courbet's comments, the most significant one being: "You'll not be finished in time. Even

I couldn't do it." Courbet was right: it was never finished. Fortunately, that fall Monet painted the smaller six-foot version. Otherwise, we would have only a few sketches to give us an idea of the whole composition.

By year's end, financial problems and a neglected lease put an end to the Monet/Bazille tenure on rue de Furstenberg. They were evicted on January 15. Their plan to go their separate ways did not please Bazille's father: "I'm sorry about your decision to separate from Monet. He's a hard worker who must occasionally make you feel embarrassed about your own laziness. I fear your being alone on a good number of mornings, or even whole days, they will pass in your *dolce far niente*" (December 28, 1865).

Aunt Lecadre's friend Armand Gautier helped in the search for a new atelier. For the second time Monet found himself on the rue Pigalle on the edge of Montmartre, this time in a tiny place on a fourth floor. The small dimensions put an end to any notion of finishing his twenty-foot behemoth for the Salon. But it had one advantage: it was a ten-minute walk to rue Truffaut and Camille Doncieux.

The March deadline for Salon entries loomed. Although in separate studios, Monet and Bazille marched along in parallel fashion. Bazille had also rented a small atelier on the Right Bank. As soon as both were installed in their separate spaces, each went to work on an over-seven-foot canvas. Toward the end of January, Bazille wrote his mother that the *jeune fille au piano* was not going smoothly: "What is really horribly difficult is the woman. And there is the problem of this green satin dress which I have rented and her blond head which I fear I will not do well."

The rented green dress then becomes a part of the story. It seems that once Bazille gave up struggling with his "blonde," the dress moved over to rue Pigalle. Monet had never done a life-size portrait. With only a few remaining weeks in a dark and cold February, his choices were limited. The idea of painting a single figure was an attractive one, especially when the model brought not only her bearing and her beauty, but her warmth and, perhaps—we don't know—even love into the cold studio of a young artist.

If there was a problem with fit, Camille could get around it by donning the fur-trimmed black velour jacket over the dress. They decided on a tiny feathered hat as the right accompaniment for the gown and the jacket. They must have tried out various poses, settling on one that had Camille standing

with shoulders firm, torso slightly arched, her body placed with her back to Monet, and to the viewer, while turning her face toward him so he could paint her partial profile. A gloved hand is raised to adjust the tie of her hat, a movement that might suggest leave-taking.

Monet, standing before his immense canvas, took a position so that we are looking down on the vibrant green-and-black-striped satin gown that swells out behind Camille as she makes her slow, dignified movement. But the meaning is not completely evident—what is she doing? Is she in the process of leaving? It's not clear. As Uwe Fleckner suggested in the catalogue of *Monet und Camille,* the 2005 exhibition at the Bremen Kunsthalle, what we see is in no way "a glimpse of everyday life; it is a pictorial mise en scène."[2] It is a pose similar to the one Camille took the previous summer when she modeled for the figure to the far left in *Le Déjeuner sur l'herbe.* Camille exists here as *the* contemporary woman, the one seen in the latest fashion magazines or in the windows of department stores. As image and idea it was one that had strong appeal for both the artist and his model. With her body turning, head tilted up, her hand in a self-conscious gesture, Camille exudes elegance and a quality of display, one that apparently came naturally to her. Using broad strokes, Monet focused on the full sweep of the dress, with its multiple folds of opulent fabric enhanced by the movement of the jacket's fur border and crowned by his model's fine face with its look of inwardness, its aura of veiled discretion. This time Monet did not quite hide her face. He touched in the slight wisp of dark hair coming down over Camille's cheekbone, her thick, dark eyebrows and lowered lids, the shadows beneath her eyes, her strong nose, and dark pink lips, beneath which he placed a shadow emphasizing the shape of her chin. Monet painted deftly, modeling the figure firmly with bold strokes, fashioning the dress with a handcrafted tactile quality and placing the figure against a dark red curtain. As soon as one layer of paint was dry, he'd be back to take it up again. By the end of February, he had given birth to a Camille who was no longer the teenage girl from the neighborhood, but an aloof, elegant, mysterious Parisian woman.

All that remained was to fill out the entry forms and transport the canvas to the Palais de l'Industrie on the Champs-Elysées. Before this could be done, however, Monet had to decide what to call his painting. When an artist put a portrait in the Salon of a woman who is not known to the public, it was

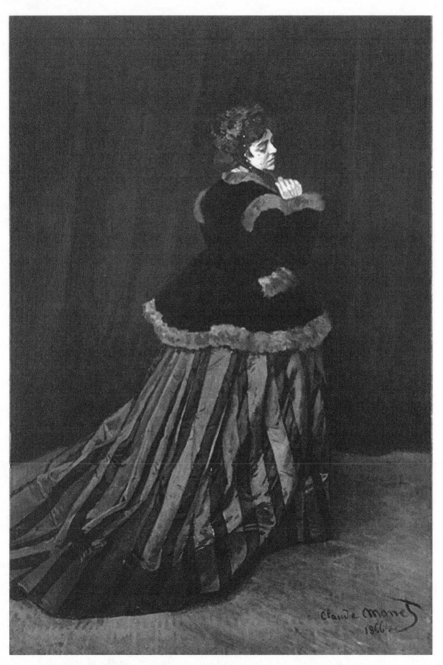

Monet, *Camille*, 1866. Bremen, Kunsthalle

normal to label the canvas with an impersonal title such as "Portrait d'une femme," although in this case "Portrait de Mlle C." would have been perfectly acceptable. Monet, however, wrote "Camille" into the registry. It was a public statement of sorts, one that is surely best read as a declaration of love.

The Salon of 1866 came together in an atmosphere of crisis—so many works were turned down. One painter's suicide was laid at the feet of the harsh judges. Bazille's girl at the piano was refused. Even Manet's two submissions were sent back to the artist. But Monet's *Camille,* as well as a landscape he had done in Fontainebleau, were not only accepted (along with 1,998 other paintings), but the big portrait was among the few works chosen by the press for serious attention. It received both praise and criticism, along with a lively dash of ridicule, a specialty of the Parisian press. Every year the prestigious journal *L'Artiste* selected a few works to immortalize through poetry. This year one poem was addressed to *Camille: Parisienne, ô reine—ô noble creature.* In *La Vie Parisienne* (May 5), Félix Y supplied his own drawing of the painting and accompanied it with the line: "Camille: Happy in her striped dress without crinoline, sucking contentedly," having reconfigured her raised hand, moving it from the ribbon of her hat and placing her thumb in her mouth.

French art criticism, like French politics, is always contentious and never one-sided: the noted critic Edmond About felt satisfaction to find *Camille* in the *salle de débarras*—the room he perceived as full of works fit to be thrown out. He complained that "a dress is no more a painting than a sentence written correctly is a book. What does this outfit mean to me if I cannot understand the body beneath, or the banal contour of the model, if the head is not a head, and the hand no more than a paw?" Charles Blanc, conservative critic for the *Gazette des beaux arts,* had even darker thoughts, finding in *Camille* "a type of woman that we know, often painted in many layers of pearl white and flaming red, she passes proudly, protected by both her vices and her elegance" (1866). Willem Bürger (pseudonym for Théophile Thoré), a liberal critic, was enthusiastic, but he made an inaccurate remark that has endured as fact into modern times when he proclaimed that "this opulent canvas was made in four days." After the art dealer Firmin Martin saw it, he wrote to Monet's friend Boudin that it was "a painting, not a portrait," a perception that many in the community of artists understood to be a great compliment.

Of all the reviews, however, the most extraordinary one appeared on May 11 in *L'Evénement:*

I confess that the canvas which made me pause the longest is M. Monet's *Camille*. Now here is an energetic and living work. I had just passed through the cold and empty rooms, tired of not finding a single new talent, when I caught sight of this young woman, trailing her long dress, penetrating into the wall, as if there had been a hole there . . .

I do not know M. Monet, I don't believe I have ever before looked carefully at one of his works. Nevertheless, I feel he is one of my old friends. And this is because his painting has recounted a whole history of energy and truth.

Yes, indeed! Here is a temperament, a man in a crowd of eunuchs.

This noticed appeared in the fifth article by the newly minted art critic for *L'Evénement,* Emile Zola, writing under the pseudonym "Claude." Nothing could have pleased Monet more than the appearance of this unknown writer on the horizon. Two days later the celebrated caricaturist Gill put a sketch of *Camille* on the cover of *La Lune.* Under it he posed a question: "Monet or Manet?—Monet. But is it to Manet we owe this Monet? [Mais c'est à Manet que nous devons ce Monet?] Bravo! Monet; Merci! Manet." Again pleasure swelled in Monet's breast, but for Manet it was yet another insult heaped upon the rejections he had received. The critic Edmond Duranty wrote to the painter Alphonse Legros: "Manet is very tormented by this rival Monet" (Manet est très tourmenté par son concurrent Monet).

Monet's decision to put his painting before all Paris as *Camille* was a bold act, a public statement that this was no ordinary model, but a particular woman. This could not have come as a surprise to the Doncieux family, who certainly had some idea about how much time their daughter was spending with the young artist. The Monet family back in Le Havre must also have known, as the Bequin Billecocq clan were much involved in Monet's success at the same time that they were touched by his "financial difficulties . . . I bought a series of drawings for 200 francs," wrote Théophile in his journal. His sister

purchased a painting, as did his father, and also Théodore. Between them they contributed more than a thousand francs to Monet's well-being in the period of the Salon. Théophile reports that he "went frequently to the Salon and there was always a crowd around the works of our artist, especially before his *Camille.*" They even got to know Camille. Théophile was in the habit of organizing "theatricals" in his Salon, and one evening "Claude and Camille Monet reinforced our troop . . . Camille Monet was an excellent *comedienne,* as was her husband. . . . They were particularly good in the comical roles." " So this girl who had become the toast of Paris—at least for a couple of months—was now being introduced around as Mme Monet.

Willem Bürger ended his remarks about Monet's painting in his "Salon de 1866" with the remark: "Henceforth, Camille is immortal and will be called *The Woman in the Green Dress.*" This is exactly what happened: Camille faded, and "The Green Dress" took over. After Camille's death in 1879, Monet seldom spoke her name in public. In an interview with François Thiébault-Sisson in 1900, Monet reminisced about his early successes, describing the praise he received for "Woman in Green." He made no mention of Camille's name.

In 1924 Camille Mauclair published *Claude Monet,* a book that became one of the most respected reference books on Monet. In it he gave the standard account of the painting, the one most often repeated: "To replace the *Déjeuner,* Monet, determined to exhibit, painted in a few days, the portrait of a woman, to whom he gave the name *Camille.* It subsequently became known as *The Woman in the Green Dress.* It portrays a beautiful woman attired in a dark colored jacket trimmed with fur and a silk dress with black and green stripes."[3]

But Monet never allowed the real history to be totally lost. When the Bremen Kunsthalle purchased the painting in 1906 from the Berlin dealer Paul Cassirer, the director wrote to the artist, asking for information about the model. Monet replied: "It is indeed Mme Monet, my first wife, who served me as model, though it was not necessarily my intention to do a portrait of her, but merely a Parisian figure of that time, the likeness to her is complete."

A Garden Full of Dresses

Even before *L'Artiste* recognized *Camille* as the "triumphant Queen of Paris," and before Zola had singled out Monet as *the* new talent in the Salon, as that "man in a crowd of eunuchs," model and artist had left the city. Camille moved away from her family, presumably without their blessing or approval, and Monet fled his creditors. The nineteen-year-old girl could not possible have imagined that most of her future would be lived under the shadow of severe financial insecurity.

Despite the popularity of *Camille,* it had not attracted a buyer. Of course the Beguin Billecocq family had been generous in the period with the purchases they made, but this was not sufficient to provide Claude and Camille with the funds they needed in order to live. Monet was still dependent on an allowance from home. And that was complicated. Aunt Lecadre remained Monet's best hope of support, but even she could not always be counted on. After the opening of the Salon of 1866—but before the reviews were published —Monet wrote to Armand Gautier: "Bad news from Le Havre. My aunt has decided to cut off the money she pays for my lodging with this month. I'm completely shattered." Gautier intervened, and Aunt Lecadre was willing to reconsider, but she made it clear that she knew of her nephew's debts and had no intention of paying them.

A few weeks later Monet informed Gautier that: "I [no mention of 'we'] have moved. I've found a little house near Ville-d'Avray and I have made an important decision, that is, to leave aside for the moment all the big things I was doing since they just eat up money and put me in debt." He had explained all this to his aunt, and, thanks to Gautier, she seemed satisfied. The following

month, again to Gautier: "I write to thank you for your goodness and for the interest you have taken in me. . . . my aunt appears to be delighted." Gautier had sent her Zola's article from *l'Evénement* (as had three other people). For the moment all was well in Le Havre. In addition: "My success in the Salon helped me to sell several paintings and since I have seen you I have made 800 francs."

Ville d'Avray, a small community to the southeast of Paris, near the Parc de Saint-Cloud, was noted for its lovely ponds. Corot had focused on them in several paintings. Monet might have described his move as an opportunity to find some new landscape subjects. But the remark he made to his aunt about leaving aside "all the big things" was far from the truth. The minute he and Camille settled down, he started to assemble a structure for an eight-foot painting. He was still determined to realize the goal he had set for himself with the *Déjeuner:* a large figure painting placed within a landscape. And this time he would go a step further: he would execute it completely in natural light—that is, out of doors. He intended to submit it to the next Salon.

Fortunately "Mme Monet" was there to make it possible. If *Camille* had been a celebration of courtship, the new painting is the story of love possessed. Leaving her family to become the mistress of a poor artist was a big risk for Camille Doncieux. But then, Claude Monet wasn't just any poor young artist. He was dynamic and determined, full of wit and also terribly attractive as we know from the photograph he had taken in 1864 by the recently established photographer Etienne Carjat. It provides us with an image of twenty-four-year-old Monet, stylishly dressed in light pants, dark coat, white shirt, and tie, with his right hand in his pocket pulling back his coat, a gesture that reveals a striped vest beneath. His forceful brown eyes under dark eyebrows look straight ahead, and his dark hair falls down to his collar, lips closed under a small mustache and thin vertical strip of hair on his chin—*l'impériale,* as it was called. Renoir described the impression Monet made on the other artists at Gleyre's. His fine dress and his worldly manner earned him the nickname of "the dandy."[1] It's not difficult to understand Camille and her desire to be in Ville d'Avray, to collaborate in the realization of the fabulous creations that Claude continually described for her. It was a new world—a beautiful world—and it was the world to which she now committed her life.

What Monet wanted to do was to realize what had eluded him in Fon-

tainebleau. As he explained years later to the Duc de Trévise: "I wanted to do this painting *sur place et d'après nature*" (after nature in a particular place), in a way that no other painter had ever done.[2] To manage the large canvas in the outdoor setting, he described to the Duc how he had dug a trench in the tiny garden and then established a pulley system that enabled him to raise and lower the painting into the trench so he could easily access every part of the canvas.

By early summer, the small garden with its single tree in the center and its curving path displayed a flower-studded lawn and a fully flowering white rose bush. Into this charming but restricted environment Monet made plans for placing four beautifully attired women wearing light summer dresses. Three of these dresses—all white—had been worn the previous summer in Fontainebleau—one by Camille and two by "the blonde." The fourth, a beige-rose dress and jacket, ornaments at the shoulders and wrists, mother-of-pearl buttons descending in a straight sparkling sequence from throat to ground, was new. Three of the women form a group on the left side of the painting, two standing, while one is seated on the grass. Deeper in the garden, to the right of the tree, the fourth figure—a redhead—in a familiar polka-dotted white dress, moves forward with outstretched arm, apparently to pick a rose. We are invited to gaze upon this graceful figure in brilliant sunlight, and on the beauty of the movement of her full-volumed skirt and her flared jacket. The powerful presence of her white form is balanced by the equally brilliant white dress worn by the woman seated in the foreground. For art historian Robert Herbert they appear to be touched by "the strongest sunlight ever yet to have shone in a French painting." The skirt of the woman seated in the foreground is embroidered with black braids and spreads out like a cloud where it is touched by the sunlight, and then shifts to lavender where it falls into shadow. She holds a pale coral parasol in her left hand, which casts her head and face in shadow. Nevertheless we must admire her tiny yellow straw hat adorned with green braid from which hangs a ring of small golden bells, held firmly in place by a sumptuous yellow bow. All the while she concentrates on the accumulation of red and white flowers placed in her lap and fingers the leaves of the blossoms.

The other two figures stand in the shade of the trees in powerful contrast to those in brilliant sunlight. One, in perfect profile, wears the green-striped

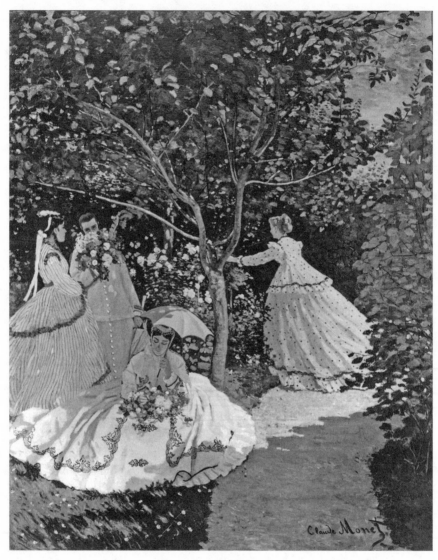

Monet, *Women in the Garden,* 1866. Musée d'Orsay, Paris.
Bridgeman-Giraudon/Art Resource, N.Y.

white dress from the previous summer, but she has added a stylish hat that resembles a red crown woven with green leaves and covered with white flowers. A white ribbon tied under her chignon falls down her back, while a garland of flowers descends as a necklace under her chin. Behind her, the woman in the beige-rose dress—the kind worn for society visits—holds a parasol in her gloved hand while plunging her nose into a sumptuous bouquet of flowers.

Monet continued his love affair with *la mode.* There is a total psychological disconnect between the figures in this painting; no narrative is suggested by their close proximity, nor any indication as to why they stand or sit. We recognize them as intimate cousins of the stiff and artificial figures prominent in fashion magazines and department store advertisements throughout the Second Empire. In other words, it's a painting without a narrative. Its focus is light and color, and it is highly dependent upon Camille's marvelous ability to show off the latest fashion to great effect. The painting is about a partnership into which I believe Camille stepped gladly in full support of her lover's quest to make a daring new statement in modern French painting.

Again Monet showed little interest in Camille's face. He has given us a profile, a pair of eyes gazing over a bouquet of flowers, a mask with lowered eyelids in the shadow of the parasol. There is only one known photograph of Camille Doncieux—a passport image made in 1871—and it has all the defects of the normal passport photograph, but it does tell us that her eyes and her eyebrows were the strongest things about her face. Camille's face was not what interested Monet—rather it was her form and figure and her ability to wear clothes. We recognize her even when her back is turned. At this point in his career Monet was just as concerned with the female body as was Manet or Courbet, but, unlike them, he did not engage with it directly. Rather he reveled in its ability to be adorned. As he moved to conquer the Paris Salon, he invented his version of bourgeois modernity in a form that was central to Second Empire taste. And Camille became his talisman, his solitary actress in the scene of his creation, the one he hoped would lead him to victory. She was as much his as the *Lady with the Unicorn,* who had been captured on a flowered ground in the company of an emblematic beast in a tapestry at the Cluny Museum—a work Monet no doubt knew, although he may not have thought of it as having any relationship to the very modern painting he was in the process of creating. And he, like the medieval artist, has captured his *dame.*

Let's imagine their days in the tiny backyard: Camille getting into one dress, then another, trying out various positions, and constantly waiting for the sun to come out since light and shadow meant everything. Most authors see Camille's role only in the three dark-haired figures on the left of the painting. The redhead must be someone else. But who? Monet didn't have money for a professional model. Would they have invited a friend from the city to join them in their intimate retreat? It was more likely that Monet pushed his brush into the vermilion oil on the other side of the palette in order to fashion that voluminous red chignon. A decade later Claude painted Camille as a blonde dressed in a Japanese kimono. Why not a redhead in Ville d'Avray?

Big works cost money. By mid-June Monet had spent what he had made from the sales in the wake of his recent success. Probably much of it had gone into paying back his debts. He speculated about whom he might ask for help, and he decided on Courbet, who had recently become a friend and mentor: "I have no money, not even enough to post this letter, so excuse me, but you know what it means to make a painting, you more than anyone can understand my troubles." Monet believed he was being punished for being too ambitious as a beginner. Stretching the truth, he told Courbet that his family considered his big painting (*Camille*) a complete flop, and now refused him any more money. He closed his letter with a greeting from "La Monette," who was very desirous to have a visit from Courbet. She particularly looked forward to fixing a meal for him—another typical Monet exaggeration (June 19, 1866). It's hard to imagine what this nineteen-year-old thought about entertaining and cooking for a man who was a legendary force within the world of modern painting.

Courbet arrived on a cloudy day. He was astonished to find that Monet had stopped work because of the weather. And this made Monet wonder whether this man he so admired was incapable of understanding the path he was on, that he was seeking to portray nature's reality in terms of light. Couldn't Courbet see how determined he was to capture exactly what happens when light strikes a surface and how the colors undergo change during these moments of illumination?

As the summer wore on and their debts mounted, Monet decided they must abandon Ville d'Avray. So he took his mistress in the direction of the part of France he knew best: Normandy. But not Le Havre or Ste.-Adresse. That was family territory. Instead they went to the seaport town of Honfleur, settling

in at the Ferme Saint-Siméon, an inn where Monet was known. He had made trips there since 1857, when he and the Beguin Billecocqs had stopped there for lunch. And he and Bazille had put in some time painting around the inn two years earlier. It remained an informal place that was very welcoming. The owner, Mère Toutain, would set up trestle tables in the orchard, where she presented guests with large plates of seafood and tumblers of homemade cider. Further, Honfleur was close to Le Havre—thirty minutes by steamer—enabling Monet to visit his family. Camille would remain behind. Bit by bit, she was learning the ways of her new bohemian life, and, like Hortense Fiquet, she would be spending a great deal of it alone.

In the period when Monet and Camille were in Honfleur, Courbet was the guest of the young Comte de Choiseul at his luxurious villa in nearby Deauville. In a letter to his old friend Boudin, Courbet mentioned that he had seen "Monet and his lady yesterday evening at the Casino." The Comte hoped the Boudins would join the four of them for dinner at his villa. Again a glimpse of the couple's sociability: they were an attractive pair to invite.

Months passed. Focusing on the harbor of Honfleur, Monet painted incessantly, concentrating on the complicated combinations of ships and masts and sails. But bills were a problem, particularly those from their landlady in Ville d'Avray. She threatened to seize the paintings Monet left behind. He turned to Bazille in Paris: "Tell her not to seize my things; it would be terrible for me if they were sold. Do what you can to get her to be patient." Monet did manage to have his big four-figure work brought to Honfleur, and, early in 1867—under very different light and weather conditions—he went back to work on it. He would submit it to the next Salon along with a view of the port of Honfleur. By this time they must have realized that Camille was pregnant.

Anticipating the March deadline for the Salon, and in all probability wanting to put some distance between him and the new "problem," Monet left for Paris, leaving Camille alone in Honfleur. Bazille told his mother that "Monet has arrived out of the blue with some magnificent canvases, which will be highly successful at the Exhibition. He will stay with me until the end of the month."

The Salon jury of 1867 was extraordinarily harsh, and all the young artists—Cézanne, Bazille, Pissarro, Renoir, Monet—were refused. It was an enormous setback for Monet. He had had such high hopes for 1867. It was

the year when the Salon ran concurrently with the Universal Exposition, the Emperor's magnificent celebration designed to make it clear to the world that Paris was the most beautiful city that had ever existed, and that France was the center of progress and modernity. Being refused was a shock. Monet began to understand that achieving the success for which he longed was going to be much more difficult then he had imagined. And he desperately needed money.

Monet took his big garden painting to a shop on the rue La Fayette. The owner, M. Latouche, was willing to place it in his window so that Monet's friends and other artists might see it. Evidently Zola was among them, for although the painting was not in the exhibition, he included it in his Salon review. To Zola, Monet was a "true Parisian," but one who had managed to take "Paris into the countryside. He is incapable of painting a landscape without including gentlemen and ladies in elegant clothes. He seems to lose interest in nature if it fails to show the imprint of our customs."[3]

By the time Zola's review was published, the big canvas was on its way to Montpellier. Bazille, staunch friend and great admirer, made the extraordinary offer of purchasing the work for 2,500 francs—an enormous amount of money in 1867 for a painting by an emerging artist. Bazille planned on paying the debt off in monthly fifty-franc installments. He believed he could manage this by taking it out of his monthly allowance. Both men would eventually discover this was a bargain they should never have struck.

Frédéric Bazille was killed in the Franco-Prussian War in November 1870. The painting then belonged to his parents, who, a few years later, agreed to an exchange with Manet: Monet's *Women in the Garden* for a portrait of their son by Renoir and owned by Manet. Then, in 1876, Monet initiated a second exchange in order to get it back, giving Manet a painting that Manet himself had painted of Camille in 1874 in Argenteuil. *Women in the Garden* was a work Monet consider as having been critical to his development as an artist, and he wanted to keep it for himself. He finally parted with it in 1921, when he sold it to the French government for two hundred thousand francs.

Between 1867, when Monet put his refused painting in Latouche's shop, and 1921, when it went on exhibition in the Musée du Luxembourg, few people had ever seen the work. Arséne Alexandre published a monograph on Monet just as it was being unveiled to the public for the first time. He called it "Women

Picking Flowers" and described its "bizarre charm," these women in "huge pale-colored skirts with patterned braiding contrasting with their tight-fitting jackets and tiny hats." He was convinced that its elegance would have totally seduced the nineteenth-century public had they ever gotten a chance to see it—that is, if it had been accepted for the Salon. If that had happened, said Alexandre, "the career of the artist might have gone in a completely different direction." In other words, he concluded that, had the jury accepted the painting—thereby encouraging Monet to continue painting in this vein—the world would have been deprived of one of the greatest landscape artists in the history of painting.

Alexandre was far more interested in the dresses than in the model whose name, apparently, he did not know. But we can imagine Monet, as he readied his large early work for transportation from Giverny to Paris, remembering Camille, as she got out of this dress, putting on that one, sitting, standing, heading for the rose bush at the end of the path, long ago in their tiny *hortus conclusus*.

TWELVE

Without a Sou

In May 1867 Frédéric wrote to his father in Montpellier that his atelier was so stuffed with his own work that, when Monet had arrived, he had obliged him to put his paintings under the bed where he slept. No document informs us as to the whereabouts of Camille, now six months pregnant.

Monet must have talked about the problem a great deal while he stayed at Bazille's. I suspect it was Bazille's idea that he simply inform his father of what had happened and appeal to him for help. That's what Bazille would have done. Oscar wrote home on April 8. A few days later Bazille also wrote to M. Monet, giving him his own sense of the situation. Neither of the younger men's letters has survived, but we do have Adolphe Monet's response to Bazille's letter. First he assured Bazille that he was not annoyed by this "friendly intervention" into his son's affairs. What followed was primarily an overview of his own thoughts about his son's approach to his career. He was sorry that Oscar had been refused by the jury, a fact that he must have just learned from his son's letter. But the father saw him as being on the wrong track: "If he clearly repents and is ready to . . . mend his ways, which depends totally on him, for there is only one way to succeed and that is for him resolutely to follow the path of work and order. . . . he must renounce his extravagant ideas and his past conduct." Apparently the "extravagant" idea was the eight-foot garden painting that had just been refused by the jury.

M. Monet then moved to the second problem, "the question of his mistress." He was appalled that his son had mentioned it at all. "Normally one doesn't speak of these things . . . this is very naïve of him." It seems Monet had told his father that he believed Camille had some rights "because she

will be a mother in three months." Adolphe Monet's views were harsh: "It's obvious that the only rights she can have are those he wishes to give her." But what really bothered the senior Monet was that Oscar had talked about it. And Adolphe Monet knew from whence he spoke! Further, the sharpness of his statement makes us wonder if Claude Monet still did not know he had a half-sister, now seven years old, for whom Adolphe Monet had assumed some financial responsibility, but the difference in the father's eyes was the fact that he had an income, and his son did not. Oscar was simply engaging in a luxurious lifestyle he could not afford. Of course he would have to leave this woman.

Camille Doncieux now entered one of the worst periods of her life. The few details we know come from a single source: the nine letters Claude Monet wrote to Frédéric Bazille in 1867, all beginning with the salutation *Mon cher ami*. They provide no insight into what Camille was thinking or feeling, or how she got through her days, but without these letters she would simply be a name on the official document in the manner of Hortense Fiquet.

Bazille kept Monet's letters. After his death in 1870, they remained in the Bazille family home in Montpellier, virtually unknown until Gaston Poulin published *Bazille et ses amis* in 1932.[1] This book provided much new information about Monet's early career and work. In it *Camille* was transformed from being "a beautiful woman attired in a dark colored jacket trimmed with fur" into a real person. Nevertheless, in the 1930s there was so little knowledge about Monet's work from the 1860s, and so little interest in his paintings from the 1870s, that what came to light in these letters was not absorbed into the Monet literature until after World War II. Then—very slowly—*The Reader* became *Camille Reading* (Baltimore, Walters Art Museum), *The Embroiderer* became *Camille Embroidering* (Merion, Pennsylvania, Barnes Foundation), *La Japonaise* became *Camille Monet in Japanese Costume* (Boston Museum of Fine Arts), and *The Walk, Woman with a Parasol,* became *Camille and Jean on a Hill* (Washington, National Gallery of Art). And thus Camille Doncieux entered the Monet story for the general public.

Adolphe Monet's letter forced hard choices on his son: was he to be cut adrift from his family or must he leave Camille? Neither appealed to the son; probably neither was even possible in his mind. Just as Cézanne had to construct a careful way to formulate his life a few years later, Claude Monet

learned to walk a thin line between family and the woman in his life, hoping against hope that the money would continue.

Monet found a room for Camille on the main floor of a building at 8 Impasse Saint-Louis (now Square Nollet) in Batignolles. It was only a few blocks from her parents' apartment. He then contacted a medical student named Ernest Cabadé and arranged that he would be there when the time came for Camille to deliver—facts that emerge in Monet's letters to Bazille. But in the same letters we learn that his interest in Manet's one-man show, soon to open on the place d'Alma, was even more pressing on his mind: "I will send you an account of all that," he wrote to Bazille, who had left Paris for Montpellier. As soon as he had seen the show, which opened on May 24, Monet planned to leave for Ste.-Adresse in order to spend the summer with his family. Only toward the end of one letter does he bring up the subject of Camille: "I don't know what to do, she is sick in bed and has no or very little money. Since I leave on the 2nd, at the latest on the 3rd, I want to remind you to send me at least 50 francs by the 1st. I beg you, don't forget" (May 21, 1867).

The family knew Oscar's mistress was to have a child in July. Apparently he bargained on the fact that if he remained with them through the summer, it would be the sign that he had followed his father's advice, that she would henceforth not be a part of his life. Monet's June 25 letter to Bazille gives a rosy picture of the early summer in Ste.-Adresse: "I am in the heart of my family. . . . Everyone is delightful in my regard, full of admiration for each stroke of my brush." This was quite a change from his visit a few years earlier when he had been shown the door with no invitation to return. He had started new work, even sold a little marine painting and a view of Paris. He told Bazille how important this was as it allowed him to help "cette pauvre Camille," whom he referred to as "very nice, like a good child she has become reasonable which makes me even sadder." She would give birth in a month. Monet hoped to spend ten or fifteen days in Paris, but to do so he needed money. Could Bazille manage a 100- or 150-franc advance in his payments for *Women in the Garden?* He also referred to a discussion he had had with Cabadé before leaving Paris. Evidently he was considering the possibility of placing the child in a foundling hospital. At the same time he did believe "it is quite an awful thing to take a child from its mother. The idea makes me feel bad."

One week later, Monet picked up his pen again to tell his *cher ami* that

"Camille hasn't got a *sou*. I just received a letter from Cabadé who asks me to send money. He has nothing left." Monet excused himself for coming back yet again to Bazille, but "this poor woman is in need." Further he mentioned his fear that he himself was "going blind." The doctor told him he should give up working out of doors (July 3, 1867). It was clearly a pattern. Monet demanded that others—Camille, Bazille, Cabadé—assume responsibilities that should have been his. And when the pressure of the lie became too much, in one way or another, Monet "got sick."

Monet heard nothing from Bazille, so he wrote again. He opened in an accusatory fashion: "You are not kind." Then he continued to describe the problem of Camille and the absence of a sou. "I have nothing and I can send her nothing. I fear she will deliver from one day to the next; in what position does this poor woman find herself? I beg you *mon cher ami,* save me from this because my anxiety is obvious around the house. . . . I will be horribly unhappy if she delivers without the necessities, without care, not even something to cover the little one." Aside from that, as he expressed in the same letter with an extraordinary degree of detachment, "all goes well here, work, family." He felt that if it weren't for this coming birth, "I could not be happier" (July 9, 1867).

A week later another letter went off: "Send me 150 or 200 francs as fast as you possibly can." He informed Bazille that he intended "to do what you have advised for this child and for Camille. I count on being in Paris to see for myself, depending on how the mother reacts and how she looks, I shall see what I should do." Clearly the matter of keeping the child was still in question, and Bazille was for giving it up. Aside from that, "I work continually." Monet then proceeded to give an account of running into a mutual friend—the painter Antoine Guillemet—in Honfleur: "He is thrilled with my new work" (July 16, 1867).

Finally, late on a hot Thursday afternoon on August 8, in the little room on the Impasse Saint-Louis, Cabadé delivered Camille's son, who was now two weeks past due. The birth was registered three days later in the *mairie* of the Seventeenth Arrondissement. The document declares that Jean Armand Claude Monet, the "legitimate son of Claude-Oscar Monet and of Camille Léonie Doncieux, his wife" was born on "Sunday, the eleventh of August." Their landlord, Alfred Hatté, witnessed the document. The second witness

was Zacharie Astruc, a critic and artist whom Monet had known since his return to Paris after the army. Astruc, a extremely kind person and an adamant supporter of the new painters, was the man who had introduced Monet to Manet the previous year. This, plus the fact that he himself had been born out of wedlock, may have made him open to Monet's request to sign an official document he knew to be false. The altered date was probably in the interest of concealing the fact that Monet was not there on August 8, when his son, Jean, was born.

Théophile Beguin Billecocq was aware that Monet wasn't there for the birth of his son. In his journal he noted, "Claude not present—in Normandy." He also knew that the parents weren't married: "Such a situation happens all the time these days, so it doesn't astonish me. Claude and Camille will recognize their child; others might have put him in an orphanage. They'll get married later."

The day after the trip to the *mairie,* Monet headed back to Ste.-Adresse. It was necessary to return to Normandy immediately, as he explained in his August 12 letter to Bazille: "in order not to upset the family, and because I didn't have enough money to stay in Paris." The most threatening problem was that "the mother has nothing to eat. I was able to borrow what was strictly necessary for the birth and for my return here, but neither she nor I have two pennies to rub together." He described the new baby as his "beautiful big son," and that "in spite of everything I feel love."

We can barely imagine the enormity of the nightmare of these days for the twenty-year-old mother. She was at the center of the event, yet everything was out of her control. The biggest reassurance she had about her future was the fact that Claude had gone to the *mairie,* declared the boy to be his son, and created the fiction of a marriage ceremony that had never taken place.

Where were Camille's parents during their daughter's difficult entry into motherhood? That Camille and Claude rented a room close to the Doncieux apartment suggests they may have hoped for some assistance from that quarter, but Monet's letters give no indication that Camille received help from her family. In precisely the month that the couple secured the room in the Impasse Saint-Louis, something major did happen to affect the lives of the Doncieux family: Antoine-François de Pritelly, the tax collector from Rueil, died, making Camille's ten-year-old sister, Geneviève, his sole heir, and giv-

ing Mme Doncieux the right to enjoy the usufruct over the inheritance as a whole. The primary benefit would be the rental income from Pritelly's house in fashionable Bougival on the Seine. Apparently in response to that legacy, M. Doncieux drew up a new will of his own in which he left twelve thousand francs to Camille at the time of his death. Apparently Claude Doncieux now saw Geneviève as being adequately provided for. But this wouldn't help Camille in her lonely impoverished state as a new mother. The Pritelly legacy however did have immediate benefits for the Doncieux, most notably that they were able move to a larger apartment at 17, boulevard de Batignolles, a grander place for which they now paid 1,400 francs a month.

The fall and winter saw Monet parceling out his time between his family in Le Havre and his family in Paris. On New Year's Day 1868 he wrote to Bazille from the Impasse Saint-Louis. The letter opens with a familiar refrain: "I have received nothing. I am without a single *sou*. I've gone through this day with no heat and the baby has a cold." Further there are the debts to pay, "tomorrow and the day after." This lament was followed by a strange rewriting of their past agreement: "When you bought my painting, you were to give me 100 francs each month; last May you promised me 500 francs, and at the time of Camille's delivery, you said you would help me, and all that has been reduced to 50 francs a month and these little sums don't help me at all. I never dare say anything because you seem to believe you took this painting as an act of charity, and when you give me money you give the impression that you are making a loan and I never say anything. . . . It seems to me you are able and my position is critical enough for you to think about it a little. . . . Believe me, *mon cher ami,* only necessity allows me to enter into such a discussion and I assure you it causes me great pain" (January 1, 1868).

Bazille, who often let weeks go by after having received one of Monet's begging letters, wrote back immediately: "If I didn't know how unhappy you are, I certainly would not take the trouble to answer the letter I received this morning. You are trying to demonstrate that I do not keep my promises, but you have only succeeded in showing your ingratitude. Never as far as I know have I had the air of giving you charity. I know better than anyone the value of the painting I purchased, and I am sorry I am not rich enough to make the conditions better for you. . . . You know well enough that I bought your painting for 2,500, payable at 50 francs a month, and *pas un sou de plus.* . . . I did

not wish to receive your bitter letter; I am very unhappy to know you are in such a sad situation, but I will not suffer being accused of indifference or of ill will when I have supported you as much as I can. F. Bazille."

Such excruciating reproaches are capable of separating friends forever. But Monet and Bazille overcame this moment. When April came, Bazille was there to stand as Jean's godfather when he was baptized in the church of Sainte-Marie des Batignolles. Julie Vellay, Camille Pissarro's companion, was godmother. Monet had become friendly with Camille Pissarro—the painter who came to mean so much to Cézanne in the early 1870s—since their meeting at the Académie Suisse in 1860. Pissarro and Vellay were living together and already had two children, but on Jean Monet's baptismal document Julie gave her address as 8, Impasse Saint-Louis—that is, she wrote down Claude and Camille's address. Perhaps she did not wish to enter her actual address into an official document since she and Pissarro were not married, and his family was strongly opposed to the possibility of such a union.

Monet did one painting that brings alive the joy he felt at becoming a father. The painting is large—almost four feet tall—and, given the fact of the meager quarters in the Impasse Saint-Louis where the child had arrived with nothing "to cover him," it seems totally amazing. We see Jean, wide awake and peacefully snuggling under a white blanket in a handsome bassinet with a flowered fabric cut into scallops, edged in pink ribbon and circling the oval form of the bassinet. Above him is a bar holding a large drape of the same fabric. This can be pulled forward to protect little Jean from drafts and light. His cap is adorned with a blue bow, and there is a toy lying across the cover, while his right hand holds a rattle in a rather imperious fashion. Beside him, in a somber striped dress and a small white cap covering her hair, sits his nurse, who intensely watches her charge.

Somehow the painting does not accord with the picture of poverty we read about in Monet's letters. Where did they get the beautiful bassinet, and who modeled for the figure of the nurse? The mystery has been solved by Théophile Beguin Billecocq's journal, in which he wrote: "For Camille, who was unable to nurse, I hired and paid for a good nurse from Champagne for the fair-haired boy who has come into the world. This fine woman, named Eulalie, has done excellent work, and Camille rapidly gains her strength while the little doll is becoming a beautiful baby."

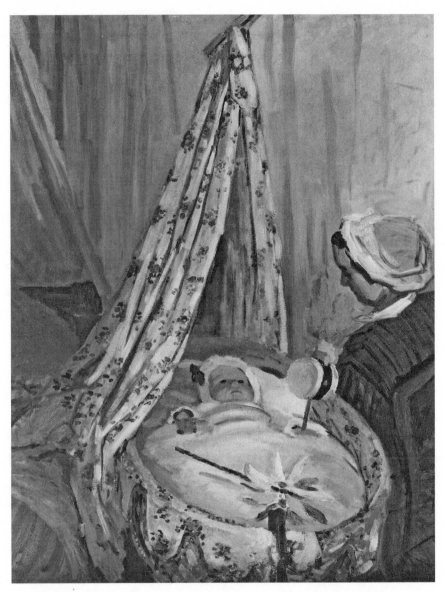

Monet, *Jean Monet in His Cradle*, 1867. Washington, D.C., National Gallery of Art

Théophile ends his August 1868 journal entry with a personal meditation on virtue of charity: "It is important to help those who are near to one when we are able. Society is too selfish. When you have the means, you have to give freely." It is clear that Bazille was not the only friend to receive Monet's letters signaling their wretched state of poverty.

Why Did He Marry Her?

Almost three years after the birth of Jean, on whose birth certificate Claude Monet and Camille Doncieux appear as man and wife, they got married. For the little family, the period separating the two events was one of frequent moves, enormous uncertainty, and debilitating poverty. Monet's professional life did not improve; it was a time of egregious affronts and perilous failures. But Monet continued on, painting seascapes, still lifes, and an occasional portrait, his desire for success always in the foreground of his mind.

After the phenomenal number of rejections at the Salon of 1867, Bazille organized a petition and sent it to the Comte de Nieuwerkerke, the Superintendent of Fine Arts, requesting another Salon des Refusés. One hundred and twenty-five artists signed the petition. They didn't get a second Refusés, but they got a concession: two-thirds of the jury for the Salon of 1868 would be elected by a pool of artists who had exhibited in the Salon at least once. The rest would be appointed by the government. For the young Naturalists the most important result of this small opening of the system was the election of Charles Daubigny, a Barbizon artist who favored plein-air painting. Thus, Monet and others of the Guerbois group approached the Salon with a more positive outlook than in the past, and, in fact, they tasted some success that spring. Both of Manet's paintings—one a portrait of Zola—were accepted, along with two works each from Bazille, Renoir, and Pissarro. No one expected Cézanne's submissions to be considered, and they weren't. But Monet had only one work accepted, a painting called *Boats Setting Out from the Port of Le Havre*. Zola, by now a friend, praised its force and freshness. We don't know what it looked like, since, when the Salon closed, it was seized by creditors

and never seen again. Monet took the acceptance of a single work as a mark of personal disrespect, and, soon after the baptism, he took Camille and Jean away from Paris.

Monet and his friends visited the forest of Fontainebleau less frequently now. They had begun looking for sites along the Seine. In the spring of 1866, Zola wrote to Numa Coste about discovering a "region still unknown to Parisians, and we have established our little colony there." "Our little colony" referred to the group from Aix, including Cézanne and Valabrègue, but Zola was also happy to share his discovery with Monet. He recommended the Auberge Dumont-Rouvel in the hamlet of Gloton, outside the village of Bennecourt, telling Monet he would be received there in a manner that was "simple and cordial." So, on an April day, the family boarded a train at Gare Saint-Lazare. They would reach Bonnière-sur-Seine in less than two hours, then make their way to Bennecourt by ferry, crossing the river to Mme Dumont's inn. Ten years later Zola described such a journey in the lives of his fictional characters Claude Lantier and Christine Hallegrain: "They took the ramshackle old ferry boat, worked by a chain, across the river to Bennecourt. It was a lovely May morning; the little waves glittered like spangles in the sun and the tender young leaves shown green against the cloudless blue of the sky. . . . [T]hey came to the intriguing little country inn and grocery store, with its big general room that smelt of washing and its vast farmyard full of manure heaps and dabbling ducks" (*The Masterpiece,* 156).

Monet hoped that time spent in this hamlet on the Seine might help him calm down and allow him to get back to work. He must have produced several paintings during their weeks in Gloton, but there is only one we can be sure of: *On the Bank of the Seine at Bennecourt.* It has a freshness and a directness that Monet had rarely achieved to date. We are looking at one of those luminous spring days that Zola had described in his novel. Camille is seated on a grassy carpet studded with flowers; she looks back across the river at the inn where they are staying. We don't see the inn itself, for it is hidden by the branches of the tree under which Camille has taken her place, but we see its reflection in the river. They have arrived here in a small boat which is moored close to where Camille sits. Jean was with them, and X rays tell us he was positioned in Camille's lap, but for some reason Monet later painted him out. Occasionally writers refer to the residual white splotch as a dog. The tree

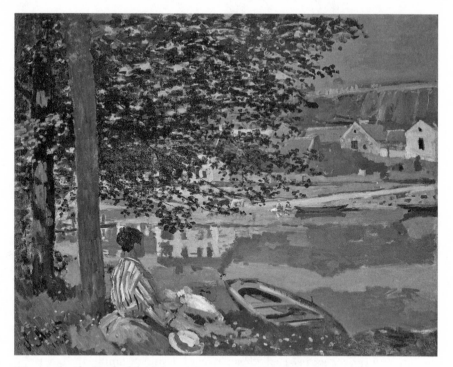

Monet, *On the Bank of the Seine at Bennecourt,* 1868. Oil on canvas, 81.5 × 100.7 cm. Potter Palmer Collection, 1922.427. The Art Institute of Chicago

trunk, its branches, Camille's figure, and the boat all frame the scene on the other side of the river and establish a solid foreground, while the picture as a whole is unified by the blue sky reflected in the river and the blue sky above a distant hill. This sense of unity is further set off by Camille's blue-and-white-striped dress and straw hat with its bright blue band. It's a balanced play of surface and depth that appears effortlessly achieved.

Monet worked with large brushes loaded with paint, dabbing in houses, reflections, leaves, grasses, and flowers, resulting in a work that has a broad, fresh quality to it and that gives the appearance of a somewhat spontaneous work, so much so that it is frequently called "the first Impressionist landscape." Did Monet think of it as a new step toward what he was trying to realize? A question that is more interesting for me is whether Camille sensed that her own place in the scene was less that of an actress, as before, and more that of

observer and anchor. She witnesses the luminous world being re-created by her lover, who is hard at work behind her back.

Zola and Antoine Guillemet showed up in Bennecourt while Monet and Camille were there. Was it the memory of those days and his conversations with Monet, who was surely full of complaint about the recent rejection of one of his paintings, and then seeing him at work, observing his relationship with Camille, that led Zola to place Claude Lantier and Christine Hallegrain in Bennecourt after Lantier's horrible experience of having his work laughed in the Salon? Zola described the way his fictional painter sought to renew himself in the country environment: "When he went and set up his easel on one of the islands Christine would go with him. She would lie in the grass at his feet, her lips slightly parted, gazing into the blue, and there, amidst the greenery, in the wilderness where only the murmur of the river broke the silence, she appeared so desirable that he continually left his painting to lie down beside her and let the sweetness of the earth lull them both into oblivion" (p. 162).

Claude Lantier spent four years in Bennecourt; Claude Monet stayed for less than two months. Unlike Lantier he did not have a private income. Again, turning to Bazille, Monet wrote from Paris on June 29: "I was thrown out of the inn—*nu comme un ver* [naked as a worm]. I stuck Camille and my poor little Jean in a shelter in the country for a few days." He told Bazille that he was on his way to Le Havre "to get something out of my collector," a reference to Louis Gaudibert, a rich collector whom he did not refer to by name. Right now he needed Bazille to do whatever he could for him. Monet instructed him to write in care of General Delivery, "because my family wants nothing more to do with me. I don't know where I will sleep tomorrow." The letter ends with a provocative P.S. about having thrown himself in the river on the previous day, the implication being that he had attempted suicide: "Happily nothing came of it." Much is made of this in the Monet literature to illustrate the extremes of his desperation. To me this claim resembles "going blind," a point of pressure put upon poor Bazille in hopes that he would come through with the necessary help.

Guillemet stepped into the breach to help Camille and Jean, still in Gloton. On July 17—that is, more than two weeks after Monet had left Benne-court—he wrote to Zola, now in Paris, telling him to be at the station at 10:15 in order to meet the train from Bonnières on which he would find Camille,

whom he affectionately referred to as "la volaille Monet" [Monet's bird], and Jean. Guillemet had already written Monet with a full description of the abandoned ones: the illness of his son, the flood of tears from Camille who "has turned into a waterfall." Monet's letters became less and less precise about his situation and about their future; in one letter, according to Guillemet, "the word 'patience' figures 71 times," and it, too, produced a torrent of tears. Guillemet's counsel to the *pauvre femme abandonée* was to go to Le Havre immediately and rejoin *l'infidèle.* She took his advice. Zola arranged for their change of trains in Paris.

They were to arrive in Le Havre at 9 p.m. on Wednesday, July 22. Monet then took his family to Fécamp, a popular resort on the English Channel about thirty miles north of Le Havre. They registered in a hotel, but Monet quickly found a small furnished cottage—*très bon marché.* But it didn't work, as they couldn't pay the hotel bill. Monet summed up the situation in a letter to Bazille, pointing out that if his friend's fifty francs had shown up at the beginning of the month—as the money should have—they would now be living in a nice little cottage. Yet, here they were in the hotel with "a sick baby . . . and not a nickel . . . all this makes me crazy about money, and never being installed well enough to work" (August 6, 1868).

Salvation came through the good auspices of the Gaudibert, a wealthy family from Le Havre that had come to believe Monet was an artist worth supporting. In early September, Louis Gaudibert invited Monet to come and stay in his chateau just outside of Le Havre with the proposition that he paint a portrait of himself, his wife, and his son. But perhaps the nature of the commission seemed too far removed from the kind of work Monet wanted to be doing, so when he wrote to Bazille from the chateau that fall, he declared, "Painting isn't working anymore for me, and I no longer count on glory . . . I see everything darkly." More complaints followed.

As far as we know, Monet made no mention to Bazille about another source of money that came his way that summer: Arsène Houssaye, editor of *La Revue du XIXe siècle* and of *L'Artiste,* a man of considerable importance in the Paris art world, purchased Monet's big portrait of Camille from the Salon of 1866. It had been included that summer in Le Havre at the Exposition Internationale Maritime. Houssaye paid eight hundred francs for it and implied that he would leave it to the Musée du Luxembourg, Paris's museum of modern

art. In the end it was sold at auction. Camille's portrait had even received a medal at the exhibition, placing an additional fifteen francs in Monet's pocket. The work was reviewed in the local paper, though hardly in a manner to please either Monet or Camille. One critic mentioned "Camille's gait," and from "the provocative way in which she tramps the pavement, it is easy to guess that she is not a society woman, but a *Camille*."[1] Such publicity surely did nothing to improve the situation with Monet's father.

By the end of October, the Monets moved to Etretat, another town on the English Channel but closer to Le Havre. When winter came Monet's mood picked up: "I am very content, really delighted." Now, as he told Bazille, he was "ready to do something really serious." And he expounded on the pleasure he felt each evening when he returned to his *maisonnette* to find: "a warm fire . . . and a good little family. If only you could see how nice your godchild is at this moment. It's delightful to watch him grow; my god how happy I am to have him. I'm going to paint him for the Salon. . . . This year I shall do two paintings of figures, an interior with a baby and two women and one of seamen *en plein air,* and I will do them in a truly marvelous fashion."

Setting the stage for the first of the paintings to be made in this *façon épatante,* the words Monet used to describe his approach, he stretched a canvas more than seven and a half feet tall, its size alone heralding the importance of the enterprise. "An interior with a baby and two women" must have surprised Bazille. Monet had done some fine still lifes, and there was Jean's baby picture, but he had shown no interest in "interiors." As Monet worked out his scheme, he ended up with three rather than two women—a mother, a visitor, and a maid—along with a baby, and an empty chair. The mother and baby are seated at the table, while a visitor leans against the window ledge and the maid appears to be coming out of a cupboard in the back off the room.

It's a curious painting. Monet was trying something in which he had previously shown little interest—telling a story, for we are looking at a scene suggesting both past and future actions. The child has recently been playing on the floor, where his doll and ball can still be seen, and the visitor, dressed in black—perhaps in mourning—has just arrived, not yet having removed her gloves. Obviously the father is late. His newspaper waits, his eggs are unpeeled, the wine bottle at his place still uncorked, while his wife's wine is already poured and her eggs are gleaming white and ready to eat. She watches her

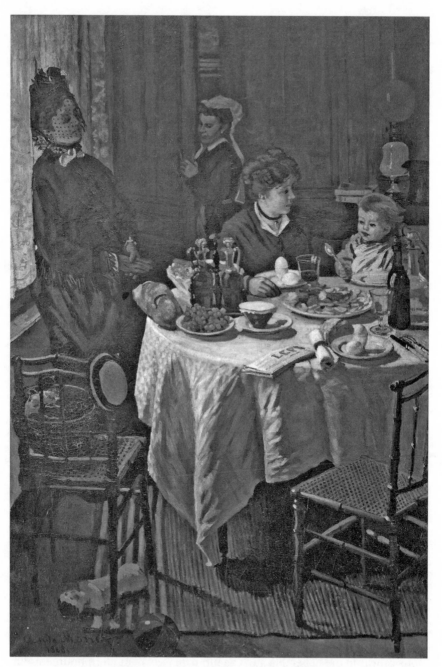

Monet, *The Luncheon*, 1868. Frankfurt, Kunstinstitut

bright-eyed child reach out impatiently for the food he sees before him. And yet the "story" doesn't add up to much. Except for the mother's eyes focused upon the child, there is virtually no rapport between the figures.

Camille must have enjoyed her participation in creating the new "serious" painting. She is back in her actress role, showing off an appealing display of her current life, or at least the life she wanted, though, in actuality, it was barely hers. She must have been instrumental in arranging the room, floating the big white cloth over the table, and preparing the food. And, of course, she is the model. Some historians see Camille only in the dark-haired visitor, but not in the mother with lighter brown hair. But, as we have seen, Monet does change hair color when it suits the painting. And the nature of Claude and Camille's collaboration was fully established. She was his model. But the maid called for someone else, most likely a woman who actually worked in that position in the Monet household.

We might even see this painting as a gift to Camille, a look into the future to what their lives would one day be. Monet bathed the mother and child in a warm light, emphasizing the mahoganies, rusts, reds, and ambers. He provided them with good food and drink and the promise of a husband soon to arrive. The suggestion of the husband's imminent appearance, too, strikes an autobiographical note. It hadn't exactly been the life Monet had given Camille until this point, but, as he wrote to Bazille in his December letter, "Thanks to this Mr. from Le Havre [M. Gaudibert] who has been helping me, I am enjoying the most perfect peace since I am now free of all those problems. Consequently my wish is to stay always like this, living quietly in a corner of nature. I assure you I have no desire to be in Paris, nor do I miss the reunions at the café Guerbois."

In style and subject this painting clearly relates to *Jean Monet in His Cradle*. Both are interior scenes rendered in rich color and full volumes in order to depict with great care the objects in view. These effortful productions are based on a hoped-for life and look quite different from the more instinctive, fresher canvases Monet produced in the forest of Fontainebleau and on the beaches of Normandy.

The Luncheon, however, was not done simply in terms of Monet's response to the pleasure of those winter days in Etretat. He painted the enormous canvas in the belief that such an intimate view of modern bourgeois life

portraying figures and their surroundings in a style that heightens the sense of reality would be a sensation at the Salon.

Even before the canvas was finished, the delight Claude and Camille had experienced during the Etretat winter had petered out. By January 11, as Monet wrote to Bazille, in spite of the energy he had for what he was doing, he could not go on. There was no money to buy paint, and "the Salon is approaching and I don't want to stop what I have begun." Could Bazille buy some paints for him? It could be deducted from "our account." Monet listed the colors. After white, black, and cobalt blue, he made a note: *"beaucoup."*

But for some reason Monet hesitated, and he did not send *The Luncheon* to the Salon of 1869. Perhaps he did not consider it finished. Instead he entered two landscapes, one of them showing a magpie in the snow. Both were rejected. Théophile Beguin Billecocq reported that this "plunged him into a profound despair. He came to see me often and we talked about it for hours."

Arsène Houssaye advised Monet that he ought to move closer to Paris. On June 2, Monet wrote to the editor that the Salon refusal made it clear such a move was necessary: "This rejection has taken the bread from my mouth, and in spite of my low prices, collectors and dealers turn their backs on me." M. Gaudibert helped him to find a place in the village of Saint-Michel, west of Paris in the hills above Bougival, a bathing spot and pleasure garden on the Seine.

A bad summer was about to begin. Monet, Camille, and Jean survived only with the help of friends: the Pissarros were nearby in Louveciennes, and Renoir was frequently visiting with his parents in Voisin, a few miles from Saint-Michel. At one point Renoir reported to Bazille: "I'm at my parents, and am most always round at the Monets where things are, incidentally, pretty bad. Some days they don't eat." When Bazille's fifty-franc installment did not arrive in early August, Monet sent off a characteristic reminder: "Have you any idea in what situation I find myself . . . no bread, no wine, nor fire in the kitchen, and no light" (August 9, 1869). A week later, a second letter left for Montpellier. Monet felt Bazille could behave as he did only because he was a man who had never known want: how else to explain this "lack of concern for the misery of other people?" (August 17, 1869). And the following week: "If I get no help, we shall die of hunger" (August 25, 1869). This was too much. We do not have Bazille's response, but apparently he suggested Monet might

try to get help from his own family for a change, or he might even go to work! "You have said that in my place you would start chopping wood." (September 26, 1869).

In his September letter Monet accused Bazille of having recently finished large quantities of paintings while "this year I have done nothing." This was not quite the truth, for he and Renoir had been painting together at the bathing resort called La Grenouillère (the frog pond), where they produced wonderful works generally considered pivotal in the creation of the new style we call "impressionism."

The weather cooled, and the hordes of pleasure seekers left, while Claude, Camille, and Jean stayed on. Monet went into the city as little as possible. But it was important for him not to lose his place as a significant member of the Batignolles group. Thus he managed to be in Paris and be among the sitters for two group portraits. That winter Henri Fantin-Latour, a somewhat conservative painter but a close friend of Manet's and a loyalist in the Guerbois ensemble, composed a group portrait showing six friends gathered around Manet, who is seated before a canvas, palette and paintbrush in hand. Here Manet, portrayed as their leader, is shown working on a portrait of Zacharie Astruc. Gathering around the two men are the German artist Otto Scholderer, Renoir, Zola, and Edmund Maître, a musician and a close friend of Bazille, who stands beside him. Then, in a tiny space behind Bazille, almost as an afterthought—which he may have been—stands Monet.

Fantin-Latour's painting was surely the inspiration for Bazille's *L'Atelier de la rue de la Condamine,* which treats the same subject but in a more open and informal fashion. Bazille shows us his own spacious studio where friends gather to talk, to listen to Edmund Maître at the piano, and to examine Bazille's latest work. Manet is shown standing in front of the painting, obviously giving his opinion. Bazille listens attentively, and probably it is Astruc who stands behind the two men. It's frequently assumed that the figures engaged in conversation to the left, one leaning over the railing of the staircase, the other seated on a bench below, are Renoir and Monet, but their features are so generalized that it is hard to distinguish. Clearly friends were not called upon to spend the kind of time modeling for Bazille as they had been for Fantin-Latour.

Spring arrived. It was time for Monet to get the big luncheon scene off to the Salon, along with his second entry, a landscape. By waiting until 1870,

Monet entered his work with greater hope of success since eighteen members of the jury were now elected by artists who had participated in past salons, and everyone anticipated a liberal jury. To his horror, he was turned away again, a defeat made even more painful when he realized that all his friends—Bazille, Renoir, Manet, and Pissarro—had been accepted.

By the time Monet learned the disappointing news, he already had a new plan, but this one was of a very different nature. He would marry Camille. Working through a notary, by early April Monet managed to get the consent of his father. There ended Claude-Adolphe Monet's participation. Publication notices of the intent to marry were posted in both the town halls of Bougival and of the Eighth Arrondissement of Paris. By June 2, the notary, Maître Aumont-Thiéville, had the marriage contract ready. This document provided for separate ownership of all their effects, giving Camille protection from Claude's debts. It included the gift of twelve thousand francs, which had previously been decided on by Camille's father, although most of it would not be payable until three months after his death. For now, Camille would receive just two years of interest at 5 percent, that is, twelve hundred francs a year. It was a pathetically small dowry.

The ceremony uniting "Claude Monet, resident of Bougival and Camille-Léonie Doncieux, resident of 17, boulevard des Batignolles" took place on the morning of June 28 in the *mairie* of the Eighth Arrondissement. The mayor presided, and the official document was signed by four witnesses: "Gustave Manet [younger brother of Edouard and Eugène Manet], lawyer, thirty-five years old; Antoine Lafont, journalist, thirty-five years old; Gustave Courbet, painter, fifty-one years old; and Paul Dubois, medical doctor, twenty-nine years old." In a book on Monet written shortly after the artist's death, Georges Clemenceau [in 1870 mayor of Montmartre, and, in the distant future, prime minister of France], who became a close friend of Monet's, recalled how, in the old days, he and Monet occasionally got together with Dubois and Lafont [who would become a deputé in Paris]. According to Clemenceau, both men were interested in Monet's work and were proud to own some of his paintings.[2]

Even if Gustave Manet, Paul Dubois, and Antoine Lafont were friends, they could not have been very good friends, as their names have never come up before in any Monet document or letter. And where were the real friends—

Bazille, Renoir, and Pissarro? Was Monet so put off by their recent success in comparison to his own failure that he did not approach them? Or was it more of a business decision to choose new friends who might be interested in purchasing his work, rather than inviting poor painters like Renoir and Pissarro to act as his witnesses? This is difficult to understand. We know that Théodore Beguin Billecocq was in the picture; although unable to attend the nuptials, he did buy two paintings at the time for seven hundred francs, which surely constituted a wedding present. As for Bazille's absence, it would seem to be another indication that all was not right between the two old friends.

Courbet was a friend, but he doesn't quite fit either. A few weeks before the wedding, Monet sent "la petite Monette" around to see Courbet to ask him if he would be their witness. More importantly, he wanted her to see if Courbet could lend them some money. In an unpublished letter of considerable length (in the Institut Néerlandais in Paris), Monet reminded the older painter how many times he had supported him in the past and told him of his hope that he will do so again. He wrote of the unexpected expenses connected with the marriage, as well as with their departure from the house in Saint-Michel. That move had been costly. He explained about his own family, their opposition to the marriage, thus rendering him unable to go to them. In contrast, he reported Camille's family "well disposed toward their daughter and has promised to give us the sum of 12,000 francs on the day of the wedding. This is what makes it possible for me to come to you, having the certainty of being able to pay you immediately after the marriage." For Claude Monet, facts were often not quite facts.

Camille Doncieux's union with Claude Monet was finally legal, and her child legitimate. It seems she was now on better terms with her family; we even imagine the Doncieux being at the wedding. For Camille it had to be a day of profound joy. But for Monet, the marriage plan may have been a last ditch effort to build up his empty coffers, for his lack of money remained his biggest problem, and his consistent failure at the Salon made the future very bleak indeed.

Rodolphe Walter, the primary author of the text for the Wildenstein catalogue, had a different idea about why this wedding took place when it did. He describes it in terms of the political situation in 1870. By that summer there was much talk, especially among Emperor Louis-Napoleon and his

advisers, regarding Prussia's moves to expand its power to the south. Everyone knew that Chancellor Bismarck had his eye on the vacant throne of Spain and intended to place a member of the Hohenzollern family on it. Such a move would further isolate France, thus observers speculated on the probability of war. Walter points out that, on the day of the wedding, Monet had no official document to verify his military service. This fact was noted on the forms that were sent to the Hôtel de Ville. According to Walter, such an indication "was liable to lead Monet directly back to the medical board," and he concludes that "Monet's marriage constituted a reason for exemption."

An aspect of the question "Why did he marry her?" that is seldom considered is, what part did love play? Lacking any letters between the two participants, we can only guess. There is no way to know how many times, once Monet finished a painting, that he then lay "down beside her and [let] the sweetness of the earth lull them both into oblivion," which is how Zola imagined Claude Lantier and Christine Hallegrain in Bennecourt. We know nothing of this. But from all evidence Camille Doncieux was a lovable charmer—a favorite among Monet's friends. She is "la Monette," or "Monet's bird." According to Théophile Beguin Billecocq she was a "ravishing" creature, full of "kindness and grace." She participated in theatricals, wore clothes marvelously well, went to the casino, made dinners for Monet's friends, and, after the little family settled down in Argenteuil, she would be sought after by the painters in their circle to model also for them.

Claude Monet both used and ill-used Camille Doncieux. But Camille and Jean were his family. He adored his son, and he certainly loved her. Further, there really was no one else. The only family member who had real concern for Monet, who might have accepted Camille and remained a part of their lives, was Aunt Lecadre, and Marie-Jeanne Lecadre died on July 7, 1870, one week after the wedding of Camille and Claude.

For Camille the marriage was the ultimate promise. No matter how frequent his absences, she would not be abandoned. The owner of the empty chair would always find his way back to his place at the table.

The Second Empire Disappears

That summer of 1870, with the threat of war in the air, Monet decided to bundle up as many paintings as he could and cart them over to store at Pissarro's home in Louveciennes. By July 19, the day on which France declared war on Prussia, Monet had settled with Camille and Jean in the Hôtel de Tivoli in Trouville, a fashionable seaside resort across the Seine estuary south of Le Havre.[1] Nine days later, a very ill Emperor and his fifteen-year-old son left Paris for the front. It was a wild dash to war, a war without allies, and one judged by history to have been without strategy. August witnessed French defeats one after the other. The August 6 battle at Fröschwiller saw the loss of eleven thousand Frenchmen. When the terrible news arrived, Bazille decided that the only thing to do was to volunteer. Just as Monet had once done, he chose a Zouave unit. When Edmund Maître received this astonishing news, by return mail he wrote: "You are mad, stark raving mad, I embrace you with all my heart. May God protect you." Renoir was with Maître as he wrote and penciled a comment at the bottom of the letter: "Triple shit, stark raving bastard!" (August 18, 1870). Renoir was drafted in October.

Fashionable vacationers in Trouville were able to follow the depressing news of the war while reading their papers on the beach. The most devastating announcement came on September 5, the day on which the papers described the Emperor's surrender to the Prussians at Sedan. But most vacationers remained in their comfortable hotels through the month, wondering how their lives were to be changed. What did they think when they read the descriptions of people smashing imperial emblems in Paris? Increasingly they paid attention to the words "la République."

It was not a productive summer for Monet. We know he finished only a single river view, the kind of painting he had enjoyed doing in the past, plus four others depicting the fashionable promenade, the hotels, and the elegant Parisians with whom he and Camille had little in common. In addition, there are five small studies of Camille on the beach. She wears a tiny flower-covered hat while shielding herself with a parasol from the sun. For one of the paintings she posed for two figures, both in the same blue–and–white–striped dress she wore in Bennecourt. In most her face is hidden by a shadow or veil, or is simply left undescribed beneath the thick deposits of paint. The scenes are full of sand and sun and perky clouds—the atmosphere of lazy vacation days. But downplaying her facial features might suggest a withdrawn Camille; sometimes she is barely there at all, lost in summarily placed brushstrokes. The largest of the group (18½ inches wide, in the National Gallery in London) shows Camille in profile, wearing a white dress, though Monet has painted it primarily with gray pigment to show the shadow cast by Camille's parasol. Across her knees, the area not in shade, are brilliant diagonal white strokes of pigment—whiter than the clouds in the sky—that are in a sense the focal point of the painting. Holding her parasol tightly in both hands, Camille simply stares off into space, the sparsely populated beach spreading out blandly behind her. An empty chair, a purse dropped on the seat, and a child's shoe on one of the back supports separate Camille from a second woman's figure, also under a parasol that she has let fall back on her shoulder to enable her to hold a newspaper in her hands. It is usually assumed that Camille's companion, a woman dressed in black, is Mme Eugène Boudin. The Boudins were in Trouville that summer, and decades later Boudin remembered their time together when he wrote to Monet: "I can see you with that poor Camille in the Hôtel Tivoli. I have even kept a drawing I made showing you on the beach. . . . Little Jean is playing in the sand and his papa is sitting on the ground with a sketch in his hand." It really was a "poor" Camille, who was there, posing for her husband while she watched the rich at play, mistress of an empty purse, reading a newspaper about the country at war, married yet unacceptable to her in-laws, and with no real plans for the future.

Monet had to do something. He could not return to Paris, nor could he remain on the Normandy coast. Even though he was married and had a family, apparently he still feared being called up to the military. He had been watching

the crowds assemble on the quays waiting to board boats for England, commenting to Boudin: "It's a sad thing to see." Nevertheless, by September 5 he had a passport. But he lacked cash. A few days later, with a heavy heart, he went to Le Havre to ask his father for money. He wrote to Boudin about not having enough money to pay the owners of the Tivoli, and about how those people made him feel "afraid." He wanted Boudin to get a letter to Camille without anyone in the hotel knowing about it. His father was "sick" over the situation in which his son had placed himself in Trouville. But apparently Adolphe Monet came up with the money. What he failed to mention to his son, however, was that in a few weeks he himself was planning to marry his own mistress, Amande-Célestine Vatine, his deceased wife's maid. It is not clear when Monet found out that she had become his stepmother.

We do not know when the Monets left for England. But it was before October 6, for on that date Zacharie Astruc, poet, painter, and good friend who had signed Jean Monet's birth documents three years earlier—wrote to his wife, castigating "Frenchmen who have left the country, those who have run away are contemptible. We will hate them. Monet has fled to England." The two men never reestablished a friendship.

When the Monets arrived in London, they took a room in Arundel Street (today Coventry Street), off Leicester Square, the center of life for French refugees. The first documented evidence of Monet's presence in London is his participation in an Exhibition for the Benefit of the Distressed Peasantry of France. Charles Daubigny, the highly respected Barbizon artist who had unsuccessfully supported Monet's painting for entry into the Salon of 1868, was one of the organizers of the exhibition. Monet knew and admired Daubigny, and it was through the older painter that Monet made his most important contact in London. When Daubigny introduced Monet to the art dealer Paul Durand-Ruel, who had recently moved his operation from Paris to London, the first word out of his mouth was "*Achetez!* [Buy!] I promise to retake any you can not get rid of and to give you my paintings in exchange." In December, Durand-Ruel included one of Monet's works in his First Annual Exhibition of the Society of French Artists. It was through Durand-Ruel that Monet learned that his friend Pissarro had also arrived in London. He and Julie, now pregnant with their third child, left Louveciennes just before the Prussians arrived. They had received news that a small contingent of Germans was now billeted in their home.

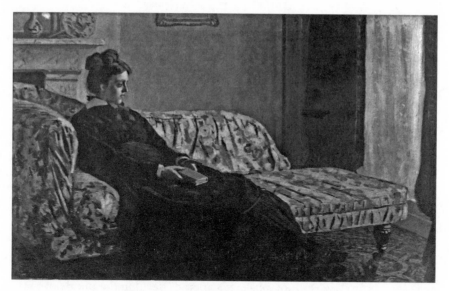

Monet, *Repose,* 1871. Paris, Musée d'Orsay

By early 1871, Camille and Claude had moved from the center of the city to Bath Place (today Kensington High Street). It was here that Monet executed his only London painting of Camille. He called it *Repose.* Here we find a Camille we've never seen before. Though partially in shadow, we see her face for the first time, motionless, eyes downcast, tiny mouth, lips tightly closed. All her verve and elegance are gone. She is twenty-four years old and looks incredibly vulnerable, wearing a dark dress, blue squares on a black ground, with a black underskirt. It has long sleeves with white cuffs, and a high neck closed by a little red bow tied under her chin. In her hands, lying flat in her lap, is a closed book with a red cover. Her body slumps into a chaise lounge covered with cheap flowered material which, not really belonging this old piece of furniture, has been tucked into place. Camille finds herself in a sparsely furnished, gloomy London flat with its dark draperies framing a vertical slash of white—the transparent curtain concealing her view into the street, a place she may have found to be lonely and uninviting.

There is a curious detail about life at 1 Bath Place in the spring of 1871 which has come to light recently. It was the year of the decennial census, the results of which became widely available in 2005. The new information

prompted the journalist Martin Bailey to write a note about it when he discovered that neither Monet nor Pissarro was recorded as being at the addresses we know for them: "Where were Pissarro and Monet on the night of 2 April?" he asks. "Camila" Monet and four-year-old Jean were at home at 1 Bath Place, along with a nineteen-year-old lodger from Dieppe, but no Claude Monet. Bailey believes both artists deliberately evaded the census.[2] But might the census-takers have arrived at the doors of both residences at a moment when the painters were out and the women were alone? This must frequently have been the case. We know that Monet and Pissarro painted together that spring. After a day by the Thames, might they have retired to a café in Leicester Square to be together in the company of other Frenchmen, rather then return to ill-furnished, badly lit rooms, morose wives, and cranky children? Julie and Camille had to cope with the burden of solitude in this foreign place in which neither spoke the language. How were they to understand the questions of the census-taker? Whatever took place, it's another detail in the puzzle of these young wives' days during an exile not of their choosing.

We know six works that Monet painted while in London, and *Repose* is the only one he exhibited that year. The others were landscapes—Hyde Park, Green Park, a view of the Thames, the Houses of Parliament, boats in the port of London. He must have judged his painting of Camille, with its dark colors, restricted space, clear volumes, strong verticals and horizontals, as closer to what he thought to be English taste. Monet entered it in the French Section of the International Exhibition at South Kensington in May 1871, along with the reduced version he had made of his famous *Camille,* plus a work identified in the catalogue as *Entrance to Port of Vionville* (a misprint for Trouville).

Durand-Ruel put both Monet and Pissarro's work in his second London show. Nothing sold. A critic for *The Saturday Review* found the French artists' conceptions "about nature all but unintelligible to the average run of Englishmen." Both submitted work for a show at the Royal Academy. Nothing was accepted. Pissarro wrote home to Theodore Duret that only now did he begin to understand how gracious and beautiful things were in France: "What a difference here, one receives only contempt, indifference, even rudeness; among fellow artists there is jealousy, mistrust and egotism—here it's not about art, it's all commerce" (before June 5, 1871).

These months of exile were punctuated by bad news, both personal and

political. Bazille was killed in a battle south of Orléans on November 28. We don't know exactly when the Monets found out about this devastating loss, only that they learned of it by reading the French newspapers in London. Then, on January 17, 1871, Adolphe Monet died. Monet immediately hired an attorney to collect his share of the inheritance, thought it was now greatly reduced as a result of his father's marriage. Next came the news that Pissarro's house had been pillaged—over a thousand paintings had been destroyed. Monet had to face the probability that the works he left in Louveciennes were gone.

Reading the newspapers from France was to bear witness to one catastrophe after the next, such as the humiliating peace terms ratified by the new National Assembly, which forced France to give up Alsace and Lorraine and to pay an astronomical sum as indemnity. The German High Command finally moved out of Paris, and the French legislators established themselves in Versailles. They read about the proletarian units of the National Guard demonstrating against the Versailles government, and the efforts of the Left to establish an autonomous republican Commune. Claude and Camille would have had little idea of exactly what that meant. They would soon read of the extreme actions taken by government troops, and of the Commune's ultimate defeat in May. One of the incendiary acts of the Communards was the destruction of the column in the place Vendôme, the monument commemorating the campaigns of the first Napoleon. The newspapers reported that Courbet had been instrumental in pulling it down, and that he had been executed by a government firing squad. Monet wrote to Pissarro: "What an ignoble thing for the Versailles Government to do. This is all making me sick. I no longer have the heart to do anything" (May 27, 1871).

By the beginning of June, when Durand-Ruel finally purchased one of Monet's paintings, he was ready to pack up and take Camille and Jean out of England. Rather than go back to France, however, they took a boat to Holland. It's odd they were in such a hurry—maybe another undesirable rent bill had come due—for their best friends, Julie Vellay and Camille Pissarro, were about to be married. Had they stayed two weeks longer, they could have been their witnesses at the wedding, which took place in the Registry Office of Croydon on June 14.

The "Impressionist" Couple

The Monets were back in Paris by November 1871. This was at about the same time that Paul Cézanne and Hortense Fiquet returned to the city. Claude settled Camille and Jean into a hotel near the Gare Saint-Lazare, an area they knew well and, fortunately, one that bore few physical scars from the Commune. Shops were open and cafés were bursting with customers. It must have been a relief to be back. And they probably had little time to worry about the generally shaky state of affairs such as the "provisional" status of the new republic. But, like the Cézannes, they surely made a pilgrimage down to the river to gape at the burned-out hulk of the Tuileries, the Cour des Comptes, the Palais de Justice, and the Hôtel de Ville. They would also have taken a detour to la place Vendôme to see Napoleon's column lying in a heap. Courbet had not been shot for his role in its destruction, as they had thought, but was now incarcerated in the old jail of Sté-Pelagie.

The Pissarros had returned to Louveciennes months earlier. Julie was about to give birth for the fourth time. Soon after their return Monet wrote to Pissarro: "When you write, tell me if my wife can come to visit yours without causing any inconvenience." Julie and Camille had been each other's principle support during their difficult exile, and they must have longed to tell each other all that had happened since they last spoke.

Julie's sister, Félicie, had written to the Pissarros in London, warning them about what they should expect when they got back. She had gone to the village to inspect the condition of her sister's home now that the occupiers had left. It was beyond recognition. This was all a pregnant woman needed; nevertheless, Julie had to set about scrubbing, mending, repairing,

and replanting. One detail was particularly repugnant: the Prussian soldiers had used Pissarro's paintings to protect themselves from splattering blood thrown off by the chickens and rabbits they slaughtered in the yard. His canvases ended up in a dung heap.

Monet was luckier. Most of the paintings he had stored at Pissarro's home survived. They may have been hidden away in the "armoire under the staircase" and so remained undiscovered by the Prussians, according to Félicie. A month later Monet wrote that he needed some of these paintings. Further, we learn from this December 21 letter that, in fact, they had never visited Julie, because they were "caught up in the rush of moving."

When they returned to Paris, Monet alerted his friends of their need for a place to live. Edouard Manet, who had remained in the capital throughout the occupation and the Commune, came to their aid. His family had been friendly with Louis-Eugène Aubry, the recently deceased mayor of Argenteuil, a town on the north bank of the Seine, a little more than nine miles from the center of Paris. Aubry's widow, Madame Aubry-Vitet, was willing to rent the Monets a house at 2, rue Pierre-Guienne, across the road from her property. It was only a short walk to the river, as well as to the railroad station. She wanted a thousand francs a year, payable in quarterly installments, and they accepted the deal. On January 2 Eugène Boudin wrote to F. Martin about his plans to attend a "housewarming *chez* Monet. He's very well situated."

After four peripatetic years of living in cheap rooms and hotels, sometimes fleeing in the night for lack of funds, the Monets had a house. When did Camille understand she finally had a "home"? It may have been that first winter, when Monet set up his easel inside the house to look through the sheer white curtains—which may have just been hung—drawn back on the double doors in order to paint Camille outside in a black dress with a matching coat trimmed in gray. She stands in the snow, her hands to her chest and a bright red shawl over her head and shoulders, and looks back at Monet. Her small face is a perfect oval, her look tentative, barely described, dark-eyed uncertain as she gazes back at her husband working away inside their new house (*The Red Cape*, Cleveland Museum of Art).

This was a real house, with a cellar, a main floor, bedrooms, and an attic. Best of all was the garden: over two thousand square feet of planting space. As soon as the weather permitted, the garden became the focus of family life. Like

Louveciennes, Argenteuil had been occupied by the Prussians. Presumably the garden was not in good shape, but when spring came Monet was ready to paint whatever blossoms were able to bloom again. Usually Camille was there, too, sometimes there was one of her, sometimes two, posing in her usual way. For a painting called *Camille Reading* (Baltimore, Walters Art Gallery). Claude had her sit on the grass under a lilac bush, a book in her lap. She wears a luscious pink dress and a hat of the same fabric, its ribbon forming a puffed bouquet at the crown of the hat, which is tied under her chin. Monet has daubed her spread-out skirt with sunlit swatches to match the lilac petals above, and a soft light plays across her face. What a contrast to the painting he made of Camille one year earlier in London! I like to imagine Camille wearing this dress in June 1872, when Comte Théophile Beguin Billecocq arrived with his wife to be greeted at the door by Monet's "delicious wife." Art historian Paul Tucker describes Camille in this painting as "the ultimate embodiment of feminine beauty and suburban leisure set in an enchanting locale far from the pressures of modern life."[1] Poverty and exile seemed a lifetime away.

At about the time the Monet family returned to France, Paul Durand-Ruel also returned to Paris, reopening his gallery on the rue Laffitte. He came back full of enthusiasm for the new painters and began to purchase their work *en grosse*. All of Monet's friends benefited: Manet, Pissarro, Renoir, Sisley. And he himself welcomed Durand-Ruel's interest with open arms. In 1872 the dealer purchased twenty-nine of his paintings, putting ninety-eight hundred francs into Monet's pocket. If we include the three-hundred-franc interest from Camille's dowry that arrived in December, we recognize that, at last, the Monets were not poor.[2] They hired two servants. They drank good wine. Monet took on a gardener. He bought a boat, fitting it out with a cabin in which he was able to paint. It became his floating atelier. The Monets were finally living the life they felt they should be living. This must have been especially true for the artist, who had suffered deeply from his father's lack of support, always feeling in many ways he had been robbed.

In 1873, Claude Monet looked with pleasure on all that surrounded him: his wife, his son, his home, the streets of Argenteuil, the banks of the Seine, the new bridges that were being rebuilt after being destroyed in the war. We know this best because we see it in his paintings, rather than reading about it in his letters, which are far fewer during the Argenteuil period. And he did

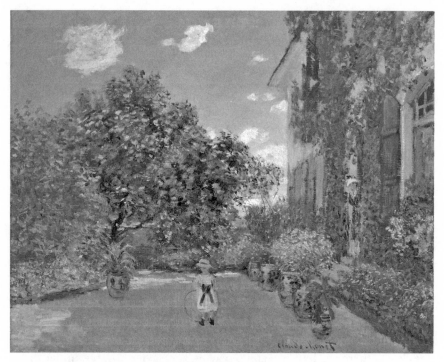

Monet, *The Artist's House at Argenteuil,* 1873. oil on canvas. Chicago,
The Art Institute of Chicago, Mr. and Mrs. Martin A. Ryerson Collection, 1933

not have such a friend as Fréderic Bazille to whom he could open his heart, as
well send his pleas for money. But Théophile Beguin Billecocq gives a clear
sense of the Monets' lives when he wrote in his journal: "The melancholy
periods are now just bad memories . . . his son Jean a charming little boy,
mischievous and intelligent. And regarding the charming Camille, she greets
us with great kindness and simplicity." When the Monets came for dinner in
November 1872, Théophile saw "a man at his height, serene, full of joy," and
he purchased a few more drawings.

This pleasure in their new life is clear in *The Artist's House,* a canvas
painted in the summer of 1873. Under a blue sky with shifting clouds, sunlight
illuminates the corners of a yard filled with stone dust and outlined by six blue
and white Delft pots that the Monets had purchased in Holland. In the very
center of the terrace, with his back to us, we see Jean in a yellow straw hat and

a dress with a big blue bow tied in the back. He holds his hoop and somehow looks smaller and more vulnerable than a five-year-old boy. The open space is surrounded by a profusion of fuchsias, geraniums, lilies, and daisies. Camille, dressed in blue and white and wearing a yellow hat with a blue bow, steps out of the door of her ivy-clad house. We imagine mother and son about to leave on an outing. Tucker sees the still, solitary figure of Jean as "strange" and wonders if "the woman at the door told the boy something he did not want to hear."[3] There are many ways you can read this painting, for it has the effect of a scene from a play. Actually, throughout Monet's domestic paintings done in Argenteuil there are usually small suggestions of some kind of narrative, but never narratives that are totally distinct. Usually they take place in the garden where Monet worked out scenes placing his principal actress, Camille, along with other models. Is it possible that she participated in the planning of these works? Surely it was she who selected the dresses, which are key elements in the scenes.

In another view of *Monet's Family in the Garden* (Zurich, Bührle Collection) Camille's image dominates the foreground. Comfortably seated in a lawn chair, holding a parasol in her white gloved hands, she faces us. It's not clear if there is a hint of a smile playing across her lips, but under those distinctive dark eyebrows her powerful eyes stare boldly into ours. There's no doubt we are looking at a very self-assured lady of leisure. Jean crouches in the middle ground holding his hoop, with a maid standing by, ready to hand him his baton. The background is taken up by a clump of red geraniums, a hedge, and part of a new house being built on the adjoining lot.

In *The Bench* Monet depicted the same view, the same red geraniums, and an edge of the same new house, but for this painting he moved his easel slightly to the right in order to focus his attention on Camille, now seated on a long black bench. She wears the same black toque with a white flower and red ribbon on her head, the same white gloves, but a different dress. It, too, is of the latest Parisian design: smart white bow at the neck, a black velvet jacket with pale sleeves from the shoulders to the elbows, wide black cuffs, and a soft, diaphanous overskirt with black banded edges floating over the dress beneath. Leaning over the back of the bench is a distinguished-looking bearded gentleman wearing a top hat. Half-smiling through his beard, a twinkle in his eyes, he looks intently at Camille. But she turns away, staring soulfully into

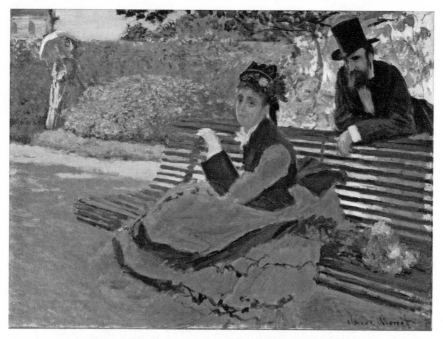

Monet, *Camille Monet on a Garden Bench,* 1873. New York,
The Metropolitan Museum of Art, the Walter H. and Leonore
Annenberg Collection, Gift of Walter H. and Leonore Annenberg, 2002.

the distance. There are shadows under her eyes, and her mouth is downcast.
She rests her left elbow against her dress and holds her gloved hand in the air.
We see a thin streak of white paint between her fingers—a piece of paper or
an envelope? She pays no attention to the bouquet of flowers—apparently a
gift from the gentleman—thrown down on the bench behind her. In the back-
ground, beyond the red geraniums, under a white parasol, stands a woman in
blue—a friend, a chaperone? We're relieved she is there because the presence
of the bearded man feels ominous. Once again there is a suggestion of narrative,
but one that is ambiguous; perhaps it has no meaning at all, although Tucker
says that this is doubtful.

In the 1870s, critics writing about the new art, including Zola, were call-
ing for a reconfigured version of narrative painting, one more in accord with
contemporary impulses in literature and recent authors who had given up

history and the literary epics of old to discover a new form, one that was less concrete, more nuanced. Monet seems to have been attempting something of the sort here, with Camille serving as his willing collaborator as he sought to formulate a "modern conversation piece."

The male model in *The Bench* was Gustave Manet, Edouard's youngest brother and one of the witnesses at the Monet wedding.[4] This brings to mind another facet of the Monets' lives in the suburbs. There is no evidence that they became part of local Argenteuil society. Of course, Camille would have known trades people and would have dealt with the director and instructors at Jean's school, but it doesn't seem to have gone any further than that. Family members who knew Monet later in life, when he lived in Giverny, reported that he seldom interacted with residents in the village, that small talk offended him. Probably the experience of Argenteuil was not much different. By train the Gare Saint-Lazare was only fifteen minutes away. The friends they saw continued to be those whom Monet had encountered in the ateliers of Paris and the cafés of Batignolles, as well as the very bourgeois society of the Beguin Billecocqs.

In early September 1873 Monet dropped a note to Pissarro: "Renoir's not here—you can have the bed." During the summer and fall of 1873 Monet's friends gathered round. Their conversation was focused on what kind of organization they could put together to defend themselves against the new situation in the arts—which was turning out to be even more difficult than it had been under the Second Empire. The new director of fine arts, Charles Blanc, was advancing a more authoritarian state apparatus, setting down rules for artists and attempting to govern public taste. Blanc was particularly ferocious about the Salon, an annual event he believed had now become a "bazaar." In 1872, the first Salon to take place under Blanc's direction, only 1,536 paintings were accepted, roughly one-half the number shown in the last Salon of the Empire. Sitting around in Monet's garden that summer, the malcontents discussed how to develop the idea advanced by Pissarro: to put together an association of painters, sculptors, and other artists in which a person could simply pay dues and hang his or her work in joint exhibitions.

Renoir often stayed in Argenteuil that summer, and, while he was a guest at the Monets', he created portraits of both his host and his hostess. When he looked at Camille, he saw quite a different woman from the one we know

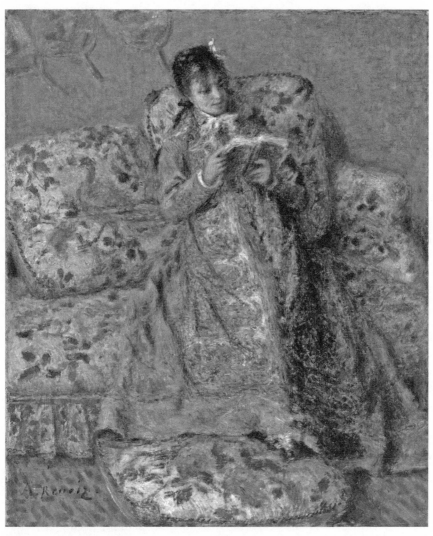

Renoir, *Camille Monet Reading*, c. 1873. @ Sterling and Francine Clark Art Institute
Williamstown, Ma.

in her husband's work. Instead of focusing on pose and dress while playing down Camille's face and her emotions, as Monet usually did, Renoir watched his twenty-six-year-old hostess move easily about the house in an enchanting peignoir resembling a Turkish caftan, and he saw real beauty. He observed the way she threw herself down on a flowered sofa with enormous cushions—a big bird strutting across a pillow next to the one into which Camille snuggles—the way she settled in to read her paperback novels, crossing her feet and placing them on another big pillow. He painted her with a flower in her hair and showed her face as young and relaxed, a slight smile playing on her lips as she concentrates on her book. Three *uchiwa* fans, Japanese emblems much loved in the Monet household (Monet had included one on the wall above Camille's head in his London portrait of her), are attached to the blue wall behind the sofa. In Tucker's words, they "float into the scene like untethered balloons."

Renoir did a second painting of Camille in the same exquisite robe (Lisbon, Calouste Gulbenkian Foundation). This time she is reclining on a pure white sofa. Her legs rest across the length of the couch, her left arm falling casually on a pillow as she pores over the front page of the newspaper *Le Figaro*. "Woman Reading" was a tried-and-true subject for nineteenth-century artists, but I think we have to believe that Camille Monet was a reader, that it wasn't just a motif. Camille's dark hair against the white pillows, her red lips and bright eyes, her nonchalant air of insouciance, allow us to see her as a glamorous beauty. Renoir's approach to the female model was unparalleled within the group of new artists. This painting gave Monet great pleasure, and he hung it in his bedroom until the end of his life.

In the same period—perhaps even in response to Renoir's view of his wife—Monet painted a highly personal image of Camille. *Camille and Jean Monet in the Garden at Argenteuil* may be the only painting from this period in which we see the "real" Camille, not just a player and a model for Monet's imagined world. She and Jean are seen beyond the stone dust section of the yard—at the edge of the painting you can see part of a folding camp chair and a Delft pot. Camille is hip-deep in an abundant mass of late summer flowers. Her body is totally surrounded by squiggles of red, yellow, green, and white pigment, brushstrokes creating a rich array of flowers that fill the canvas. To our left, taller flowers of red and blue pick up the color of Camille's blue

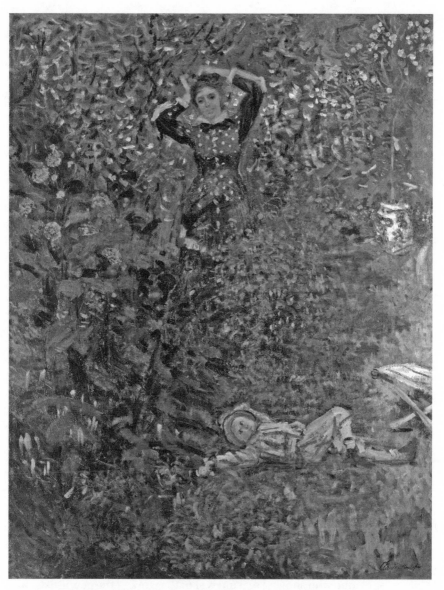

Monet, *Camille and Jean Monet in the Garden at Argenteuil,* c. 1873.
Private Collection

dress—not a chic Parisian dress, but a figure-hugging country dress with white dots and white edging on the sleeves and cuffs. Both her arms are raised high as she moves to fix the red ribbon in her hair. The most interesting thing in the painting, however, is her face. She looks straight at Monet, her expression simple, direct, and open, in no way summarily treated as it is in so many of Monet's paintings. It is, in fact, the same face we see in the Renoir canvases, but without a hint of a smile.

A short distance from where Camille stands, and echoing her raised-arms gesture, is Jean—flat on his back. He wears pale gray knickers, matching jacket, and the little yellow straw hat, a hat he seems never to be without. Jean has flung himself on the ground, halfway between his parents. With bright red cheeks, little red mouth, and very big eyes, the boy gazes at his father, just as Camille looks directly at her husband. It's a strange view that Monet gives us of his family. There is no unity between this mother and her son. Any hint of anecdote is absent. They are simply there for him in the garden he loves—his two marvelous models in all their splendor, as their second Argenteuil summer was coming to an end.

In September 1873 the Monets visited the Pissarros, now living in Pontoise. The next day Monet wrote to Pissarro: "Sad news awaited my wife when she returned from Pontoise—her father died yesterday." Charles Claude Doncieux was sixty-seven, and he died alone in a nursing home. Camille could now expect the rest of her dowry: twelve thousand francs, minus the thirty-six hundred francs she had already received. In November, Mme Doncieux sent her daughter four thousand francs, asking Camille to agree to wait four years for the final payment. This request resulted in a legal dispute. In the end, Camille never received her full inheritance.

Monet's brief letter to Pissarro continued: "Naturally we are obliged to go into mourning, and I find myself at present short of money. I would be very obliged if you could obtain a payment from M. Duret." In London Pissarro had introduced Monet to Théodore Duret, art critic, passionate supporter of Manet—someone who showed real interest in the work of the new artists. Recently he had picked out a canvas of Monet's, indicating that he would like to buy it, but the price had become a problem. Duret had written to Pissarro explaining that they had agreed on a thousand francs: "My memory is absolutely precise . . . today I sent Monet the 1,000 francs that I owe him. If he thinks he

can sell it for 1,200 francs, I'll return it to him and take back my 1,000." What Monet wanted Pissarro to do was to get the extra two hundred francs out of Duret, a task at which the older painter, in fact, succeeded. A thousand francs— the equivalent of a year's rent—was a very good price for a Monet in 1873. This is a mysterious sequence of events, for the situation in the Monet household had changed dramatically since the time when they hardly had money for food. Monet's 1873 account books record 24,800 francs worth of sales!

In 1874, however, Monet's sales did drop precipitously. Still, even if he took in only ten to twelve thousand francs, which seems to have been the case, that was more than Zola would receive for the serial rights of *L'Assommoir* in 1875, an amount so large it permitted the novelist to purchase a country home in Médan a few years later. Our astonishment is even greater when we read the letter Monet wrote to Edouard Manet on the first of April: "This morning at 7:30 A.M. Mme Aubry presented me with the quarterly rent bill. Since I was expecting you to come, I asked her to return around noon, and here I am with a bill of 250 francs while I have only 200. Could you come up with another 100 and send them to me? I will try to get Mme Aubry to wait until tomorrow or the next day." This concern over fifty or a hundred francs is incomprehensible except in psychological terms. And, of course, it takes us back to all those fifty-franc letters to Bazille.

As Monet was writing his note about his financial problem, his mind was primarily occupied with preparations for the exhibition of independent artists to take place in Nadar's old studio on the boulevard des Capucines in two weeks. Monet had committed twelve works: seven pastels and five paintings.

Critics were divided about the show: many congratulated the artists for their courageous stand against the Salon; others were critical of canvases that, to their eyes, seemed unfinished or, even worse, strange and bizarre like Cézanne's. One of Monet's canvases was a work he had done the previous year. He had painted a view of the port of Le Havre at daybreak. It was a richly atmospheric scene with the horizon disappearing into the morning mist, and he called it *Impression, Sunrise.* Several critics picked up on the word "impression," and one critic, Louis Leroy, focused on it with considerable energy. He even titled his satirical article for *Le Charivari* "Exhibition of the Impressionists." He and his fictional friend, M. Vincent, visiting the exhibition together, had the following exchange in front of Monet's picture:

"What does that canvas depict?" "Look at the catalogue '*Impression, Sunrise*,' '*Impression*'—I was certain of it. I was just telling myself that, since I was impressed, there had to be some impression in it . . . and what freedom, what ease of workmanship! Wallpaper in its embryonic state is more finished than that seascape" (April 25, 1874). The other artists' works in the show were also referred to as "impressionist," but members of the group were not taken with the term. Nevertheless, by 1877, they were ready to call the third exhibition of Independents the "Exposition des Impressionnistes."

When the show closed, Durand-Ruel sold *Impression, Sunrise* to a man who ran a large wholesale fabric business in the Paris garment district. His name was Ernest Hoschedé, and he paid eight hundred francs for it.

Things were not working out in the Aubry house, and the Monets were obliged to look for a new place to live. In June they came to an agreement with a local carpenter, Alexandre Flament, to rent the house he was building on the property next to where they had been living—in fact, we see the house in several paintings Monet made in 1873. It would not be ready until October, and Madame Aubry agreed to let them stay on through the summer. They were thankful for another season in the garden.

Manet had refused to have anything to do with the exhibition on the boulevard des Capucines. He said he believed that true professional artists exhibited only in the Salon. In spite of their differences about how a "professional artist" should behave with respect to showing work, Manet and Monet drew increasingly close that summer. Manet often stayed at his cousin's vacation home in Gennevilliers, just across the river from Argenteuil, and he was frequently a guest of the Monets. They spent a great deal of their time by, or on, the river. Monet himself painted a portrait of his studio boat lying at anchor, with the footpath of Argenteuil in the background. And Manet painted two portraits of his friends in the boat itself. First he did an oil sketch of the couple underneath the awning on the small open deck in front of the studio. Camille, body erect, the veil of her hat blowing in the wind, looks intent and unsmiling. Monet, straw hat firm on his head, his face not fully defined, holds a brush in his right hand and a palette in his left, his elbow touching Camille's hand. The two figures fill the canvas, and even without the details to complete the rendering of their features we grasp the physical reality of the couple, their bodies, their bulk, and their closeness.

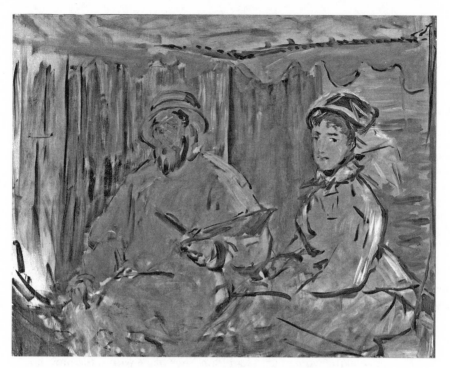

Manet, *Claude and Camille Monet in His Studio Boat,* 1874.
Stuttgart, Staatsgalerie

For the finished painting (Munich, Neue Pinakothek), Manet wanted
to show a full view of Monet's fine little floating creation as it sat lightly in
the river, with Argenteuil in the distance. Monet has taken his place in the
bow underneath the colorful awning he rigged up. Now it is *his* features—the
dark beard, his strong, handsome face in profile beneath his yellow straw hat,
his brilliant white shirt, hand poised in the act of putting paint on the can-
vas before him—that we see with the greatest clarity. Camille's figure, lightly
touched in with almost no detail, fills the entrance to the cabin. Manet gives
just the slightest suggestion of her face under her black and gold hat, its veil
blowing softly against her nose. Here we find Manet, the man the new school
of artists regarded as "our *chef d'école,*" saturating his canvas with the light,
the brushwork, and the fresh array of colors commonly used by his younger
colleague. This is a tribute, and not to Monet alone, but also to the muse, the

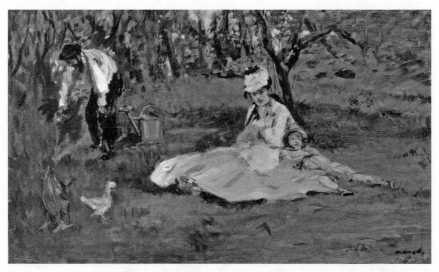

Manet, *Monet Family in Their Garden at Argenteuil,* 1874.
New York, The Metropolitan Museum of Art,
Bequest of Joan Whitney Pauson, 1975.

model, the wife, the woman who had found her place within the movement.
It is Manet's salute to the "impressionist couple."

Manet created another painting that summer with the Monet couple
as models. In it he amplified his idea of the new French artist and his family.
They are in the garden of the house on the rue Pierre-Guienne, which they
were soon to leave. This time, however, it is the seated figure of Camille that
dominates the painting. For the occasion she has chosen the purest of white
summer gowns and a splendid tall white fabric hat with a black bow and a
red flower in the crown. Her dress spreads out grandly as she takes her place
on the grass beneath the tree. In her right hand she holds a red fan spread
out in such a way that it makes a vibrant red arc beside her white dress, while
she supports herself in the pose by tucking her left fist under her chin. Jean,
wearing a blue sailor suit, has just plopped himself down beside her and leans
against her hip. With Camille and Jean, Manet has created a red, white, and
blue triangle—a *tricolore*—the colors of the French flag. It was a pointed state-
ment about contemporary politics, since Royalists and Republicans were still
fighting for control of the government. One of the favorites for the throne,

the comte de Chambord, held strongly to the position that, were he to be recognized as king of France, it would have to be under the fleur-de-lis of the *ancient régime*. Giving further weight to a political reading of the painting, the cock—the other great Gallic symbol—with his hen and chick appear in the lower left of the canvas. Monet himself, wearing a blue shirt, is off to the left, watering can beside him, as he bends down to pick a red flower. Behind the little Republican family we are greeted by a fine array of red flowers sprinkled over the fruitful landscape.

By 1874, the clouds in France were beginning to lift. At the end of 1873 the last payment of the terrible five-billion-franc indemnity imposed by the Prussians had been repaid, and the last soldier of the occupying army had left French soil (although not that of Alsace and Lorraine, the lost territories, now under the Reichstag). The economy was reviving; Paris's monuments were being restored. The new Opera had finally opened its doors. And there was a new school of artists coming boldly forward to show their work, not under the auspice of the government, but through their own initiative. Even though Manet had not seen fit to join the impressionists in their collective effort, here he chose to honor the man he saw as their leader. Further, he was depicting this "revolutionary" artist as a strong family man, one who partook of the simple pleasures and the fundamental morals desired by all good Republican citizens of the Third Republic.

While Manet was working, Renoir arrived on the scene. He saw spread out before him a truly enchanting subject, and he immediately asked Monet to lend him some materials with which he, too, could paint. He then set to work, focusing just on Camille and Jean. Though his brushwork was broader, and the expressions he gave to the faces of Camille and Jean were more vivid, their poses are exactly the same as in Manet's canvas. Renoir immediately understood the meaning of the picture arrangement established by Manet, but he introduced further clarification: Camille's hat and her fan are now red, white, and blue, and the rooster has strayed from his hen to become a large, erect chanticleer standing to the right of Camille and Jean. It is the proud Cock strutting on red, white, and blue feet, a forceful symbol of the French nation. The patriotic message is there for all to see: we may be on the premises of one of the young painters refashioning French art, and in no way are such men without loyalty to the Republican cause.

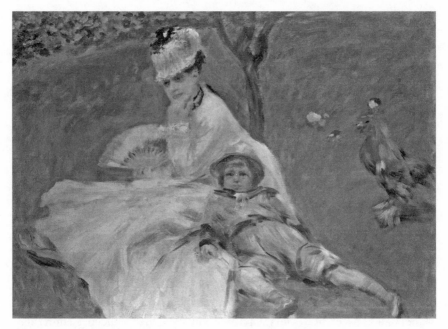

Renoir, *Madame Monet and Her Son in Their Garden at Argenteuil,*
Alisa Mellon Bruce Collection @ Board of Trustees, National Gallery of Art,
Washington, 1974, oil on canvas, .504 × .680 cm.

What a time it must have been for Camille—beautiful, admired, the center of attention from three extraordinarily gifted men. But if life seemed perfect to Camille Doncieux on that July day, there were far too few such days to come.

Money and *La Japonaise*

In the 1860s Monet had tried to fool his family into thinking that Camille and her child would not become a permanent part of his life. But even if he had been as successful as Cézanne in hiding the woman and the boy, it is clear that Monet's father would not have given him the allowance he needed. Monet became enraged when Bazille suggested he go to work, that is, that he enter the employ of someone else in order to make money. It infuriated him that Bazille, child of wealth, from a family willing to support their son's ambition to become an artist, could even think of such a thing. Monet believed that his friend had no idea what he was going through. Money was at the core of his problem. Someone had to support him.

As they embarked on the risky path of creating works totally unlike those being produced at the Ecole des Beaux-Arts and shown in the official Salons, Monet and his friends established themselves as rebels in a conservative, middle-class society. Monet's father recognized the error of such an approach: "I want to see you in a studio, under the discipline of a reputable master. If you decide to be independent again, I shall cut off your allowance without a word." He knew it was a matter of money, that if his son did not go the official route, he would be a pauper. Official institutions dominated the artistic and economic systems of France. Outsiders starved. Durand-Ruel once questioned Renoir's desire to send paintings to the Salon. The artist's response could not have been clearer: "I shall try to explain to you why I send my paintings to the Salon. There are fifteen art lovers in Paris capable of appreciating a painter without the Salon. There are 80,000 who wouldn't buy a thing from a painter not exhibited at the Salon."

The Second Empire is hailed in French economic history for the progress made in the realm of capital growth and the expansion of financial organizations. There were new types of banking institutions that fostered greater savings and more investments. The fluid sense of money and available credit provided ready opportunities for individual enrichment. And these financial possibilities were particularly beneficial to the growing middle class. Eventually something of the new wealth found its way into the world of art. So in the 1860s, when Paul Durand-Ruel joined his father in the family business, a gallery located at 1, rue de la Paix, he was sure it was the right thing to do, even if there were more works of art on the market than there were interested buyers. Unlike his conservative father, who preferred to deal with conventional painters, the younger Durand-Ruel was an imaginative man with a passionate streak that made him open to the new school of artists. Nor was he averse to risk. Thus he was willing to show paintings by Monet and Pissarro in London when no one was interested in them, and then he followed up by purchasing works from both men.

Paul Durand-Ruel had clear ideas about his role as a dealer. One thing he wanted was exclusive relationships with the artists he supported. Once that was established, he then bought large numbers of works so that he could keep them in stock. In other words, he speculated. And if an artist were really "his," he might even advance him money when needed. His role was somewhere between that of a commercial gallery owner and a patron promoting the new aesthetic he recognized in the work of Manet, Monet, Degas, Pissarro, Renoir, and others.

With Durand-Ruel's support, the Monets had finally become a comfortable bourgeois family. In 1873 he purchased thirty-four paintings totaling 19,100 francs, the average price coming to more than 500 francs a painting. Monet could stop worrying about money and live as he should: the furniture, the garden, the help, the clothes, the boat were all now within easy reach. But Durand-Ruel then found his stock too large, and he was soon selling at a loss, falling into debt. In 1874, he stopped buying paintings from Monet and his group altogether. Monet's income fell to less than half of what it had been the previous year. Still and all, 10,654 francs, which is what Monet recorded in his account book that year, was not insignificant.[1]

That fall the Monets moved next door to 5, boulevard Saint-Denis (today

boulevard Karl Marx). The house was just finished, freshly painted rose with green shutters. Their annual rent was fourteen hundred francs. According to Monet it was a "gentile petite maison." That winter, sometime after the furniture was in place and the draperies hung, he painted *A Corner of the Apartment*, an interior view of their new home. It's a view that parallels the garden scene in *The Artist's House*. Jean—now an eight-year-old schoolboy—again stands right in the middle of the picture, but this time facing us, the light falling on him from behind, casting his shadow onto the freshly waxed parquet floor. Camille, barely visible, is seated at a table in a shadow off to one side. The symmetrical composition focuses on a single window hung with sheer curtains framed by green, yellow, and white draperies. Against the white curtains, in perfect silhouette, is a shiny new brass lamp hanging from the ceiling. The Delft pots have been taken in from the garden and placed on either side of the entrance to the salon for the winter. Though the rooms in the house on the boulevard Saint-Denis were small—four to a floor; twelve in all—it provided all the space they needed. In addition, there was a large *cave* with excellent facilities for wine storage and work materials. Everything was new and well installed. Camille was surely pleased.[2]

With the expenses of the move and the loss of Durand-Ruel's support, Monet was again insolvent. Bazille was dead and Courbet was in exile in Switzerland, so Monet now turned to Manet: "Excuse me for coming to you so often but that which you gave me is gone. Here I am again *sans un sou*. If it wouldn't bother you, could you advance me at least 50 francs which would be of great help to me. . . . My wife will stop by at your place tomorrow morning between 10 and 11, at least if the weather is not too bad" (January 23, 1875).

In March 1875, desperate for sales, Monet and Renoir, along with other friends, took a large number of works to the Hôtel Drouot, the state-sponsored auction house that had been founded in 1852. Only about half of Monet's paintings sold, some for as little as two hundred francs, in no way sufficient to restore his coffers. A few days after the sale Beguin Billecocq invited him, along with Monet's brother Léon, for dinner: "He was demoralized and completely lost his enthusiasm, his gaiety, his *joie de vivre*. Back into melancholy."

During the summer Monet returned again and again to Manet: "Things are harder and harder. Since the day before yesterday I haven't a *sou*. Nor do I have credit with the butcher or the baker. . . . By return mail could you send

Monet, *A Corner of the Apartment*, 1875. Paris, Musée d'Orsay Réunion des Musées Nationaux/Art Resource, NY.

me a twenty-franc note. That will carry me along for fifteen minutes" (June 28, 1875). "If it doesn't bother you too much could you advance me the pitiable sum of sixty francs? I am in the claws of a bailiff who can really do me some harm. With that sum I can make a deal with him. He has given me until tomorrow at noon" (July 8, 1875). "You have to know that what I said to you yesterday is serious. My box of paints will be closed for a long time if I do not pull myself out of this affair. As I said: *c'est fini*" (1875).

For all Monet's talent, his charm, and his vibrant taste for life, it must have been extraordinarily difficult to have remained his friend when his improvidence was flagrant, and, on top of that, he continually exaggerated his circumstances.

Monet slacked off a bit that summer. Though concentrating on the same subjects he had been painting ever since they first arrived in Argenteuil—boats in the river, the banks of the Seine, the poppy fields, the poplars—he did fewer works, and they are often not as inspired as their predecessors.[3] As in the past, Camille and Jean were often with him, turning up in many of his paintings, usually as faceless specks in a distant field.

Monet did, however, create one truly splendid image of Camille and Jean during the summer of 1875. He had them stand on top of a hill so that he could look up at them against a blue, cloud-dappled sky. Camille wears another ensemble we have not seen before—a diaphanous white dress with a matching jacket—its edges thrown into movement as he rapidly carried his brush loaded with white paint over the surface. The folds of her dress, enlivened by the energy of the breeze, take on shades of blue and gray, green and yellow. Her green parasol just touches the top of the canvas, shading her face, which we see in a three-quarter view. The unseen sun is a powerful presence, re-creating Camille's figure as a shadow plunging down over the yellow-flowered, green-tufted hill to the bottom edge of the painting. The combination of her figure, her parasol, and her shadow makes Camille into a strong vertical presence, with the wind rustling through her skirt to create an image full of movement and portraying a vision of one of summer's loveliest days. She looks down at her husband, her inquiring eyes half-hidden beneath the veil blowing over her face. As in most of Monet's paintings, Jean is at a distance from his mother, standing on the descending side of the hill. We see him only from the waist-up. Erect, hands in his pockets, he wears a boater shirt, dark blue tie, and wide-brimmed

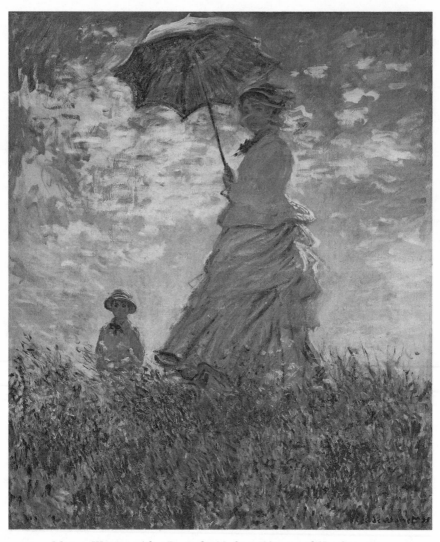

Monet, *Woman with a Parasol—Madame Monet and Her Son*, 1875.
Washington, D.C., National Gallery of Art

yellow straw hat, and his big round eyes look straight ahead at his father. It's the characteristic pose that Monet frequently asked from his son.

Monet saw this work—over three feet tall—as an important painting, and he planned to place it in the next exhibition of Independent artists scheduled to open in April 1876. He called it *La Promenade* and sent it, along with eighteen other works, to Durand-Ruel's gallery, which was being lent to the artists for the occasion. But *La Promenade* received only minimal notice in the press. Pierre Dax, writing for *L'Artiste,* described it blandly as "singular and extremely accurate . . . a young woman with a little boy on a hill surrounded by brambles and tall grasses" (May 1, 1876).

The lack of interest was probably due to the other portrait of Camille in the exhibition. The show was large—252 paintings in all—but none attracted more attention than *Japonnerie,* as the painter labeled the canvas that dominated the central room of the show. In desperate need of a big sale, apparently Monet thought back to his first big success—that painting conceived in haste and executed with lightning speed:—*Camille.* Here again we have a large studio work—at seven and a half feet it is exactly the size of the "Green Dress"—and again dependent upon Camille's superb ability to hold a pose and to exhibit rich finery to splendid effect.

A friend had lent Monet a fabulous red Japanese kimono. It was covered with intricate embroidery, vines, and leaves in gold and green across the sleeves and the upper back, and an image of a flamboyant samurai unsheathing his sword on a panel stitched onto the broad lower back of the garment. The Monets went to work in a borrowed studio on the boulevard Saint-Denis. They laid a tatami mat on the floor and attached their Japanese fans to the blue-gray studio wall, throwing a few more on the floor. We can imagine Camille trying out one pose after another. In the end they agreed that her body should be in profile while turning her face toward her husband. Monet then reached around and pulled the lower part of the robe forward in order to center the warrior's head, and he arranged the bottom of the robe's thick edge in a broad curve so that it would fill almost the entire width of the canvas. He asked Camille to raise her right hand high and hold the red, white, and blue fan—the same one Renoir had painted. Their most astonishing decision was to bury Camille's dark locks in a blond wig. The two of them must have laughed at the absurdity of it all—this grotesque, dark warrior, with his pasty white arm reaching down

to hold sword and sheath, providing an echo to Camille's raised arm with her patriotic fan, its white center so brightly painted that it casts a glow over her cheeks, her red lips, her blond hair. To the right, on the same level as Camille's coyly tilted head, is another fan, one that is separate from the rest and painted a rosy red in contrast to the muted blues, grays, and greens of the others. This fan is tilted in the opposite direction from Camille's body, and on it we see the shoulders and face of a Japanese woman—a beautifully coiffed geisha—who appears to be looking with astonishment at this curious French rival.

The first we hear that such a painting was under way is in a letter Monet wrote to Philippe Burty, France's most prominent critic-collector of *Japonisme*. Monet wanted Burty to know that he was working on "one of those marvelous actor's robes that are superb to paint" (October 10, 1875). This letter would seem to be an advertisement. Monet hoped to draw the attention of an important and sympathetic critic like Burty, who might write about the work since it touched upon his own special field of interest.

There may have been a further motive for Monet to create this unusual painting that was so unlike everything he had done in recent years. Once again he may have been initiating a friendly competition with Manet. In 1873 Manet had begun work on a portrait of Nina de Callias, one of the more remarkable women in Paris who was known for her salon, which was well attended by many of the most interesting artists and writers in the city. Manet fitted out Mme De Callias in an exotic North African costume and asked her to take a pose reclining on a day bed. Behind her, on the studio wall, he placed an array of Japanese fans. We do not know if Monet had seen the work, but he knew about it, as the poet-painter Charles Cros had written a poem, "Scène d'atelier," about the experience of visiting Manet's studio. When the poem was published in the *Revue du monde nouveau* in February 1874, it was accompanied by an engraving of a Manet sketch showing Nina, head tilted to one side opposite a fan bearing the face of a Japanese woman tilted in the opposite direction.

The exhibition opened on March 30, attracting more interest from the critics than its predecessor did in 1874. No work was singled out for more attention than *Japonnerie,* the title under which Monet entered this new portrait of his wife. As Zola had heaped praise on *Camille* a decade earlier, his review of *Japonnerie* was full of admiration. For him Monet was "incontestably the

Monet, *La Japonaise* (*Camille Monet in Japanese Costume*), 1876.
Boston, Museum of Fine Arts

head of the group." Alexandre Pothey felt that Monet was eager to prove he could do something besides landscapes: "He has set about to do a most striking life-size figure. She is a Parisian of an amusing sort with blond hair, dressed in a Japanese costume of unbelievable richness. Connoisseurs who are looking for solid colors and resolved impastos will find this piece a true delight, even though it is a little strange" (*La Presse*).

Almost every critic found a place for words such as "étrange" or "bizarre." One writer set the tone of his review with the word "Saponnerie," implying it was a foamy soapy thing. "He has shown a *Chinoise* [*sic*] in a red robe with two heads, one is that of a *demi-mondaine* placed on the shoulders, the other that of a monster, placed we dare not say where" (S. Boubée in *Gazette de France*); "A head taken out of a Parisian coiffeur's window, turns back with a smile and appears to make fun of a Japanese grotesque making unsuccessful efforts to free itself from the under parts of her robe" (M Chaumelin in *Gazette des étrangers*).

Snide remarks aside, the painting dazzled the Paris art world; "a pistol shot," cried Charles Bigot, another critic. In the middle of the month, even before the show closed, Monet put his canvas in a sale at the Hôtel Drouot. The catalogue recorded it as being part of the "Collection of Modern Paintings of M. XXX"—that is, an anonymous seller. In actuality "M. XXX" was Ernest Hoschedé, the energetic entrepreneur who had purchased *Impression, Sunrise* from the first show of the Independents in 1874. To everyone's astonishment it went to an anonymous buyer for 2,020 francs. Cézanne could hardly believe it, immediately writing to Pissarro: "2 mille francs?!!" Monet was present at the auction. Art historian Hélène Adhémar suggested that he arrived at an understanding with Hoschedé and simply repurchased the work himself at a fictitious price that he himself had set, one that would provide plenty of publicity for him—which it did.[4] It was a trick he had learned from Durand-Ruel. And it probably explains Monet's letter to Gustave Manet that included the caution: "Repeat to no one what I told you *au sujet de la Japonaise*" (May 7, 1876).[5]

Of course, no one spoke of Camille as having anything to do with the painting. Ten years earlier "Camille" had been on everyone's lips, but it was a name that referred to a painting, not a person. Almost no one knew at that time there was a real Camille. Now, at least in art circles, Camille was well

known, but, under the disguise of a blond wig, in 1876 her name was never mentioned.

Many years later, in 1918, two prominent dealers, Georges Bernheim and René Gimpel, visited Monet in Giverny. They were curious to know if the artist had heard that one of their rivals, Paul Rosenberg, had purchased the painting, which now went by the title *La Japonaise aux éventails,* for one hundred and fifty thousand francs. They expected Monet to be pleased. Instead he sloughed off the news with a demeaning reference: "Eh bien! Il en a une saleté [a piece of junk]," making it clear that, when he painted it, it was solely with the hope of making money, but it had never been the sort of thing he believed in as an artist. He also told them that it was a portrait of his first wife, who had dark hair, but, on that day, "I put a blond wig on her." Gimpel then went to Rosenberg's to see the painting. No matter what Monet said, he recognized it as a truly beautiful work. Rosenberg now wanted three hundred thousand francs for it.[6]

It was purchased by the Robert Lehmans in New York but soon found its way back to the gallery of Joseph Duveen. Finally, in 1956, the big work got a permanent home at the Boston Museum of Fine Arts. When the museum purchased it, the editor of *Connoisseur* spoke of it as "sometimes called a portrait of Madame Monet, but it was not intended as a likeness as she only served as the model."

No one can look at *La Japonaise* without feeling it does not fit in with the rest of Monet's paintings from the Argenteuil years. Monet's modern biographer, Marianne Alphant, was put off by it: "Under this grotesque warrior and this blond wig that so strangely disfigure Camille, we are able to perceive an index of intimate tensions—something menacing, mocking, inarticulate." At this point in her book Alphant hints at the notion of trouble within the Monet marriage. Paul Tucker had a similar idea in discussing Monet's garden pictures from a biographical point of view; he found in them an "emptiness and hints of boredom together with the engaging but indifferent gazes of Camille and Jean [that] could be interpreted as signs of familial estrangement."[7]

Could it be that such views result from reading back from a story that has yet to unfold, but one that has led these authors to cast a shadow over Camille and her husband during the Argenteuil years? I think that Camille adored modeling for her husband. And surely this man, for whom painting

was the primary force in his life, found immense pleasure in her gifts. I see their work together as a sign of shared pleasure. Camille must have looked forward to choosing her costumes, discussing her poses and positions and the way she would take the roles assigned by her husband. They were a good team, and *La Japonaise* was an important moment in Camille's effort to help her husband address the bad situation in which they found themselves. It is full of wit and laughter, providing us with our most resplendent view of a smiling Camille.

We do understand that the big studio painting—which surely brought back memories of their days together working on *Camille*—was about money. Very few Monet letters written between fall 1874—when the Monets moved to the house on the boulevard Saint-Denis—and spring of 1876, the time of the second exhibition of Independent artists, have survived. Half of them are to Edouard Manet, and there is one to his brother, Gustave. All are about money. Monet had never met Victor Choquet, but he talked Cézanne into bringing this man, who had shown such interest in his colleague's work, out to Argenteuil. Choquet left that day with a drawing and a pastel under his arm, leaving behind one hundred and twenty francs—not enough to change Monet's desperate circumstances.

More than ever Monet needed a new collector, and, in the spring of 1876, during the period of the exhibition, one did appear. Georges de Bellio was a Romanian homeopathic doctor who had started to buy Monets in 1874. Monet probably did not know him well when he wrote to him in June 1876 to express his eagerness to have de Bellio come to Argenteuil and look at his recent paintings. Two weeks later he wrote again: "Since your visit I have worked a great deal . . . this would be the right moment because once again I find myself suddenly interrupted by need and this damned question of money." De Bellio's response to Monet's needs was a stunning purchase of five paintings. Then another letter to de Bellio in July: "I did not dare to speak yesterday, fearing I might misuse your kindness, but I am in extremely embarrassing circumstances without a *sou* and without knowing where to turn." And on July 25: "I cannot get out of this crisis, the creditors won't budge, and, save a sudden apparition of rich collectors, we shall be thrown out of this nice little house where I live modestly and where I am able to work so well."

The summer of 1874 was now a distant memory. Where did the money

go? This information is nowhere to be found in the account books. Did Monet discuss his financial quandary with Camille? Their way of life was threatened to such a degree that he was surely forced to go over it in some fashion. The turnaround in the nature of their affairs must have come as a bitter realization to Camille.

A Patron

In June 1876 Théophile Beguin Billecocq attended a dinner with his wife at the home of Ernest and Alice Hoschedé. The Monets and Georges de Bellio were also there. Théophile took note of the "plush lifestyle" in the apartment on the boulevard Haussmann, one made comfortable by numerous servants and major-domos, "but for my taste it's all a little too nouveaux riche." In the course of the evening he learned that Claude was to go to the couple's country home—the château de Rottembourg in Montgeron, fifteen miles southeast of Paris—at the end of the summer to do some paintings of the château and the park.

Beguin Billecocq had met the Hoschedés and de Bellio at the opening of the exhibition of Independent artists in Durand-Ruel's gallery in April. And he had an opinion about all three. De Bellio was "pleasant" but Beguin Billecocq felt he had a "look in his eye that was more that of an avid horse trader than of a doctor looking to help those in need." Then there was the other rich patron—Hoschedé—"at first sight likable but a bit slow for my taste." Hoschedé presented him to his wife, "a woman of character and one who clearly appreciates luxury for her toilette was one assembled from the very best shops of the capital."

In July Théophile and Léon Monet took the train out to Argenteuil to visit Claude and Camille. The painter's morale was very low. His paintings weren't selling except to Hoschedé and De Bellio, who were paying very low prices —just enough to cover their rent. "These false friends are not what it takes to raise Claude Monet's spirits. Léon gave him 500 francs. I did the same."

Nevertheless, the invitation to Montgeron was a godsend. Hoschedé told Monet he could choose the subjects himself, and he advanced him the

necessary funds for materials. It was everything Monet needed—the ability to work on a grand scale, for which he long had an inclination, money for supplies, and new subjects at a time when the fascination of Argenteuil subjects was beginning to fade. Further, it was a break from a daily life that had become difficult.

Immediately after his arrival, Monet set to work on views of the park. He focused on the rose garden and did at least four paintings of the pond, the shimmering waters captured in the warmth of the late summer sun. Hoschedé had arranged for tracks to be laid to the château so that guests could arrive in comfort by train. Monet painted a view of a locomotive just arriving. He brushed in dabs of red, white, and yellow, vividly portraying the blossoms as they fell over the railing at the place where the train would momentarily pull to a stop. But his most extraordinary choice of subject was a distant view of the red brick château, seen among the trees, beyond a grassy hill, over which roam twenty-one giant white turkeys with drooping red wattles, twisting their heads, pecking at the ground, and generally creating a visual clamor. It was to be one of the four major panels for the commission. Even though it was not finished, Monet was so pleased with his turkey painting that he entered it in the next impressionist exhibition. A reviewer described the way people were overcome with laughter the moment they caught sight of the work. At the same time he thought it took great courage "to dare to throw these creatures to the wolves"—in other words, to the public.

In the fall Monet took up another new subject: an *allée,* alive in reds and yellows encompassing a group of hunters, individuals small in size within the richness of a vast autumnal setting. Hoschedé and friends, guns ready, wait for their quarry as they face into the woods. The dead pheasants and rabbits they have already bagged lie on a leafy carpet in the foreground.

Presumably Monet had the opportunity to get to know his hosts. Hoschedé, son of wealth and a director of Hoschedé-Tissier, Bourely & Cie, was a well-known *bon vivant* who was frequently to be found in the same Parisian brasseries patronized by the artists. Monet was both grateful and impressed when he arrived in Montgeron. He had no idea that the lavish life he observed was maintained by the slenderest of threads and barely attached to the primary source of such luxury: money.

Hoschedé, born in 1837, was of Cézanne's and Monet's generation. He,

too, had a father who had begun modestly and later managed significant success in business. During the Second Empire, when new and beautiful fabrics meant everything to the mood and the look of high society, Edouard Hoschedé became one of the leading Paris purveyors of fine textiles, enabling him to build successful commercial outlets and a solid fortune. His son, Ernest, grew up enjoying the benefits of this hard work, while caring far more for its bounty than for his father's business, to which he gave only halfhearted attention. This was a disappointment for his parents, as was the girl he wished to marry, even though she was the daughter of a prominent and wealthy member of the Belgian community in Paris. Nevertheless, in 1863, Ernest took nineteen-year-old Alice Raingo as his bride. His parents did not attend the wedding. Alice's father gave the couple a dowry of one hundred thousand francs, plus an additional fifteen thousand francs for her trousseau. This is such a sharp contrast to the twelve-thousand-franc dowry the Doncieux decided upon—but did not actually give—for Camille.

Three years after the Raingo/Hoschedé wedding, Alphonse Raingo purchased the château de Rottembourg. Thereafter the younger Hoschedés spent their summers in Montgeron with Alice's family. Ernest would leave in the morning to work in the city, returning in the evening. Three daughters arrived, one after the other: Marthe, Blanche, and Suzanne. Finally, in the summer of 1869, Alice gave birth to a son, Jacques, and a few months later she lost her father. Her mother had died the previous year. This meant that Alice, as the oldest Raingo child, inherited the château in Montgeron.

Ernest's father died a few years later, in 1874, giving him a kind of freedom he did not have under his father's watchful eye. Since business had never been his primary concern, he now felt free to turn his attention to what interested him above all else: modern painting. Aware that her son was spending more time in galleries than at their stores, Ernest's mother reproached him. In the fall of 1875 he told her that he understood "my presence [in the business office] has become impossible." He informed her that he simply did not plan on going to the office anymore, but in other respects—referring especially to his reckless spending habits—he would mend his ways. Since he now regarded the château at Rottembourg as essentially his, he became focused on a monumental redecorating scheme for the estate. He did this at exactly the moment when the Hoschedé business was on the verge of bankruptcy.

Alice kept a journal. From this document we discover that she had known since August 1875 that the Hoschedé affairs were going "very badly."[1] Further, the couple had completely exhausted her dowry. Alice suspected their apartment on the boulevard Haussmann was threatened. And, indeed, when she returned to Paris for Christmas, she found that bailiffs had already taken many objects and some of the furniture. A year later—August 1876—Alice believed things were getting better. She understood that Ernest had reorganized the business—the inventory was good—things looked possible. In her journal she expressed the hope "that we have overcome our problems."

It was in that spirit that she greeted Monet when he arrived at the château. In spite of the fact that Alice Hoschedé was very reserved, in the course of the fall Monet got to know his elegant hostess. Upper-class in her bearing, a devout Catholic, warmhearted and maternal, Alice was eager to please those around her. It was also in her nature to become anxious when things became uncertain or in any way strained. Her children—since Germaine arrived in August 1873—were now five in number. They were her constant and best companions during the long summer days in the country.

Monet was still in Montgeron in November when he wrote to de Bellio expressing his hope that the collector might go to Argenteuil and pick out a painting "before the creditors get there. . . . Such a sale would help my wife who has been left without any money." Could de Bellio give Camille one hundred francs immediately? And he was still in Montgeron on December 4, when he wrote to Gustave Manet, telling him that he would be unable to pay him the money he owed him anytime soon.

In the authoritative Wildenstein catalogue, we find a statement which includes a singular reflection on what happened at Montgeron in this period: "When it was necessary for Ernest to return to Paris in order to try and put his affairs in order, the painter found he was alone with Alice Hoschedé and her children. The young woman had all the time to compare the "great artist" to the infantile person who was in fact her husband. Did things go beyond that?[2] The question hangs in the air, and continues to do so. In the catalogue of the 1995 Monet exhibition in Chicago, Charles Stuckey blandly notes in his dense chronological outline of Monet's life for September 1876: "It seems likely that Alice Hoschedé and Monet fell in love during Ernest Hoschedé's absences on business in Paris and that Monet is the father of Alice's youngest

son, Jean-Pierre, born in August 1877."[3] Edward Lucie-Smith, in *Impressionist Women,* refers to the attraction between Alice Hoschedé and Monet, and that they "may have become lovers as early as 1875."[4] It's doubtful Claude Monet and Alice Hoschedé knew each other in 1875.

This gossip, repeated endlessly, comes into the twenty-first century almost as fact. I want to go back and consider the "facts." We have two people living under enormous stress, each with mounting fears about their individual futures and those of the people dependent upon them. One is a devout Catholic with five children, the other an ambitious and penniless artist with a wife and child, whom he was not able to care for adequately. In addition to these obvious difficulties, the more important person for Monet in the Hoschedé household was his patron—Ernest, who remained his friend for several more years. Further, Hoschedé never questioned the paternity of Jean-Pierre, and, in later life, neither Claude Monet nor Alice ever treated Jean-Pierre as anything other than the son of Ernest.

My thoughts turn to Camille. What went through her mind when her husband stayed away so long? Surely Monet assured her that it was necessary for his career, and I imagine she believed it. But to be left alone, with no money, for such a long period, especially after their joint effort to put his career back on track with *La Japonaise,* must have stretched Camille's endurance to the breaking point. Monet's stay in Montgeron made of her life an endless time of worry, suffering, and loneliness, with some anger and jealousy thrown in whenever she considered her husband's life at the château, a place described by a commentator as maintained by "squads of discreet, efficient servants."

By Christmas Monet was back in Argenteuil. He had to start thinking about the next exhibition, the third for the Independent artists. He made an extraordinary decision: to focus his energies on the railroad station, on the place at which he arrived and from which he departed each time he went into Paris: the Gare Saint-Lazare. The idea may even have occurred to him after he painted the train pulling into the little station at Montgeron. Fortunately he had a new friend, a younger artist—and a very rich one—Gustave Caillebotte. After Monet's painting of Jean and Camille in their home on the boulevard Saint-Denis (*Interior of an Apartment*) failed to sell at auction in the Hôtel Drouot, Caillebotte purchased it. And he was now willing to help Monet with the rent for a ground-floor studio near the railroad station. In that studio Monet

created his series *La Gare Saint-Lazare.* He placed seven of these smoking, steaming wonders in the Independent exhibition that spring, the first show at which the group chose to designate themselves as "Impressionists." Monet put in thirty paintings—one-third of them were owned by Ernest Hoschedé, including three of the new Gare Saint-Lazares.

Besides Monet's problem of finding more collectors to buy his work, there was something even more pressing on his mind in the spring of 1877: what to do about Camille? When he returned from Montgeron, he found her seriously ill. He now wrote to Georges de Bellio in his capacity as a doctor: "New misfortunes devastate me. It's not enough that I have no money, but my wife is seriously ill and the local doctor wants the opinion of another doctor. I am very frightened . . . we would be happy, my wife and myself, if you would advise us, because they are speaking of an operation that truly horrifies my wife. I cannot exactly tell you the name of the illness, but it has to do with an ulceration of the womb. And I am going to take the liberty of coming to see you tomorrow morning (Sunday), and if, as I hope, you are willing to give me your assistance, I will ask you for the necessary explanations." The "horrifying" operation was a hysterectomy, a procedure that Camille elected not to have.

The couples' financial situation did not improve, either. In June Monet turned to Zola: "Would you, could you, help me out? If I do not pay by tomorrow evening, Tuesday, the sum of 600 francs, our furniture and everything we possess will be sold and we shall be out on the streets. I don't even have the first *sou* of this sum. Every sale on which I counted will not happen at this time. I am filled with despair to think of the reality of this for my poor wife. Addressing you is my last effort in the hope that you will lend me 200 francs. This would be the exact amount necessary to give me a little time."

The Monets knew Camille's illness had to do with her uterus, so it must have come as an enormous shock to learn she was pregnant.

We don't know if Monet was in touch with the Hoschedés that summer. Alice was in the last trimester of a pregnancy, and Ernest was running out of cash. In June, he borrowed one hundred thousand francs from Emile Barre, a local art dealer. He guaranteed the debt with a large number of paintings, including ten of his Monets. Barre did not particularly care for impressionist painting, so Hoschedé promised the debt would be paid off in cash. But Barre lost faith: the next step was the bailiffs. First they emptied out the Paris apartment,

but it did not bring enough money to pay the debt, so, in the middle of August, Ernest Hoschedé declared bankruptcy.

Alice, in Montgeron with the children, knew nothing of this. In her journal that week she mentioned only that Ernest seemed "sadder and more preoccupied than ever." She herself was feeling sick; she was sure her child would come any day now. Suddenly a friend came to her with a desperate letter from Ernest about their imminent bankruptcy. He alluded to thoughts of killing himself, begged her not to curse him, and said he had left Paris. Alice had only enough time to collect her jewelry and the silver. By August 20, the home she had inherited from her father became prey to creditors. She prepared the children to leave for her sister's home in Biarritz. They departed the château just before everything was seized. As their train headed south, Alice Hoschedé's sixth child, Jean-Pierre, was born. She had him baptized in the "wagon de souffrances" before they arrived in Biarritz.

Monet spent the fall of 1877 turning out a great number of paintings. When he wasn't painting, he was chasing clients. By the end of the year he was in contact with Eugène Murer, an unusually complex individual whom he probably met through Pissarro. Murer made his living as a pastry chef and a restaurant owner. He was also a novelist manqué, and somewhat attached to a bohemian socialist crowd. In the middle of December he began visiting Monet's studio, and soon after purchased five rough sketches for around fifty francs each. On January 8, 1878, Monet wrote Murer: "Excuse me for not having come to thank you for your kindness, but for the last ten days I've been like a cat on a hot tin roof. My wife is very sick. Also my son. More than that, we must move by the fifteenth without knowing where we shall go." The fifteenth arrived; the Monets were still in the house on the boulevard Saint-Denis, from where Monet wrote to de Bellio: "In two days—that is the day after tomorrow—we must leave Argenteuil. In order to do that our debts must be paid. Since I saw you I have had the fortune to realize 1200 francs. Now only 300 are missing. . . . Will you do me one *last* service and advance me 200 francs?" Five days later he went back to Murer: "I've come to ask a service. I hardly dare but here I am in this cruel situation. Our furniture is loaded on a carriage, but I do not have a *sou* to pay the mover. Would you do me the enormous service of advancing me one hundred francs. Without that I do not know what to do. If you can not spare that, give the porter what you can, but really try for one hundred francs."

The familiar pattern: Monet was apparently incapable of stating the exact truth to a potential lender about either dates or sums of money that he needed. It was a round-robin of manipulation as Monet took his family from crisis to crisis. We can barely imagine the effect on Camille as she watched her life spin out of control.

The Monet family's next address was 26, rue d'Edimbourg in Paris. It was a five-room flat on the third floor of an apartment house near the Gare Saint-Lazare. We would not know the address except for a letter to another new patron, Paul Gachet, the homeopathic physician from Auvers who befriended many of the young painters, including Cézanne and Pissarro. Monet began: "It takes courage to come to you with my difficulties and to ask you to do something for me, but the doctor who came to see my wife today said she would deliver tomorrow or the next day." Monet said he knew he was already in Dr. Gachet's debt; nevertheless, could he spare one hundred francs as an advance on another painting?

Michel Monet was born in the apartment on the rue d'Edimbourg on March 17, 1878. He was healthy; his mother was not. On the very day of the birth, Monet went to the Ministry of Foreign Affairs to discuss their situation with Beguin Billecocq. He informed his old friend that Camille had an incurable illness and that her suffering was great. At the same time Edouard Manet and Emmanuel Chabrier went to the mairie of the Eighth Arrondissement to declare the birth. Chabrier, a composer friend of Edouard's, had no particular connection to the Monets. But the occasion ultimately proved to be financially profitable for Monet, for the following month Chabrier purchased three Monet paintings.

Hoschedé continued to struggle with the terms of his bankruptcy. On June 5 and 6, 117 paintings, all works by his favorite artists, went on the block at the Hôtel Drouot. Among them were fourteen Monets, including the four decorative panels for Montgeron. Georges de Bellio got *Impression, Sunrise* for 210 francs. Hoschedé had paid 800 francs for it in 1874. The whole lot sold for 69,448 francs—an average price of less than 100 francs per painting. It was a catastrophe. Pissarro, even poorer than Monet, and also with a pregnant wife, watched nine of his works go for 404 francs. As he said: "The Hoschedé sale killed me." As a result of the bankruptcy, Hoschedé spent a month in prison.

Death in a Village by the River

In the spring of 1878 Paris was ready to celebrate. Had it been only a few years earlier that France faced a humiliating defeat at the hands of the Germans, followed by Paris becoming the breeding ground for the revolution of the Communards? Now, to the astonishment of the rest of Europe, France appeared reborn. She would be host to a universal exposition marking the "baptism of the Republic," and it seemed everyone in the city had the energy to prepare for its inauguration on the first of May. On that day Paris was alive with joy, taking pride in her rediscovered confidence, even though it was held together by the thinnest of threads. Spontaneous dances erupted in streets and squares, many lit by newly installed electric lamps.

There was not much to celebrate in either the Monet or the Hoschedé household. In 1878, each man was forced to look at his life and consider his once-dreamed-of future gone. Each wife, with a new baby adding to her responsibilities, was worn out by worries and by the recognition of her powerlessness to alter the destructive course of the events affecting her life. Both families had rented apartments in Paris's Eighth Arrondissement: the Monets resettled just north of the Gare Saint-Lazare, and the Hoschedés near the Parc Monceau.

Monet was just scraping by, relying on old friends like Zola, to whom he had written in April: "We don't have a *sou*, nothing to bring home the bacon; on top of that my wife is not well and has need of care. As you probably know she has happily given birth to a marvelous boy. Could you lend me two or three louis [a gold coin worth 20 francs], even one if that would not be too difficult for you? I can pay you back in a couple of weeks." As an afterthought he added, "Camille would be pleased if Madame Zola would stop round for

a visit." He then turned to de Bellio: "Because you have had the kindness to tell me that you always have a *louis* at my disposition that I come to ask you for it . . . today I really need it" (May 16, 1878).

Adding to his difficulties was the fact that Monet was nearly unable to paint. He was caught between the necessity of remaining home to care for Camille and their new son, and the inability to go out because of the constant bad weather that spring. When he could get out, he usually set up his easel on the island in the Seine called the Grande Jatte, or in the Parc Monceau. Most of these canvases were purchased by Dr. de Bellio.

But as bad as things were, even Monet could not ignore the palpable excitement in the streets as spring turned to summer. Officials had proclaimed June 30 as the day on which France was to celebrate a "Festival of Peace." July 14, commemorating the storming of the Bastille, would have been more appropriate, but conservatives in the government feared the date might bring a return of violence in the streets. Thus they selected a day with no historical importance. Parisians responded with energy, stringing flags and bunting from their windows and across the façades of their apartment houses. Festoons adorned the length of the streets. Fascinated, Monet plunged into the crowds: "I liked the flags. On the first 30th of the June national holiday, I was walking with the tools of my trade in the rue Montorgueil; the street was bedecked with flags and there were huge crowds; I spotted a balcony, asked if I could paint from it. And then I departed without anyone knowing who I was."[1]

Monet captured the intensity of the day, its animation, the flags of red, white, and blue fluttering in the dazzling midday sun. Later in the afternoon he walked east a couple of blocks to the rue Saint-Denis, borrowed another balcony, and again worked to put the quivering life of a thousand flags alive in the summer breeze on his canvas. In less than two weeks de Bellio took *Montorgueil* "in settlement of debt," and a few days later a bankrupted Hoschedé bought *Saint-Denis* for a hundred francs, which the seasoned speculator turned around and sold to Emmanuel Chabrier for two hundred francs.

Monet and Hoschedé remained on good terms, each doing whatever he thought might help as the two of them faced their parallel predicaments. That summer they arrived at a much more important agreement than anything that had to do with buying or selling paintings: they decided to combine households. Blanche Hoschedé, who would have been twelve at the time,

remembered: "In 1878 and 1879 we were very close to the Monets who had two children and we would meet them quite often in the Parc Monceau where Monet was painting. We also saw them frequently in his atelier. Around July 1878 our two families rented a house in Vétheuil for the summer, but we stayed for three years."[2]

At the beginning of September, the pastry chef Eugène Murer opened a letter from Monet: "Probably you have heard I have planted my tent on the banks of the Seine at Vétheuil in a ravishing spot from where I will be able to bring back some good things when the weather is better."

Vétheuil was—and remains—a village of enormous charm. The thirteenth-century church of Notre Dame sits high on a hill overlooking the clustered red-roofed houses surrounded by green fields. The land extends down to the banks of the Seine, turning in a perfect oxbow at the southern edge of Vétheuil. In the middle of the river is the Ile Saint-Martin, on the opposite shore the village of Lavacourt, beyond which stretch the hills and the forest of Moisson.

The move provided Monet with a whole new range of subjects. Exactly how did the arrangement come about? Was it part of extended negotiations between Monet and Hoschedé as they imagined the painter coming up with new works which would then be sold by Hoschedé? Did Alice and Camille cement a friendship during the summer as they strolled with their new babies in the Parc Monceau? And how was Vétheuil selected as the place to which they should go? It could be that Claude and Camille had become acquainted with this attractive village during their summer visit to nearby Bennecourt a decade earlier. And we know that Hoschedé liked to hunt in the region around Vétheuil.

The village had three things to offer: beauty for Monet, cheap rents for two cash-strapped families, and isolation, of value for two men with profound worries about creditors. And Vétheuil was indeed isolated. The train out of the Gare Saint-Lazare followed the Seine, crossing and recrossing the river, stopping frequently, arriving at Mantes some hours later. From there it was necessary to complete the last 8 miles in a public coach run by a certain M. Papavoine. He made the run twice daily. In other words, it might take the better part of a day to reach Vétheuil. Neither family would be expecting the visitors they had received in Argenteuil and in Montgeron.

Although the distance made it difficult for Monet to show work to pro-spective clients, he was the one who gained the most from the move. Not

only did he find fresh subjects, but he secured help with his sick wife and two children. Alice Hoschedé was well versed in mothering and in caring for those who were ill. And with her came a cook and a nurse. As for Hoschéde, Marianne Alphant has suggested that, after having been sentenced to a month in prison, he found that Vétheuil was a perfect place to drop out of sight and recover from the dishonor of bankruptcy.

Their first residence was a small house on the edge of town along the road to Mantes. Hoschedé paid the rent. It's hard to imagine six children, with little to keep them occupied, plus two babies, four adults, a nurse, and a cook all living together in such limited quarters. Clearly it was intolerable, and by October 1 Monet signed a lease on a larger house on the other side of town. The new place, which would not be available until December, rented for six hundred francs a year, due in quarterly payments. In Paris each family had paid more than twice that amount.

It's hard to imagine that this change made things better for the women and children. Although Vétheuil did have a church, a baker, a butcher, a green-grocer, as well as a *charcuterie,* a hotel, and a *tabac* there was neither a school nor a doctor, and Camille had remained in bad health since Michel's birth. She tried drinking eau-de-vie, thinking it might take the edge off her pain. It only made her drunk, followed by days of sickness. Monet wrote to de Bellio: "She is extremely weak and feels pain every minute. She took the 24 packets according to your instructions and here we are again with this pain and no remedy. I am sorry that you are so far away. Perhaps if you saw my wife, you would be able to find a remedy. Should we wean the baby who is getting bad milk and who tires his mother?" He hesitated to ask de Bellio to invest a whole day in coming to Vétheuil, but he assured him that if he were to come he would "see a superb countryside and we would do our best—Hoschedé and myself—to see that you would pass a nice day" (September 26, 1878).

They hired a tutor for the children, but by early November she had had enough. Ernest wrote to his mother that he had begun to give the children their lessons.

In December they moved to the other side of town and took up residence in a slightly larger house on the route to La Roche-Guyon. It had a central entrance, a window on either side of the door, and three windows above. The house backed into a cliff, on top of which rested the impressive manor of their

landlady, an Englishwoman named Elliott. After entering the house through a small vestibule, you had the choice of turning right into a square sitting room with a fireplace or left through a narrow room leading to the kitchen. On the second floor there was an identical arrangement, with a small room over the kitchen. The servant's bedroom, which came with a toilet, was in the attic. Needless to say, the house did not compare favorably to the Monet residence in Argenteuil, not to mention the château de Rottembourg. How did they do it? How could they have survived in such close quarters? It seems that, when in Vétheuil, Ernest chose to stay at the local inn, the Cheval-Blanc. Monet could only look forward to the arrival of spring, at which time he would be able to walk across the little dirt road and down a long flight of stairs into the meadow, and then contemplate the river and the hills beyond and consider some new subjects. And there in the water he would find his floating atelier, which he had tied up there after they arrived.

As the year drew to a close, Monet was in despair: "I'm not a beginner anymore; to be in this situation at my age is sad—always begging" (to de Bellio, December 30, 1878). The majority of Monet's letters preserved for us—and many more must have existed—are along the lines we know so well: "I'm in great difficulty and would be most obliged to you if you could help me a little" (to Duret, January 13, 1879). He assured Murer that the fact that he had been unable to deliver the paintings he had promised was not the result of wanton neglect: "I am acting as nurse for both my wife and our last child whom we almost lost" (March 25, 1879). He was able to show some works in the fourth group exhibition scheduled to open in April only because of Caillebotte's willingness to spend his own time borrowing Monet's older works from various collectors. As far as new works went, Monet reported, "There is nothing."

By May things had hit bottom. We know this from two letters written on May 14. He told Hoschedé how much he suffered "in order to finish paintings that do not satisfy me and that give pleasure to so few people." To Manet he complained of being "totally flattened, totally discouraged; I've had painting up to my eyeballs, and I can't imagine dragging on in this miserable existence . . . without any hope of ever arriving." He was writing because of his debt to Manet, and he explained that what little money he had went toward medication and doctor visits. He had brought in a certain Dr. Tichy from La Roche-Guyon to care for both Camille and the baby, "who is almost always sick."

The letter to Hoschedé had the most immediate implications. Monet felt it necessary to inform his "partner" that he knew he would never earn enough from his paintings to cover "what we need to live the life we have here in Vétheuil. Unfortunately that is a fact." Monet believed that "we can no longer be very agreeable company for you and Mme Hoschedé, myself more sour every day, my wife almost always sick. But we are who we are." He wanted neither to be an "obstacle" for Hoschedé, nor to increase his debt to him. "I feel far too much the emptiness is forming around me and the impossibility of facing the share of our expenditures if we continue to live together. . . . It's best we see things as they are." Monet admitted that he had had "dreams of work and happiness" when they mutually agreed on this arrangement, but in fact "everything is bad and I don't believe I fool myself when I say that our departure will be an enormous relief for everyone in the house. I even believe that it would be profitable for you here in the country where, in the eyes of shop people as well as the servants, we are seen as being your responsibility: that adds up."

The letter startled Hoschedé. He returned to Vétheuil immediately. After he got there, he wrote to his mother, who herself had been helping to finance the impoverished household on the road to La Roche-Guyon. He told her he didn't think Camille had much longer to live: "Her agony is slow and sad."

In fact, Camille lived on into the summer. Perhaps her health even improved slightly. Early in July, Monet went to Paris looking for clients, but he returned empty-handed. Hoschedé, in Paris at the time, managed to sell a Vétheuil painting to Duret for 150 francs. Alice began giving piano lessons. But none of this covered daily expenses. Alice wrote to Ernest: "The grocer is demanding 3,000 francs, the widow Auger [owner of the Cheval-Blanc] 800, the draper, Mme Ozanne, is impossible to appease. I feel absolutely abandoned by you. . . . What are you talking about—pulling out all the stops with your mother?"

By August Camille could not keep her food down, and Monet wrote one of his most desperate letters to de Bellio: "For a long time I have hoped for better days, but, alas, today it is necessary for me to lose all hope. My poor wife suffers more and more. I do not think it is possible to be any weaker. Not just that she can no longer stand up, but she can not even take the smallest amount of food though she is hungry. We must be continually at her bedside to

watch and wait for her smallest desire in hope of helping her in her suffering, and sadder still, is the fact that we cannot always satisfy her desires because there is no money. For the past month I have not been able to paint for lack of paints, but that is nothing; for the moment what frightens me the most is to see my wife's life in jeopardy. . . . She is no longer losing blood, but a lot of water. The ulceration seems to be healing, but she still has the *métrité* [inflammatory illness of the uterus] and dyspepsia. Her stomach and her legs are swollen and often her face. She vomits constantly and it is hard for her to breathe" (August 17, 1879). Monet then went on to ask de Bellio for three things: advice about what to do for Camille, help with selling his paintings in Paris, and money. He must have read the reply to this letter with a sinking heart. There is no mention of cash, but de Bellio described his visit, along with other friends, to a studio on the rue Vintimille, where they were able to examine some of Monet's recent paintings. The canvases seemed so unfinished that no one in the group could dream of buying them: "My dear friend, you are stuck in a vicious circle and I don't know how you will get out of it. To have money you must have paintings, and to have paintings you must have money." As for Camille, there was just a little P.S.: "I am sorry to hear that Mme Monet is in the state of which you paint such a black picture. But let us hope that with care—a great deal of care—she will recover." Dr. de Bellio certainly did not believe his own words.

On August 26, Alice wrote to her mother-in-law that she was spending all her time nursing Mme Monet. Death was not far off, so she had taken into her own hands an arrangement that she believed to be of the greatest importance: she got the local priest, Abbé Amaury, to arrange for the "rehabilitation" of Claude and Camille's marriage. Since they had not been married in the Church, something had to be done so that Camille would be able to receive the sacrament of Extreme Unction. Ernest wrote to his mother on September 1: "Thanks to Alice she received the last sacrament yesterday and today she seems a bit calmer."

On September 4, Monet once again unburdened himself to de Bellio: "How sad is my situation, alone in the world with two children, with no resources, without a cent to my name." The next day he picked up his pen again: it was all over—Camille had died at 10:30 that morning, "having suffered horribly."[3] Into this letter Monet folded a pawn ticket. Would de Bellio take it to

the pawnshop to collect a medallion, the only piece of Camille's jewelry they had not sold: "I want to be able to hang it around her neck before she leaves." The burial was to take place in two days. Alice wrote to her mother-in-law describing the difficult hours during which she and her "courageous" daughters remained "in vigil over the poor dead woman." On Sunday, the Confrères de la Charité came to the house and placed Camille in her coffin. Only the two families and a few friends in the village participated in the funeral. They followed the coffin up the hill to the little graveyard overlooking the town, the meadows, the river, the forests, and the hills beyond. It's doubtful that Camille's mother and sister even knew of her death—that tie had long since been sundered.

A few days after the funeral Alice again wrote to her mother-in-law: "The poor woman really suffered, it was a long and terrible agony, and she was conscious to the last minute. It was agonizing to watch her sad leave-taking of the children. But it was my great joy, in the middle of all this sadness, to see my poor friend receive her God with faith and conviction as she took the Last Sacraments."

Monet had told Hoschedé that, when they planned to move to Vétheuil, he had dreamed of "work and happiness." It seems he gave little thought to what it meant to take a sick wife to an isolated country village without a doctor. But Monet's thoughtlessness about bringing Camille to Vétheuil doesn't mean he didn't care. I believe he cared a great deal, and on the day that he faced the *fact* of her death, his instinct drew him spontaneously to set about creating his final homage to the woman he loved, the woman who had been his great model. Years later, in conversation with Georges Clemenceau, he described how he felt as he sat beside her body: "I caught myself watching her tragic forehead, almost mechanically observing the sequence of changing colors which death was imposing on her rigid face." He saw her head on the pillow, falling slightly on her shoulder, her body encased in a white cloth. Monet then took up his brush, loaded it with a sequence of blue, rose, grey, and white pigments, transforming the cloth into something else. There is a dazzling beauty to the entire surface of the small painting. Is this Camille once again his bride? Short comma-like strokes give a feathered movement that transforms the whole blue-rose canvas into a transcendent surface. Her tiny almond-shaped face, closed eyes, and crooked smile occupy but a small part

Monet, *Camille on Her Deathbed,* 1879.
Paris, Musée d'Orsay

of the canvas. Yet we recognize Camille as her shroud takes on a semblance of motion. Then Monet took the end of his brush and drew some long straight strokes in the wet pigment across her chest. It's not clear, and probably not consciously intended by the atheist Claude Monet, but somehow the suggestion of a Cross lies there on her body.[4]

When Boudin's wife died a decade later Monet wrote: "I share in your pain for I have passed that way and know the emptiness it leaves" (March 18, 1889).

Occasionally in later years Monet would place the figure of Alice and her daughters in his landscapes, but it was never the same. He had lost his great model. A extraordinary creative partnership had come to an end.

Epilogue

As far as we know, the household on the road to La Roche-Guyon continued somewhat unchanged for two more years, although Ernest was more and more preoccupied with his new role as editor of an art journal in Paris. At first Claude and Alice pressed him to spend more time with his family. Not surprisingly, tensions—especially over money—developed, and by the summer of 1881 the relationship between Monet and Hoschedé was no longer friendly. If Monet was in Vétheuil, Hoschedé was excluded. When Hoschedé came for his son's First Communion, Monet managed to be out of town. Late in 1881 Monet, concerned about schools for his children, found a new place in Poissy, a town also on the banks of the Seine but closer to Paris. When Monet moved with Jean and Michel, Alice Hoschedé and her six children went with them. Before they left Vétheuil, Alice arranged for Michel Monet to be baptized in the church of Notre Dame. Her own son Jacques and her daughter Marthe served as his godfather and godmother. Once the joint family moved, the relationship between Monet and Alice became an open scandal, a situation that continued to complicate the lives of all three adults until March 1891, when Ernest Hoschedé died. The following year, Claude Monet and Alice Hoschedé were married.

In January 1882, soon after the move to Poissy, Monet paid twenty-four francs so that Camille's grave would be maintained for fifteen years. The concession was never renewed. But the grave was not destroyed, nor was the space sold to another family. For a while it was maintained by an elderly servant of the Hoschedé family, and then it slowly became overgrown to a point that it was no longer visible. In the 1960s, when the Wildenstein group began their research

on Monet, they brought this problem to the attention of the town officials of Vétheuil, and the municipality undertook a restoration of the grave.

Monet kept the painting he had made of Camille on her deathbed in his bedroom until the end of his life. No one, save family members, knew of its existence until Georges Clemenceau mentioned it in *Claude Monet: Les Nymphéas,* published two years after Monet's death in 1926. At some point, author and gallery owner Katia Granoff persuaded Michel Monet to let her have the painting. In 1963 Granoff donated it to the Louvre, and it now hangs in the Musée d'Orsay.

Rose Beuret

Rose Beuret and Auguste Rodin

Camille Doncieux and Hortense Fiquet would probably not have become friends if they had met, and, as far as we know, they never did. Their husbands, however, might have encountered each other in a café in Batignolles before either girl came into their lives in the later years of the Second Empire. In the 1870s, both men were involved in the exhibitions of independent artists. The first independent show in Nadar's studio in 1874 was such an important event that we can imagine the two women making their way to the gallery on the Right Bank. Did they see each other—or even meet? Probably not. But of one thing I am sure—neither woman ever met Rose Beuret. Rose was a peasant —pure and simple. For her, a contemporary art show in the 1870s, even if she had been living in Paris at the time, would have been unthinkable. She was a different kind of girl than Hortense Fiquet, and she would hardly have known what to say to Camille Doncieux.

In many ways, Auguste Rodin is also a stranger to this narrative. Monet and Rodin may have both been born in Paris within forty-eight hours of each other in November 1840, but they didn't meet until they were in their forties, and they didn't get to know each other well until 1888, when Monet pursued Rodin—rather than another painter—to be his partner in what turned out to be the most important show of Monet's career—the exhibition in the gallery of Georges Petit in 1889. Rodin did not frequent the fashionable cafés in his youth; I doubt that he ever set foot in the Café Guerbois. Nor did he write home for money. It was more like him to send money home. His parents, born in the provinces, immigrated to Paris in the first half of the century, and they managed their lives on extremely limited means.

But even more than family, what separated Rodin from Monet and Cézanne was the medium in which he worked. Sculptors lived different lives than painters. They worked in groups, not only with their hands, but with their whole bodies. And if they couldn't sell their art, they took menial jobs; they joined large studios as plasterers, wood carvers, and ornament makers. And they had different dreams than painters. Of course the Salon mattered, but even more than success at the Salon they wanted a big commission from the City, or even the State. They longed to see their statues in public squares and flanking entrances to great architectural monuments. Rodin was an assistant in the studio of Albert Carrier-Belleuse in July 1869, at the time when the four large groups for the front of the new Opéra were being brought to completion. Among the four, the most heralded and controversial work was *La Dance* by Jean-Baptiste Carpeaux. Rodin remembered how, on the day of the unveiling, he and his co-workers finished work early in order to "be on the steps of the Opéra to cry out our admiration for the masterpiece and for the artist." In contrast to finding buyers at the Salon, in galleries, and at the auction houses, this was what an aspiring sculptor wanted.

When war broke out in 1870, Rodin went into the National Guard. There was no one to buy his way out of service, to rent him a house in the south of France, as Cézanne's mother had done for her son, or to help him to scrape together passage to England, as Claude-Adolphe Monet finally did, even if he found it irksome. Only extreme myopia would eventually set Rodin free. Brussels was his escape. He headed north to continue working with Carrier-Belleuse, who had secured a commission for the sculptural decoration of the new stock exchange in the Belgian capital. During the years when the young painters were fighting to put their work before the public in the exhibitions which they boldly mounted themselves, Rodin was in Brussels, working in quasi anonymity. It was a kind of economic exile.

In spite of the contrasts, Rodin has often been seen with Cézanne and Monet as the trio of great French artists whose collective work formed the basis for so much that followed in twentieth-century art. And as a couple Rose Beuret and Auguste Rodin enter into my story by the fact that they, too, encountered one another in an undocumented meeting, one that paralleled that of Hortense Fiquet and Paul Cézanne, and of Camille Doncieux and Claude Monet. It, too, happened some place in the streets of Paris in the 1860s,

a meeting presumably provoked by the eye of an artist who felt that within his gaze was someone who was "just right"—who knows, a girl who might even agree to model for an artist. Hours in the studio led to a different kind of relationship, one that resulted in the birth of a child, and the beginning of a life-long family connection.

Rose Beuret, unmoored from her family, her town, and her friends, and without any education, must have been totally at sea when confronted with the scale and complexity of the capital of France to which she arrived sometime after 1860. As far as we know, unlike Hortense Fiquet and Camille Doncieux, Rose came to Paris alone. But in her life she had had something that had barely been part of either Hortense's or Camille's lives: a sizable family with deep roots in a particular region of France. Her natal village was Vecqueville, in the Department of Haute-Marne in eastern France. It was here that Rose Beuret grew up surrounded by siblings and a large assortment of relatives. To this day the stone cross that marks the grave of Rose's parents, Etienne Beuret and Scholastique Clausse, is easy to spot near the entrance of the local cemetery, and within the region you can still look in the local telephone directory and find Clausses and Beurets.

Born in 1844, Marie Rose was the couple's first child. They had settled in Vecqueville, the home of the Clausse family. The Beurets were from Join-ville, two miles to the south. When Rose was born, twenty-four of the four hundred and thirty-seven Vecqueville residents were Clausses, and most, like Etienne and Scholastique, depended on the vineyards surrounding the village for their livelihood. A year and a half after Rose was born, Angelique arrived, and she was followed two years later by Marie Honarine and then Catherine Léonie and, still later, Anna Philomine. Finally, in 1856, there was a son, François Jules.

Etienne and Scholastique chose their eldest child to be the godmother for their first son. The baptismal record is the only document that allows us to imagine one day in the life of young Rose. The ceremony took place in the church of Saint-Rémy on a July day in 1856. Saint-Rémy, a Gothic stone-vaulted church, still stands, though today it is in much better condition than it was on the day of the baptism. The nineteenth-century Municipal Council had not been successful in amassing the necessary funds to repair the roof and gutters. It would have been hard to ignore the buckets on either side of the

nave that were put out to collect rainwater that had come in through the holes in the vaults of the roof. Nor did bells ring out on the day when the first Beuret son was baptized, since the *cloche* had been dismantled years earlier. Nevertheless, the familiar Latin words were spoken, and when François Moriva, the baby's godfather from Joinville, was asked what to expect now that Faith had come into the life of François Jules through the intermediary of Holy Mother Church, he knew how to answer for the speechless babe: *la vie éternelle.* We assume that Rose remained silent.

Though Saint-Rémy was not in good repair, it was a beloved monument, the one remaining emblem of the town's ancient foundation and a focal point for its citizens who lived somewhere along its fourteen streets. Other amenities of Vecqueville were the *épicerie,* the café, the butcher shop, the foundry, and the quarry, but no school. That was still seven years away, and when the *école communale* was finally inaugurated, it was for boys only. Girls would have to wait until 1882 for their school to be established.

Saint-Rémy was situated on la Grande-Rue, the main route connecting the larger towns of Saint-Dizier to the north and Joinville to the south. At the crossroads you could look down the sloping descent toward the river Marne, or you could look up over the fields and see the new railroad tracks that snaked across the countryside after traversing the new viaduct on la Grande-Rue. At the time of François Jules's baptism, the new line had been in use for only a year.

The house the Beurets rented was just down the street from the church. We assume it had two stories like most of the houses on la Grande-Rue. It would have had an earthen floor, a red tiled roof, and an attached room behind the house for animals. By 1856 Rose had four younger siblings, including the new baby. Her day would probably have begun before dawn. There was wood to gather, a fire to light, and water to be fetched, and during the day she would have helped with caring for the younger children, as well as doing household chores and tending to the animals and, in the warm months, the kitchen garden.

The census for 1876 indicates that Etienne Beuret, previously listed as a "winegrower," now made his living as a "quarry guard," though he still owned several small vineyards and surely continued to think of himself as a winegrower. The hills surrounding the village were crisscrossed in all directions with vineyards. Rose must have participated in spring planting, when

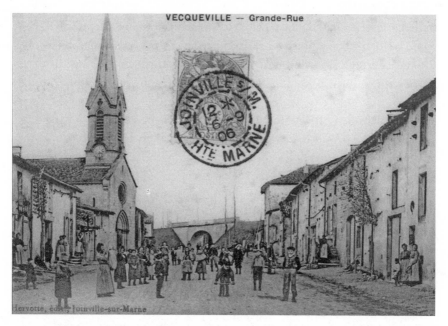

Vecqueville, *La Grande-Rue,* with the church of Saint-Rémy and the railroad viaduct

the little vine stocks were placed by hand in staggered rows, and then again in the fall harvest, the happiest time of the year in winegrowing country, when the whole community came together. Women and girls took to the hills with their baskets and little billhooks to clip off the clumps of ripe grapes, while the men worked the presses, crushing the grapes under their bare feet before pouring the juices into the vats. At the end of the day everyone gathered under the trees for a hearty meal followed by dancing around the biggest vat. They drank and they sang:

> Ah! Lisette, I've got an itch to go to the harvest,
> And to pick in your little *pa-pa*
> To pick in your little *panier d'osier*[1]

Times were not particularly good for those families living in Haute-Marne who depended on agriculture for their livelihood. Nevertheless, the familiar ways remained in place. But after the Emperor signed new foreign

trade agreements in the 1860s, prices for local produce began to decline. First wheat went down, and then wine. The historian Jean-Louis Maigrot describes those who lived in isolated villages such as Vecqueville in the middle of the nineteenth century as people who worked hard, knowing "neither Sunday, nor feast day" and who were able to get by through the force of their wits and their frugality. After 1860, however, the profound economic changes led more and more people to leave the region. Increasingly Haute-Marne became a depopulated countryside. Those who stayed were ever poorer, ever more conservative. In Maigrot's words: "le départment se fige"—it fossilized.[2]

Some time before the census of 1861 the Beurets moved from la Grande-Rue to a side street, the rue du Faubourg. Here Scholastique gave birth to another daughter, Maria Ailisa and, finally, in 1863 to her last child, a son, Edmond Théodule. That would have brought the number of children in the house to six. But there were only five. The Beuret's eldest child, seventeen-year-old Rose, no longer lived at home.

Why did she leave? She was so young and had lived in such an isolated part of the world that it is hard to imagine her throwing a cold eye on her mother's life and deciding it was not the life what she wanted for herself. Did she quarrel with her parents? Or was Rose pregnant? The most common reason for unmarried country girls to leave home was because they had gotten pregnant and wanted to avoid bringing disgrace to their families. They hoped that in Paris they would find someone who could deliver their child and then find a way to place it in a home. This was the route that a young unmarried Alexandrine Meley had taken to solve the problem of an unwanted pregnancy several years before she met Emile Zola.

In the period when Rose Beuret was contemplating her departure from Vecqueville, twenty-year-old Auguste Rodin was living with his parents, John-Baptiste Rodin and Marie Cheffer, and with his older sister, Maria, in an apartment on the rue des Fossés-Saint-Jacques, located on the Montagne Sainte-Geneviève on Paris's Left Bank. From the front window of their three-room apartment, which was located on the fifth floor, the Rodins could look out over the roofs of the buildings across the street and see the famous dome of the church of Sainte-Geneviève (not to be resecularized as the Panthéon until 1886).

From age fourteen to seventeen Auguste studied to become an artist at

the Ecole Spéciale de Dessin et de Mathématiques—known more commonly as the "Petite Ecole," to distinguish it from the Ecole des Beaux-Arts, which was the "Grande Ecole." In his last year he was particularly keen on working from live models in drawing classes. But even more than that, when he first walked into the clay room and learned to model he felt he had "mounted unto the heavens." This was to be his future. The plan seemed less sure after 1858 and 1859, when he competed and failed the entrance competitions for admittance at the Ecole des Beaux-Arts as a student in sculpture. Now he was less sure. But his father, a clerical worker in the Paris police department, didn't want him to give up his ambition. Thus, Jean-Baptiste Rodin began to write letters of exhortation to his son, admonishing him not to lose heart. Sometimes M. Rodin would underline what he felt were the most important sections: *"The person who wants to succeed will attain his goal. . . .* In this way he will achieve the will to do it, that is to say a kind of male energy, not female. What I fear in your case is that you are becoming something of a pushover, because you let yourself become discouraged. . . . It is necessary to be energetic, to sweep away all signs of slackness or effeminacy." The son rewarded this vote of confidence when he created a fine bust of his father in the manner of a republican of Roman times. It is the first surviving sculpture from the hand of Auguste Rodin.

In this period, the summer of 1860, the Rodin family was making what must have been a dramatic plan for members of that household: Mme Rodin and Maria were planning to go by train to visit Madame Rodin's family in Lorraine in order that she might see her sisters again and that Maria might make the acquaintance of her cousins. They departed on August 10. Immediately letters between the two siblings began to fly back and forth, providing almost daily news. These letters allow us to see the depth of feeling between brother and sister, as well as the enormous contrast in their characters. Maria's letters are forthright, precise, packed with rich descriptive detail, while Auguste's are full of concerns: were the train seats too hard, was it too drafty, and what about the "two-hour wait in the night air at Châlon?" Maria sent home orders: "Eat well. Don't get bored. . . . Tell me about my starling, does he still talk? We are pleased you are earning 5 francs a day. Water my roses." In Auguste's letters we can feel his emotional agitation in his sister's absence: "The weather is nothing but sad since your departure." He was "encompassed by solitude

and ever attentive to her flowers "since they bloom just to replace you in your absence."

The Rodin women spent part of their visit in the village of Avril, and while there one of Maria's great pleasures was getting to know the parish priest. Once back in Paris, she wrote to him reflecting on their conversations and how they had led her to a "new understanding." She was especially conscious of it on the day when they celebrated the Feast of the Assumption. It had meant everything to her; in fact, she had now ordered a diadem to be placed on the statue of the Blessed Virgin Mary in December for the Feast of the Immaculate Conception.

By the end of the following year, we find Maria packing her trousseau as she prepared to become a "bride of Christ," and in September she moved from the little apartment on the rue des Fossés-Saint-Jacques in the Fifth Arrondissement to the spacious seventeenth-century residence of the Community of Saint-Enfant-Jésus in the Seventh Arrondissement. She counted on her brother to remain at home and take care of their elderly, and increasingly ailing, parents. Soon after her arrival she wrote the family to let them know that "for the first time in my life I am truly present in our beloved epoch." Maria officially entered the order as Sister Euphemia on September 21, 1862. But the pleasure of her new life was short-lived. That winter, Sister Euphemia contracted smallpox. She died on December 8, the Feast of the Immaculate Conception, at the age of twenty-five.

The depth of suffering and the dismay experienced by Auguste Rodin over his sister's death can be measured by the radical decision he made within days of Maria's death: he took on her life by joining a Catholic order. Judging by letters Maria had written to her brother in recent years, this was a sharp change of course. In the past she had upbraided him for having "separated [himself] from the Faith." But now, Auguste took up the task that she had not been able to fulfill. He joined a small and recently established order called the Fathers of the Blessed Sacrament, founded by Pierre-Julien Eymard "in reparation to an outraged Christ for the sins of modern times." The extreme nature of this decision serves as a valuable gauge of the depth of Rodin's devotion to his sister, and it's hard to ignore that her temperament—her sharpness, her bossiness, her hard-working decisive nature—turns up again and again in the women to whom Rodin drew close in the years to come.

Auguste remained with the fathers for only a few months. It's an extremely small episode in a long and complicated life, one that might easily be overlooked except for the fact that while sharing devotions with the priests in their house on the Faubourg-Saint-Jacques, Rodin created the second work of sculpture we know from his hand: a bust of Pierre-Julien Eymard. The work shows real growth. Only a few years earlier, when he modeled the bust of his father, he was depending on lessons learned in the antiquities galleries of the Louvre, but in order to fashion Father Eymard's tense and sharp-edged face, he found his inspiration in more recent examples of modern French sculpture, particularly in the work of David d'Angers. Auguste Rodin was ready to go back, to put on his smock and pick up spatulas to poke and spread his clay, and to try again to exhibit that perseverance his father wanted to see in him.

From Vecqueville to the Banks of the Bièvre

Conceptually the ideas that grew into a French national rail system were worked out during the July Monarchy. The railroads were to become central to the creation of a national territory. They would replace river navigation, and, as an international transit system was developed, the Atlantic ports would become the ports of Europe. The bureaucrats and engineers of the Second Empire put most of it in place, and how well the system worked is clear from the role the new railroads played in the lives of every individual in this book. It was how Cézanne and Zola got to Paris in the first place, and it was the critical factor in Cézanne's constant trips back and forth to Aix-en-Provence. Monet was able to reach the Normandy coast with ease. Rodin's mother was able to board a train in order to make her first visit to her childhood home in Lorraine, and Rodin himself headed into exile in Belgium by rail, and, a few years later, thanks to the rail system, he made his way to Italy.

But here I want to focus on Rose Beuret's trip, made around 1861 or 1862, and to think of it in comparison to Emile Zola's trip in 1858, when he left Aix-en-Provence. His mother had written him from Paris: "Sell the four pieces of furniture that remain. It will be enough to buy a third-class ticket for you and your grandfather. Hurry. I'm counting on you." Zola's biographer, Henri Mitterand, reflected on the difficulties of this voyage for the young man of eighteen: "He had no father, no money, no diploma, no line of work, no roots.... He was *déraciné*, uprooted from his childhood to be thrown on the hard pavement of the capital where he knew neither the places nor the ways of being." But Zola had a mother waiting for him at his destination, and a

grandfather by his side in the third-class rail carriage—and he was educated, and, most important of all, he was male.

What was such a trip like for a girl like Rose Beuret? Did she go alone? Were there stations along the way in this brutal transition from being a member of a large family in a tiny village to being a girl on her own in the capital of France? With the exception of François-Jules, drafted into the army in the 1880s to serve in Algeria, none of the other Beuret children left the familiar countryside of Haute-Marne.

It was the Saint-Dizier–Joinville line that passed through Vecqueville. Everyone in the village must have been fascinated by what was taking place before their eyes. Some even sensed danger, while others saluted France's technical accomplishments and her entry into the modern age. Residents of the villages surrounding Joinville were now only eight hours away from Paris—a trip that previously had been a five-day coach trip. All Rose had to do was walk—or ride in a cart—two miles down the road to Joinville, where the new station had opened for travelers in the shadow of the great plateau with its famous ruins left from the days of the Lords of Joinville. A train arrived for the first time in 1855, and the event was featured in *L'Echo de la Haute-Marne:* "Nothing could be more attractive than the Saint-Dizier–Joinville line. One is almost always in contact with the river—this really is the Valley of the Marne. . . . The track is good, only a few inclines, many gentle and gracious curves and bends. . . . The 39-km trip [twenty-four miles] took only 47 minutes, including the two stops" (July 18, 1855).

The journalists who wrote about the event were full of enthusiasm, praising the new possibilities in transportation and the beauty to be experienced while taking such a journey through the countryside. It's quite probable that Rose's emotions were more on the side of awe and dread than on delighted anticipation as the ponderous iron locomotive came into view, squealed to a stop, hissing white steam and discharging thick black fumes. How was it for her to mount the steps of a brightly painted wooden car poised on enormous wheels and to look about for a place among so many strangers on one of those hard wooden seats?

When Rose Beuret arrived in Paris, the city was home to nearly 1.7 million people, more than 58 percent of them born in the provinces, most of

them, like Rose, coming from northeastern France. These were exactly the kind of people that bothered Alexander Dumas when he accused the railroads of bringing "trainloads of young people from the provinces, especially girls from the lowest classes who, being so close to natural savagery, retain their animal appetites for sensual indulgence."

We can barely imagine the confusion—and surely the fear—experienced by a girl like Rose as she embarked upon a life in the large, complex city of Paris. "Fourmillante cité" was how the poet Baudelaire described it: "Ant-seething city full of dreams, where in broad daylight, phantoms solicit the one who passes" (*Les Sept vieillards*). We might hope that, along with her fears, Rose also had a few dreams as she set about getting to know her new home, only recently transformed from its medieval self into a modern metropolis with boulevards where gas lights burned all night long, and where there were hotels, department stores, and theaters. It even had a transportation system with thirty omnibus lines, each marked by its own color. A great central market complex was rising on the Right Bank, and there were plans for a new opera house. The Emperor had recently issued a decree requiring building owners to clean their façades every ten years. In the better neighborhoods each spring men on scaffolding were seen scrubbing away to satisfy the imperial desire for Paris to be a city of splendor and light.

In some of the arrondissements, however, the physical situation was a far cry from the urban aesthetics deemed the order of the day by Napoleon III and his prefect, Baron Haussmann. Things were coming together in the new neighborhoods on the Right Bank, such as Batignolles, where the Doncieux family lived, or the areas to the west toward Neuilly. But on the Left Bank in the outlying lands in the southern part of the city a totally different situation existed. In contrast to the well-built bourgeois apartments of the Right Bank, these quarters were full of squalor and dullness. They were referred to as *les faubourgs souffrants* (the miserable outskirts). Most Parisians didn't regard them as part of their city. They were neither city nor suburb, but a sort of no-man's land.

It was into such a place that Rose Beuret settled after she arrived in Paris. She had a room on the rue Tiers (today rue Paulin Mery), a tiny street, newly created and near the place d'Italie. It was in a part of the Thirteenth Arrondissement known as the *Maison-Blanche,* so named for an isolated white house that

Paris, *La Fontaine à Mulard* near rue Tiers.

once stood beyond the eighteenth-century tax-collecting gate around which new arrivals from the country settled in makeshift hovels. By the time Rose arrived, the area had evolved into an accumulation of small houses and shops, outdoor eating places, and garbage heaps over which laundry was strung on lines. Public services and lighting were nearly nonexistent.

There were no sewers, nor paved streets. Instead people made their way along vast ruts full of water. Markets were few, and drinkable water was expensive, so people like Rose were forced to walk some distance to fetch water from public fountains. The entire quarter was cut through by the river Bièvre, which smelled of excrement, rotten meat, and tannin. It twisted through the neighborhood in an S shape, bounded on either side by tanneries, laundries, and chemical works. Rose Beuret's residence was located in the midst of this dismal urban blight, populated by a random mix of people, many of them quite undesirable. She must have spent more than a few lonely nights longing for Vecqueville.

Most of Rose's neighbors were either migrants or working-class people displaced from their old neighborhoods now being torn down to make way for the beautiful new boulevards of the Right Bank. And rue Tiers may not have been Rose's first home in Paris. One aspect of life in Second Empire Paris was its continually changing physical reality, which resulted in poor people being forced into move after move. When Emile Zola's mother bid him hasten to Paris, it was to join her in a rented place in the Latin Quarter—it, too, an unkempt and dubious neighborhood. Between February 1858 and

April 1861, when Cézanne arrived in the capital, Zola had lived at five differ-
ent addresses. In general rents rose slightly during this period, but Zola paid
a little less with each change, reflecting his deteriorating financial situation.
In April 1861, when he moved into a furnished room on the rue Soufflot, he
was paying fifty francs a year for a place to put his head at night. It must have
been the worst of the worst.

We don't know what Rose paid. Rue Tiers was so tiny it didn't even
get a line in the cadastres, the land registries that provide us with the basic
information on the residential buildings of Paris. Like Zola, she certainly lived
in a *garni,* that is, a cheap furnished room. And, like the majority of women
in her situation during the Second Empire, she earned her living with her
hands and a needle. Her employer, Mme Paul, had a shop near Gobelins, the
great manufacturer of tapestries. While Camille Doncieux was focused on
the new fashion industry as a consumer, Rose Beuret found her place at the
other end—as a worker. Mme Paul's workroom would have been a supplier
not for the sumptuous clothes of *haute couture,* but rather for the ready-to-
wear market available in the department stores. These emporia were totally
dependent on cheap female labor now available through the rapid migration
from the country. The girls who made up the workforce were the ones Jules
Simon agonized over in *L'Ouvrière* (*The Worker,* 1862), pointing to their low
pay, long hours, and inadequate air, light, and heat, plus the threat of harass-
ment from their employers.

Jules Michelet's *La Femme,* published in 1860, was the single most influ-
ential book in France on the subject of women. Although it was about women,
he intended it to be read by men. Central to the book was a plea for a return
to traditional family life, which he saw being sacrificed in the cesspool of a
degenerate Empire. He bemoaned the separate paths being taken by modern
men and women: "Man, however weak he may be morally, is nevertheless on a
train of ideas, inventions, and discoveries. . . . Woman, hopelessly left behind,
remains in a rut of the past about which she herself knows little." Michelet's
biggest worry was for the seamstresses who were about to be annihilated by
the sewing machine. And, "the worst destiny is for a woman to live alone.
Alone! The very word is sad to utter. What obstacles present themselves to
the solitary woman! She cannot go out in the evening. She dare not enter a
restaurant. All that is free to a man is troublesome for her. How cautiously does

she shut herself in. She lives on the fourth story, and makes so little noise that the occupant of the third believes that there is no one above him."[1]

This is how Rose Beuret's contemporaries would have seen her life as she struggled to make a place for herself in the city of Paris during the Second Empire.

A Woman's Body

With the collapse of the Empire and the establishment of a parliamentary form of government, social thinkers hoped that some of the problems faced by women like Rose Beuret would be ameliorated. But change was slow in coming, and even at the end of the century a writer/politician such as Charles Benoist continued to think about the modern needle-worker in terms that could have described Rose's life in the 1860s. He saw these laborers as modern-day martyrs, describing the *gargotes* where they took their meals as greasy spoons, "filled with masons, carpenters and messieurs of every kind." Among his friends was a judge who told him about the stories that confronted him in the courtroom on a daily basis:

> The young seamstress is alone, has almost no education, is little given to self-reflection, and lives far from the atelier. She leaves her room before dawn and returns on foot through dark alleys after nightfall. She is on her own, or worse, with her pals. Temptations are not lacking. She, who earns barely enough to eat, who has dined meagerly at midday and in haste, while passing the day bent over her work, dreams about being able to eat like this one or that one in a restaurant.
>
> One day—and it will not be long in coming—she will meet a young man like herself, a worker, a good and enterprising fellow. She will resist to the best of her ability, but for all sorts of reasons her best is not good enough. First of all, she is poor, but also she is pretty, has a lively spirit, is at one and the same time both girl and woman.

Little by little her conscience begins to sleep; her resolve deserts her as she faces an onslaught of Parisian *blague* that eats away at her like acid. One evening the little worker gives way. Through a half-open door she slips into an obscure place. She will never come out again. The best thing that could happen would be what one calls a *collage* [state of cohabitation]. Usually the seducer is not one of those libidinous bourgeois whom socialists charge with all the vices of our society. The truth is that most of these women fall for workers like themselves. A child arrives. She works; he works; life is bearable. But, then there is a second child. He leaves.[1]

Might Rose have dreamt about an artist as she wondered how to get out of her dreary solitary existence? Such ideas had wafted through the putrid air of the back alleys of the Left Bank for decades, even before Henry Murger published his *Scènes de la vie de bohème* in 1847, with its dashing description of the adventures of the seamstress Mimi and her vigorous pursuit of the poet Rodolfo. Such stories were full of passion and excitement. When the Goncourt brothers picked up the theme a few years later in *Germaine Lacerteux* (1864) they saw the story through a dark and frightening prism, basing their novel on the real life of a domestic who had been in their employ. This girl had come alone to Paris when she was in her teens, suffered rape, gave birth to a stillborn child, had her marriage hopes dashed, became pregnant again, and then suffered further from debt, alcohol, and, finally, death. It is the basic tale of a female migrant's vulnerability in the city once she has lost the protection of her family.

Perhaps Rose met Auguste Rodin in one of those dreary *gargotes*. However it happened, she found an artist who was kind and who became her friend and then her lover, her lifetime companion, and, finally, her husband. When they met Auguste had a studio on the rue de la Reine Blanche in the Thirteenth Arrondissement near the Gobelins factory not far from Mme Paul's shop where Rose worked.

For a poor young artist, finding models was a most difficult task, just as it had been for Monet in 1865 in the forest of Fontainebleau. Professional models charged a franc an hour at a minimum, and such a fee would have been out of the question for a young man just having left a religious community. An

alternative course would have been to pay a small fee to work from a model at the Académie Suisse, where male models were available three weeks a month, female models one week. A friend of Zola's who often went there reported that the models, although not quite prime material, were "tolerable." In that case, however, it would not be *your* model, nor would their poses be those you particularly wanted.

I have always imagined Auguste and Rose meeting somewhere along the rue Mouffetard (today avenue des Gobelins), the large artery connecting the rue de la Reine Blanche to the new quarter of la Maison Blanche. At twenty-three years of age, Auguste Rodin was not a very prepossessing man. He was short—just over five feet, three inches—with thick auburn hair which he combed to the right. He had a slight mustache and a modest beard, though it was barely visible. If he had a particular mark, it was his exceptionally penetrating blue eyes. They had a searching quality about them. It wasn't just the extra effort of looking because he was myopic, it was something more—he was always looking. Though four years older than Rose, Auguste was more unsure and more timid than she. Rose, oldest of six children and on her own for some time, had a force that must have been foreign to this shy young man. Maybe she reminded him of his sister. Late in life, in a confidential conversation with the British socialite Victoria Sackville, he endeavored to describe the way in which he remembered his first months with Rose: "Elle s'est attachée à moi comme une bête" ("She attached herself to me like a crazy person").

At some point in 1864, less than a year after Rodin walked away from the Fathers of the Blessed Sacrament, Rose agreed to come to his studio, to step out of her heavy clothes, and to climb upon a model's stand. Her willingness enabled him to begin his first life-size nude figure. When they were old the artist and the model had separate memories of this time in their lives. She remembered the pose: standing, one hand on her head, holding up her hair, while she lowered her other hand as if putting a mirror down. She also recalled how cold it was, and that the pose went on for hours and hours. He remembered the pose as one that was not too difficult, one that she could easily resume after breaks: "I did not want to exhaust her," he said. He was glad she was not a city girl. He admired her "physical vigor and her firm flesh of a peasant's daughter, she had that lively, frank, definite, masculine charm that augments the beauty of a woman's body." Rose exuded force, and it fascinated

him. But he found he was never quite content with his figure. He would take up moist clay again and again—ten times, fifteen times, almost right, not quite, but "when I was near my bacchante [as he came to call the figure] I forgot all that I had suffered. The joy I felt when I found a single contour that worked! As the day drew to an end to interrupt my work with the progressive approach of shadows, I saw my statue shed its details, revealing only its large planes, its silhouette, and finally its mass alone appeared."

Sundays were special: "After a long séance in the morning, and as recompense for an exhausting week, we walked: through the Parisian *banlieue* out toward the fields and far into the forest." Their walks were similar those Emile Zola took in the same part of the city, in exactly the same period. Zola, accompanied by Berthe, the woman he called Laurence in his semiautobiographical novel *La Confession de Claude* (1865), vividly described passing through the *terrains vagues* of Montrouge, its neglected muddy fields stricken with desolation, misery, and a kind of lugubrious poetry. Not a tree to be seen in those unconfined lands surrounding the city. Then, after hours of walking, they reached real countryside where they experienced "the intense and indescribable delight lingering amid sunlight and shadow, and they drank in the fresh air."

Rodin worked on the *Bacchante* for almost two years. Finally he considered it finished: "I was happy because I understood that I had put everything of myself into her." Exactly at this moment, as Rodin was searching for a way to raise the money to pay for a plaster mold to be taken from the clay figure, he was forced to change studios. He hired movers, and "at the end of the day, when everyone was extremely tired, without any warning, two workers picked up my figure, one by her feet, the other by her head, and as they moved a few feet, the armature swayed, it twisted, the clay fell off. . . . My poor Bacchante was dead."[2]

The bond between artist and model, however, held fast. Taking lumps of clay, he fashioned her face, this time successfully fixing it in plaster. He captured her presence as something direct and forceful. Although unable to provide the golden tints of her brown eyes that flamed and sparked with emotion when provoked, he gave them life and acknowledged the fierceness of her peasant beauty. He articulated her cheekbones, her half-open mouth, quivering nostrils, and the magnificent masses of hair falling in dense clumps

on her forehead, down the nape of her neck, and across her collarbone. It is an extraordinary portrait, remarkable for an artist with as little experience as this one had, and even more remarkable for its time: Second Empire portraits normally represented pretty girls, all smiles and dimples, coy turns of the head, flouncy ribbons, and innumerable bows.

Posing sessions for both sculptures, and others now lost, took place early in the morning or in the evening, though not in the dark winter months when there was no light. Both artist and model worked long hours to pay their rents, and Auguste had to help his parents, who, due to his father's illness, had been forced to move to Montrouge, one of the towns on the southern edge of Paris incorporated into the city in 1860 as the Fourteenth Arrondissement. The senior Rodins took a small apartment on rue de la Tombe-Issoire, the old route out of Paris in the direction of the city of Orléans.

Rose would arrive in the studio after she finished at Mme Paul's shop. Then, under Auguste's tutelage, she learned how to hold her body, which meant sitting still for long periods of time, never fidgeting, but not letting go of her inner energy, for that was her special attractiveness. There was the pose and there was the gaze, and two young people began the dance of casting a spell over one another. Delacroix once wrote in his journal: "Whenever I wait for a model—every time, even when I am most pressed—I am overjoyed as the hour passes and when I hear the key turn in the door, I tremble." There is no doubt that Auguste Rodin shared such feelings. For him the living model would remain the central issue from his first work to his last. And for a lonely girl from the country, to know that someone was waiting when her long days with her needle were over—well, that must have made up for a great deal.

In the summer of 1865, before the *Bacchante* was finished, Rose knew she was pregnant. When did she tell Auguste? What was his reaction? He still lived with his parents, and, as far as we know, he played little part in planning for the birth. Since he would not be with her, nor, in the manner of Claude Monet, would he search for a medical student to deliver the baby, Rose had but one choice—to go to la Maternité. This institution, founded in 1814 on the egalitarian principles of the Great Revolution to help poor women who were without family and without resources to give birth with no charge, was located in one of the seventeenth-century convent buildings of Port-Royal. It was within walking distance from rue Tiers.

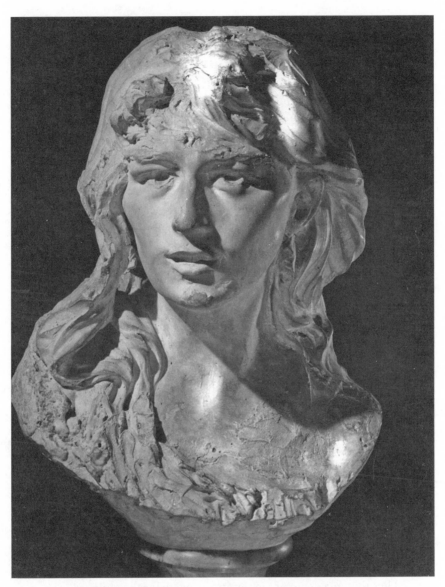

Rodin, *Mignon,* plaster, c. 1864–65. Paris, Musée Rodin

To gain admittance to la Maternité Rose had to put together the right papers: her landlord's written testimony that she had been in residence for at least a year, which would allow her to obtain a certificate from the police. Such a procedure had become necessary because the hospital could no longer handle all the women pouring in from the provinces and in need of its services. In January 1866, when Rose entered la Maternité, 89 percent of the mothers had been born outside of Paris. When she arrived at the hospital, she also had to establish the fact that she was in her ninth month. Further, she had to convince the administration that she could not afford to pay a midwife for a home delivery. Before 1852, indigent women had been admitted as early as their seventh month, but, owing to the steady increase in the number of young women migrating to the city, this was no longer feasible.

In her book *Poor and Pregnant in Paris, Strategies for Survival in the Nineteenth Century,* Rachel Fuchs makes it clear that a woman with any kind of financial resources went to great pains to avoid la Maternité. As important as its foundation had been for poor women, it had become associated with death and destitution. If you could afford a midwife, you stayed home, so it would seem that Rose's situation was even worse than that of Hortense Fiquet or Camille Doncieux. Rose was fortunate in one respect, however, for the woman who assisted at bringing her son into the world was Adéle Alliot, the extremely experienced head of midwifery at la Maternité. Rose had her baby baptized while she was in the hospital.[3] She gave him the father's first name, while the father gave him no name. He would always be Auguste Beuret.

Rose left la Maternité on the January 30, eight days after she gave birth. It was an early release. Most of the women in her ward were there for two weeks. As the moment of her discharge drew near, the officials raised an important question: would the mother be taking her offspring with her? If not, hospital administrators would inform the police, who would draw up a declaration permitting authorities to send the child to the Hôpital des Enfants-Trouvés, the foundling hospital across the street. Rose's commitment to keep her baby entitled her to a small sum of money and a layette for the child.

Rose Beuret fit the profile of the majority of the women at la Maternité: single, in her early twenties, from the provinces, residing in working-class neighborhoods, and earning her living as a domestic or in the sewing trades. Another thing she had in common with the other women in her ward: twelve

Engraving after M. A. Demarest, *Devant la maternité,* c. 1900.
Paris, Bibliothèque Nationale de France

out of thirteen were unaccompanied by the men who had fathered the children to whom they would be giving birth.

It's not clear when the three became a family. Nor do we know when the Beurets learned of the existence of their first grandchild. Rose could barely write. The handful of letters still in the Musée Rodin present us with short, awkward missives, so we don't imagine her writing a letter to her parents telling them about the birth of her son. But eventually they got the news. Only one letter from Rose's father has been preserved. It was written in 1879, a few months before his death. It was addressed to "mes chers enfants," and in his will Rose is listed as "Marie Rose, femme d'A. Rodin, sculpteur à Paris." Even without a wedding ceremony Rose lived all her life as the "wife of the sculptor, Auguste Rodin."

When did the elder Rodins learn of their grandchild? Apparently Auguste waited a couple of years before he brought Rose home. The only account of the meeting is found in a book by Judith Cladel, Rodin's dedicated lifetime biographer (she wrote four books about Rodin between 1903 and 1936). Cladel got to know Rose in the 1890s, when she herself was a young woman in her early twenties, and she in time began to feel a great deal of sympathy for the woman lost in the background of the celebrated artist's life. Cladel became an advocate for Rose, an approach not exactly common in Rodin's circle. When she embarked on her long career of writing about Rodin, Cladel began to ask Rose every question she could think of about her early days with the sculptor. So we rely on her report about the Sunday when Auguste brought Rose to the rue de la Tombe-Issoire for the first time: "His mother had put on the pot-au-feu, Thérèse brought a cake, they would dine together with the cousins. . . . That's when they saw Rose for the first time." He had never mentioned her to his family. He simply brought her home. And he was totally unable to bring up the subject of the child, so he asked his mother's youngest sister, Aunt Thérèse, if she would be the bearer of this news.[4]

The fact of an illegitimate child would not have shocked the neighbors in the Thirteenth and Fourteenth Arrondissements. For migrants and workers, and certainly for artists, it was a period when informal sexual relations were the norm. It was most common for couples to behave as if they were married even though they had never gone through any kind of ceremony. A study for the years 1846–47—"Du mariage et du concubinage dans les classes populaire

à Paris"—estimates that one-third of such couples had been together for more than six years.[5]

The arrival of this child surely caused little rejoicing in the Rodin household. As a pious Catholic, Mme Rodin could not have enthusiastically given her blessing. Further, the resources of the household were already stretched to the extreme. Where would the money come from to support the new family?

A few years before his death in 1934, Auguste Beuret gave an interview during which he spoke about his family life. He could not have been clearer: "We were very poor when I was born, so no one was happy about my arrival, only my grandfather. But he was blind and couldn't help a great deal."[6]

Montmartre and the Commune

Soon after his son was born Auguste Rodin moved his new family to Montmartre. The change is usually described as necessary so that he could walk to the studio of Albert Carrier-Belleuse, who was now his employer. Carrier-Belleuse, who was the most prominent commercial sculptor of the Second Empire, had an atelier on the rue de la Tour-d'Auvergne in the Ninth Arrondissement. The rue Hermel, Rose and Rodin's first address in Montmartre, was certainly closer to the Carrier-Belleuse establishment on the rue de la Tour-d'Auvergne than they would have been had they remained on the other side of the river, but they were on the far side of the big hill—*la butte,* as it was called—close to the city's outer fortification wall, which meant they were hardly next door to Carrier-Belleuse's studio. But to put some distance between themselves and the family on the rue de la Tombe Issoire may have also played a role in the decision to move.

Rodin, now twenty-six years old, had shown his commitment to Rose when he brought her home after the birth of their son, and to little Auguste when he enlisted Aunt Thérèse's help in making the child's existence known. The move further solidified their sense of being a family. Auguste could have left Rose in the company of the other unwed mothers in the Thirteenth Arrondissement. Such women were to be found on every corner. But he did not. Rose had good reason to feel more secure in her new life.

Like the Maison-Blanche and Batignolles, Montmartre was among those villages newly incorporated into Paris. Recent arrivals were not unlike the newcomers Rose saw in her old neighborhood—indigents looking for cheap lodgings. But in this new neighborhood, high on a hill, the air was fresher, and things must have felt better. In addition, the great height of Montmartre gave it a sense

of isolation. Even omnibuses didn't come there, so in some ways it might have felt for Rose like being back in a provincial town. Until recently Montmartre had a true rural quality: windmills grinding wheat into flour, vineyards producing wine, and quarries providing "plaster of Paris." The last quarry had closed in 1860. When Auguste and Rose arrived the remaining windmills were being turned into pleasure sites that would soon serve as inspiration for painters.

I think it was a good move for Rose. It was her first real home in Paris, and Montmartre, with its shady streets and quiet lanes, was good for walking a child, even if the rue Hermel did lead out to the Porte de Clignancourt, a rather desolate area filled with ragpickers scavenging for a living. The family then relocated to the rue Marcadet, a very long street described by a contemporary, Albert Wolff, as being so far from the center of the city that it totally escaped "the vigilant eye of the Conseil Municipal." He reported that the cobblestones were in such bad shape, that drunks stumbled into holes and broke their heads on the few remaining stones. Many houses had deteriorating walls that were reconstructed with paving stones, and broken tiles that were replaced with paper. Tenants constantly worried that their ceilings would collapse.[1]

Rose and Auguste were hard workers. She had the daily tasks of caring for their son, firing up the stove, fetching water, sewing the family's clothes and keeping them clean at the public laundry, all the while continuing to earn money by contracting out for sewing jobs. Each day Rodin walked about a half hour to the spacious establishment of Carrier-Belleuse, an artist with a large number of commissions and therefore in need of dozens of assistants. If you wanted to understand the business of sculpture, Carrier-Belleuse's shop was the place to be. Rodin was content with this job, a fact he confirmed some years later: "I was very happy to go to Belleuse because it took me away from an ornament-maker to one that made figures."[2] Nonetheless, Rodin was critical of the vast majority of works coming out of Carrier-Belleuse's studio: "The main object was to please the uncultivated, often vulgar, fancy of the commercial world. To accomplish this, the living model was dispensed with, haste took the place of thought and observation, a bad style of modeling was practiced, and a manner of finishing equally reprehensible."[3] At night Rodin returned to his own studio and tried to cleanse himself of these bad practices. His "living model" was always waiting.

This is a period in Rodin's life for which there are no contemporary

Rodin, *Young Mother*, lead pencil, pen with brown ink
on bluish paper, c. 1866. Paris, Musée Rodin

documents. When the couple left Montmartre in 1871, most of their possessions remained in the care of a landlord, a man who took no care at all. As Rodin told American sculptor Truman H. Bartlett, this man, whose name was Robinet, sold "a large number of sketches, a quantity of valuable plaster casts and a clay figure, larger than life."[4]

A few works may have escaped destruction—small terra-cottas of a mother nuzzling her child, a seated mother and child twisting into a complicated pose, drawings of mother and child peacefully enthroned—all the ways in which Rose was learning to hold her small young body in various positions at the behest of her artist-mate as he searched to understand the human form and what he could do with it. And there were other lessons Rodin wanted Rose to learn, especially how to wrap his clay sculptures with wet rags to keep them

Rodin, *Mother and Child*, terracotta, c. 1866–67. Paris, Musée Rodin

from drying and falling to pieces before he could preserve them in a plaster mold. Rose would go on doing this until the end of her life.

Late in life Rodin described his memories of this period in Montmartre to the critic Gustave Coquiot. He spoke of himself as being "fiercely in love with my work. And I had such a sickly pallor—it was the pallor of poverty. But an ardent nervous overexcitement pushed me to work without respite. I never smoked. It just would have been a distraction, and I couldn't bear that even for a single moment. I got through my fourteen hours a day and never rested except on Sundays. And then—my wife and I—we went to some *guinguette* and ate a big meal, three francs for the two of us. It was our total recompense for a week of work."[5] This was the man Rose knew as they began their life together. And "hard work" would dominate their lives for a long, long time.

Sometimes they spoke of their boy. Sharing memories of these conversations with Marcelle Tirel, a secretary who worked for Rodin in the twentieth century, Rose recalled that "he was a beautiful baby, but very naughty. He cried all the time. M. Rodin used to get in a rage!—the crying disturbed him when he was working. . . . One day he said to me, 'Rose, I'm glad it's a boy.' I answered, 'If only he hadn't your nasty character!' to which M. Rodin responded, 'If only he's an artist and works like me!'"[6]

By the end of the decade Carrier-Belleuse was developing clients in other European capitals, especially in Brussels, now known as "little Paris," where new building projects were numerous and opportunities for decorative sculpture abounded. In the summer of 1870 Rodin headed north to begin working on one of Carrier-Belleuse's new commissions in the Belgian city.

Rose was alone with the child on July 19, the day Napoleon III made his fateful decision to declare war on Prussia. At first the conflict must have seemed far away, not something to interrupt the daily business of earning a living, taking care of a four-year-old, as well as watching over the sculpture in the studio. We do know, however, that a week after war was declared one of Rodin's co-workers at Carrier-Belleuse's studio in Paris wrote to him in Brussels that "things are not at all calm at this moment."

Everything changed, however, after the Emperor's defeat at Sedan on September 1. The war, which to that point had not gripped the minds of many a Frenchman and Frenchwoman—it was just "the Emperor's affair"—was now about to change everyone's life. September 4 saw the establishment of

the Government of National Defense, and, for the third time in less than a century, France became a republic. In Paris there was an immediate *levée en masse*, with compulsory registration for the National Guard.

Rodin returned to take his place in the 158th Battalion in the 4th Company of the National Guard. It wasn't that he was particularly patriotic; it was simply what all his friends in the ateliers of Montmartre were doing. A healthy young man in civilian clothes could not walk the streets without being insulted. Companies were raised from neighborhoods, each composed of men from various adjacent streets. Two of Rodin's best friends, Almire Huguet and Alphonse Germain, joined the 4th Company on the same day as Rodin. They would be paid one and a half francs a day, plus seventy-five centimes for wives and twenty-five for a child. Félix Pyat, politician of the Left, demanded that there be the same consideration for "common-law wives." A luxury industry like decorative sculpture closed down immediately. There was one cadre of workers that was heavily in demand—anyone who had experience in the clothing industry, for there was plenty of work making uniforms. It is likely that at this point Rose became the primary breadwinner for the family.

As food stocks dwindled, two and a half francs—their official income—were worth almost nothing. By Christmas that sum would have bought them one egg or two rats. Rodin did, however, earn a bit on the side. He told Bartlett that he modeled portraits of two officers in his company for thirty francs each. But basically, as he reported in the same interview, the young family had "no money, food and fuel soon became scarce, and misery, cold, and hunger were almost unendurable."[7] Rodin remembered that at first they were happy to eat horsemeat (horses in Paris were consumed at the rate of five to six hundred a day), but finally they were reduced to bread alone.

On January 5 the Germans began shelling the city. It continued for three weeks, a shell exploding every two or three minutes. Only the Left Bank, however, was within the range of Herr Krupp's giant steel guns, so Montmartre was spared. Nevertheless, Rodin had had enough. He was myopic, a physical handicap that warranted a discharge. He now made that request. In January there was one failed attempt to break the German blockade. By February there was a new government, which had been elected for one purpose—to make peace. On March 1 the painful terms of the armistice, which included the surrender to Germany of most of Alsace-Lorraine and the responsibility

for an astronomical indemnity of five million francs, were ratified by the new National Assembly. On that day Rodin was back in Brussels.

Rose was alone again. Besides supporting herself and the child, she was responsible for a studio full of sculpture, mostly works in clay needing constant attention. Each day Rose would inspect the wet rags that she had previously put on the soft modeled surfaces and replace those that were drying out, hoping no cracks would appear.

For the moment it seems that Rodin was quite content. He was happy to be out of the National Guard, to be away from Paris, and, most of all, to be back at work. Carrier-Belleuse had secured one of the biggest commissions to be had in Brussels—the decorative sculpture for the new stock exchange. There was a job waiting. Rodin found a room over a tavern in the middle of the city and settled into a daily routine.

Rodin's first letter to Rose from Brussels exudes contentment. He's been to the country; the day was beautiful, and he "rejoiced in pure air." However, he never stopped thinking of her. He would frequently hear the song she always sang; it kept going through his mind: "Soldats qui m'écoutez / Ne le dites pas à ma mère" ["You soldiers who listen to me, don't tell my mother"] . . . "You see . . . I am overcome by an attack of tenderness." But enough! Not wanting to be "tyrannized by sweet emotions," he moved on to serious things: "When you moisten my figure, don't moisten it too much or the legs will get too soft. I am well pleased that you are taking care of my plasters and my clays." He sent money, not only for Rose but also to his parents. He instructed her to go shopping for his mother. Regards to various people; no mention of Auguste.

This letter—to our knowledge the first that Auguste Rodin ever sent to Rose Beuret—indicates that Rose was schooled enough that she could read. We do not have her answer, but in another of his letters he complained that she has not explained things very well: "Give me more details." What we know from her letters is that she was unable to explain things "in detail." Like the majority of country girls in nineteenth-century France, Rose was semiliterate; she could read, a skill she would have learned in catechism classes. Writing was personal; it was a way to free yourself, and that notion was never part of Rose's life.

In March, when the French Assembly returned to the palace of Versailles, the legislators put a series of Draconian economic measures into place and moved to disarm the citizens' militia. Rose must have immediately felt the

tension in her neighborhood. The men in Rodin's old company were among those talking about rebellion against the government, and the nearby cabarets had been turned into political clubs. During the siege, the National Guard of Montmartre had been armed with hundreds of cannons. Now the government wanted them back. On March 18, early in the morning, regular army troops trudged up the steep and narrow streets of Montmartre. They planned on taking the cannons by surprise. The local National Guard got wind of the plan and took to the streets, followed by the women and children of the community. Barricades sprang up, officers were manhandled, and the crowd grabbed two commanders, took them into someone's garden, and shot them.

As the streets filled with chaos and the government was no longer able to govern, conservatives began to leave the city. Many had drawn the conclusion that Paris was capable of going to war with itself: Parisian against Parisian. The immediate need for a credibly elected city government was clear to all. These elections were held on March 26, and the revolutionaries won. With the desire to associate themselves with the Jacobins of the Great Revolution, they took the name "Commune." The people of Montmartre now assumed that it was their resistance that had paved the way to a new era in French history. The leaders of the Commune tried to arm, equip, and supply the National Guard in order to turn it into a real army, but drunkenness and negligence were endemic, and they met with only limited success. Commerce had almost ceased, and there were huge factional divides within the Commune. In April, after much disagreement, the leaders of the Commune voted to remove the Vendôme column, which commemorated the first of Napoleon's military triumphs but now seemed to be "a symbol of brute force and false glory." Gustave Courbet, as a member of the Commune and a delegate from his arrondissement, was enthusiastic about the idea.

On May 21 the Versailles troops went on the attack. Commune leaders called on every citizen to take to the streets and join in building barricades that would be used to block the movement of the troops. In order to stop the government onslaught, mobs began setting fire to buildings. Over a three-day period many of Paris's monuments and buildings were at least partially gutted: the Tuileries, the Palais-Royal, the Palais de Justice, the Préfecture de Police, the Légion d'Honneur, the Ministère des Finances, and the Hôtel de Ville. This last building was the headquarters of the Commune. Members of

the group burned it down themselves to prevent its capture. The following week, which lives in French history as "Bloody Week," the Versailles troops proceeded to massacre some twenty-thousand Communards.

From Brussels an anguished Rodin wrote: "I am sick at heart as I write. My poor Rose, where are you? Write immediately. I am also writing my parents. What has become of them? Write soon. I can send a little money. Oh that I could press you to my heart Rose *tout à toi*."

In May 1871 Hortense Fiquet, staying in Provence, had to bear the indignities of her son's grandmother wishing she did not exist; and Camille Doncieux lived in poverty in a land where she could not communicate. But it was Rose Beuret who lived through the Commune in the streets of Montmartre.

Rodin's letters from the summer of 1871 are full of worry and expressions of love. "I haven't a *sou* at the moment . . . get my pants at the *mont de piété* it's free now."[8] She should find the landlord and assure him money would be forthcoming. Rodin was not sure if he would stay in Brussels, but if he did she must join him: "*Ma pauvre chérie,* how I long to kiss you but I can't bring you here yet." He blames himself for not being with her, for not having money, "*enfin mon petit ange,* everything has an end, even this misfortune."

On October 1 Rodin sent the rent money for the Montmartre apartment, plus enough for moving expenses along with instructions about which sculptures to pack and which to leave behind. Rose was also to "go see papa and tell me how you find him." This is the first we learn that Auguste's father was now alone. Marie Cheffer Rodin had died on August 23 at the age seventy-two, presumably from the sufferings of starvation experienced during the siege and the terrible strain of the Commune. Rodin must have heard the news only after her death, and he did not return to Paris. He relied on Rose and his cousin Auguste Cheffer to help him determine what should be done with his father, now blind and with his mental health seriously deteriorating. In Brussels Rodin was busy looking for a room in the village of Ixelles, a suburb on the southeast side of the capital. He was overjoyed that Rose would join him, but she did not come until after Christmas. Did she remain in Paris to spend the holiday with their five-year-old son, given the fact that they had decided he would not accompany his mother to Brussels? Young Auguste would remain with his grandfather, and with an extraordinarily generous Aunt Thérèse, who had opened her home to her nephew's family.

Ixelles

They were the most beautiful days of our lives.

RODIN

"I went everywhere in Belgium," reads a line in a manuscript in the Library of Congress in Washington. But the "I" is penciled out, and inserted in its place is a "we." The sentence and the change are part of the notes that American sculptor Truman Bartlett took down during his conversations with Rodin in 1887. This small correction betrays a fundamental fact about the years Rose and Auguste spent in Belgium: they experienced them together as a couple, and more than a decade later Rodin remembered them as "beautiful."

This was Rose Beuret's second journey by train, and, though Brussels was not that much farther from Paris than Vecqueville, this time the destination was a foreign country. The journey was probably no less emotional, but she would have experienced emotions of a different kind. She was leaving behind a city scarred by burnt-out ruins and plagued by shortages of every kind, but the end of the journey would be sweeter. This time she would not be alone in a strange new place.

The room that Auguste found for his "Rosette" was in the rue du Trône in Ixelles, a town of some thirty thousand residents. Just as Montmartre had been absorbed into Paris in 1860, Ixelles had recently become part of Brussels. It was a community with two separate identities: *Haut* and *Bas.* Haut-Ixelles, or, as it was known locally, "the *faubourg*," sat solidly on a plateau outside the old Namur Gate leading into Brussels proper. It was bourgeois, francophone, and cosmopolitan, whereas Bas-Ixelles, with its rolling hills and lovely ponds, stretched out toward the countryside beyond. Its residents were farmers, small business people, indigents, and modest *rentiers* of independent means. Artists felt comfortable in Bas-Ixelles where rents were low and the air was pure.

The open spaces, the fields and gardens, supplied sites for the new landscape style of the young painters, while cabarets provided the requisite locations for talk and drink late into the night. This is where the French couple made their home.

They would both stumble with the new language. Many residents spoke French, but many did not. Rose would have been particularly aware of this when she did her marketing. The people of Bas-Ixelles continued to speak Flemish, just as they had done before the Napoleonic occupation at the beginning of the century. It's what everyone spoke in the tanneries, the soap factories, and the breweries, the enterprises that provided the town's major centers of employment.

This was a community that maintained its old traditions. Each spring the townspeople came together to celebrate the *Kermesse*. The civil guard, the choral societies, and the workers' associations with insignias and unfurled banners wound their way through the squares and the streets. The procession formed in front of the church—firemen in line first, followed by the police, then the *garde rural* in apple-green outfits, followed by the children and religious groups. The fair, with its donkey races, wheelbarrow races, greasy poles, and cockfights came later, and then, late into the night, dancing in the *guingettes*.

Ixelles would be Rose's home for the next six years. Its daily routine had a simplicity reminiscent of the country life she left almost a decade earlier. It must have been a profound relief after the terrible days of the Commune and the confusion of Paris.

They had time together. They made long journeys on foot without regard for where they were going. They explored Gothic cathedrals, visited old Flemish towns—Ghent, Bruges, and Antwerp, where Rodin was stunned by the power and force he discovered in the art of Rubens. He talked of these things to Rose; she began to learn what it meant to look at art. As for Rodin—who had known only an urban life—he began to learn about nature. In the forests and valleys surrounding Brussels he discovered something he had never known before, later in life insisting that "it was Belgium that taught me about light."[1] They would take off in the morning—Auguste with his box of paints, Rose with an umbrella and lunch—and head into the forest of Soignes. There Rodin would pass the day identifying motifs he wanted to paint. Manipulating impastos and colors, he rendered the trees, the light on walls of stuccoed cot-

Rodin, *Picnic in the Petite Sablière, Forest of Soignes,* oil, c. 1872–74.
Paris, Musée Rodin

tages, clouds, windblown grasses. In one painting, the forest rich in autumnal colors under a moody cloud-filled sky, we see a small figure in blue—Rose in profile seated by a blue and white picnic cloth—a tiny souvenir of a partnership cemented in those days.

Rose settled in to mend Rodin's clothes back into shape, to cook and to clean. Auguste's deep chestnut locks had grown longer, and his beard had filled out. It gave him a look of strength that was new. The one thing Rose did not do was model. The sculpture he was now making—mostly decorative work for large architectural complexes—did not call for a live model. He did friezes for the stock exchange, then decorative work at the Royal Palace. In 1874 it was the Music Conservatory and the Palais des Academies. To obtain commissions such as these he was aided by a new relationship with a Belgian sculptor, Joseph Van Rasbourgh, whom he had met in Carrier-Belleuse's studio. The two found their working partnership so successful they went to a lawyer to draw up

a contract. It was signed on February 12, 1873; they were now Van Rasbourgh-Rodin—dedicated to the production of artistic and industrial sculpture. Their headquarters was in a stable behind Van Rasbourgh's home at 111, rue Sans-Souci. It was good for Rose, too. She had become intimate with Valentine Van Rasbourgh, a friendship that would last all their lives (many years later Rose would become godmother for Valentine's granddaughter Rosette). Rose now spent much of her time in the atelier, continuing her apprenticeship in learning to master the practical problems of sculpture production. Proudly she referred to herself as Rodin's *garçon d'atelier*. Rose felt a part of something, and she was "Madame Rodin"—no questions asked.

The contract gave them a sense of security. But it was not perfect, for Van Rasbourgh was designated "director of sculpture," with "the prerogative of . . . signing all artistic work." This made practical sense. As a Belgian, Van Rasbourgh was capable of obtaining commissions unlikely to be given to a Frenchman. But in Rodin's eyes—and surely also in Rose's—it didn't make sense for long. Van Rasbourgh had far less talent than Rodin. Further, Rodin did most of the work. When Bartlett asked Rodin if he would have left Belgium if he had been able to get work on his own, the sculptor replied, "Perhaps not. I did not know that I had any talent. I knew I had skill, but I never thought I was anything more than a workman. I never signed my work and I was not known." Bartlett asked him it they had "any intimate and appreciative friends there?" Rodin told him that they had "good friends, but they could not help me much. We lived very modestly in one room in the rue de Bourgmestre near the military. Rent was 10 francs [a month]. We had a garden and lived out doors. We had our wine from France [sent by the Beuret family]—bad wine there and our garden twice as large as our room, one tree and a cat in the garden. They were the most beautiful days of our lives."[2]

The couple had moved from their little room in the rue du Trône to a larger one in the rue de Bourgmestre. It was far out at the edge of town near the beautiful ponds of Ixelles and the splendid medieval abbey of Cambre. These joys made up for the new and longer walk to the atelier in the rue San-Souci. They had rented from a horticulturist, M. Hautefenne, whose splendid gardens (a section remains extant in the Parc Jadot, which now serves as an entrance to the Musée des Enfants) surrounded their own little garden, which was blessed with a large spreading tree under which they took their evening meal in warm

weather. There was not only a cat, but a dog, a goat, and rabbits as well. Rose cultivated her own garden. A country girl came back to life.

The people they saw were neighborhood craftsmen and small merchants. Rose was drawn to the upholsterer and his wife, and even more to Jules Thiriar, the doctor who had operated on Rodin when he suffered from a hernia and of whom the sculptor made a handsome bust in payment for this service. And Rodin was making friends at the Cercle Artistique et Littéraire, center of intellectual life in Haut-Ixelles. These friends Rose did not know. Rodin began to collect books, picking up translations of works by Caesar, Seneca, Lucien, Plutarch, and Shakespeare.

Although Rodin experienced periods of discouragement about his work, it was a better life than either he or Rose had ever known. Apparently they were able to relegate the worrisome letters from Paris to the back of their minds. At first, news about their son did not sound too bad. He was going to school and doing well in reading. However, his uncle, Auguste Cheffer, did refer to him as a "vrai diable," saying that he carried on like a "polichinelle" ("a little rascal"). Both Rodin's aunt and his cousin thought it would be best if Rodin himself came to Paris in order to impose some kind of discipline on his son. By the summer of 1873 things were disintegrating; Aunt Thérèse wrote that she felt young Auguste was simply not honest. She told her nephew that he had to take a strong position: "Tell him you will put him in prison for stealing." The following year Rodin finally made the trip to Paris to visit his eight-year-old son and his seventy-one-year-old father, who was falling ever deeper into a paranoid depression. Perhaps young Auguste improved after this visit, at least for a while. In Cheffer's next report there is a tone of resignation: "The child is all right; we just let him do whatever he wants to do." But by December 1875 the call for parental intervention could not have been clearer: "I speak to you as the father of a family. He has his faults and he has his good qualities but if no one takes him in hand, it won't be long before he will have nothing but faults." Where was Rose in this crisis? Her thoughts, uncommitted to paper, leave us in the dark. There is no evidence Rose made any trips to Paris before her definitive return in 1877. The history of the couple's Belgian residency makes it clear that they had no wish for a family. In their intimate life they must have made every effort not to bring another child into the world.

Rose's thirty-five-year-old husband had waves of deep discouragement—

after all, he had been working for years on large public sculptures that were visible on major buildings in Brussels, but none were associated with his name. Otherwise he had shown and sold decorative busts—à la Carrier-Belleuse—in exhibitions around Belgium, some even in London, but it didn't add up to recognition. A breakthrough came in 1875 when, for the first time, his work was accepted at the Paris Salon. He showed two busts, one being the head of Bibi (later known as *The Man with the Broken Nose*), the plaster head he had made in the studio on the rue de la Reine Blanche and that had been turned down for the Salon of 1865, but which Rodin now had translated into marble. The execution of the work was done in Paris by his old friend Léon Fourquet.[3] Through the technical process of "pointing" which allowed the artisan to transform the plaster head into marble, and then to place on a nude chest—the work now looked classically inspired and thoroughly Salon-worthy.

This success—modest as it was—fueled Rodin's ambition, and he now conceived of a new project, one that would be all his own. The first thing he did was to hire an iron worker to put an armature in place sufficient to support a life-size figure. He then engaged a young soldier to model for a standing nude figure.

As Rodin began working on his figure, another ambition came into focus: he longed to see the great nudes of antiquity—even more, he wanted to know Michelangelo's work firsthand. During the summer of 1875 art journals were full of talk about Michelangelo and the plans taking place in the city of Florence to celebrate the four-hundredth anniversary of the great Renaissance artist's birth. Rodin felt he had to go.

Rodin and Rose must have talked endlessly about the idea of the journey and whether they could afford it. He finally managed the arrangements and left for Italy in March 1876. Only one letter remains from his trip. It was mailed from Florence. The first thing he told Rose was how hard it was to throw out the sausage he had bought in Pontarlier. It was his last morsel of French food. He was unsure if he would be able to eat in Italy. But to his surprise, eating and drinking "aren't bad here." At the very moment he was putting pen to paper, he was, in fact, drinking a glass of Italian wine to Rose's health. The big event described in the letter was his encounter with the sculpture of the great "magicien," the works of Michelangelo. Rodin was confident he had learned a "few secrets" from the master of the Medici Chapel. Rome, Naples,

and Venice would be next; Paris in two weeks. He made reference to getting a little jacket for Auguste and closed with a standard instruction: "Don't dampen my figure too much."

"The figure"—the most important thing Rodin had ever done—now dominated their lives. It was a simple yet highly emotional nude, a man standing tall, body moving ever so slightly in a gentle contrapposto, right hand griping his head, while the left was raised to shoulder height. The face bore the marks of both suffering and longing. Rodin gave it a title. He called it "The Vanquished One," and, when it was finished, he took it to the hall of the Cercle Artistique et Littéraire in order that the literati and the critics of Brussels with whom he now associated would be able to see it, hopefully with appreciation. He never could have imagined what happened next. One of those critics, recognizing the extraordinary lifelike quality of the figure, took it upon himself to raise a question: "What part has casting from life played in the making of this plaster?"

For both Rodin and Rose, this was crushing. Their investment in this statue was so big, the care and the work had taken so long, that the accusation of Rodin's having employed a dishonest studio practice—that of taking a mold from a living body—was a blow striking at the very fabric of their lives. As Bartlett observed a decade later, at the same time that Rodin was creating this figure of a "young warrior waking from the half-sleep of unknown strength," he was, in a sense, also fashioning an idealized self-portrait. He started to mount a campaign to save the statue and his own reputation. In February he persuaded the editors of Belgium's leading daily paper, *L'Etoile belge,* to publish his letter inviting any connoisseur or critic who wished to come to his studio in order to examine the sculpture and the model side by side. Then in March he took the plaster figure to Paris, where it was accepted for the Salon under a new name: "The Age of Bronze." The new name changed nothing; the slander was repeated, and he was obliged to continue his campaign for his statue and his own legitimacy. Rodin spent the rest of the year in Paris fighting with bureaucrats and critics, getting people to attest to the validity of the statue's originality, and trying to figure out his next step in making a living as a sculptor.

Rose remained in Brussels. She was responsible for overseeing the work in the studio. Seven letters containing Rodin's instructions to Rose have been

preserved. Even though his writing is impossible, punctuation almost non-existent, and repetitions continual, they give us a fair idea of how she spent her days:

> I want to work on my Ugolino and must have it. my Byron monument is molded and reassembled there is a side where the edges are not clear *it is necessary to reestablish the profile and to put it back on its side* and the joshua is it molded? By ordinary post I want you to send various little sculptures that I am going to indicate to you the child on the lion which is in pieces the draped woman that Paul copied tell me how much you spend how our affairs are going but before everything send me Ugolino have it packed and send it by ordinary post there is also a leg that has not been molded I will be able to take it when I come but I do not want to lose time because everything depends on when the jury passes on it and where they place it.

The "it" on which everything depends is "the figure" that remained Rodin's full-time preoccupation. The latest news of his struggle was central to every letter: "Here I have real fear for the work the politics of the country are not reliable I don't know how to act." His second greatest concern was money: "I have expenses in every direction and no more money when you come it will be necessary to help me out." This was his warning that she would have to take up her needle again in order that they might live. Infrequently Rodin mentioned the rest of the family: "Papa va bien le moutard aussi" ("Papa is fine the kid also").

Many years later, Louis Willemsen, who had been a young helper in the atelier in Ixelles, wrote to Rose: "I remember what you said one day in the rue sans-souci: 'monsieur Rodin is a *chef d'école* and he will succeed.' He has succeeded admirably and you have the right to be proud, Madame, because you have contributed mightily to the success of monsieur Rodin."

Rose remained in Ixelles by herself for nearly a year. There is no way to know if that hardship was difficult for her to bear, or, if, on the contrary, her role in the "business of sculpture," and her sense of having found a place for herself in a congenial community, was in some way adequate compensation.

The one surviving thing that is completely Rose from the time she lived in Belgium is Rodin's portrait of her, the work previously known as the "Mother of the Artist" (see page XX). Part of the responsibility for this erroneous identification is to be found in Cladel's biography of Rodin. When she described the death of Marie Cheffer Rodin, she informed her readers that "at least a portrait remains, a painting that reveals a tormented face, one that is a little haggard, we could almost call it that of a hunted gypsy." When Cladel looked at the painting she felt that the expression she found there was one of "angry exaltation."[4] This was a curious way to think about the pious Mme Rodin, and it should have given Cladel second thoughts about her identification. It is even more curious because Judith Cladel knew Rose Beuret, although they did not become friends until Rose was in her fifties. And Cladel may not have seen the painting until after the deaths of both Rodins in 1917. But the confusion illustrates the enormous change that Rose Beuret underwent—from the twenty-seven-year-old who went to Belgium to the woman who lived in Paris at the end of the century. She became old. Further, it again emphasizes the absence of curiosity the world has had about Rose Beuret, not only on the part of Rodin scholars, but on the part of the public at large, for the painting has been hanging in the Musée Rodin since its early days.

In this painting Rose is no longer the beautiful girl *Mignon* but a mature woman who has worked hard, one who lived on her own through those terrible events of 1870–71 in Paris. Her cheeks have filled out, her mouth is closed and diminished—no hint of a smile—her thick brown hair that once tumbled down in heavy waves has been cut short. But Rodin focused on a singular quality of Rose that remained part of her character all her life—her intensity and her passion. Here it is made visible in the big brown eyes that dart quickly to one side, the asymmetry of the face half enveloped in shadow, the lips firmly closed, the unkempt hair blown back, all projecting Rose's stubborn nature, but also her apprehensiveness. Cladel looked at the painting and perceived a quality of angry exaltation like the romantic portrayal of a hunted gypsy. I don't see that. For me the face is not so much "hunted" as haunted. There is a kind of fear, an uncertainty, the inkling of a dark premonition.

Then there is the signature, so prominent at the very center, the black sign on the white tie that circles Rose's throat as if to say: "She's mine."

The Return Home

When Rose boarded the train for Paris in December 1877, we imagine her reviewing her memories of a war-torn city. But upon her arrival, she found much changed. To the world's amazement, Paris had regained a great deal of her former splendor. Buildings were being restored, new streets had become working thoroughfares, department stores were enlarged, the splendid cafés on the grand boulevards were packed with patrons, and a multitude of new theaters had opened their doors, most especially the Opèra, that fabulous unfinished legacy of the Empire. The avenue de l'Opèra, widely viewed as the most beautiful street in Europe, had been inaugurated a few months before Rose's return. The sumptuous apartment houses on either side of the avenue created the perfect perspective for the most glamorous opera house on earth. And the lights—those gas lights—they were everywhere, at least on the Right Bank. Paris was the most brilliantly lit city in the world.

This, however, was not the Paris to which Rose returned. She was certainly aware of it—that other Paris, Right Bank Paris—but it would not be where or how she would live. A society lady from the Right Bank following her first visit to the Left Bank, reported that everything was "cheaper on that side—flowers, cakes, writing-paper, rents, servants' wages, stable equipment, horses' food." Rodin had grown up on the "cheap" Left Bank. It was the place in which Rose landed when she arrived from Vecqueville, and it was where they resumed their Parisian life. They collected Rodin's father and their son and returned to the neighborhood where he grew up, the Latin Quarter, between the Luxembourg Gardens and Sainte-Geneviève, in which students and workers shared the sidewalks of crooked narrow streets that angled up the Montagne Sainte-Geneviève.

No doubt the Rodin/Beuret household had more than one address following their return, but the archives reveal only 268, rue Saint-Jacques, which was not far from Aunt Thérèse's apartment at 218. There were little businesses and shops on the ground floor at 268, a building in which the majority of residents—washerwomen, waiters, painters, pensioners, and students—lived in single rooms, each with one window. Were the Rodins also crowded into a single room, or did Rose have the luxury of two in which to care for her brood? The reality of watching over this difficult boy and the blind, half-demented old man must have come as a shock—such a change from the rue du Bourgmestre, with its garden and her animals.

The humbleness of their living quarters becomes apparent in a story Rodin told Truman Bartlett. He had put his big figure (*The Age of Bronze*) into a show in Ghent, where it won a prize. When a distinguished Belgian art critic arrived at 268, rue Saint-Jacques to present the prize to Rodin, he was astonished by the simplicity of the surroundings before him. "Is this where M. Rodin lives?" he asked Rose, who answered the door. When she answered in the affirmative, the critic, in disbelief, queried further, "The sculptor?"

When Rose stepped out of her door into the narrow rue Saint-Jacques, an old street taking its name from a thirteenth-century chapel of Saint-Jacques, she would hurry by the sites of the great Catholic orders that once dominated the long artery: the Benedictines, the Oratoriens, the Visitandines, the Ursulines, and the Carmelites. Most were no longer there. The men of the Revolution had seized these properties, sold off the lands, and put the buildings to new uses. Only Saint-Jacques du Haut-Pas, right next door, and the ancient abbey of Val-de-Grâce, long since transformed into a military hospital, maintained the physical beauty of their origins. The great religious houses were gone; all that remained were communities like the Petites Soeurs des Pauvres, orders of nuns committed to serving the poor and the destitute of the district. These were their neighbors—familiar to the Rodins, and now becoming so to Rose.

Rodin made the decision to move back to Paris because he wanted a real sculptor's career. And his hope rested in his big figure. If it was noticed in the Paris Salon, there might be a future for him in France. It was noticed, and he did receive some reviews. They were controversial, but it was a start. In the short run, however, the move had brought them ever worse economic deprivation.

Rodin was going in ten directions at once looking for work. Good work for a sculptor was basically public work, and public work depended on political patrons. This was a problem. As Rodin had written to Rose before her return: "The politics of the country are not reliable and I don't know how to act." The couple had been in Belgium throughout the entire period when France was led by a right-wing regime fundamentally opposed to a republican form of government. Many of its leaders were eager to restore the crown. When it became apparent that such a restoration was unlikely, the Right finally committed itself to a parliamentary system. The Republic was confirmed in 1875. But the tensions between the *Centre Droit,* the *Centre Gauche,* the *Extrême Gauche,* and the *Opportunistes* (moderates) remained. No wonder Rodin was confused. It was clear to him, however, that understanding politics mattered for his future. Within weeks of Rose's return from Brussels, new elections were held that cemented the fortunes of the republicans. Thus, in 1878, as Frenchmen greeted the new year, they could almost believe that this Third Republic might really be their future.

One result of this change was an opening up of opportunities for significant sculpture commissions. Rodin competed in several of them, something he could not have done without Rose being there to model.

First there was the competition for an allegorical group that was planned for the *rond-point* of Courbevoie, the suburb west of the city where Parisians had mounted their defense in 1870. Once this location had been marked by a statue of Napoleon, but the Government of National Defense dumped that figure in the Seine. Its base remained, waiting for a new monument and a permanent remembrance of the way Parisians had defended themselves against the Germans. In April 1879 the General Council of the Department of the Seine announced a competition for a two-figure group to be presented at the Ecole des Beaux-Arts in November.

Because Rodin had a number of other jobs, and not all of them in Paris, he and Rose worked primarily on Sundays and during the long summer evenings in a studio borrowed from Rodin's oldest friend, Léon Fourquet. Léon knew Rose well; in fact, he was the first person to know that such a person as Rose Beuret existed in Auguste's life. Sometimes they brought their son along, and Rodin used the opportunity to teach the boy the ways of an atelier. Sweeping out the studio and keeping it clean were high priorities,

but he also taught him how to prepare balls of modeling clay. Recalling the studio as an adult, Auguste Beuret said it was where he learned to draw, using scraps of paper and old shirt cuffs. He began to think that he, too, would become an artist.

The commission's requirement was for a female allegory and a male combatant. Rodin wanted to put the power of the struggle and the image of fight into the female figure. He saw her as a Genius of Liberty wearing a Phrygian cap, her body elevated, arms outstretched, shrieking her fury across the land, as a dead hero slumps across her body. The project required Rose to get up on an elevated platform, nude to the waist, and to hold her arms outstretched for long periods of time. Occasionally Rodin needed her to leap and to yell with all her might. The yell was the focus of the work; its force picked up by arms' thrust and tightly clenched fists. These gestures were reinforced in the final model by a pair of wings attached to back of the torso. One was broken, but both strenuously beat the air. Rodin reproduced Rose's short proportions, and upon that body he layered a muscular mass.

In developing his idea Rodin was emulating the central figure in one of Paris's most famous reliefs: the figure of the winged *Marseillaise* in François Rude's *Departure of the Volunteers of 1792* on the Arc de Triomphe at Etoile. Rodin had great admiration for the work and enjoyed the idea of relying on this particular source—after all, the *Marseillaise* had just been officially named the national hymn—plus the fact that the new monument would be installed in a direct axis with the Arc de Triomphe at the farther end of the avenue de Neuilly. Something that must have amused both Rodin and Rose was a familiar story that had circulated through the ateliers of Paris about Rude's wife, Sophie, who modeled for his female allegory in the big relief. It was said that she would sometimes lose her energy and let her body go slack. At these times Rude would shout, "Yell louder." We have to imagine Rodin doing a good imitation of his famous predecessor.

Concurrently another project was in the works. Ever since the reconfiguration of Paris, and the addition of the surrounding villages to the city proper, political leaders had been commissioning new buildings to serve as administrative centers. They were the *mairies,* the town halls. And with the Republic firmly established, they wanted images to give symbolic confirmation of this fact. Rodin decided to compete for the bust of the Republic to

Rodin, "Genius of Liberty" for La Défense, plaster, 1879. Paris, Musée Rodin

Rodin, drawing for "La République," 1879. graphite pencil, pen and grey wash,
Paris, Musée Rodin

be installed in the finished *mairie* of the Twelfth Arrondissement, a building which had been burned down during the Commune.

Turning the petite upper body of Rose into an greater-than-life-size Republic of France was a real challenge. It was not Rodin's practice to make drawings before he attacked the clay, but in this case he may have done so.[1] It was more to get an idea of what he wanted to emphasize than it was to reproduce Rose's features, but it was still Rose. He concentrated on three elements: a powerful torso, strong features, and an elaborate casque covering the hair.

The completed sculpture, done within a few months, has an extraordinary quality of concentrated power, a perfect image of resilience and force, just what the republican bureaucrats should have wanted, but didn't. As one critic reviewing Rodin's submission said: "No, it is certainly not here that we find our amiable republic" (*Petite moniteur universel,* December 17, 1879).

The head and torso are in slight torsion. The work gains much force from the large columnar neck that is stretched taut, exposing a mass of tight muscles. But the face, a shadow passing over it by hair pushed forward under the projecting peak of an elegantly detailed Renaissance helmet with necklames edged in a twisted cord design, is clearly Rose. Every feature of the Belgian portrait is there but exaggerated, made large, given more power, especially the down-turned mouth, the high cheek bones, and the frighteningly focused eyes. The turmoil and emotional force in the facial expression are behind a remark made by Judith Cladel (and repeated ever since) that Rodin captured Rose's expression during one of their frequent quarrels. Everyone who knew Rose spoke of her temper, but sculpture is not a photograph. A work of sculpture takes weeks or months of interminable posing sessions. Although we might imagine Rodin instructing Rose to remember their last fight and to "think of how angry you were" so that her expression might become the one he wanted.

In the end, Rodin's bust of the Republic attracted no attention in the competition, and it was eventually renamed *Bellone,* the goddess of war. A few years later Rodin confessed to Truman Bartlett that he should never have entered these competitions in the first place. His vision of what he wanted to create and what the official republican judges wanted to put in their buildings were simply miles apart.

Judith Cladel's remark about Rose's anger and the couple's frequent

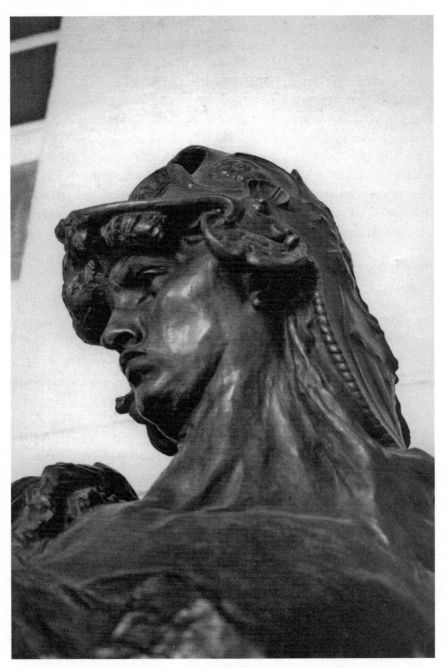

Rodin, "La République" (now known as *Bellone*), bronze, 1879. Paris, Musée Rodin

quarrels should not be our primary guide to the Rodin-Rose relationship in 1879. In spite of cramped quarters, shared with two difficult human beings, and a singular shortage of cash, the few letters we have from this period tell of a relationship that remained close and full of understanding. When Rodin was forced to look for work outside of Paris, his letters to Rose were lively and filled with an intimacy that is palpable. From Nice he wrote about the world he was discovering on the Mediterranean coast: the oleanders, the indolent sailors strolling on the quays, and "the beautiful women of the south (I hope it doesn't make you angry that I tell you that)." For the first time in his life he took a dip in the sea: "If I had the courage to go swimming every morning I would become strong. But it's a little cold when one doesn't know how to swim." He was full of counsel for his "petite menagère" ("little housekeeper"), advising her to "take care of yourself, of papa and tell Auguste to fill 15 notebooks with horses and riders."

Rodin returned to Paris in July, only to depart again in the fall to work in Strasbourg. He liked the town, but he also confessed that he did "not know how to get through the nights alone." He was even getting up to work at four in the morning. Nevertheless it was "with ardor." He assured Rose that he knew she was working as hard as he was, and reminded her how important it was to save money. But most of all he wanted her with him: "Ah *petite* rose the thing I want most is for a good fairy to pick you up in the air and bring you to me because I want to. . . . Oh but I was about to say something silly but I love you with all my heart." After his signature he added a note about how much he wanted her to write: "Tell me everything that you do don't hide anything." But Rose could barely write. His next letter began reproachfully: "You never fill your paper it sounds like you don't want to sit too long at your writing table." He even threatened that she might need to write for another whole year because Strasbourg is "a paradise of delights," a place in which he might like to stay. Before he ended his letter, he took back the threat: "I see you in a desperate state. . . . Don't get angry I'll come back soon or I'll send for you," and he closed with a plea that she take care of herself, that she not get sick: "*Ah, ma chère ami* [sic], explain to me all the troubles you are having now because they truly interest me."

Something Auguste still didn't seem to understand about Rose was that she could barely write.

The Commission That Changed Everything

Rodin returned home that winter to find the city so cold that the Seine had frozen over. These were bitter days, and not just because of the weather. As Rodin approached his fortieth birthday, he was profoundly aware he was still living the life of a journeyman sculptor, spending most of his time on projects that were not his and that gave him little satisfaction. However, two things had happened in 1879 that offered some hope. His Salon entry, a *Bust of Saint John,* though ignored by critics, was recognized by the judges as worthy of an Honorable Mention. The second thing that mattered was an important change in the political arena: a young deputy in the National Assembly who had sought Rodin out personally at the Salon of 1877 to congratulate him on "his figure" had become the Undersecretary of State for Fine Arts. His name was Edmond Turquet. When Rodin came home from Strasbourg, he lost no time in making an appointment to see the new secretary. Perhaps Turquet would remember him, and perhaps he would rescue the much maligned figure that he had admired two years earlier. In fact, Turquet was open to such a request, and he proceeded to appoint a committee of bureaucrats and critics to go to Rodin's studio and have a look at the figure. But their report was not favorable: "M. Rodin is not yet capable of modeling a figure correctly." Rodin—and surely Rose as well—was crushed.

Rodin then found support in an unlikely place: at the national porcelain manufacture of Sèvres, where he where he was now working two days a week. There he became friendly with two other employees, Georges and Maurice Haquette. Sometimes he and Rose would pass a pleasant evening in the company of Georges and his wife, who happened to be Edmond Turquet's sister-in-law.

It was critical in the sequence of events that unfolded in the spring of 1880. The brothers successfully lobbied Turquet for a second committee to examine *The Age of Bronze.* This time the group was made up of sculptors—some of them among the most respected in Paris. And when they went to Rodin's studio, what they saw was "a testimony to energy with a power of modeling that is rare and of great character." They were unanimous in their opinion that the figure had nothing to do with casting from life. Turquet acquired the work for the State and ordered it to be cast in bronze.

The minister was smitten. He had discovered a new and unknown artist of merit. He asked around. Years later Rodin told a friend: "He made inquiries about me just as one gathers information about a maid one is considering hiring." Turquet listened warmly to the Haquettes' enthusiastic recommendations about Rodin's work. The idea of an actual commission came up; in fact, Turquet had one in mind, and he talked with Rodin about it throughout the spring of 1880. They reached an agreement, and Turquet wrote up the commission for a "decorative door destined for the Musée des Arts Décoratifs." Given the fact that the museum had not yet been built, it was a curious commission, but, for a man desperate to be recognized, that hardly mattered. Turquet, in his largesse, allowed Rodin to choose the subject. What Rodin wanted do was a series of reliefs based on one of his favorite poems: Dante's *Divine Comedy.*

There must have been great excitement at 268, rue Saint-Jacques during those summer days when Rodin would arrive home and explain to Rose the latest step in the negotiations. By July he had been notified that he had the right to occupy a state-supported atelier at the Dépot des Marbres on the rue de l'Université. Then finally, on August 16, Jules Ferry, the Minister of Public Instruction, signed the official order for the work. Rodin was to receive eight thousand francs for the finished doors. The first installment of twenty-seven hundred francs would arrive in October.

This commission changed their lives forever. It became the focal point of Rodin's life for the next decade. Further, it allowed him to gather round him a number of assistants, one of whom was a talented young woman by the name of Camille Claudel.

Even with the new source of income, Rodin and Rose didn't move to a better apartment for almost another two years. They found a place on the rue

du Faubourg-Saint-Jacques, a street that continues the rue Saint-Jacques in a southerly direction. Their apartment, number 39, was just beyond the newly finished boulevard Port-Royal and near la Maternité, where their son had been born. A ten-minute walk from there put you on rue de la Tombe Issoire, so they were still moving in the same familiar part of the city. The new apartment—*troisième étage sur la cour* (third floor overlooking the courtyard)—had four rooms. And now they could afford to be more particular about where they lived. The wallpaper was all wrong. In signing the lease Rodin indicated that they found it "just too awful." He requested that their landlord, M. Marsal, cover it with a coat of white paint.

By the time of the move in spring 1882, the whole pattern of their lives had changed. Rodin was so focused on his "door" he could think of little else. When he did find time to relax, it was with new friends—mostly artists—several of whom he celebrated by fashioning their portraits. His group met for meals at the Café Américain. They referred to themselves as members of the "Pris de Rhum," a mocking swipe at the "Prix de Rome," the official honor for which most of them had secretly longed, but for which none of them had ever qualified. This was a very different, more conservative kind of group than that collection of habitués that had gathered at the Café Guerbois in the late days of the Empire. One of Rodin's closest friends in the group was the history painter Jean-Paul Laurens. The sculptor modeled Laurens's portrait and put it in the Salon of 1882, where it caused a mild sensation. Critics were now beginning to consider Rodin's portraits equal to those fashioned by the great Renaissance masters.

Rodin did not neglect Rose in his series of portraits made during this period. He studied her face in a manner that was close up and intimate but without the overt passion he demanded when she modeled for his political monuments. These new works related more closely to the portrait he had done of her in Ixelles, but now, rather than describing her features, he aimed at modeling something deeper, more personal and private. In her lowered eyelids, down-turned mouth, and lips that let only the slightest breath of air pass, there is the most profound quality of inwardness. The surfaces are smooth, and Rose's beautiful hair is pulled back with only a wisp of suggestion of curls across her forehead. From a contemporary photograph we know this is exactly the way she wore her hair in the 1880s.

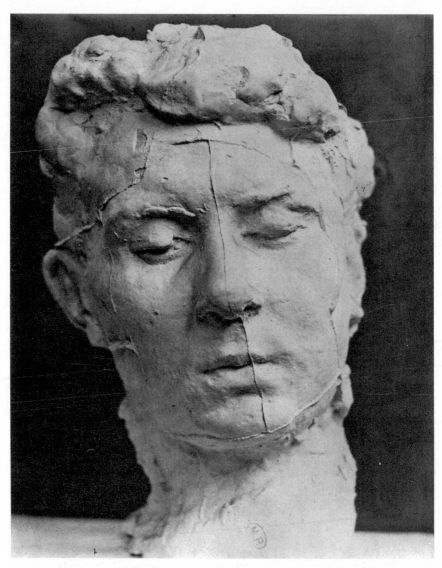

Rodin, plaster Mask of Rose Beuret, plaster, 1881–82. Paris, Musée Rodin

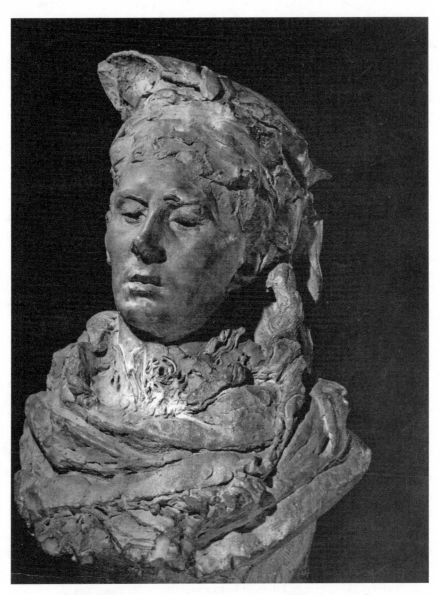

Rodin, Alsatian Woman, terracotta, 1881–82. Paris, Musée Rodin

Soon after completing Rose's head in plaster, Rodin reworked it in terra-cotta, covering her hair with a roughly made Alsatian peasant's cap and placing a lace collar around her neck. Beneath this he twisted skeins of clay—one upon the other—giving the impression of a garment while providing a forceful base for the head. He tilted the whole work back, resting it on a base, the direction adding strength to the asymmetrical play of the forms. The tense and contained image in this unusual work has the power to project the inner force of his model—of Rose—and he immediately put the work into an exhibition in Rouen in October 1882.

A further accomplishment of the early eighties was Rodin's mastery of printmaking. He was particularly intrigued by drypoint and the way the incised lines yielded velvety blacks on either side of the needle's trajectory across the plate. In 1882 he began a drypoint series of his *Bust of the Republic,* which he now called *Bellone.* The work shows Rose, hair falling freely in long, heavy waves on either side of her face, a face heavily set within the shadow of the ornate Renaissance casque. This is Rose, a woman still in her thirties, with a face that betrays a certain sensuality, and yet a face suffused with sadness. Rodin gave one of the impressions to her as a gift, inscribing it at the bottom, "à ma femme."

Occasionally they relaxed. Henri Thurat, Rodin's cousin by marriage, remembered how he and his wife, Berthe, took long walks on Sundays with Rose and Auguste. The four of them would search for a country inn where they could pack in a good lunch of boiled meat and cabbage. Rose was definitely part of the social set of Rodin's artist friends and their wives. She went gladly with the Dalous, the Alfred Bouchers, and the Haquettes. But she did not accompany Rodin when he was invited to participate in the Salon of Mme Juliette Adam, the great hostess of the Third Republic, where, in 1881, he met Léon Gambetta, president of the Chamber of Deputies. Nor did he take her to the home of the prominent collector Ménard-Dorian, let alone to Victor Hugo's famous house on the avenue Eylau, where, by 1883, Rodin was permitted to make drawings of the great man in-between dinner courses.

The social awkwardness for the couple is made strikingly clear by a memory Judith Cladel included in her 1936 biography. Judith's father, Léon Cladel, a prominent writer of the Naturalist school, enjoyed bringing artists and writers together for informal dinners at the Cladel home in Sèvres. By

Rodin, *Bellone* drypoint, dedicated to "ma femme," 1882. Paris, Musée Rodin

1882 Rodin was included in some of these parties. On one occasion, when the dinner was finished, the writer proposed that he and the children—Judith was then about ten—accompany Rodin on his way home. Rodin made it clear that he intended to go by way of the Parc de Saint-Cloud, where "I have a rendezvous with my wife." As they entered the woods, at a distance they saw the silhouette of a woman wearing a large hat and sitting on a bank. Cladel wondered why Rodin had not brought her along to dinner: "We would have been happy to receive her. But his response came with an embarrassed little smile: 'cette une sauvage.' 'Then, we shall tame her.' Blushing and silently thanking his host with an affectionate look, he squeezed my father's hand and left. But, with his next visit, he did not bring his wife. She would wait for him for hours and Rodin's friends were totally ignorant of his private life."[1]

If Rodin did not want to include Rose in social occasions he regarded as high-tone bourgeois affairs, she still remained a solid member of the team that kept his sculpture business going. In the early 1880s, interest in his work was developing among English collectors. Committed to a London trip in 1882, Rodin found he was unable to have lunch with a Paris inventor of a new process of bronze plating that he was trying out. He relied on Rose to fill in: "I hope my darling that to please me you'll go on Sunday to have lunch with Monsieur Danielli." A year later from London: "You'll receive a letter from the man who's supposed to do the photography of the bust of *la République*. . . . You should be at this man's disposal on the day he tells you." And again: "My dear little Rose, On Sunday get dressed and go to the rue de l'Université to see the concierge Mr. Baton and ask him to show you my *Ugolin*. See if it's in good shape. I'll probably be back Thursday" (May 28, 1883).

Financially, things improved. In the fall of 1884 the family moved again to a better apartment, this time on the rue de Bourgogne (around the corner from the present Musée Rodin) near the Invalides, and nearer to Rodin's studio on the rue de l'Université. They had an additional room and two more windows in this apartment, for which they paid two hundred francs above their previous four-hundred-franc rent.

While they were living on the rue de Bourgogne Rose fell ill for the first time. Through a local laundress they met a physician named Dr. Vivier, who treated Rose. Soon after her recovery the Viviers moved to Châtelet-en-Brie, thirty-five miles southeast of Paris. It wasn't long before Vivier got an anxious

summons from Rodin. It seems that Rose had had a heart attack. The doctor came immediately and agreed to take her into his home for a period of convalescence. It was the beginning of an important relationship that would last a lifetime. The Vivier home became a refuge for Rose during many of Rodin's long absences throughout the rest of their lives.

As Rodin's reputation grew, so did the curiosity about his personal life. In 1887, when Truman Bartlett was conducting his interviews with Rodin for the *American Architect and Building News*, Rodin invited Bartlett and his son, Paul, to dine at 71, rue de Bourgogne. Paul mentioned the evening to Adrien Gaudez, a sculptor in their circle. Gaudez could hardly believe his ears. He told Paul that he had no idea that Rodin was married.[2]

Edmond de Goncourt, one of the most malicious gossips in Paris, recorded (and surely embellished upon) a conversation he had with Octave Mirbeau, a critic and a new friend of Rodin's. Goncourt asked about Rodin's wife. "Oh! she's a little washerwoman without any capacity for communication with him and in total ignorance of what he does." "Does he have children?" "Yes, a son, a strange son with a queer eye and the head of an assassin. He never says a word and passes all his time at the fortifications drawing the *backs of soldiers,* backs which his father says can occasionally display genius. . . . Actually, this son is seen only at dinner, then he disappears."[3]

Auguste Beuret showed every sign of being the neglected child that he was. Judith Cladel got to know him in the twentieth century, when, as a middle-aged man, he was able to talk about himself and his youth. She described him as a *"pauvre garçon,* undisciplined, bohemian by nature, capricious, put off by any kind of rule, incapable of sustained efforts." He told Cladel that the best times in his life were those he spent in Vecqueville, where his parents sent him to live with his uncle. He had been happy living with the peasants. They didn't care a jot about learning. However, even in Vecqueville things didn't work out. He was as unruly in the country as he had been in the city, and Rose's family packed him up and sent him back to his parents in Paris.[4]

Another memory of Auguste Beuret comes from Jules Desbois, a sculptor who worked in Rodin's studio. He remembered the day there was a knock at the door of the atelier, and upon opening it he was amazed to find a pathetic figure dressed in rags asking for "Monsieur Rodin." His boss spoke to the visitor in a lowered voice; then they left together. When they returned after

lunch, the stranger was dressed in decent clothes from the nearby secondhand shop. "Sit there and work," was all Rodin said. But a half an hour later, under the pretext of having an errand to run, the man left. "It's my son. He'll come back when he has sold the suit and eaten the money."

Rose and Auguste were not displeased as they saw the approach of Auguste's twentieth birthday, at which time he would be eligible for the military. They hoped this might become his career. Auguste was inducted into the army in 1887.

In Rodin's professional life at this time, political matters were frustrating his plans. As the 1880s progressed, it became increasingly clear that the Third Republic lacked sufficient funds to build a museum of decorative arts. For six years Rodin invested the longest and most intense hours of his life in this project, but by 1887 he didn't even want to talk about it. When a journalist asked to interview Rodin about the sculptor's big relief, he received the following response: "We can talk about the way a sculptor sees nature or even about art in Paris, its hopes and its dreams, but what we cannot talk about are *my doors.*"

The biggest thing happening in France in this period was the planning that was under way for the Exposition Universelle to celebrate the centenary of the great Revolution. Gustave Eiffel had been commissioned to build a tall tower to serve as the linchpin of the entire show. In Rodin's mind this might be the right moment to unveil his door. It's what he hoped for, but he could not find the way.

Another possibility for getting his work into the public eye arrived during the summer of 1889. The idea was Claude Monet's. What if they were to mount a joint show to run concurrently with the Exposition in a commercial gallery? As he considered the idea, Rodin wrote to Gustave Geffroy, a prominent critic and friend to both artists: "My door is more and more my total occupation. I can only show a few things, almost nothing. I'll simply have my name with Monet's and that's it." But Monet dragged him along, and, their show opened on the rue de Sèze in the gallery of Georges Petit on June 21. Rodin had thirty-six works in the show. The effort of getting it ready exhausted him. According to the June 23 entry in Edmond de Goncourt's *Journal,* there were moments during the installation when Rodin exploded: "It seems the most terrible scenes have taken place, during which sweet Rodin suddenly became

a Rodin none of his friends had ever seen before, screaming: 'I don't give a damn about Monet, I don't give a damn about anyone, I'm only interested in myself!'" Surely a Goncourt exaggeration, but there is no doubt it was a time when an extremely nervous Rodin was under great pressure.

For both artists the show was a triumph. Rodin could hardly have dreamed that critics could now see his work in the way they did—"a poet in three dimensions." They said he was creating something no one had ever seen before in sculpture, making figures with the power and the passion that was equivalent to the verses written by Chateaubriand and Baudelaire. Orders began to arrive. Petit confirmed four orders for works in marble, one with a price set at twenty thousand francs.

Given this success, it came as a surprise to many of Rodin's friends that he did not remain in Paris to bask in the praise. He left almost immediately after the show opened. His only letter to Rose written during the period when the exhibition was open was a message of what she should do with his mail: "give [Desbois] the letters that were not included in my suitcase; you made a mistake and left some out, while putting in some of those which were not supposed to be included. Look for anything that has to do with the exhibition in the rue de Sèze." P.S.: "I am making some progress in architecture, and at this moment I am in Toulouse. You can spend a few more days with our friend Vivier. . . . Don't forget to go to the Exhibition often" (August 9, 1889).

Architectural drawings based on medieval doorways that Rodin thought would help him with his design of the frame for his door—the stated goal of the trip—had nothing to do with his trip to the south of France. He was traveling with Camille Claudel, the young sculptor who had become his student in 1882 and who was now his mistress. They were away for two months; after visiting the Pyrenees, they traveled to Auvergne, and then on to Switzerland.

As far as we can judge from the letters that remain to us, the master-pupil relationship turned into an affair by 1885. Such a statement could not have been made before 1988, when four letters from Rodin to Camille turned up mysteriously at the Musée Rodin. As Claudel's biographer Odile Ayral-Clause points out, though the Rodin-Claudel affair was fairly well known in the nineteenth century, it was never spoken of in print. Even Judith Cladel, who knew a great deal about it, mentioned it only by inference, avoiding any use of the name, Camille Claudel.[5]

Camille Claudel was twenty-four years younger than Rodin. The Claudel family, especially Camille's famous brother, the writer Paul Claudel, came to see Rodin as a villain, a man who had used a young, innocent, talented woman for his own purposes. These accusations hung like a shadow over the half-hidden story of their relationship. But once we were able to read Rodin's letters to Camille, we were able to grasp how profoundly he loved her. In the earliest letter, apparently written in 1885, Rodin addressed her as "ma féroce amie," after which he proceeded to tell her how distraught he was in view of her indifference and coolness in his regard. He spoke of searching for her in all "our favorite places." He pleaded: "I can't spend another day without seeing you." And he promised: "My Camille be assured that I feel love for no other woman, and that my soul belongs to you." So Rose had been put aside as the emotional center of Rodin's life. She must have been the recipient of a large number of lies and half-truths throughout this long, dark period.

Camille Claudel did not remain indifferent. As Rodin's stock rose in the highly competitive Parisian art world, he began to look like someone she might want to depend on—for life. So what of Rose? Those who knew Rose, and those who only gossiped about her, knew her as "Madame Rodin." But Camille Claudel knew this was not the case, that her mentor was very much not married, even though she herself had invited him and "his wife" to come to her home and meet her very bourgeois parents. Years later Louise Claudel wrote to her daughter about "the disgraceful comedy you played for us! I was so naïve that I invited the 'Great Man' to Villeneuve with Mme Rodin, his concubine! And you, playing the sweet young thing, were living with him as a kept woman."

A remarkable document, in Rodin's hand, was found with the letters he wrote to Camille. It was signed and dated 12 October 1886. In it he made a series of promises, among them the promise to have "no other student other than Mlle Camille Claudel . . . so that there will be no chance of rival talents being created"; also, he said he would help her get her work into exhibitions and reviewed by critics. But the promise that stands out is the one outlining a spring trip to Italy where "we will stay for 6 months, living communally in an indissoluble liaison, after which Mademoiselle Camille will be my wife."

Once her goal was set, Camille Claudel fought hard. She was jealous of every woman in Rodin's life, and of none more than Rose Beuret. In the

Camille Claudel, "*Le Collage,*" 1892.
Paris, Musée Rodin 2008 Artists Rights Society
(ARS) New York/ADAGP, Paris.

fall of 1890, the Rodins moved to yet another apartment, this one on the rue des Grands-Augustins in the Sixth Arrondissement near the Pont Neuf. A few months earlier Rodin had rented the "Folie Neufbourg," a dilapidated old eighteenth-century building on the boulevard d'Italie, not far from where Camille lived. This was to be a studio which they would share. But when night fell Rodin returned to the rue des Grands-Augustins, a fact that embittered Claudel. She expressed her angry scorn of Rose in a series of caricatures. And it would appear she gave them to Rodin, as they have always been a part of his personal collection. One shows the old couple, locked in an embrace and waking up in bed, the woman—pug nose, hair piled on her head—taking her clawlike index finger and pushing it into the flesh of her sleeping partner. It bears the title "Waking Up, Mild Reprimand by Beuret." In "The Jail System" we see a naked hag, big feet, dropped buttocks, pacing, guardlike, outside the enclosure containing her bearded prisoner in chains. And finally there is *Le Collage* ("Glued Together," slang for an unmarried couple living together), under which Camille wrote, "Ah! It's true! That does hold?" Two pairs of buttocks are glued together, Rose with pendulous breasts, on all fours, while Auguste, pulling with all his might, holds on to a tree trunk as he struggles to wrench himself free.

271

Camille penned her angry caricatures in the early 1890s. In them she revealed her scorn for Rose; she also revealed her fear of losing the contest. For her part, Rose was terrified that it would be she who would be left. Many years later, tears running down her face, she described all the New Years Days she had spent alone, "while Rodin was squandering money and flowers on that 'odious C.'"[6] Rainer Maria Rilke never knew Claudel, nor did he know Rodin and Rose in this period, but later on he heard about that time and how exhausted Rodin was, "not because of work, but because of the unhealthy situation in that apartment without sun on the rue des Grands-Augustins."

Early in 1892 Camille moved out of the Folie Neufbourg and took a place near the Eiffel Tower at a significant distance from the boulevard d'Italie. It was her decision to become independent of Rodin, and, from that time on, Claudel's letters to Rodin took on a coolness, the distance between them becoming ever more evident.

Mathias Morhardt, a writer and journalist who was close to both Claudel and Rodin, explained his perspective to Judith Cladel when she was writing her biography. He was convinced that Camille "wanted Rodin to leave his poor old Rose, who had been his companion during his days of poverty and who had shared his long misery. But he could not bring himself to do it."[7] This view of the situation is echoed in the words of Emile Bourdelle, who worked as one of Rodin's assistants in the 1890s. As Bourdelle explained it to his wife, Cléopâtre, "It was something very important in himself, something at the very base of who he was, that kept him from abandoning poor Rose, that's all."[8]

The Cladels—Judith and her widowed mother—lived just around the corner from the rue des Grands-Augustins. Judith remembered her walks by the ancient building where Rodin lived with his "old mistress," which is the way she referred to Rose, who was not yet fifty. Sometimes Judith would look up at their windows, and she would think about that "sad woman, partially hidden behind a curtain."

A House in Meudon

"One morning a moving cart stopped in front of the old house. Rodin himself supervised the loading of a few pieces of furniture and a large number of sculptures onto the cart. He said that for his wife's health, as well as his own, they were obliged to move to the country. He chose Bellevue and they moved into an apartment in a narrow little lane called the chemin Scribe."[1]

But it wasn't Rose's health that made them leave Paris. A broken heart was more like it. As Camille Claudel needed breathing space, so did Rodin; the move established distance between him and memories of his life with his beloved protégée. But Rodin must have understood that life away from the city would be better for Rose as well.

Another problem was "Balzac," Rodin's most important commission since "The Doors." To it he now attached all his hopes for a major success. The commission had come to him a couple of years earlier thanks to the intervention of Emile Zola, who had made the decision in 1891 immediately after assuming the presidency of the Société des Gens de Lettres. The prominent writers' organization was committed to seeing a monument to Balzac, one of its most important founding members, raised in a public place in Paris as soon as possible. Rodin understood that the commission resulted from a personal decision on Zola's part and wrote to the author he so admired: "It's thanks to you, here I am the sculptor of Balzac and patronized by Zola." He committed himself to delivering the work in 1893. Although he had made dozens of studies by the deadline, a monument was nowhere in sight. It was another reason to get out of town.

The weather was still cold during the first week of April in 1893, when

Rodin and Rose moved into the Maison du Chien Loup—so named for the door-knocker in the shape of a German shepherd. The house, high on a hill in the Bellevue section of Meudon, southwest of Paris, was owned by M. Durand, a stone carver who worked in the cemetery of Montparnasse. They would share the premises with a gardener, Joseph Berchery; his wife, Maria; and their six children. Rodin probably decided on taking this particular apartment because of the atelier on the top floor, from which he could look down and follow the course of the Seine all the way to the Ile Seguin. But, to be sure, he continued to do most of his work in Paris.

It was a bad period. Rodin began to travel for escape. One brief trip took him to Giverny, to Monet's home, where Paul Cézanne was also expected for a visit. Monet had hoped to wrench Cézanne free from his isolation in the south, so he invited him along with Rodin and the writers Gustave Geffroy and Octave Mirbeau, the two men who contributed so much to the success of the their 1889 exhibition. When Rodin met Cézanne—it was for the first time—he shook the painter's hand affectionately, a gesture that moved Cézanne to tears, for he held Rodin, this artist who had recently been named an officer in the Légion d'Honneur, in great respect. Later Cézanne took Mirbeau aside, exclaiming: "He's not proud, Monsieur Rodin; he shook my hand!"

Rodin's depression and sense of loss continued well into the nineties. Though no one could replace Camille, there were a number of women now seeking his company. One was a young Parisian socialite, Hélène Porgès Wahl, with whom Rodin spent a day walking in the Engadine during a trip to Italy at the end of summer 1895. Following the pleasures of that tête-à-tête, he wrote some highly reflective personal letters to Wahl in which he shared his sense of growing old, of knowing that he had many things yet to do, things which others had already grown tired of but things which "I still want." In a letter written from Menaggio, Rodin confessed to Mme Wahl that "except for my sculpture, I have lived as a rude man, a stranger to beautiful things!" (September 1, 1895). A few days later, from Lugano, he posted a letter to Rose. No confession here, nothing of intimacy, simply: "I'm on my way home. I was in Milan where I couldn't sleep because of the heat. Otherwise I'm fine . . . don't expect me for another 10 days or so."

In Rodin's absence Rose suffered from familiar bouts of jealousy. She spoke of her pain to their neighbor, Mme Renard, who had often been in the

couple's company. Mme Renard assured Rose that she was certain "Monsieur Rodin vous aime." To this Rose simply replied that there were ways to love and ways to love.

Some of Rodin's unfulfilled yearnings came to focus on a house. He had discovered it one day while walking in Meudon. On a hill, on the opposite side of town, he came across a brick villa. It was not particularly old, though it was constructed in *style Louis XIII,* with vertical chains of yellow stone, a high roof, dormers, and a prominent chimney. Running the width of the house there was a big sign: à VENDRE OU à LOUER (For sale or rent). On the other side of the house he discovered a large artist's studio. Upon inquiry he found that the property belonged to a painter, Mme Delphine de Cool, a recent widow who felt the house to be too isolated for her to live there alone. She had already vacated, and it was now available. Rodin decided that this was what he wanted—this would be his house. At first he thought he'd rent, but that didn't work out, and in December 1895 he purchased the Villa des Brillants for 27,300 francs.

Rodin and Rose moved in. There were no houses near the villa, nothing but bushes and trees, a great tangle of greenery. When Rodin returned from Paris in the evening he walked down the long allée, bordered on either side by a row of chestnut trees, into a paradise of silence. He could go to the edge of the property and look into the valley, past the houses of the town of Meudon with their red-tiled roofs, and pressing against the banks of the Seine, beyond to the Pont de Sèvres, and further still to the woods of Saint-Cloud and Ville d'Avray.

Rose surely took enormous pleasure as she mounted the front steps of *her* house, turning right into the little salon, opening the folding doors to the dining room, going upstairs where she found two bedrooms on the *premiere étage*—the back one would be hers. Rodin took the front room, in which he placed his new bed—*style Louis XVI*—so that from his bed he could survey the river's bend, the bridge at Sèvres, and the steeple of Saint-Cloud. Over it he hung an enormous painted Spanish crucifix. Up another flight of stairs there were four more rooms. They would easily accommodate the servant they would soon hire, and there remained plenty of room to store the hundreds of boxes Rodin had been accumulating of his correspondence and records. Finally, there were tiny steps up to the large attic. Rose would actually spend

Auguste Rodin and Rose Beuret in the garden of the Villa des Brillants in Meudon

the bulk of her time in the basement, cooking, washing, and making sure the *cave* was amply stocked. She still received shipments from the family vineyards in Vecqueville.

They called it their "chateau," and they loved it, especially the garden. They moved the furniture in—beds, tables, chairs, some paintings that artist friends had given to Rodin. No rugs. The whole thing was too much for Auguste Beuret, writing, when he had apparently been urged to come for a visit: "Je ne peut pas m'habitue au Chateau" ("I can't get used to the Chateau") (November 20, 1901).

On September 2, 1902, the German poet Rainer Maria Rilke, having just signed a contract to write a book about Rodin, arrived at the Villa des Brillants for the first time. That evening he wrote a long letter to his wife, Clara, about his day. Among his many observations was "the villa, which he [Rodin] himself calls *un petit château Louis XIII*—is not beautiful." A few years later Rilke came back, this time to work as Rodin's secretary, and to live on the property as if he were one of the family. There were other foreigners who

served in a similar capacity. Two of them—Frederick Lawton and Anthony Ludovici—were from England, and they, too, wrote about their experiences. The former, impressed by the "Spartan severity and apparent incongruity of arrangement" he found in the villa, described it as a "nondescript" house. When Ludovici entered the dining room for the first time, he was "immediately struck by its plainness. But for a dozen white straight-backed chairs and a trestle table, the room was entirely bare; the walls, which were of a pale, even colour, stretched out on all sides with nothing but a picture by Falguière to relieve their reposeful monotony, and the floor was uncarpeted." Rodin, sensing implicit criticism, became defensive, pointing out the benefits of having "no obtrusive and artificial objects" that might prevent him from being in harmony "with the fields and hills about me." The same defensiveness arose when Ludovici looked around for a comfortable chair in which he might sit. Rodin lashed out at the "self-indulgence" of English comfort: "When I am tired I go to bed altogether."[2]

The Danish painter Fritz Thaulow and his wife, Alexandra, who had become good friends of the couple, also noticed how much pleasure Rodin got from "the peace and quiet which reigned in the simple rooms where there were hardly any chairs to sit on."[3] The majority of visitors to the Villa des Brillants, mostly people who had known nothing but bourgeois comfort all their lives, could not imagine the poverty in which their hosts had formerly resided, and thus their present situation seemed incomprehensible.

These apparent lacks concerned Rose very little. What she gloried in was the experience of stepping out of doors. She became free as she had not been since she left Vecqueville. She walked into the garden, her dogs, Cap and Thérèse, following in her steps as she visited her pigeons and her canaries. But her favorites were the parrot and the tame monkey. She was angry when Rodin declared that the henhouse would have to give way to becoming yet another storage space for sculpture. Maybe she forgave him in 1906, when he got it into his head to purchase a horse. Ludovici was living with them at the time, and he reported that the project was discussed at many a meal: "Of course, the idea of a horse and carriage of their own completely took Madame Rodin's breath away." She was very worried about the domestic aspects of such an undertaking. Where would a coachman sleep, and what would be the arrangements about his food? It all worked itself out when they did purchase the horse, and

Rose Beuret with coachman and horse in front of the Villa des Brillants

M. Griffuelhe, who lived nearby, sold his cows in order to become their coach-man. From this time on, in good weather, between 6:30 and 7 in the morning, Rodin and Rose could be seen setting out for a ride in the country.

The horse had been such a success that Rodin began to think about buying Rose a cow. He got the idea from Dr. Vivier. In the fall of 1906 the couple visited the Viviers in Châtelet-en-Brie, and it was then that Mme Vivier mentioned the cow to Rodin. She told him he could get one that gave excellent milk for about 350 francs. After various problems and months of negotiations, Dr. Vivier was finally able to write on January 7, 1907: "Coquette (that's the name of your cow) was put on the train today. . . . She is very sweet, but for the first few days be prudent, just until she knows you." How can we not imagine the joy of Rose Beuret as she made the acquaintance of Coquette?

Our knowledge of Rose at home—what she looked like, how she inter-acted with guests, and the dynamics of Rodin and Rose as a couple—is best discovered in the writings of the live-in secretaries who occupied the little three-room cottage on the edge of the property. They—these substitute sons—usually ate with the Rodins. Their initial perception would be one of being scandalized by Rose, by her appearance, her temper, her lack of conventional

manners. On his first visit to Meudon in September 1902, Rilke had been invited to stay for lunch,

> which was taken in the open and was very odd. Madame Rodin (I had seen her before—he did *not* introduce me) looked tired and on edge, nervy and listless. . . . Scarcely had we sat down when Rodin began complaining about the unpunctuality of the meal. . . . Thereupon Madame Rodin got very agitated. *Comment puis-je être partout?* [How can I be everywhere?]. . . . A flood of violent words came out of her mouth, they did not sound exactly angry, nor ugly, but as though coming from a person deeply aggrieved whose nerves would snap the next moment. A restlessness possessed her whole body—she began to push all the things about on the table, so that it looked as though the meal were already over. . . . Rodin was quite calm, went on talking very quietly, saying *why* he was complaining, outlined his complaints with precision, spoke at once gently and inflexibly. . . . Sometimes Madame took part [in the conversation], always talking very jerkily and passionately. She has grey hair, dark, deepset eyes, looks thin, listless, tired and old, tormented by something. After the meal she spoke to me in a very friendly way—for the first time as mistress of the house—invited me, whenever I was in Meudon, to come to lunch.[4]

In September 1905 Rilke moved into the little cottage on the property. By then he had become close to Rose, and he described her to Clara as "a good and faithful soul." Just like a family, the three of them would go on day trips together, to Chartres to see the cathedral, or to Versailles. In an enthusiastic letter home Rilke wrote of how on "the last three mornings we have gotten up quite early at 5:30, yesterday at 5 even, and drove out to Versailles." Rodin and Rilke carried on lengthy discussions about what it meant to be in harmony with nature, "and while we talk of these things, Madame Rodin picks flowers and brings them: autumn crocuses or leaves. Or she draws our attention to pheasants, partridges, magpies (one day we had to turn home early because she had found a sick partridge and took it with her to care for it), or she collects mushrooms for the coachman" (September 20, 1905).

Rainer Maria Rilke with Rose and Rodin in front of
Rodin's gallery of antique statues in Meudon

Rilke left in May 1906. The following month Ludovici arrived to take
his place in the little cottage on the side of the hill. He met Rose as soon as
he arrived: "Madame Rodin appeared—a frowning, tragic little figure, clad
in a light *negligee*. She seemed quite unable to take more than a perfunctory
interest in my arrival." Ludovici soon noted the stream of visitors who came
to visit Rodin's studio, and he observed that the artist usually invited them to
lunch: "I was frequently moved by the extreme agitation shown by the poor
little woman when she used to come to discuss the arrangements with me.
She hated these functions . . . and bewailed the fact that these people insisted
upon disturbing her in her peaceful rural retreat." Ludovici grew to like Rose,
however, and to feel protective of her: "All of us at Meudon used to address
Rose Beuret as Madame Rodin, and when the prurient curiosity of certain
lady visitors prompted them to question me privately concerning Rodin's
relationship to the silent, handsome old lady who used to sit anxiously at the
table, never daring to draw attention on herself when guests were present, I

invariably lied that Rodin was legally married to her. It is only right to reward such gross indiscretion with false intelligence."[5] After spending six months as a virtual member of their family, Ludovici concluded: "I have no hesitation in saying that [their relationship] was an exceedingly happy one," and that Madame Rodin "was certainly indispensable to the great man with whom her lot in life was cast."

Perhaps women understood better how demoralizing it was for Rose to be constantly receiving the large number of intruders who trooped up the entrance allée of the Villa des Brillants to visit "Monsieur Rodin," as Rose called him when they were in the presence of anyone else. Alexandra Thaulow had understood immediately. She knew the meaning of those dark, suspicious glances, and she had gone out of her way to win Rose's trust. On her first visit to Meudon she went down to the kitchen at once, and "seated myself on the threshold in order to help her shell the peas for our dinner."

Another female visitor was the Hungarian writer Sandor Kémeri. She had met Rodin through their mutual friend Anatole France, and she came out to Meudon for the first time in 1906. As she and Rodin moved through the great exhibition space, examining his works together, Rose walked in. "She reminded me of a poor little bird that has flown in through an open window, wondering if it was among beings that are good or bad." But Rodin then left the two women alone, and they soon became friends. It was clear to Kémeri that Rose Beuret loved Auguste Rodin with all her being, and that whatever was bad in their shared life came from other women. "She was jealous even in old age. She was like a guard dog—faithful—but she could bite."[6]

TWENTY-EIGHT

The Dark Side of Being
the Old Mistress of a Genius

On a hill, not more than half an hour's journey from Paris, this greatest of all living sculptors—the "Shakespeare in Stone," as he has been called—has his studio and his unpretentious dwelling house. At the age of sixty-five, he has at last come into his own, and his genius is now universally recognized.

WILLIAM G. FITZGERALD, 1905

Balzac was finally finished in 1897. At last the public would be able to see Rodin's statue. On May 1, the opening day of the Salon of 1898, visitors immediately grasped its monumental presence at the far end of the Galeries des Machines in the Champs-de-Mars. It was big, white, and grand. Clearly its power was extraordinary, yet a drumbeat of condemnation was quick to sound—*ordure* (garbage) and *monstreuse* were adjectives favored in the press. The real blow, however, came on May 9, when the Société issued its statement: "The Committee of the Société des Gens de Lettres regrets that it has the duty to protest against the sketch exhibited at the Salon by M. Rodin, in which it refuses to recognize a statue of Balzac." Many of France's leading contemporary artists—Monet, Toulouse-Lautrec, Maillol, Debussy, Valéry, and Anatole France among them—banded together to open a subscription in order to collect the money necessary to see *Balzac* erected somewhere in the capital. In the end, Rodin turned his back on the venture. He took his seven-foot plaster figure home to Meudon.

To understand what happened next it's worth asking the question: *if* the French government had built the new Museum of Decorative Arts in which it would have been able to install Rodin's door, now called *The Gates of Hell*; *if* his *Monument to Victor Hugo* had been the one chosen to honor Hugo in the Panthéon; and *if Balzac* had been cast in bronze by the Société des Gens des

282

Lettres and installed at the Palais-Royal as Rodin had hoped; would he have made the decision he did in the closing year of the nineteenth century, a decision that was to alter his life profoundly—as well as that of Rose Beuret—forever? Probably not.

After the debacle of 1898, Rodin surveyed the work in his various studios and understood how much he had produced, yet the fact was, with the exception of *The Burghers of Calais,* commissioned by the northern port city in 1885, and a monument to the painter Claude Lorraine for the city of Nancy, none of his major works had resulted in planned installations in their intended locations. Rodin then turned to exhibitions, and particularly to the idea of mounting a major exhibition to take place at the time of the 1900 Exposition Universelle, the great world's fair with which the government was planning to celebrate the turn of the century. He selected a site with a distinguished history for such use: the place de l'Alma on the Right Bank near the river. It's where both Courbet and Manet had mounted personal exhibitions when they, too, were sidelined by officials of the French art world. Rodin borrowed money, hired an architect, and planted himself and his work at the edge of the gigantic undertaking in which seventy-six thousand exhibitors from all over the world were expected to set up displays in order to show off their art, their civilizations, and their discoveries to one another, as well as to millions of visitors who would come to Paris that summer. There would be Germans, British, American, Scandinavian, Japanese, and Italians, along with many others, walking into Rodin's exhibition, and he would be there to greet, to explain, and to show off his art to any curious visitor who might care to come inside. One such visitor was Helene von Hindenburg, a twenty-one-year-old woman from Berlin who arrived with her mother. She later recalled her encounter with Rodin in his pavilion at the place de l'Alma: "He stood there with his long beard, his head bowed, silently contemplating one of his statues. At first he did not approach us. Then the miracle occurred. A new world, filled with a light that appeared to emanate from his work, opened before my eyes. The vibrations of my feelings led him to me and we found speech, speech that was to last between us beyond death itself."[1] And, in fact, they remained devoted friends until separated by war.

The Exposition Universelle would end on November 12. But Rodin was enjoying himself, and, as the exhibitors around him were closing their doors,

The Pavilion of Alma rebuilt in 1901 next to the Villa des Brillants

he kept his open. He thought of applying for permission to remain there in-definitely, but such an official blessing seemed unlikely, and demolition work got under way the following spring. Everything was packed up and sent to Meudon. Rodin invested fifteen thousand francs for the purchase of the land in front of their house, which was to accommodate the reconstruction of his pavilion. He made the purchase in Rose's name, but this "gift" would give her little pleasure. Into it Rodin installed the creation of a lifetime. The critic Gustave Coquiot wrote of the manner in which the new building conquered this "serene place." Like a classical temple it was "saturated with light as ma-jestic peacocks walk around fragments of antique statues beside the master's own plasters now filling the *hall-musée.*" But Coquiot also recognized the museum as a testimony to "the bitterness of Rodin's life, all the injustices, all the hatreds that have assailed him . . . all the projects for works that remain simply projects." They were all there to be seen.[2]

For almost six years Rose had been able to live freely in her country abode. Now Rodin invited the world to come and see what he had done in his lifetime, and the daily rhythm of the Villa des Brillants changed for-ever. If, in their earlier life together, Rodin had felt it was impossible to bring

Rose—so uninstructed in the ways of society—into polite company, that was the past. The villa was Rose's home, and almost everyone who visited made her acquaintance.

We get the flavor of Rose's new "social life" from a visit by a young art critic writing for *Corriere della Sera*. Ugo Ojetti came to see the new pavilion shortly after it was erected. He and Rodin were deep in conversation about the Etruscans, the Greeks, and Michelangelo, when Rodin suddenly remembered they hadn't had lunch: "He began to clap his hands and to call out, 'Rose, Rose, you've forgotten our lunch!' . . . At the top of the stairs there appeared a spare, unkempt, perspiring old woman, all nose. . . . She held up two bottles of wine to defend herself from the reproof. Under one arm she was carrying the folded tablecloth. . . . '*Vite, vite,*' Rodin repeated harshly. . . . That good little old woman standing up, her hands on her hips, watched us eat, pleased by our appetite. . . . After they had their coffee, Rodin poured out another glass of wine and with a regal gesture, without looking at her, said: 'Rose, sit down here. You're going to drink a glass of wine with us.'"[3]

Though Rose was four years younger than Rodin, the gossip was always about "the old woman." A characteristic story went like this: "One day, when some friends were dining with Rodin, one of them said to him in confidence: 'Monsieur, why don't you get rid of this terrible old woman who prowls about the place? What you need is a fresh young housekeeper who would make your life worth living.' Rodin seemed to enjoy the joke immensely and often told afterward how discomfited his friend looked when he explained that the terrible old woman was none other than Mme Rodin herself. And thus Mme Rodin became known as the artist's wife—but she . . . never took part in any of the entertainments; always waited on the table, did the cooking and the housework, all as a matter of course."[4]

Those who got to know Rose saw her in a different light. Like Rilke before him, Ludovici found her worthy not only of his attention, but also of his affection. In his "Reminiscences" he spoke of being "honored" to have been taken into her confidence in those moments when she needed to confide in someone about the difficulties of her life at the Villa des Brillants. Nevertheless, he reported that she was basically uncomplaining "about the treatment she received at the hands of her lord and master . . . her devotion seemed to set no limit. . . . Occasionally she might perhaps come to me, lamenting over the

many harassing engagements and activities that sometimes conspired to ruffle Rodin's temper; or she might in a rare mood of revolt comment bitterly upon his thoughtlessness in asking her to put on his boots directly after luncheon, instead of before the meal, as the effort of bending over his feet and buttoning his boots, so soon after eating, disturbed her digestion."[5]

As the stream of dignitaries intensified, so did the stories of encounters with Rose. Lawton tells of the day the prince of Annam arrived. Rose, busy doing the laundry, had seen the foreigners walking in the yard but didn't think her presence was necessary. However, the prince announced that he wished to meet Mme Rodin, and she was summoned. She came from the laundry room, full of embarrassment, apologizing for her appearance. But understanding, the prince held up his hand at the moment he addressed her, saying: "Madam, see this hand, it can draw, and paint, and dig."[6]

We hear a similar story about the visit of the Japanese ambassador. Rodin, sensitive to the Japanese love of flowers, ordered white peonies, pink roses, and white carnations to be scattered about the bases of his statues. The ambassador, assuming this special courtesy must have been the work of the sculptor's wife, asked to be presented to her. Rose was called, only to appear once again "in a blue apron, sleeves rolled up and arms covered with soap-suds."[7]

Sometimes when Rose was informed in advance that an important visitor was expected, she would go to some trouble to make herself ready for the guest's arrival. Such a person was Minister Georges Leygues, whose portrait Rodin was working on at the time. Ludovici tells us that "she thought it necessary, in view of the eminence of the visitor, to make an especially noble effort in her apparel; and to Rodin's horror, he espied her just before lunch through the open door of the studio crossing the garden in a brilliant confection of crimson silk or satin. I was immediately summoned to the studio by the master, and, leading me aside, in a few hurried sentences he ordered me to prevail upon Madame Rodin to change her dress instantly, and to adopt a quieter garment, no matter how long her change of toilet might delay the meal."[8]

Famous people from many countries made the pilgrimage to Meudon. Many of them met Rose, but there was one visitor whom Rodin made sure would not meet her. On March 6, 1908, King Edward VII of England, having finished his official visit with Armand Fallières, the president of France, drove out to Meudon in the pouring rain to visit Rodin. The two men had met at

Buckingham Palace a few years earlier. For this day Rodin wanted it to be clear: Rose was to stay in her room. Judith Cladel tells us that "she watched the arrival of the august visitor in the company of a faithful servant from behind the Venetian blinds."[9]

Rodin's foreign secretaries provide the clearest understanding of what it was like to be in daily contact with Rodin. Ludovici found that it was "never an easy task to be associated . . . with a man of genius." In fact, he realized he himself was unable to maintain the necessary attitude of unflinching sympathy, tolerance, and devotion, and at the end of six months he departed. He also noted, that, what he himself had been unable to give, Rodin received from the large flock of women now surrounding the sculptor. His predecessor, Frederick Lawton, had come to the same conclusion, noting that Rodin did not form intimate male friendships; rather, "an essential requirement of his soul is feminine affection."

By the time Rodin was in his mid-sixties, he had begun to accept the idea of his own genius as credible. How could he not? So many people had told him it was so. And when the words of approbation came from a female admirer, it pleased him immeasurably. Such a person was Jelka Rosen, a German painter living with Frederick Delius in Fontainebleau. She wrote to him about the "sublime moments" she had spent in his presence, and that she just wanted to be able to touch the "brow of his genius." Such expressions of admiration became ever more frequent, fueling Rodin's ego and encouraging him to yield his friendship to a bevy of younger women.

His secretaries have told us how Rodin spent his days: up at dawn (or earlier), work in the studio, a little trim to hair and beard by the hairdresser before eight, and then several hours for correspondence and paperwork. Ludovici called him a *monstre paperaissier,* noting that "two whole rooms in the Villa des Brillants were given up to this passion for the accumulation and preservation of the letters, invoices, vouchers, estimates, and receipts of a lifetime." Then Rodin was ready to greet guests, who might stay to lunch, after which he took the train into the city. If there was no function in Paris in the evening, he would be home for dinner and retire at sundown or soon after.

Marcelle Martin met Rodin in 1906 and worked for him on and off until his death. Of all his secretaries she was the one who spent the greatest amount of time with Rodin and Rose together, and she described the dynamics between

them, which seem to have consisted of a rich stew of heated arguments: "He and his wife would quarrel over the merest trifle. Both possessed uncertain tempers and they sulked like a couple of children. They were ashamed of themselves, but neither would give in. As these fits of temper became chronic, they devised a highly original cure. The first to get in a temper and aggravate the other must hand over a hundred-franc note as a penance. I was to be the judge, and to be truthful, I must admit that it was always Rodin who began. He would fly into a rage for nothing at all." Martin described Rose's jealousy as acute and evident to everyone: "She had a mania for posing as a victim when people came near her, especially if they flattered her." But Martin was convinced that "Rodin never really loved anyone else." I see this as an "in-house" point of view. Martin was extraordinarily loyal to Rose.[10]

Rodin's afternoons were almost always spent in Paris, primarily at his studio on the rue de l'Université, but he had to check on other studios as well, on his marble carvers and his mold makers. And he reserved a great deal of his time for his women—women as models, women as adoring public, and, some-times, women as lovers. These are the years in which Rodin drank to the fullest of his intoxication with women's bodies, making thousands and thousands of drawings—sometimes a half dozen models would be lingering in his studio—it was his "bacchanalia on paper." It's an obsessive collection of spontaneous recordings of the inner dynamics of women's sexuality. Sometimes he asked models to masturbate or to make love to each other. And it seems that with Rodin they were not uncomfortable or embarrassed. Rather, they were free. Did Rose know of these drawings? I can't say. A small number were published in a special issue of *La Plume* in 1900, causing British critic Arthur Symons to conclude that "the principle of Rodin's work is sex." After going through boxes and boxes of these late drawings of women, curator and author Catherine Lampert came to consider the drawings as direct manifestations of Rodin's libido—his way of paying "homage to the natural beauty of every woman."[11]

In Rodin's lifetime some who knew these drawings considered them the work of a man who was becoming senile, even depraved. But now it's not unusual to find critics claiming them as the most original and finest production of his late years. After 1900 Rodin no longer needed to worry about money. He was regularly commissioned to do portraits of prominent people; he was able to sell casts of finished works or have marbles pointed up by others sculptors

from existing plasters. He did receive two major commissions, however, for monuments to Whistler and to Puvis de Chavannes, both artists for whom he had great admiration. But he never finished them. He was more focused on things that gave him pleasure, and his drawings did just that.

Of the dozens and dozens of women who modeled, one stands out: Gwen John, a young painter from London who arrived in Paris in February 1904. A few months later she was knocking on the door of Rodin's studio: could she pose for him? She was tall with a strong body, small breasts, a columnar neck, a receding chin and long reddish-brown hair parted in the middle. She modeled for some of Rodin's erotic drawings, but of much greater importance she posed for the greatest monumental figure he created in the twentieth century: the muse for the "Whistler Monument."

Gwen John comes alive in this particular story, however, for another reason: she wrote Rodin almost a thousand letters documenting her affair with him. It started after posing sessions. They made love in his studio, but before long he was visiting her in her room on the boulevard Edgar Quinet, near the Gare Montparnasse, from which Rodin departed for Meudon at the end of his afternoons in Paris. Quickly and radically Rodin's interest and focus on her body in its various manifestations changed John's whole life. When he suggested that he try and sell some of her drawings, she turned the offer down; she no longer wanted to be an artist: "I am your model, and I want to stay being your model for ever. Because I'm happy." She fell so hastily and deeply in love with Rodin that all else paled. She took to writing him almost daily, expressing her contentment over their relationship, the joy she felt when his "thumb" was thrust into her "affair" and that even when her "poor little affair" was worn out, it wanted more. Nor was John particularly threatened by the existence of "his old mistress." She knew they slept in separate rooms. Once she even went to Meudon, peered over the garden fence of the villa in order to catch a glimpse of Rose. She thought Rose had great dignity.

Did Rose know about Gwen John? Probably not. So many women passed through his studio. Judith Cladel referred to John as just another one of his "hysterical models." But Rose remained, at this time, a regular part of Rodin's life. She accompanied him to friends' homes and frequently put in considerable effort to cook lunches for visitors to Meudon. Among the guests who came in the spring of 1906 were Mr. and Mrs. George Bernard Shaw. They

both enjoyed pleasant sociable moments with Rose at the Villa des Brillants. Judith Cladel remembered that at such times, when guests offered their thanks, Rose was apt to say in a mildly embarrassed fashion: "I'm just an old peasant, who's never been to school, but I was well brought up."[12]

Since Rodin had such an obsessive habit of holding on to letters, we know that scores—maybe even hundreds—of women were interested in knowing the great sculptor, of visiting him in his studio, of socializing with him or, in some cases, sleeping with him. He kept the majority at a distance, and he tried never to be rude. In 1907, however, he fell off the edge. As Rilke put it a few years later in a letter to his dear friend Lou Andreas-Salomé: "Rodin . . . has simply gone to the bad, just as though all his unending work had never been."

The first concrete thing we know about the woman who would lead him "to the bad" is a letter bearing the date March 15, 1907. It was addressed to "Mon Amour adoré," and it was signed "ta petite femme, Claire." On that March day Rodin was in Menton working on a bust of Joseph Pulitzer. She wrote him that, while he was away, "Life stops! I am living in an abyss, a nightmare, and only two days have passed since you left me. . . . All my life, all my body calls to you."

These passionate words came from the pen of a forty-three-year-old American woman, daughter of a prominent New York family and wife of a marquis of a prominent French family. Their union in Saint Patrick's Cathedral in New York had been blessed by the Pope. She was Claire Coudert, and he was Charles-Auguste de Choiseul-Beaupré. Apparently the first contact with Rodin was made by the marquis. He needed advice about selling some family sculpture. The marquise was not far behind.

By 1907 Rodin was spending significant periods away from Meudon. When he did write to Rose, his letters were dry and brief. In July he and Claire were at Boix-le-Houx, a modest manor house in Brittany belonging to Charles de la Belinaye, Charles-Auguste's older cousin and the man who had been his guardian since he was four years old. On July 29 Rodin wrote three words to Rose: "Back Wednesday Evening." In September he settled in again at Boix-le-Houx and would be there for a month and a half. In an evasive letter to Rose he told her that his studies of "the cathedral" were going well. Would she please have his secretary send all his correspondence in care of "le comte Labelinaye near Fougères."

Letter to Auguste Rodin from Rose Beuret

It was clear to Rose that their life had changed profoundly. Presumably the few letters in Rose's hand possessed by the Musée Rodin all date after 1895, since such small personal documents were kept only after the move to Meudon. Some appear to have been written during trips Rose made to Vecqueville to visit her brothers. All are short. In them she addresses Rodin by the familiar "tu," something she never did in public. They are ungrammatical and full of misspellings as in "J'ais reve a toi—cette neuits" ("I dreamed of you last night"). But one of these letters stands out as no other, for it is an extraordinary cry of pain: "Mon cher auguste un mots de grasse je suis si Maleureuse pour quoi" ("My dear auguste send me word for pity's sake I am so unhappy why"). This letter must stand for us as a mark of the torment Rose Beuret experienced in the years following Rodin's encounter with Claire de Choiseul, a period during which she seems to have barely been a factor in Rodin's life.

In 1907 Gwen John also knew something was wrong. She sent hysteri-cal letters and telegrams to Rodin. He wrote her in September after having received her "desperate letter," and he proceeded to give her fatherly advice about not tiring herself and how she should work in a regular fashion, but he never addressed her real fear that their affair was over. When it finally became clear to John that this American was her enemy, she made her feelings known to Rodin in no uncertain terms: "This woman who makes you forget everything. And she is malicious and without intelligence."

Rodin was surprised when he received a letter from Rilke in early Sep-tember 1908. The two men had not been in contact since spring 1906, when the sculptor had peremptorily fired the poet. That was during the period when Shaw came to Meudon to sit for his portrait, at which time Rodin's secretary lost his heart to the witty British writer, and in Rodin's eyes this behavior posed a question of loyalty—in other words, he was jealous. The contents of Rilke's unexpected letter were to have significant ramifications for Rodin's relationship with Claire de Choiseul. The poet wrote with enthusiasm: "You've got to see this beautiful building and the room where I live since this morning." Rilke had moved into the Hôtel Biron, a distinguished chateau-like mansion surrounded by a large acreage on the Left Bank across from the Invalides. This fine residence, designed by Jean Aubert in the first part of the eighteenth century, was home to the Biron family until the Revolution. Then, after various residencies such as that of the papal legate and of the Russian ambassador, in 1820 the government of King Charles X handed the Hôtel Biron over to the Société du Sacré-Coeur de Jésus, an order of nuns dedicated to the education of young women. In 1905, under the Law of Separation, when the French Republic reassumed possession of a large number of religious properties, the nuns were ordered to vacate the premises. By 1907 they were gone, and individual rooms were made available for rent. Artists found them hugely attractive. Along with Rilke, Jean Cocteau, Henri Matisse, and Isadora Duncan had taken rooms in the now deteriorating building.

By October Rodin had rented four rooms in the Hôtel Biron, and, little by little, over the next few years he took over the entire building. Claire referred to it as "our enchanted abode." Rilke, somewhat aghast at the constant pres-ence of the marquise, wrote to his wife, Clara: "And now it transpired why the Marquise is there: to lead Rodin slowly down from the great heights beside

some merry watercourse. Perhaps Rodin really does need this now, someone to climb down with him, carefully and a little childishly, from the high peaks he was always straying among" (November 3, 1909).

By 1908 it was clear to Rose that, once again, her whole life was in question. In July she had received a letter from the Marquis de Choiseul. He told her that he could no longer accept the fact that "my wife is a constant presence in the atelier of M. Rodin." He believed that Rose, too, must be finding the situation intolerable. And he sent a letter to Rodin to tell him that he was "out of his mind about this affair," and that he assumed "Madame Rodin" must "want a separation." We know little about the motivation behind these letters; what we do know is that the marquis never left his wife and that he was glad to accept money from Rodin, who even paid gambling debts for the marquis.

Rodin and the marquise went to Dijon for Christmas and New Years that year. On New Year's Eve Rodin sent Rose a two-word telegram: "Friday evening," indicating when he would return to Meudon.

The following year, when the social register appeared, the marquis and the marquise were no longer listed as such. They had turned into the "Duke and Duchess of Choiseul." We do not know the reason behind this change since nothing had changed in Charles-Auguste's life to make him a "Duke."

In November 1910 Rodin turned seventy, and the duchess planned a celebration to take place in front of Rodin's enlarged *Thinker,* now installed before the Panthéon. It was a major social occasion, to which the sculptor was brought in the automobile of Undersecretary of State for Fine Arts Dujardin-Beaumetz, and the guest list was published in *Le Figaro.* Few of Rodin's old friends were among those invited; nor are we surprised that Rose was not mentioned. By now, many people who had previously closed their letters with a greeting for Rose asked to have their wishes bestowed upon "the Duchess."

When Rodin wasn't traveling, he and the duchess usually spent their afternoons at the Hôtel Biron. By 1911 he was the sole tenant. Claire had moved into the position of overseeing the business side of Rodin's work—she more or less doubled his prices. She made important decisions about who might be a worthy client and at what price. Claire entertained a large number of Americans at the Hôtel Biron, though she was not above making some people feel unwelcome. When Gertrude Vanderbilt Whitney, then an aspiring sculptor, arrived in town and wanted to meet Rodin, she found the "duchesse" in

"absolute control," and noted that Choiseul was capable of stopping a visitor wishing to see Rodin by informing him or her: "No use disturbing him since I am here. I handle everything. I am Rodin!"[13]

Rodin's worldwide fame grew with each year; in 1911 his work was exhibited in eight countries. At the International Exposition in Rome, organized to celebrate the fiftieth anniversary of the Italian Republic, he showed the first bronze cast of his enlarged *Walking Man,* along with a number of other works. Four of his loyal patrons joined forces to purchase, as a gift to the French government, the new monumental bronze. It was to be installed in the courtyard of the Palazzo Farnese, the French embassy in Rome. In early 1912, wanting to oversee the installation, Rodin and the duchess headed for Italy.

They were to be the guests of John and Mary Marshall. Marshall was an American who Rodin had met some years earlier in London. In 1908 he had been working as an agent for the Metropolitan Museum of Art, and in that capacity came to Rodin's studio to draw up a provisional list of sculptures to be purchased by the New York museum. While Rodin and Claire were with the Marshalls, John sent five long letters to Edward Perry Warren, his friend from Boston who now lived in Sussex. The letters are important, for they are the best—and probably the most disinterested—descriptions we have of Rodin with Claire de Choiseul. The first was written on January 24: "Rodin arrived to-night at 7:30 from Genoa, Madame de Choiseul with him." And the last concludes: "Mary and I have had a splendid fortnight, and have made them, I think, pretty happy." The Marshalls were riveted by the duchess: "She is a 'fascinating talker.'" And they noted how much Rodin enjoyed listening to her; furthermore, he enjoyed "our appreciation of her. Rodin had to play second fiddle to her, and evidently liked doing it." She would tell "Balzacian tales . . . over which Rodin laughs like a cow." "This is the woman who is running Rodin. She is devoted to him, and he to her." "It is beautiful to see them walking together, like father and daughter, or husband and wife." The Marshalls understood, as Rilke had, the sharp turn Rodin's life had taken in the direction of pleasure, and it seems there was no one in the world able to provide it quite like this New Yorker, at once witty, elegant, and vulgar, possessed of a fine-tuned practical side and a remarkable head for business.

When Claire was alone with Mary she brought up the subject of "Rose," making it clear that Rose was not really Rodin's wife, "but a servant and a

model to whom Rodin was intensely faithful. But Mrs. Rodin can neither read nor write; she adores him but cannot understand him, and she longed that he should remain poor." Claire insisted she did not want to separate the couple, but she wanted to free Rodin "from her influence." She bragged about how she finally "got control"—in other words, when she met Rodin he was making only "12,000 dollars a year. She has brought the figure up to 80,000." Generally she took credit for his now being stronger and healthier than he had ever been.[14]

From Rome Rodin kept in touch through his secretary in Paris. To one of his letters, he added a P.S.: "Go to Meudon and look into the health of my wife." If Rose herself received any letters from Rome, we do not know of them.

The duchess had told Mary Marshall that Rodin was finally secure in the Hôtel Biron, that she, the duchess, had worked it all out with the French government. Nothing could have been further from the truth. Trouble started soon after their return to Paris. Enthusiastically the couple had attended a new ballet by Debussy, *L'Après-midi d'un faune,* staring the Russian dancer Vaslav Nijinski. Rodin then allowed his name to be attached to a favorable review of the performance. But many in Paris considered the ballet shocking and obscene. Overnight a press campaign was launched to put an end to the idea that the Hôtel Biron might one day become a Musée Rodin.

This vexation was followed by the disappearance of a box of Rodin's drawings from the Hôtel Biron. Mme de Choiseul blamed Marcelle Martin, Rodin's secretary. But then Choiseul herself came under suspicion. One of Rodin's oldest and most faithful friends, Edmond Bigand-Kaire, was at the time at his home in Marseille, but he knew what was happening and was determined to intervene. A letter preceded his trip to Paris, stating, "I have serious things to say to you." When Bigand-Kaire finally spoke to Rodin face to face, it was to tell him that he believed that it was the duchess herself who was robbing Rodin. He felt this to be such a grave matter, that he was recommending the police be brought in. Martin seconded his view. Now she, too, told Rodin "the truth"—with proof—as to the real nature of *la Duchesse:* "Poor Rodin! He cried over his love like a fifteen-year-old schoolboy. We were in the big studio at Meudon. He sank back against the 'Ugolino' statue with sobs. 'I am a fool, an unhappy wretch.' I did not spare him, but made him see how ridiculous he

was, how he was degenerating towards absolute collapse." Martin then spoke "of his wife, his old comrade, so simple, so pure, in her love for him, her only lover. I preached my little sermon and he heard me out."[15]

Judith Cladel, Rodin's great lifetime biographer, was also one of the great myth-maker about his life. Her description of the day Rodin broke with the duchess reads as follows: "He sent word to Rose that he would be back in the evening, as in the old days, after he had finished work in the city. It was a simple and grand statement. She went out to the road at the end of the row of Chestnut trees to wait for her old husband '*Bonsoir, Rose!—Bonsoir, mon ami.*' Without another word, he offered her his arm and they walked to the house, and took up their life again." The image of this pastoral evening walk, the pleasant reconciliation could not be more unconvincing. My imagination counts on Rose's gift for anger still firmly in place. Toward the end of summer, Rodin fled to Belgium, and Rose got sick.

Rodin spent his sixty-fifth to seventieth year bewitched by the charms of an enchantment woven around him by a fascinating foreigner bearing a noble French title. He seemed to forget his life-long commitment as a serious, hard-working artist in exchange for this spellbinding offer of entrance into a world of superficial amusements filled with laughter. As Rilke said, "She led him down from the great heights to some merry watercourse." Breaking off with Claire de Choiseul was probably devastating for Rodin. But Bigand-Kaire—and perhaps others as well—must have made it eminently clear that he had the choice of continuing to enjoy the pleasures of life with his *duchesse* or of becoming the first sculptor in the history of France to have his own museum. Rodin was still clearheaded enough to make the more sensible choice.

The last great lady to arrive in Rodin's studio may not have been a duchess, but she was truly a *grande dame,* a fabulously wealthy, incredibly glamorous aristocrat—Victoria Sackville-West. Since 1906 she had been discussing the possibility of Rodin doing her portrait, but she did not arrive at his studio until November 1913. He took her out to Meudon to meet Rose. After taking in the "curious agglomeration of grandeur and great discomfort" in which the couple lived, she noted that Rodin spoke little to Rose, while "with me he never stops." She also discovered that Rose's asthma was so grave, and her coughing so extreme, that she could not be left alone in the night. Rodin had started to spend his nights in her room rather than his own.

That winter Rodin and Rose, both in ill health, left for the Riviera, while Lady Sackville planned on spending the winter months in Italy. On her way south she stopped in Roqueburne to see them. In her diary she confessed that Rose got on her nerves: "She stuck to us the whole time and even came in the car when I took him to the Post Office. . . . He requested that I should go every day with *them* for drives. She is an awful old bedint [her private word for the lower class] and a leech, so peevish and says nothing or grumbles." Returning home from Italy by way of Paris, Lady Sackville made time to come out to Meudon, where she found Rodin "miserably unhappy. He told me that life with old Rose was unbearable now, and he wanted to leave her. Rodin reported that Rose 'lui donnait des coups qui lui faisaient mal'" ("she would hit him and it hurt").[16]

Sackville-West's memory of the events and the way she described them are articulated with her habitual flair for drama. Perhaps Rodin did say such awful things of Rose, but there was no sincerity in his threat, although he did leave for London in July in order to be at the opening of his show at Grosvenor House. When he returned home, he was exhausted, and, on July 26, he took Rose out to the Viviers' in Châtelet-en-Brie so they might both get some rest. That was the day on which the Austrian government rejected the Serbian reply to its ultimatum—the ultimatum that would lead to the dissolution of the Serbian state. Rodin was probably unaware of these events in another corner of Europe, but if he did read the newspapers that day he would not have imagined that this conflict might somehow affect his own life. But Rose's nephew Emile Beuret, who had been looking after the Hôtel Biron in Rodin's absence, grasped the importance of the event and wrote to them in Châtelet-en-Brie: "I don't want you to think I'm giving you advice, but it might be expedient if you made some provision at the bank; given the way things are going, when one thinks about the situation in Paris, that could become a problem, and I must tell you that in case of mobilization, I will leave immediately" (July 28, 1914).

Rodin and Rose arrived at Gare de Lyon in Paris on August 1 to be greeted by headlines telling of the assassination of the great Socialist Jean Jaurès, leader of the French peace movement. The next day, as bells pealed in towns and cities across France, Emile Beuret packed up and left the Hôtel Biron. The general mobilization had begun.

The War and the Wedding

The sound in the street is a long continuous murmur. One might think
it was a public holiday on which everyone is silent.

LE FIGARO, AUGUST 2, 1914

The silent faces of Parisians reflected the solemn facts of the news. Buses,
requisitioned to transport troops, began disappearing from the streets. Rodin
left the Hôtel Biron and headed for Meudon in the automobile he had recently
purchased, but he was stopped and his car commandeered for government
use. A peasant heading toward Meudon gave the artist a ride home in his cart.
When Rodin arrived at the Villa des Brillants, he found Rose in tears. Their
horse, Rataplan, had also been seized. Further, "Rodin was totally without
money."[1]

At first the news from the front was positive. The French effort focused
on reclaiming Alsace and Lorraine. But the press was censored, and most of
the news was propaganda. By the middle of August the myth of a short war
began to fade.

Rodin wrote to Judith Cladel, urging her to see Albert Dalimier, the
secretary for fine arts, to talk about measures that should be taken to protect
his museum. He himself called in several strong men, who were able to move
his bronzes into the basement of the Hôtel Biron. At the villa he informed
most of the staff he would have to let them go. He then asked Marcelle Martin
to go to Saint-Ouen, where his forty-eight-year-old son Auguste lived with
Nini, his mistress. Martin was to bring them to Meudon. She reported that it
took only a few days for the quarrels to begin: "I do not wish you to call me
papa. You must call me *Maître* or *Monsieur*, as your mother does." "Never!"
was the angry reply. "Very well, then you shall go!" "I will, at once!" But Rodin
moved to put the situation back together: "Don't lose your temper; don't be
a fool." The pilgrimage of luminaries to Meudon had ceased. Now, according

to Martin, "we were almost always alone." Rodin was confused: to go or to stay? And if he left, who would protect his work?[2]

By the second half of August telephone communications with the front were completely broken. Conversations in the streets made clear the mounting anxiety. Those who were old enough thought back to the siege in 1870, and lines at the rail stations grew longer and longer. As the German army got closer to Paris, the government made preparations to dynamite the bridges. On August 30 a German monoplane flew over the capital, releasing a banner bearing the message: "Parisians, we have a *rendez-vous*, we Germans are at your door." The plane then dropped some bombs, and two people were killed. That same day, a pale and unsmiling Rodin arrived at the Ministry of Fine Arts, where, by accident, he ran into Judith Cladel. He told her he was leaving. She wanted to know where he was going, and he responded, "Marseille." "In this heat? It would be good neither for you, nor for Mme Rodin." Cladel proposed that the two of them join her and her mother the following day. They were going to Cheltenham in England, where Judith had two sisters.

On September 1, as the French legislature was debating its own departure from Paris, Rodin and Rose met Cladel and her mother at the Gare Saint-Lazare. There Rose, "old and frail, white-haired beneath her large black-lace hat," clung to her husband. By dawn they were in Dieppe, ready to board an overcrowded boat that would deposit them on British soil five hours later. Arriving in London was Rose's first experience since Ixelles of being in a place so foreign, and here even fewer people were able to understand her. Rodin, who had been to England many times, didn't speak the language either. Usually he was met at the train, often with great fanfare. It was little more than a month since he had been the guest of the Duke of Westminster, the richest man in England, and had escorted Queen Mary through his exhibition at Grovesnor House. Now he was almost as lost as Rose. They asked plaintively, might they go along with the Cladels to this place called Cheltenham?

On September 3, a day on which the German army was within eighteen miles of Paris, Rodin and Rose found themselves settling into Mrs. Gandy's rooming house at the center of a picturesque town on the edge of the Cotswold Hills. The Cladels were also staying at Mrs. Gandy's. Cladel noticed the decline of Rose's initial good-natured approach to the journey. She was now despondent, and this led her to resurrect her past resentments against

Rodin and the life he had given her. Fights began anew. Rodin tried to calm her down and suggested that they go and buy her some new dresses. In the company of Judith Cladel they headed for the fashionable London shops with Rose grumbling, "I won't wear them."

Two times a day Judith and her sister went to the center of town to pick up the latest paper. When they returned to Mrs. Gandy's they read the news to Rodin, and the three of them would study the maps that showed the heavy black line of German troops coming nearer and nearer to Paris. One morning, at breakfast, unfolding the paper, Judith cried out, "The cathedral of Rheims is burning! . . . German explosives have set off a fire!" This led Rodin to seek to associate himself with Roman Rolland's pacifist movement. He wrote to the novelist in Switzerland: "This is more than a war. This scourge of God is a catastrophe for humanity that divides the epochs" (September 25, 1914).

Although the German army had seemed invincible, the French army fought back successfully, stopping them at the Marne River and saving the capital. As soon as it began to look like Paris would not be occupied, Cladel made plans to return. Rodin was less sanguine. As he wrote to the Duke of Marlborough's American mistress, Gladys Deacon, in October, "The Germans can always come back." Once Cladel had departed, with no one to negotiate their life in the provincial town, time weighed heavily for the couple. So they made their way back to London. While staying at Hotel Europe, Rodin began to reestablish his contacts with some of his former patrons, the majority of them members of the upper echelons of British society.

Mary Hunter, who had sat for two portraits from Rodin's hand—works that made a great stir when shown in both Paris and London—extended an invitation to her home in Epping Forest. Charles Hunter, one of England's wealthiest coal barons, and his wife, Mary, one of the great society hostesses of the period, had opened a hospital for wounded officers. Now they extended hospitality to Belgian and French refugees in their home, a place described by Henry James as the "most beautiful and vast of old Jacobean houses." In October 1914, when the refugees from Meudon arrived, the American expatriate author was also a guest at Hill Hall. He wrote to Edith Wharton about Rodin's appearing with "his never-before-beheld and apparently most sordid and *inavouable* little wife, an incubus proceeding from an antediluvian error, and yet apparently less displeasing to the observer in general than the dreadful

Henry Tonks, *Portrait of Rose Beuret,* 1914.
London, Tate Gallery

great man himself." Another guest at Hill Hall was the British painter Henry
Tonks. He, too, got to know the French "refugees." He was no more impressed
with Rodin than James was: "Why I have never heard him say anything except,
'Dieu, que les arbres sont beaux'" ("My God, the trees are beautiful"). Rodin
and Rose must have felt social discomfort at every turn. Tonks reported that
they were seldom seen except at meals, although he often watched them at
a distance, walking together in the park.[3] And the painter did make pastel
drawings of the couple, showing a seventy-year-old Rose in her little white day
cap held tight with a black ribbon, ruffles framing her lined face, prominent
nose and chin, her big darting eyes looking apprehensively off to the right in

a fashion that is startlingly reminiscent of that long-ago portrait that Rodin painted in Belgium.

Rodin was in constant touch with Eugène Guioché, one of his mold-makers who was keeping watch over the Villa des Brillants. In October he closed one of his letters to his employee with the remark: "Don't forget we're at war and in England things are difficult." The difficulty may have been Hill Hall, and so once again they headed back to London. One of Rodin's closest English friends, the sculptor John Tweed, a frequent guest at Meudon, had arranged for them to stay with Emilie Grigsby—"the American princess"—in her large house on Brook Street in Mayfair. Did Rodin and Grigsby speak of the important overlap in their lives in the person of Charles T. Yerkes? Yerkes, Rodin's first American patron, had died in 1905, and although he was married to someone else, Grigsby had been Yerkes's great love. After his death, she found she had a fortune enabling her to settle into fashionable London in a grand style.

When the refugees from Hill Hall arrived in Mayfair, Rose was out of sorts, to such a degree that she refused to come down for dinner. Miss Grigsby was sure that the problem must be her inappropriate clothing, and asked if she might lend Rose some of her own things. Rose's response, as it has been reported, powerfully characterizes the stress she was under in these unfamiliar and alien surroundings. Her defense was to clarify her situation as best she knew: "Mademoiselle—you don't understand. I'm here under false pretenses. You see, I'm not really his wife, and I shouldn't be here at all!"[4] The denizens of these great English houses seem to have gotten on Rose's nerves. She defended herself with a firm declaration about the truth of her life rather than offering any kind of polite, socially acceptable pretense of being someone she was not, even to the point of making clear she was not married to the man with whom she had spent her whole life.

Things didn't work out in Mayfair either. Rodin next got in touch with John and Mary Marshall, who were now in England. He told them he was thinking of going to Rome, even though, as he revealed in a letter to Gladys Deacon, he was very worried about Italy remaining neutral. Mary Marshall wrote from East Sussex that he and Rose would be more than welcome to use their apartment on the Via Gregoriana. And so they prepared to leave England. On November 12 Marcelle Martin received a telegram: "Come this evening Hotel Terminus Saint-Lazare 8 o'clock." When she arrived, she "found him

Rodin and Rose with Albert Besnard and his wife at the Villa Medicis in Rome in 1915. Photograph by John Marshall

[Rodin] sitting in his underclothes. . . . He announced that he was going to Italy to do a bust of the Pope. 'Did he ask for you?' 'No.'"[5]

By November 18, Rodin and Rose were on a train bound for Rome, traveling in the company of the American dancer Loïe Fuller. Much of Rodin's time in Italy was spent in negotiations with Fuller, who was promoting his art in America. Together they composed a list of works for the 1915 Panama Pacific International Exposition in San Francisco, scheduled to open the following June. Fortunately John and Mary Marshall had preceded them to Rome, thus Rose did not have to worry about dealing with the Marshall's Italian servants.

Rodin and Rose spent approximately three months in Rome in the winter of 1914–15. We know little of their activities, but we do know Rodin managed to obtain introductions to various people at the Vatican as part of his plan to make contact with Pope Benedict XV, who had assumed the Chair of Saint Peter during the first week of the war. It wasn't just to do a portrait of the Pope that Rodin had come; he apparently believed that if he were able to talk with the Pope about the war, he might be able to influence Benedict—who had made clear his commitment to remaining neutral—to come to the aid of the Allied cause.

Rodin and Rose spend some time with compatriots Albert Besnard and his wife. Besnard, a prominent conservative painter, had been appointed director of the French Academy in Rome the previous year. When Besnard caught sight of Rodin he took note of his altered hairstyle and thought to himself, "Well, he's given up that curled forelock that had been so favored by the Duchesse." Besnard was sure that Mme Rodin, who "now accompanies him everywhere," had been influential in the change. And although Besnard was hospitable—after all, Rodin was France's most famous artist—in his book written a few years later he revealed himself as definitely not an admirer. He concluded that Rodin had come to Rome more to amuse himself than anything else. "I believe that basically he finds the world too preoccupied with the war and not enough with him."[6] This was harsh criticism—it probably reflects some jealousy—but it is one of several observations made by those who knew Rodin in his late years that indicate a loss of perspective, a sense that fame had overcome any sense of balanced judgment he once had, and that he had entered into a period of confusion, only made worse by the war.

The difficulties in Rose's life were becoming increasingly serious during the period they spent in Rome, for she was sick. She not only suffered from chronic bronchitis, she now had asthma. Finally it became clear to Rodin that he had to take her home.

On February 27 Marcelle Martin had lunch with Rose and Rodin at the Hôtel de Bourgogne in Paris. Even though Rose was full of a thousand details about their trip, Martin could see how sick she was. They called a doctor, who ordered heroin to make her sleep. She stayed asleep for hours and hours, alarming Rodin to such a degree that he tried to shake her into consciousness. It was a matter of days before she was back at the Viviers' in Châtelet-en-Brie. Rodin then boarded a train once again for Rome. He was determined to make a portrait of the Pope.

Rodin was still in Rome in May when Dr. Vivier wrote wanting to know "what's become of you in that *ville eternelle?* Does the noise of war continue to disturb the tranquility of your meditations? Certainly *les sauvages* will not get to Rome—nor, it seems will they get to Paris or to Châtelet." Vivier wrote of how extraordinarily impressed he was with the heroism of "our soldiers," but didn't omit a swipe at the government, expressing the hope that it would soon be "swept out." After his semilighthearted report, he said in truth, "Our

life is hard; we are living in constant anxiety." He saved the best news for last: "Rose is in good health."

By the end of the month, after almost a year's absence, Rodin and Rose were back in Meudon, and Rodin was back in his studio on the rue de l'Université working on the clay study for his portrait of the Pope. Marcelle Martin stopped by one day to have a look. "What's our Pope like?" she asked. "He's a fool, he wouldn't pose properly." But her general assessment of seeing Rodin that day was how tired he was: "The war overawed him, aroused his fears; as a result he had little inclination to work."[7]

In July Rodin decided to write out a will in his own hand, making "Mademoiselle Rose Beuret, born in Vecqueville, his *légataire universelle.*" This was followed by Rose drafting her will, leaving everything to her son, Auguste, and, soon after, placing the sum of a thousand francs in gold in an account in the Banque de France.

Thus begins the season of wills and donations. The focal point would become Rodin's donation of all his work to France, along with the rights of reproduction. It was a cause actively promoted by Judith Cladel and Rodin's friend the prominent critic and editor Armand Dayot. Their cause was supported by Etienne Clémentel, now Minister of Commerce and Industry and director of France's economy during the war. The preparation of the document to describe the donation precipitated a complicated discussion that went back and forth among Rodin, his advisers, the bureaucrats, and the lawyers. Then on March 10, 1916, Rodin suffered a light stroke. Now everyone understood how important it was to make the plans final and legal.

Judith Cladel believed that she should be the leading figure in establishing Rodin's museum. What she did not know was that there was another woman whose thoughts ran along the same line. Her name was Jeanne Bardey, an artist—one who was not without talent—who lived in Lyon. Rodin had admired her work at the Salon des Indépendants in 1909. At that time she sought to become his protégée, but the duchess kept her at bay. However she never completely lost touch with Rodin, and, after the death of her husband in the summer of 1915, she reentered his life with considerable energy. Bardey's first move was to find an apartment in Paris, locating one on rue Campagne-Première. She understood there was a second atelier-apartment available in her building, one that had heat. She thought it would

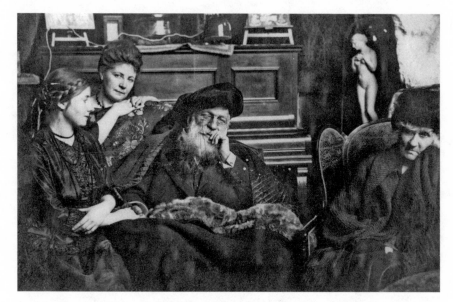

Henriette, Jeanne's daughter, Jeanne Bardey, Rodin and Rose in 1916

be perfect for Rodin. But her plans were put in abeyance when Rodin had the stroke. When she heard about the stroke she wrote immediately: "Forty-eight hours without seeing you seems very long to me. If there is anything I can do for you, do not hesitate to entrust it to me. I want to be your slave." And then, a few weeks later, she made arrangements to take Rodin, along with Rose—whom she never discounted or put aside as the duchesse had—to Lyon so that Rodin might be seen by her own trusted physician. When they returned, Rodin felt better, and he decided to put many of his affairs in her capable hands.

On July 10 Rodin had a second stroke, falling down the stairs at Meudon. Two days later Bardey called her lawyer and instructed him to meet her at Rodin's home in Meudon. A new will was drawn up and signed by Rodin: "I appoint Marie-Rose Beuret and Jeanne Bardey as my joint residuary legatees, with accretion to the survivor. I revoke all previous wills."

Most French critics have viewed Claire de Choiseul as a true villainess, a gold digger only after Rodin's wealth and fame. But there was some love in that mix. This cannot be said for Jeanne Bardey. Again we run up against

Rodin's extraordinary susceptibility to a particular type of fawning, calculating woman—the kind of woman that Rose had never been.

It was Auguste Beuret's companion, Nini, who let the word out: "There's trickery going on in there and no mistake!" Rose had come to her the previous evening and confided: "I'm no longer the only Madame Rodin; there are two heiresses now!"[8] This information was quickly passed along to Judith Cladel, who immediately went to Clémentel. He called his fellow minister at Fine Arts, and Dalimier placed guards at the Hôtel Biron, which meant that Bardey no longer had the right to walk freely in the Paris domain that she had been overseeing for months.

On August 4 several carloads of people arrived at the Villa des Brillants: the minister Clémentel; the secretary Dalimier; the chief of a division at Public Instruction, Valentino; the director of the Musée du Luxembourg, Bénédite; plus Cladel and Martin. They had all come to save Rodin's works from—as Clémentel put it—"these robbers." Cladel and Martin now took up residence in Meudon to protect the two elderly people, as well as the works intended as a gift to the French nation. Rose worked with Cladel to get her own will in order, and Rodin's bequest to the state was formally executed on September 13.

Cladel creates a sad scene that took place in the atelier in Meudon in this period. Rodin's assistant, Jules Desbois, had come to see if Rodin's last work, a portrait of Clémentel, was ready to go to the mold-maker. The little group stood around as Rose removed damp cloths from the head, while the sculptor himself—"his mind clouded"—looked on with apparent unconcern. It was instances like this that made Rose feel her power, and, a few weeks later, Martin wrote to Cladel: "She's indomitable. . . . She wants to be the mistress, to order everything, she wants people to obey her and do whatever she wishes."

Not only did Cladel and Martin take over the creation of inventories of sculptures and drawings, but it was their job to see that Rose and Rodin were comfortable. The heating system of the Villa des Brillants hardly worked; doors and windows were ill-fitting. The drains had become defective, and, further, there were no longer any decent servants to be had. The dogs had broken down the fences, allowing wild rabbits to tear up the garden. Rose was losing weight, her coughing was continual, and sometimes she had a fever. It was imperative that they find a nurse for their elderly charges.

The war was now in its third year. After the terrible carnage at the Battle

of Verdun—called "a battle from the Inferno"—that had taken place earlier in the year, the nation was weary and disillusioned. Martin and Cladel had an enormous task getting anyone to pay attention to what was happening in Meudon. The ministers had a thousand other things to worry about, but, nevertheless, the plans to create a Musée Rodin moved ahead, even though Rodin himself could no longer play a role in the effort. The matter was to be brought before the Senate on November 9. M. Bénédite had lobbied Antonin Dubost, the president of the Senate, who had no fundamental objection to the musée, but he did wonder if anything negative might result from the fact that Rodin was not married to Mlle Marie-Rose Beuret to whom he designated to inherit part of his estate. Would this establish a bad precedent?

The Senate voted in favor, although it was not the final decision. Now the word "marriage" hung in the air. And so Léonce Bénédite and Judith Cladel moved into action. It would be done. Cladel immediately went to Meudon to go over the marriage plans. Rose's main concern was that if this is "not M. Rodin's wish it should not be forced upon him." Cladel then took the "engaged couple" to a nearby jewelry store where: "with almost childish glee he slipped the little gold circles between his fingers and then held one out to Rose. He had no money, so I lent him twenty-five francs."[9]

Among Bénédite's papers we find a note about a visit he paid to Meudon on January 4 for the express purpose of speaking with Rose. He found her in her bedroom, where, in spite of the cold, she had the window open so she could breathe better. He asked if she knew "about the marriage. . . . She blushed and thanked me. Then after a short silence, smiling and somewhat agitated, she said in a low voice, 'I already have a wedding ring.'" Bénédite was curious as to why Rodin had not married her long ago, so he asked her. She explained: "He told me if I was his wife I would not obey him as well as I do."

The date was set for January 29. Auguste Beuret was ecstatic: "I shall no longer be a bastard." Most of the details were left up to Cladel: the birth certificates, official permission to hold the ceremony at the villa rather than at the *mairie,* linens and glasses for a luncheon to be brought from the Hôtel Biron. The biggest struggle was how to get enough coal to heat the villa. On Sunday, January 28, Rose was feverish and continually coughing, but all the while she insisted: "I've never felt better. Tomorrow I shall be married."

The wedding of Auguste Rodin and Rose Beuret, January 29, 1917

As Rose was trying on her wedding hat, and as Cladel, assisted by Countess Greffuhle's secretary, Eleanor O'Conner—a woman who frequently stepped in to help Rodin and Rose during the war years—was arranging the room where the ceremony was to take place, the villa suddenly started shaking, and windows began to break. Later they learned that the cause was an explosion in the Puteaux munitions factory some five miles north of Meudon. Then, another detonation shook the villa. This time, the heating system had burst, causing streams of brown water to flood the ground floor, and smoke to cover the freshly polished furniture with soot. Hours of work ensued, as sponges scrubbed the villa, auxiliary stoves were brought in from the mold-makers' quarters, and rugs were borrowed; by the next day, there was some semblance of order.

On Monday, guests and officials began to arrive. The deputy mayor of Meudon, Eugène Langlois, would officiate. Rodin's witnesses were to be his old banker friend Joanny Peytel, as well as Clémentel. Rose wanted Cladel

The tomb of Auguste Rodin and Rose Beuret. Auguste Beuret,
wearing the uniform of a museum guard, stands beside the tomb

and Miss O'Conner to be her witnesses, but at the last moment Bénédite swept the women aside, substituting himself and a certain Hyacinthe Weiler. Cladel tells us that M. Weiler had sold Rodin his automobile. Rose had never met him before the day of her wedding. Meanwhile, she had been practicing her reply to the critical question that she knew would be asked of her: "Yes, your Honor, with all my heart," but, according to Martin, when the moment came all she could say was "yes." There was a tiny undertow of laughter at the sentence about fidelity between husband and wife.

According to Martin: "The days that followed were peaceful. As there was so little coal available . . . they stayed in bed from morning till night." Two weeks later, Judith Cladel received a letter from Bénédite, informing her that Rose's bronchitis had turned into pneumonia. Cladel hurried out to Meudon, but she arrived too late. Madame Rose Rodin died in her home at noon on February 14, 1917. Her husband was by her side.

Her death was reported in newspapers across Europe and America. Within the week Kate Simpson, Rodin's favorite American patroness, wrote from New York, recalling how, early in their friendship (which had begun in 1902), "you led me to understand the debt you owed to your dear wife. You spoke to me of her help with your work and all the things for which you were indebted to her. With my own eyes I saw her devotion to you."

Cladel, closer at hand, saw things more darkly, as she told Bigand-Kaire: "The events turn in my head—I don't know where to begin. You know the sad news. Poor Rose—she was badly used. I saw her end coming for months, and as for this marriage *in extremis,* wasn't it a terrible deception? We put her in a provisory burial yesterday, waiting for authorization to transport her to the garden of the villa where *le Maître* will join her."

I think Judith Cladel did not need to feel such guilt about conspiring to put together this wedding on a cold day in the midst of war, for she, more than anyone, made it possible for Rose Beuret Rodin to die in peace.

Rodin had three more seasons to live alone in Meudon before he joined Rose in the garden. Their grave was sealed with a cast of *The Thinker,* that image Rodin had fashioned so long ago to crown his door for the Musée des Arts Décoratifs.

"The Humble Son of a Genius"

The ceremony uniting Auguste and Rose as man and wife was not a lengthy one, but, as it took place, Marcelle Martin became aware of how difficult it was emotionally for Auguste Beuret. When it ended, he "suddenly burst out crying like a child and would not have any lunch." He understood that no measures had been taken for him to be recognized. He would never be "legitimate."

After the birth of their unwanted child, neither Rose Beuret nor Auguste Rodin found themselves in possession of many instinctive parenting skills. They abandoned their son when he was young and paid little attention to him as he matured. Then, late in life, when the war broke out, they felt the need to call upon him. At Rose's death, Auguste inherited a small house on the grounds of the Villa des Brillants. He lived there with his companion Nini for the rest of their lives.

In 1931, as the fourteenth anniversary of Rodin's death approached, two German journalists who had heard talk of Rodin's son posed the question to themselves: "What has become of him?" Believing it would make a good article for their paper, *Der Querschnitt,* they organized a trip to France and made their way to Meudon. Upon their arrival, they stopped at the Petit Drapeau a local bar, and mentioned their quest to the bartender: "We are looking for Rodin's son." And with that, a whiskered man with a wrinkled face and a big nose, sitting in the shadows, looked at them and said, "Then you have found him." He explained that he spent his Sundays at the Petit Drapeau because it was the day on which he was not permitted to receive guests in the house where he lives. The house and grounds that once belonged to his parents were now part of a museum owned by the State.

Auguste Beuret, *Mein Vater Rodin,* drawing
reproduced in *Der Querschnitt,* November 2, 1931

At first he was not eager to talk with the strangers, but with some coaxing from the journalists Beuret began to talk about his life and especially about his vast admiration for his father: "a peculiar man, a great artist." He told them, "I too wanted to become an artist, but he didn't want it. I loved to draw, but my father didn't like it when I hung around the studio." After a while, the journalists reported that "the old man was seized by a veritable rage for sketching. He wanted more and more paper, and then he drew his father's *Thinker* from memory. Some of the other guests in the bar came over to admire Papa Auguste and his work."

Beuret wanted to make clear that he was sure his father wasn't against him: "He liked me very much. But he never needed anybody, no need for family. His art was sufficient for him, and my mother saw to it that no one

disturbed him, including me. Mother loved him very much and she did only what he wanted." Beuret's thoughts turned to his mother and the fact that she didn't benefit much from his father's artwork. "She was only there to serve him—the *Maître*." As he said this, the woman seated next to him (Nini) took up the thought and began to bubble over with stories about the sad life of her husband's mother as she performed the duties of the helpmate of a great artist —"Next to Rodin there was no one else for her. Not even her son."

While they talked, Beuret continued to draw. He wanted his visitors to see that he, too, was an artist and signed a sketch, "Par le Fils de Rodin Auguste Beurret [*sic*]." One of the journalists looked at the drawing with plea-sure—"Schön, sehr schön"—while Auguste reached out his hand: "I thank you that you have come, my dear friend."[1]

A year and a half later, a Frenchman arrived in Meudon with a similar project in mind—to write something about the son of the great Rodin. Roger de Montebello knew exactly where to go. He set off for Meudon on a July day and made his way between the rows of chestnut trees toward the Villa des Bril-lants, where he had an appointment with Auguste Beuret. He asked Beuret if he might see some of his drawings. The latter was pleased and said, "Come with me, I was just working on some." Immediately a concierge intervened, informing the visitor that no one who was not on the museum staff could enter any of the buildings. So Beuret brought his drawings out into the garden.

After spending some time examining these works, de Montebello be-gan to ask him about his father. What was it like to be his father's son? De Montebello was acutely aware that he was in the presence of a man who had been forced to endure myriad hidden sufferings as he lived in the shadow of a great man, all the time feeling that he himself would never amount to much. De Montebello continued to ponder these thoughts as he walked back down the path of the Villa des Brillants, leaving behind the "faded drawings and the old worker who has had to carry, the whole length of his life, the burden of being the humble son of a genius."[2]

Auguste Beuret died on April 22, 1934. A large collection of his draw-ings, many quite accomplished and occasionally confused with drawings of his father, remain in the collection of the Musée Rodin.

APPENDIX
The Value of Money

The living standard for the majority of French artists born in the 1840s and initiating independent lives in Paris in the 1860s was equivalent to that of working class people.

We learn a great deal about the cost of things during the Second Empire in a letter from Emile Zola to Paul Cézanne in March 1860 to give him an idea of what it might cost him to live in Paris. Zola indicated that Cézanne would be able to manage on 125 francs, the amount the painter's father had implied he might give him: "It is true that 125 francs a month will not allow you much luxury. I will give you an idea of what you will have to spend: a room for 20 francs a month, lunch 18 sous and supper 22 sous, which makes 2 francs a day or 60 francs a month; with the 20 francs for your room, that comes to 80 francs a month. Then you have to pay for art school. The Suisse, one of the cheapest, costing, I believe, 10 francs. In addition I count 10 francs for canvas, brushes and paints. Together that comes to 100 francs. There remain 25 francs for laundry, light, the thousand little expenses that occur, tobacco and similar minor amusements."[1]

The Second Empire
INCOME

Men working in a glove manufacturing factory	3–10 francs a day
Women working in the same enterprise	1–4 francs a day
Cézanne's allowance	150 francs a month
Monet's allowance	125 francs a month
Rodin's earnings in a decorative studio	5 francs a day
Rodin's father (clerk in the police department)	1,400 francs a year
Zola's wages at Librarie Hachette in 1862	100 francs a month

RENTS

1860 Rodin family at 6, rue des Fossés-Saint-Jacques	320 francs a year
1863 Rodin's studio on rue de la Reine Blanche	10 francs a month
1865 Monet at 1, rue Pigalle	800 francs a year
1867 Zola in a four-room flat in Batignolles	650 francs a year
1867 Doncieux family at 17, boulevard des Batignolles	1,400 francs a year

SALES

1865 Monet, *The Pointe de la Hève at Low Tide*	300 francs
1868 Monet, *Camille*	800 francs

The Third Republic

Between 1873 and 1896 the French economy experienced a long stagnation that was characterized by a succession of financial and economic crises of unusual gravity and scope. In 1882 there was a financial panic, and with that began a serious depression that lasted the better part of the rest of the century.[2] The enduring financial unsteadiness of the Third Republic provided the difficult background for the gigantic hurdles faced by young artists working in new and unfamiliar styles in a socially conservative culture.

1870s

INCOME

Working class wages	Between 900 and 3,000 francs a year
Maurice Haquette, clerk at Sèvres Porcelain factory	2,400 francs a year
A doctor in Paris	9,000 francs a year
Cézanne (1874)	Asked father to raise allowance to 200 francs a month

Hortense Fiquet (1878) | Monthly allowance of 60–100 francs for herself and her child in Paris

Rodin for employment at Sèvres (1879) | 170 francs a month, plus 3 francs an hour

Zola's income (1876) | 25,000 francs

SALES

1874 Cézanne (3 paintings to Chocquet) | 50 francs each

1878 Rodin, *La Lorraine,* marble bust | 1,800 francs (100 francs to the carver and 20 percent to the dealer)

1872 Monet (29 paintings to Durand-Ruel) | 9,800 francs

1873 Monet (34 paintings to Durand-Ruel) | 19,100 francs

1875 Monet (*The Bridge, Amsterdam* to Louisine Elder, the first Monet sold to an American) | 300 francs (c. $60.00)

1877 Monet (*Le Grenouillère* to Hoschedé) | 2,000 francs

1870s Monet sold a total of at least 140 paintings, more that 70 of them to Durand-Ruel. | Prices ranged from 50 francs to 800 francs.

RENTS

Slum rooms | 91 francs a year

Père Tanguy, artists' supply store | 200 francs a year

Cézanne and Hortense, rue de l'Ouest | 230 francs a year

Chocquet (Cézanne's patron), 198, rue de Rivoli | 960 francs a year (4-room apartment)

Monet, first house in Argenteuil | 1,000 francs a year

Monet, second house in Argenteuil | 1,400 francs a year

1880s

INCOME

1886 Death of Louis-Auguste Cézanne Paul Cézanne inherits in excess
of 50,000 francs

SALES

1880 State purchase of Rodin's *Age of Bronze*	2,200 francs
1880 Fee allotted by State for Rodin's monumental door	8,000 francs
1880 State purchase of marble bust by Carrier-Belleuse	2,400 francs
1881 Rodin's increased fee for the door	10,000 additional francs
1881 Monet's total sales for the year	20,400 francs
1883 Cézanne (2 paintings at Père Tanguy's to Gauguin)	120 francs
1884 Cézanne (1 painting at Tanguy's to Signac)	200 francs
1886 Rodin (1 marble to A de Rothschild)	6,000 francs
1889 Monet (*View of Cap d'Antibes* to Alfred Pope after Monet/Rodin show)	10,000 francs (highest price to that point for a Monet)
1889 Rodin, orders for 4 marbles after M/R show	20,000 francs

RENTS

1882 Rodin and Rose on rue de Faubourg-Saint-Jacques	400 francs a year
1883 Rodin's atelier on rue Val-de-Grâce	600 francs a year

DEBTS

1885 Père Tanguy requests IOU from Cézanne for materials	1,840.90 francs against debt of 4,015.04

1890s

COMMISSIONS AND SALES

1891 Rodin commissioned for a monument to Balzac	10,000 francs (first payment)
1896 Rodin asked to return money for failure to complete monument	10,000 francs
1891 Monet's *Grainstacks* series	3–4,000 francs each
1891 State buys bronze cast of Rodin's *Belle Heaulmière*	2,000 francs
1890s Zola's annual income	155,000–200,000 francs
1895 Monet's *Cathedral* series	15,000 each
1899 Chocquet estate sale establishes a market for Cézanne	Prices range from 145 francs for a small oil study to 6,200 francs for *The House of the Hanged Man*

PROPERTY

1859 Louis-Auguste Cézanne's purchase of the Jas de Bouffan	85,000 francs
1878 Zola buys house in Medan	9,000 francs
1891 Monet buys house in Giverny	20,000 francs
1895 Rodin buys house in Meudon	27,300 francs
1901 Cézanne buys property at Les Lauves	2,000 francs
1902 Studio built according to Cézanne's design	30,000 francs

ACKNOWLEDGMENTS

Without the help and encouragement of Carl Kaysen and of Nan Guy, this book would not exist. The same is to be said of the staff and former staff of one of the most wonderful museums in the world—the Musée Rodin. I thank Jacques Vilain, former director, and former curators Antoinette Romain in sculpture and Claudie Judrin in drawings. Others on the Musée staff who have given me considerable help over the years are Hélène Pinet, Véronique Mattiussi, Jérôme Manoukian, Anne Marie Chabot, Virginie Delaforge, Marie-Pierre Delclaux, and Hugues Herpin. Christina Buley-Uribe, formerly working with the drawing collection, has helped enormously with assembling the photographs for this volume.

Of critical importance have been the criticism and suggestions of the members of my Cambridge writing group: Sally Brady, Perrin Ireland, Rob Laubacher, Cindy Linkas, Joanne Pender, and Betsy Seifter.

I have relied on two friends close at hand in Boston, men with enormous expertise in the field of nineteenth-century French painting—Paul Hayes Tucker and Wayne Andersen. Nor could I have done without the vast resources of the Harvard libraries and the extremely fine staff that manages their holdings.

In addition I would like to thank Marianne Alphant, Philippe Bovy, Philippe Cézanne, Mme Chevrand, Danielle Coussot, Pascal-Hervé Daniel, Martine Ducousso, Stanislas and Frances Faure, Walter Feilchenfeldt, Wendy Fisher, Sylvie Foucart, Rachael Fuchs, Léonard Gianadda, Thierry Gardie, Sanford Gifford, Isabele Grel, Denis Grisel, June Hargrove, Robert L. Herbert, Michel Hinaut, David Joel, Stéphane Lahierre, Catherine Lampert, Isabelle Lefeuvre, Françoise Lutringer, Megan Marshall, Judy Metro, Guy Michel, Robert Mitchell, Luc Passion, Anne Pingeot, Susan Quinn, Theodore Reff, Michelle Petit Richard, Hildeburg Richter, Michel Royer, Joshua Rubenstein, Robert Spaethling, Jane Van Nimmen, and Rudolphe Walter.

I would like to thank the following individuals, institutions, and agencies for supplying illustrations and for giving me permission to publish them:

Museum of Fine Arts, Boston; Staatsgalerie, Stuttgart; La Fondation Jean et Suzanne Planque, Lausanne; Bibliothèque nationale de France; The Art Institute of Chicago; Sterling and Francine Clark Art Institute; Tate Gallery; Harvard University, Fine Arts Library, Photographic Collection; Wildenstein and Company; Walter Feilchenfeldt; Wayne Andersen, Philadelphia Museum of Art; The Metropolitan Museum of Art; Musée Rodin; The Bridgeman Art Library; Art Resources; Staatliche Museen zu Berlin, Neue Nationalgalerie, Museum Berggruen; Roger-Viollet.

Further I feel indebted to my agent, Wendy Strothman, for her wisdom in placing the book, and to the guiding lights of Yale University Press: Jonathan Brent, for his enthusiastic response to the book; Annelise Finnegan, for her swift response to dozens of inquires; and Jeffrey Schier, for his close attention to the actual text, line by line.

NOTES

PREFACE

1. Daniel Wildenstein, *Claude Monet, biographie et catalogue raisonné,* Lausanne, 1974–1991, vol. I, 99, and vol. IV, 64.

INTRODUCTION
Recognizing the Model and Her Work

1. Grappe, *Catalogue du Musée Rodin,* 6–7.
2. Virginia Woolf, *A Room of One's Own,* London, 1928, 147.
3. Zola made a list of sixty-five possible titles before selecting "*L'Oeuvre.*" This translates into English as "the work," implying the work of art. I have used the Thomas Walton translation, for which the title has been translated as *The Masterpiece.*
4. Andersen, *The Youth of Cézanne and Zola,* 169.
5. Hilary Spurling, *The Unknown Matisse,* New York, 1998, 307.
6. Hollander, "Working Models," *Art in America* (May 1991).
7. Masten, "Model into Artist," 17.

CHAPTER 1
Hortense Fiquet and Paul Cézanne

1. Daubié, *La Femme pauvre au XIXe siècle,* Paris, 1866.
2. Simon, *L'Ouvrière,* Paris, 1860.
3. For Cézanne's correspondence I have relied on two John Rewald editions, one published in Paris (*Paul Cézanne correspondance,* 1978), and one published in New York (*Paul Cézanne Letters,* 1984). For Zola's correspondence I have used Andersen, *The Youth of Cézanne and Zola.*
4. See appendix.
5. *L'Evénement,* May 7, 1866.
6. Emile Zola, *The Belly of Paris,* translated by Ernest Alfred Vizetelly, Los Angeles, 1996.
7. Mary Louise Krumrine, "Parisian Writers and the Early Work of Cézanne," in *Cézanne: The Early Years 1859–1872,* Royal Academy of Art, London, 1988.
8. Ibid., 16.

CHAPTER 2
Single Mother

1. Lucien Pissarro to Paul-Emile Pissarro, c. 1912, Archives, Ashmolean Museum, Oxford.
2. Gachet, *Deux amis des impressionnistes,* 57, 60.
3. Wayne Anderson points out that the title was not Cézanne's, as Renoir's brother was in charge of titles. The title may even have been a practical joke played on Cézanne by some of the artists who were not in favor of his showing with them, thinking that his work might bring negative press to the show (*Manet: The Picnic and the Prostitute,* 69, 244).
4. "Je ne puis souffrir l'attouchement ou le frôlement de personne." *Mercure de France,* no. 5, October 1907, 611.
5. Chartroule de Montifaud was a woman writing under a male pseudonym.

CHAPTER 3
Sixty Francs for Hortense

1. Rewald, *Paul Cézanne: A Biography,* 77.
2. Though not necessarily lower class, the term indicates a girl of easy virtue who could be picked up in the vicinity of the church of Notre-Dame de Lorette.
3. Usually a cute, flirty working girl.
4. In the Cézanne literature no one ever speaks of Hortense as a woman of "easy" virtue. Nevertheless, Philippe Cézanne, the painter's great-grandson, assured me that the general feeling within the Cézanne family was: "Hortense had her adventures."
5. This is a story Geffroy tells in the context of the friendship between Cézanne and Monet. Geffroy, *Monet, sa vie, son oeuvre,* 327.
6. Ambroise Vollard, *Paul Cézanne, His Life and Art,* translated by Harold L. Van Doren, New York, 1923, Chapter 8. The portrait, which now hangs in the Petit Palais in Paris, in no way looks like an unfinished work.
7. *Cézanne,* Exh. Cat., London and Edinburgh, 1954, no. 21.
8. Brown, *Zola: A Life,* 97.
9. "Nineteenth-Century Art Worldwide," www.19thc-artworldwide.org/ Autumn 2004.
10. Eventually Chocquet owned thirty-five Cézannes. The Chocquet collection was dispersed at a sale in 1899.

CHAPTER 4

Hortense at Thirty

1. Rewald, *Cézanne and America*, 72.

CHAPTER 5

A Dark Blue Wedding Dress?

1. Rewald, *Paul Cézanne Letters*, 215.
2. Beucken, "Un Portrait de Cézanne," 5.
3. Something that is *grumeleux* (Cézanne misspelled it) is lumpy, like lumpy soup.
4. Doran, *Conversations with Cézanne*, 56.
5. Cachin and Rishel, *Cézanne*.

CHAPTER 6

Fifteen Hectares of Fallow Land

1. *Crapaud* (misspelled by Alexis)—a toad. *Petit crapaud* might be used to refer to a child as a "little monkey," but Alexis's remark sounds rougher, more negative than that.
2. *La boule*—the ball—is not an attractive nickname for a wife; but *le boulet*—the metal ball attached to the feet of criminals—is a terrible label to attach to a son. The combination indicates how commonly they were regarded as burdens in Cézanne's life.
3. Philadelphia Museum of Art. In the Rewald *catalogue raisonné* it is dated between 1890 and 1892.
4. Schapiro, *Paul Cézanne*, 58.
5. Brettell, *Post-Impressionists at the Art Institute of Chicago*, 65; Cachin and Rishel, *Cézanne*, 399.
6. Rewald, *Paul Cézanne: A Biography*, 114.
7. Marie-Alain Couturier, *Se garder libre; Journal, 1947–1954*, June 23, 1951.

CHAPTER 7

For or Against Hortense?

1. Vollard, *Paul Cézanne*, 94.
2. *Correspondence*, 236. After his father's death, Cézanne's annual income was twenty-five thousand francs. If he divided it into three parts—for himself, for Paul fils (now

twenty-five), and for Hortense—each would have had about seven hundred francs a month.

3. Letter in the archives of the Musée d'Orsay.
4. Larguier, *Cézanne, ou la lutte avec l'ange de la peinture*, 143.
5. Bernard, *Souvenirs sur Paul Cézanne et lettres*.
6. Doran, *Conversations with Cézanne* (letter of February 5, 1904), 26.
7. Cachin and Rishel, *Cézanne*, 346.
8. Larguier, *Cézanne, ou la lutte avec l'ange de la peinture*, 143.
9. Geist, Sidney. *Art International*, vol. 19 (November 1975): 13.

CHAPTER 8
After October 1906

1. Rabinow, *Cézanne to Picasso: Ambroise Vollard, Patron of the Avant-Garde*, 282.
2. Rewald, *Cézanne: A Biography*, 1986, 265.
3. Archives départementales des Bouches-du-Rhône, *Monsieur Paul Cézanne, rentier, artiste peintre, un creature au prisme des archives* (2006), 264. This publication includes all the archives of the Cézanne family in Aix-en-Provence. When Marie Cézanne died some years later, Paul fils also inherited half of her estate.
4. Paul fils returned at least twice, for the burial of his first son (age two) in 1915, and a second son (three months old) in 1916. See Cézanne (Philippe), "Le silence de l'atelier (1906–1921)," 75.
5. Robert Jensen, "Vollard and Cézanne: An Anatomy of a Relationship," in Rabinow, *Cézanne to Picasso, Ambroise Vollard, Patron of the Avant-Garde*, 29.
6. Renoir, *Renoir, My Father*, 361–62.
7. Chronology, by Rebecca A. Rabinow and Jayne Warman, in Rabinow, *Cézanne to Picasso, Ambroise Vollard, Patron of the Avant-Garde*, 284–85.
8. Rivière, *Le Maître Paul Cézanne*, Paris, 1923.

CHAPTER 9
Camille Doncieux and Claude Monet

1. Frédéric Bazille's letters published by Schulman, *Frédéric Bazille*, 371.
2. Zola was in Batignolles by 1867. In 1868 he moved to 23, rue Truffaut, across the street from the Doncieux.
3. Wildenstein, vol. I, notes 215, 355.
4. François Thiébaut-Sisson, "Claude Monet, An Interview," *Le Temps*, November 27, 1900.
5. Jules Claretie, *L'Artiste*, May 5, 1866.

6. The first reference to *Le Bain* under the title *Le Déjeuner sur l'herbe* was in Zola's essay in *L'Evénement,* May 7, 1866. Late in Monet's life, when the artist showed his own *Déjeuner sur l'herbe*—a work virtually unknown to the public—to the "Duc de Trévise, he made it clear that" he had created it under the influence of Manet's painting ("J'avais fait après celui de Manet" ["I made it after Manet's"]) (*Revue de l'art ancient et moderne,* 1927, 122).

7. Marianne Alphant, *Claude Monet,* 126.

8. *Les Grands Bazars,* Paris, 1882.

CHAPTER 10

Camille—Or—The Green Dress

1. *Bulletin de la vie artistique,* March 28, 1914.

2. *Monet und Camille: Frauenportraits im Impressionismus,* Bremen, 2005, 42. Included in the exhibition was a fashion print from *Petit Courrier des Dames* (1865), showing an almost identical striped skirt (though in rose) worn with a black fur-trimmed jacket.

3. Mauclair, *Claude Monet,* 9.

CHAPTER 11

A Garden Full of Dresses

1. Renoir, *Renoir, My Father,* 101.

2. Duc de Trévise, "Le Pèlerinage de Giverny," *La Revue de l'art ancien et moderne,* February 1927, 121.

3. Mon Salon IV, *L'Evénement illustré,* May 24, 1868.

CHAPTER 12

Without a Sou

1. These letters became fully usable only after the publication of Michel Schulman's catalogue raisonné of Bazille's work in 1995, when he clarified the sequence and dating of the letters.

CHAPTER 13
Why Did He Marry Her?

1. The phrase "foule le trottoir" is a clear reference to a prostitute.
2. Clemenceau, *Claude Monet,* 1928, 58–59.

CHAPTER 14
The Second Empire Disappears

1. Robert Herbert, relying on the *Guide annuaire* of 1868, tells us that room and board at the Tivoli cost six to seven francs a day. Herbert, *Impressionism,* 313.
2. *The Art Newspaper,* May 2005.

CHAPTER 15
The "Impressionist" Couple

1. Tucker, *Claude Monet: Life and Art,* 64.
2. This was a period when members of the working class in France earned between nine hundred and three thousand francs annually.
3. Tucker, *The Impressionists at Argenteuil,* 88.
4. Information found in a letter in the Durand-Ruel archives.

CHAPTER 16
Money and *La Japonaise*

1. Information based on Alphant, *Claude Monet,* chapter 17. She relied on Monet's *carnets* in the Musée Marmottan. Wildenstein's catalogue also contains the financial information found in the *carnets,* which is very incomplete because they do not reveal the amounts that the Monets spent.
2. The town of Argenteuil purchased the house c. 2002 and plans for it to become a cultural center related to Monet's life in the town.
3. The Wildenstein catalogue itemizes 108 Argenteuil works during the thirty-three-month stay in the Aubry house, in contrast to about 65 works with scenes from Argenteuil during the twenty-eight-month period in the house on the boulevard Saint-Denis.
4. Rewald and Weitzenhoffer, eds., "Ernest Hoschedé," in *Aspects of Monet,* 69.
5. The following year the painting was back on the block at Drouot, this time for a real purchase made by Constantin de Rasty, Rumanian friend of Georges de Bel-

lio, homeopathic doctor who had emigrated from Rumania during the Second Empire.

6. Gimpel, *Journal d'un collectionneur,* 68 and 79.
7. Alphant, *Claude Monet,* 263, and Tucker, *Monet in Argenteuil,* 138–39.

CHAPTER 17
A Patron

1. Piguet archives. I have depended on Marianne Alphant's careful reading of Alice's journal. See Alphant, *Claude Monet,* chapter 18.
2. Wildenstein, vol. I, 83.
3. Stuckey, ed., *Claude Monet,* 201–2.
4. Edward Lucie-Smith, *Impressionist Women* (London, Harmony, 1989), 40.

CHAPTER 18
Death in a Village by the River

1. Gimpel, *Journal d'un collectionneur,* 178.
2. Jean-Pierre Hoschedé, "Notes Posthumes de Blanche Hoschedé-Monet," in *Claude Monet ce mal connu,* vol. I, 158.
3. The only information about Camille's illness comes from Monet's letters: vague references to "an ulceration of the womb," or "a uterine condition." Mary Gedo consulted with John Lurain, chief of gynecological oncology at Northwestern University Medical Center, who observed that the combination of Camille's age at the time she became sick and the approximately three-year duration of the illness "points to the cervix as the more likely primary site of a malignancy that eventually spread throughout her body" Gedo, "Mme Monet on Her Deathbed".
4. Some who have written about Monet's last portrait of Camille have interpreted things differently. For example, Joel Isaacson, writing of "Monet's grief and shock, felt despite, or perhaps guiltily because of, his liaison with Mme Hoschedé, are registered in a beautifully painful portrait of Camille on her deathbed after her decease." Isaacson, *Claude Monet,* 23.

CHAPTER 20
Rose Beuret and Auguste Rodin

1. "Chant de vendange," *Le Pressoir des Vignoble d'antan,* January 1997.
2. Maigrot, *La Mort et les hommes en Haute-Marne au XIXe siècle,* 61.

CHAPTER 21
From Vecqueville to the Banks of the Bièvre

1. Jules Michelet, *La Femme,* Paris, 1860, 37–38.

CHAPTER 22
A Woman's Body

1. Charles Benoist, "Les ouvrières de l'aiguille à Paris," *Le Temps,* 1895.
2. The description of Rodin's work on this figure is to be found in Dujardin-Beaumetz, *Entretiens avec Rodin,* 116–19.
3. I am grateful to Mme Martine Ducousso for having supplied me with this information.
4. Cladel, *Rodin,* 87.
5. *Annales ESC,* July–August 1978.
6. Aigner and Aczél, "Rodins Sohn, der Taglöhner," Der Querschnitt 536.

CHAPTER 23
Montmartre and the Commune

1. Wolff, *L'Ecume de Paris,* 1885.
2. Bartlett, January 19, 1889. This quotation and many that follow are taken from the articles published by the American sculptor Truman H. Bartlett in *American Architect and Building News,* 1889. The interviews took place in 1887.
3. Bartlett, January 26, 1889.
4. Bartlett, March 2, 1889.
5. Coquiot, *Rodin à l'hotel de Biron et à Meudon,* 25–26.
6. Tirel, *The Last Years of Rodin,* 130–31.
7. Bartlett, January 26, 1889.
8. The Commune declared the right of citizens to reclaim all items at the *mont-de-piété* that were worth less than fifteen francs without repayment—everything except wedding rings—"that sentimental Catholic notion."

CHAPTER 24
Ixelles

1. Mario Meunier, "Rodin, dans son art et dans sa vie," *Les Marges,* April 15, 1914.
2. Bartlett mss., Houghton Library, Harvard University, Cambridge, Mass.

3. Nineteenth-century sculptors were usually either modelers or carvers. Although Rodin had learned to carve as a young sculptor, his great talent was as a modeler, and his marble works were carved by practitioners who had been hired for this task.

4. Cladel, *Rodin*, 103.

CHAPTER 25
The Return Home

1. Claudie Judrin, *Inventaires des dessins,* vol. 2, Paris, 1986, 141, although Judrin has raised the question that the drawing might be "after" rather than before the execution of the bust.

CHAPTER 26
The Commission That Changed Everything

1. Cladel, *Rodin,* 34. When Rodin called Rose "une sauvage," he was implying that she was not sufficiently cultivated for the society of the Cladels.

2. Bartlett notes, Houghton Library, Harvard University, Cambridge, Mass.

3. Edmond and Jules de Goncourt, *Journal,* July 3, 1889.

4. Cladel, *Rodin,* 151.

5. Ayral-Clause, *Camille Claudel,* 57.

6. Tirel, *The Last Years of Rodin,* 94.

7. Morhardt to Judith Cladel, letter of August 18, 1924. Cladel Archives, Indiana University, Bloomington, Indiana. Published in Ayaral-Clause, *Camille Claudel,* 112.

8. Cléopâtre Bourdelle-Sevastos, *Ma vie avec Bourdelle,* Paris, 2005, 31. This is the same view that formed in my own mind as I wrote my biography of Rodin.

CHAPTER 27
A House in Meudon

1. Cladel, *Rodin,* 43.

2. Frederick Lawton, *The Life and Work of Auguste Rodin,* London, 1907, 280, and Anthony Ludovici, *Personal Reminiscences of Auguste Rodin,* Philadelphia, 1926, 49.

3. Alexandra Thaulow, *Mens Frits Thaulow malte,* 1929, 140. Quoted in Grunfeld, *Rodin: A Biography,* 426.

4. Rilke correspondence. Quoted in Leppman, *Rilke, A Life,* 170.
5. Ludovici, *Personal Reminiscences,* 56.
6. "Le Roman d'amour de Rodin," *Paris Midi,* November 10, 1936.

CHAPTER 28

The Dark Side of Being the Old Mistress of a Genius

1. Helene von Nostitz, *Rodin in Gespräche und Briefe,* Dresden, 1927 (English translation by H. L. Ripperger, New York, 1931) 16.
2. Coquiot, *Rodin à l'hotel de Biron et à Meudon,* 96.
3. Ojetti, *As They Seemed to Me,* 45.
4. "Rodin's Home at Meudon, Near Paris." Unsigned article among the Bartlett papers in the Library of Congress, Washington, D.C. This story is repeated in many publications.
5. Ludovici, *Personal Reminiscences,* 85.
6. Lawton, *The Life and Work of Auguste Rodin,* 134.
7. Cladel, *Rodin,* 247.
8. Ludovici, *Personal Reminiscences,* 56.
9. Cladel, *Rodin,* 247.
10. Martin married Marcel Tirel in 1916 and published *Rodin intime, ou l'envers d'une gloire* as Marcelle Tirel. It was translated into English as *The Last Years of Rodin.* Both appeared in 1923. The material here is from Chapter 5, "Rodin and Madame Rodin," of the English version.
11. Lampert, *Rodin: Sculpture & Drawings,* 143.
12. Cladel, *Rodin,* 246.
13. B. H. Friedman, *Gertrude Vanderbilt Whitney,* New York, 1978, 288.
14. Osbert Burdett and E. H. Goddard, *Edward Perry Warren: The Biography of a Connoisseur,* London, 1941, 263–74.
15. Tirel (Martin), *The Last Years of Rodin,* 37.
16. Lady Sackville's diary is owned by Vita Sackville-West's son Nigel Nicolson, and it is kept in Sissinghurst Castle. Nigel's brother Benedict published excerpts from it in *Burlington Magazine* (CXII) (January 1970). See also Grunfeld, *Rodin: A Biography,* 615–18.

CHAPTER 29

The War and the Wedding

1. Tirel (Martin), *The Last Years of Rodin,* 118.
2. Ibid., 118–27.

3. Hone, *The Life of Henry Tonks,* 113.
4. Leslie, *Rodin: Immortal Peasant,* 113.
5. Tirel (Martin), *The Last Years of Rodin,* 138.
6. Besnard, *Sous le ciel de Rome,* 1921, 195.
7. Tirel (Martin), *The Last Years of Rodin,* 144–45.
8. Ibid., 150.
9. Cladel, *Rodin,* 373–74.

AFTERWORD

"The Humble Son of a Genius"

1. Aigner and Aczél, "Rodins Sohn, der Taglöhner," 535–37.
2. Roger de Montebello, "Chez le fils de Rodin, ouvrier," *Le Rempart,* July 4, 1933.

APPENDIX

1. See Wayne Andersen, *The Youth of Cézanne and Zola,* Geneva, 2003, 105.
2. Yves Breton, Albert Broder, and Michel Lutfalla, *La Longue stagnation en France: L'Autre grande depression,* Paris, 1997; and Rondo Cameron, *France and the Economic Development of Europe, 1800–1914,* Princeton, N.J., 1961.

WORKS CONSULTED

This book is particularly dependent on letters written by the three artists. For Cézanne it is important to consult both the 1978 French edition, *Correspondance,* edited by John Rewald, which has the most useful footnotes, as well as *Letters,* edited by Rewald and translated by Seymour Hacker, New York, 1984. For Monet see Daniel Wildenstein, *Monet, vie et oeuvre,* 5 vols., 1974–91. Also Michel Schulman, *Frédéric Bazille, catalogue raisonné, sa vie, son oeuvre, sa correspondance,* Paris, 1995. I am grateful to James A. Ganz and Richard Kendall for making it possible for me to read the unpublished "Grand Journal" of Comte Théophile Beguin Billecocq, which contains new information about the Monets, and to Prince Xavier Beguin Billecocq for allowing me to quote from the journal. The bulk of Rodin's vast correspondence is to be found at the Musée Rodin in Paris. His own letters have been published in four volumes by the museum (1985, 1986, 1987, and 1992). The Musée Rodin also owns thousands of letters written to him. Further I relied on the archives of the Departments of Le Doubs, Le Jura, Haute-Marne, and the city of Paris; the dossiers collected in the Documentation Department at the Musée d'Orsay; the archives of the Library of Congress, Washington, D.C.; and the archives of Houghton Library, Harvard University, Cambridge, Mass.

THE LARGER CONTEXT

Alexis, Paul, Emile Zola, and Bard H. Bakker. *Naturalisme Pas Mort: Lettres Inédites de Paul Alexis à Emile Zola, 1871–1900.* Toronto: 1971.

Andersen, Wayne. *Manet: The Picnic and the Prostitute.* 2005.

Armstrong, Carol M. *Manet Manette.* New Haven and London: 2002.

Assouline, Pierre. *Grâces lui soient rendues: Paul Durand-Ruel, le marchand des impressionnistes.* Paris: 2002.

Benoist, Charles. *Les Ouvrières de l'aiguille à Paris: Notes pour l'etude de la question sociale.* Paris: 1895.

Borel, France. *The Seduction of Venus: Artists and Models.* Translated by Jean-Marie Clarke. New York: 1990.

Borzello, Francis. *The Artist's Model.* London: 1982.

Bowlby, Rachael. *Just Looking: Consumer Culture in Dreiser, Gissing, and Zola.* New York: 1985.

Breton, Yves, Albert Broder, and Michel Lutfalla. *La Longue stagnation en France: L'Autre grande dépression 1873–1897.* Paris: 1997.

Brown, Frederick. *Zola: A Life.* New York: 1995.

Caron, François. *Histoire des chemins de fer en France.* Paris: 1997.

Champeau, Stéphanie. *Les Notion d'artiste chez les Goncourt (1852–1870).* Paris and Geneva: 2000.

Chevalier, Louis. *La Formation de la population parisienne au XIXe siècle.* Paris: 1950.

Christiansen, Rupert. *Paris Babylon.* New York: 1994.

Clark, T. J. *The Painting of Modern Life: Paris in the Art of Manet and His Followers.* New York: 1985.

Clébert, Jean-Paul. *Femmes d'artistes.* Paris: 1989.

Coffin, Judith. *The Politics of Woman's Work: The Paris Garment Trades, 1750–1915.* Princeton, N.J.: 1996.

Crespelle, Jean-Paul. *La Vie quotidienne des impressionnistes.* Paris: 1981.

Daubié, Julie-Victoire. *La Femme pauvre au XIXe siècle.* Paris: 1866.

Daudet, Alphonse. *Les Femmes d'artistes.* Preface by Martine Reid. Paris: 1997.

Delbourg-Delphis, Maryléne. *Le Chic et le look: Histoire de la mode féminine et des mœurs de 1850 à nos jours.* Paris: 1981.

Denvir, Bernard. *The Chronicle of Impressionism: A Timeline History of Impressionist Art.* London: 1993.

Distel, Anne. *Impressionism, the First Collectors, 1874–1886.* Translated by Barbara Perroud-Benson. New York: 1990.

Doré fils, P. *Notice administrative, historique et municipale sur le XIIIe arrondissement de la ville de Paris.* Paris: 1860.

Fuchs, Rachel. *Poor and Pregnant in Paris, Strategies for Survival in the Nineteenth Century.* New Brunswick, N.J.: 1992.

Gagneux, Renaud, and Jean Anckaert. *Sur les traces de la Bièvre Parisienne.* Paris: 2002.

Gimpel, René. *Journal d'un collectionneur.* Paris: 1963.

Goncourt, Edmond and Jules de. *Manette Salomon.* Preface by Michel Crouzet. Paris: 1996.

———. *Journal: Mémoires de la vie littéraire.* Monaco: 1956.

Goulène, Pierre. *Evolution des pouvoirs d'achat en France (1830–1872).* Paris: 1974.

Green, Nicholas. "Dealing in Temperaments: Economic Transformations of the Artistic Fields in France During the Second Half of the Nineteenth Century," *Art History* 10, no. 1 (March 1987): 60–78.

Hamilton, George Heard. *Manet and His Critics.* New York: 1969.

Herbert, Robert L. *Impressionism, Art, Leisure, & Parisian Society.* New Haven & London: 1988.

Hollander, Elizabeth. "Working Models," *Art in America* 79 (May 1991): 152–54.

Jensen, Robert. *Marketing Modernism in Fin de Siècle Europe.* Princeton, N.J.: 1994.

Klüver, Billy and Julie Martin. "A Short History of Modeling," *Art in America* 79 (May 1991): 156–63.

Lathers, Marie. *Bodies of Art: French Literary Realism and the Artist's Model.* Lincoln, Neb., and London: 2001.

Lehning, James R. *Peasant and French: Cultural Contact in Rural France During the Nineteenth Century.* Cambridge, U.K., and New York: 1995.

———. *To Be a Citizen: The Political Culture of Early French Third Republic.* Ithaca, N.Y.: 2001.

Lethève, Jacques. *Daily Life of French Artists in the Nineteenth Century.* Translated by Hilary E. Paddon. New York, George Allen & Unwin: 1972.

Howard, Michael Eliot. *The Franco-Prussian War: The German Invasion of France.* London and New York: 1981 (1961).

Mainardi, Patricia. *Art and Politics of the Second Empire.* New Haven and London: 1987.

Marville, Charles. *Photographe de Paris de 1851–1879.* Ed. M. de Thézy. Paris: 1980.

Masten, April F. "Model into Artist: The Changing Face of Art Historical Biography," *Woman's Studies* 21 (1992): 17.

McMillan, James F. *France and Women 1789–1914: Gender, Society and Politics.* London and New York: 2000.

Michelet, Jules. *La Femme.* Paris: 1860.

Mitterand, Henri. *Zola: L'Histoire et la fiction.* Paris: 1990.

———. *Zola.* Vol. 1, 1840–1871. Paris: 1999.

Moffett, Charles S. et al. (curators). *The New Painting: Impressionism 1874–1886.* Introduction by Charles S. Moffett. Exh. Cat. Geneva, Switzerland: R. Burton; Seattle, University of Washington Press: 1986.

Murger, Henry. *Scènes de la bohême.* Paris: 1851.

Nord, Philip. *Impressionists and Politics: Art and Democracy in the Nineteenth Century.* London and New York: 2000.

Palau, François and Maguy. *Le Rail en France: Le Second Empire.* Paris: 1998–2004.

Perrot, Philippe. *Fashioning the Bourgeoisie: A History of Clothing in the Nineteenth Century.* Trans. Richard Bienvenu. Princeton, N.J.: 1994.

Pinkney, David H. *Napoleon III and the Rebuilding of Paris.* Princeton, N.J.: 1958.

Rewald, John. *The History of Impressionism.* New York: 1973.

Roos, Jane Mayo. *Early Impressionism and the French State (1866–1874).* Cambridge, U.K.: 1996.

Sacquin, Michèle (ed.). *Zola.* Exh. cat. Bibliothèque Nationale de France. Paris: 2002.

Shapiro, Ann-Louise. *Housing the Poor of Paris, 1850–1902.* Madison, Wis.: 1985.

Simon, Jules. *L'Ouvrière.* Paris: 1860.

Simon, Marie. *Fashion in Art: The Second Empire and Impressionism.* London: 1995.

Starr, Juliana. "Men Looking at Art: Aesthetic Voyeurism in Two Novels by Emile Zola," *Excavatio* 15, nos. 3–4 (2001): 173–85.

Steele, Valerie. *Paris Fashion: A Cultural History.* New York: 1988.

Thompson, Hannah. *Naturalism Redressed: Identity and Clothing in the Novels of Emile Zola*. Oxford, U.K.: 2004.

Tombs, Robert. *The Paris Commune, 1871*. London: 1999.

Tucker, Paul Hayes. *Manet's Le Déjeuner sur l'Herbe*. Cambridge, U.K.: 1998.

Venturi, Lionello. *Les Archives de l'impressionnisme*. Ed. Durand-Ruel. Paris and New York: 1939.

Waller, Susan. *The Invention of the Model: Artists and Models in Paris, 1830–1870*. Aldershot, U.K., and Burlington, Vt.: 2006.

Weber, Eugen. *Peasants into Frenchmen: The Modernization of Rural France, 1870–1914*. Stanford, Calif.: 1976.

White, Barbara Ehrlich. *Impressionists Side by Side: Their Friendships, Rivalries, and Artistic Exchanges*. New York: 1996.

White, Harrison and Cynthia. *Canvases and Careers. Institutional Change in the French Painting World*. New York: 1965.

Wolff, Albert. *L'Ecume de Paris*. Paris: 1885.

Zola, Emile. *Le Bon combat: De Courbet aux impressionnistes: Anthologie d'écrits sur l'art*. Ed. Jean Paul Bouillon. Paris: 1974.

———. *Au Bonheur des Dames: The Ladies' Delight*. Trans. Robin Buss. London and New York: 2001.

———. *La Confession de Claude, oeuvres complète*. Vol. I. Ed. Henri Mitterand. Paris: 1962.

———. *Correspondence*. Ed. Bard H. Bakker. Montreal: 1978.

———. *Ecrits sur l'art*. Ed. Jean-Pierre Leduc-Adine. Paris: 1991.

———. *Salons*. Eds. F. W. Hemmings and Robert J. Niess. Geneva: 1959.

———. *The Masterpiece* [*L'Oeuvre*]. Trans. Thomas Walton. Revised by Roger Pearson. Oxford and New York: 1993.

PAUL CÉZANNE AND HORTENSE FIQUET

Andersen, Wayne V. *Cézanne's Portrait Drawings*. Cambridge, Mass.: 1970.

———. *The Youth of Cézanne and Zola: Notoriety at Its Source, Art and Literature in Paris*. 2003.

———. *Cézanne and the Eternal Feminine*. Cambridge, UK: 2004.

Archives départementales des Bouches-du-Rhône. *Monsieur Paul Cézanne, rentier, artiste peintre*. Marseille: 2006.

Athanassoglou-Kallmyer, Nina M. *Cézanne and Provence: The Painter in His Culture*. Chicago: 2003.

Baumann, Felix (ed.). *Cézanne Finished Unfinished*. Exh. Cat. New York: 2000.

Bernard, Emile. *Souvenirs sur Paul Cézanne et lettres*. Paris: 1921.

Beucken, Jean de. "Un Portrait de Cézanne," *France Illustration, le Monde Illustré*, nos. 88–89 (August 1951).

Brettell, Richard R. *Post-Impressionists at the Art Institute of Chicago.* New York: 1987.

Cachin, Françoise, and Joseph J. Rishel (eds.). *Cézanne.* Exh. Cat. Philadelphia Museum of Art, Paris, Grand Palais, London, Tate Gallery, New York: 1996.

Cézanne, Paul. *Conversations with Cézanne.* Ed. Michael Doran. Trans. Julie Lawrence Cochran. Berkeley, Calif.: 2001.

———. *Correspondance.* Ed. John Rewald. Paris: 1978.

———. *Letters.* Ed. John Rewald. Trans. Seymour Hacker. New York: 1984.

Cézanne, Philippe. "Le Silence de l'atelier: 1906–1921," *Atelier Cézanne.* Société Paul Cézanne: 2002.

Conil, M. "Quelque souvenirs sur Paul Cézanne par une de ses nièces," *Gazette des Beaux-Arts,* 6th period/56 (November 1960): 299–302.

D'Souza, Aruna. "Paul Cézanne, Claude Lantier and Artistic Impotence," *Nineteenth-Century Art Worldwide* 3, no. 2 (Autumn 2004).

Feilchenfeldt, Walter. *By Appointment Only.* London and New York: 2006.

Gachet, Paul. *Deux amis des impressionnistes: Le Docteur Gachet et Murer.* Paris: 1956.

Gasquet, Joachim. *Joachim Gasquet's Cézanne: A Memoir with Conversations.* New York: 1991.

Geist, Sidney. "The Secret Life of Paul Cézanne," *Art International* 19 (November 1975): 7–16.

Gowing, Lawrence. *Cézanne.* London: 1954.

Gowing, Lawrence (catalogue), and Mary Anne Stevens (ed.). *Cézanne, The Early Years 1859–1872.* Exh. Cat. New York: 1988.

Kisch, Bob. "Paul Cézanne, *Jeune fille au piano* and Some Portraits of His Wife: An Investigation of His Painting of the Late 1870s," *Gazette des Beaux-Arts* 110 (July–August 1987): 21–26.

Larguier, Léo. *Le Dimanche avec Paul Cézanne.* Paris: 1925.

———. *Cézanne, ou la lutte avec l'ange de la peinture.* Paris: 1947.

Lewis, Mary Tompkins. *Cézanne.* London: 2000.

Mack, Gerstle. *La Vie de Paul Cézanne.* Paris: 1938.

Matisse, Henri, and Dominique Fourcade. *Ecrits et propos sur l'art.* Paris: 1972.

Monneret, Sophie. *Cézanne, Zola: La Fraternité du génie.* Paris: 1978.

Mothe, Alain (ed). *Cézanne à Auvers-sur-Oise.* Auvers-sur-Oise: 2006.

Nochlin, Linda. *Cézanne's Portraits.* Lincoln, Neb.: 1996.

Platzman, Steven. *Cézanne: The Self-Portraits.* Berkeley, Calif.: 2001.

Rabinow, Rebecca A. (ed). *Cézanne to Picasso: Ambroise Vollard, Patron of the Avant-Garde.* Exh. Cat. New Haven and London: 2006.

Renoir, Jean. *Renoir, My Father.* Translated by Randolph and Dorothy Weaver. Boston and Toronto: 1962.

Réunion des Musées Nationaux, *Cézanne aujourd'hui.* Actes du colloque organisé par le Musée d'Orsay, November 29–30, 1995.

Rewald, John. *Cézanne and America: Dealers, Collectors, Artists and Critics, 1891–1921.* Princeton, N.J.: 1989.

———. *Cézanne, A Biography.* New York and London: 1986.

———. "Paul Cézanne: New Documents for the Years 1870–1871," *The Burlington Magazine* 74 (April 1939): 163–69.

Rewald, John, with Walter Feilchenfeldt and Jane Warman. *The Paintings of Paul Cézanne, A Catalogue Raisonné.* 2 vols. New York and London: 1996.

Rivière, Georges. *Le Maître Paul Cézanne.* Paris: 1923.

Schapiro, Meyer. *Paul Cézanne.* New York: 1952.

Shikes, Ralph E., and Paula Harper. *Pissarro, His Life and Work.* New York: 1980.

Sidlauskas, Susan. "Emotion, Color, Cézanne (The Portraits of Hortense)," *Nineteenth-Century Art Worldwide* 3, no. 2 (Autumn 2004).

Société Paul Cézanne. *Atelier Cézanne.* Preface Françoise Cachin. Les Lauves: 2002.

Société Paul Cézanne. *Jas de Bouffan.* Preface Philippe Cézanne. Paris and Aix-en-Provence: 2004.

Vallès-Bled, Maïthé. *Cézanne biographie.* Paris: 1995.

Van Buren, Anne. "Madame Cézanne in Oil and Pencil." Masters thesis, University of Texas, 1964.

Venturi, Lionello. *Cézanne, son art, son oeuvre.* Paris: 1936.

Vollard, Ambrose. *Paul Cézanne.* Paris: 1914.

CLAUDE MONET AND CAMILLE DONCIEUX

Adhémar, Anne Distel, and Sylvie Gache-Patin, *Hommage à Claude Monet.* Exh. Cat. Paris, Grand Palais: 1980.

Alexandre, Arsène. *Camille Monet.* Paris: 1921.

Alphant, Marianne. *Claude Monet: Une vie dans le paysage.* Paris: 1993.

Baily, Colin B. *Renoir's Portraits: Impressions of an Age.* New Haven and Ottawa: 1997.

Champa, Kermit Swiler. *"Masterpiece" Studies: Manet, Zola, Van Gogh, and Monet.* University Park, Pennsylvania: 1994.

———, and Dianne W. Pitman. *Monet & Bazille, A Collaboration.* Atlanta, Ga.: 1998.

Clemenceau, Georges. *Claude Monet: Cinquante ans d'amitié.* Paris: 1965.

———. Claude Monet: *The Water Lilies.* New York: 1930.

Crespelle, Jean-Paul. *La Vie Quotidienne des Impressionnistes.* Paris: 1981.

Dixon, Annette, Carole McNamara, and Charles F. Stuckey. *Monet at Vétheuil: the Turning Point.* Ann Arbor, Mich.: 1998.

Fels, Marthe de. *La Vie de Claude Monet.* Paris: 1929.

Flescher, Sharon. *Zacharie Astruc, Critic, Artist, and Japoniste (1833–1886).* New York: 1978.

Ganz, James A., and Richard Kendall. *The Unknown Monet: Pastels and Drawings.* Exh. Cat. Williamstown, Mass.: 2007.

Gedo, Mary Mathews, "Mme Monet on Her Deathbed," *Journal of the American Medical Association* 288, no. 8 (August 28, 2002).

Geffroy, Gustave. *Monet, sa vie, son oeuvre.* Paris: 1980.

Gimpel, René. *Journal d'un collectionneur, marchand de tableaux.* Paris: 1963.

Hansen, Dorothee. *Monet und Camille: Frauenportraits im Impressionismus.* Exh. Cat. Kunsthalle, Bremen: 2005.

Herbert. Robert L. *Impressionism: Art, Leisure, and Parisian Society.* New Haven and London: 1988.

———. *Monet on the Normandy Coast: Tourism and Painting, 1867–1886.* New Haven and London: 1994.

Hoschedé, Jean-Pierre. *Claude Monet, ce mal connu.* Geneva: 1960.

House, John. "New Material on Monet and Pissarro in London in 1970–1871," *Burlington Magazine* 120 (October 1978): 636–42.

———. *Impressionism: Paint and Politics.* New Haven: 2004.

Isaacson, Joel. *Monet: Le Déjeuner sur l'herbe.* New York: 1972.

———. *Claude Monet, Observation and Reflection.* New York: 1978.

Jean-Aubry, G., with Robert Schmit. *Eugène Boudin.* Paris: 1968.

Joel, David. *Monet at Vétheuil and on the Norman Coast, 1878–1883.* Woodbridge, England: 2002.

Levine, Steven Z. *Monet, Narcissus, and Self-Reflection: The Modernist Myth of the Self.* Chicago: 1994.

Mauclair, Camille [Camille Faust]. *Claude Monet.* Paris: 1924.

Niculescu, Remus. "Georges de Bellio, l'ami des impressionnistes," *Revue Roumaine d'Histoire de l'Art* 1, no. 2 (1964): 209–45.

Moulin, Raymonde. *The French Art Market: A Sociological View.* Trans. Arthur Goldhammer. New Brunswick, N.J.: 1987.

Pickvance, Ronald. "Monet and Renoir in the Mid-1870s," *Japonisme in Art: An International Symposium.* Ed. The Society for the Study of Japonisme. Tokyo: 1980.

Poulain, Gaston. *Bazille et ses amis.* Paris: 1932.

Rachman, Carla. *Monet.* London: 1997.

Rewald, John, and Frances Weitzenhoffer (eds.). *Aspects of Monet: A Symposium on the Artist's Life and Times.* New York: 1984.

Schulman, Michel. *Frédéric Bazille, catalogue raisonné, sa vie, son oeuvre, sa correspondance.* Paris, 1995.

Seitz, William Chapin. *Claude Monet.* New York: 1960.

Stuckey, Charles F. *Claude Monet: 1840–1926.* New York and Chicago: 1995.

Thiébault-Sisson. "Claude Monet, An Inverview," *Le Temps* (November 27, 1900).

Trévise, Duc de. "Le Pèlerinage de Giverny," *La Revue de l'Art Ancien et Moderne* 51 (January–February 1927): 121–34.

Tucker, Paul Hayes. *Monet at Argenteuil.* New Haven and London: 1982.

———. *Claude Monet: Life and Art.* New Haven and London: 1995.

———. *The Impressionists at Argenteuil.* Exh Cat. New Haven and London: 2000.

Walter, Rudolphe. "Emile Zola and Claude Monet," *Cahiers Naturalistes* 26 (December 1966): 51–61.

———. "Les Maisons de Claude Monet à Argenteuil," *Gazette des Beaux-Arts* 68 (December 1966): 333–42.

Wildenstein, Daniel. *Claude Monet: Biographie et catalogue raisonné.* 5 vols. Lausanne and Paris: 1974–91.

AUGUSTE RODIN AND ROSE BEURET

Aigner, L., and L. Aczél. "Rodins Sohn, der Taglöhner," *Der Querschnitt* (August 1931): 536–37.

Aurel. *Rodin devant la femme: Fragments inédits de Rodin; sa technique par lui-même.* Paris: 1919.

Ayral-Clause, Odile. *Camille Claudel: A Life.* New York: 2002.

Bartlett, Truman. "Auguste Rodin, Sculptor," *American Architect and Building News* (January 19–June 15, 1889).

Bénédite, Léonce. *Rodin.* Paris: 1923.

Besnard, Albert. *Sous le ciel de Rome.* Paris: 1921.

Burdett, Osbert, and E. H. Goddard. *Edward Perry Warren: The Biography of a Connoisseur.* London: 1941.

Butler, Ruth. *Rodin: The Shape of Genius.* New Haven and London: 1993.

Cladel, Judith. *Rodin: Sa vie glorieuse, sa vie inconnue.* Paris: 1936.

Coquiot, Gustave. *Rodin à l'Hôtel de Biron et à Meudon.* Paris: 1917.

Dujardin-Beaumetz. *Entretiens avec Rodin.* Paris: 1992.

Grappe, Georges. *Catalogue du Musée Rodin.* Paris: 1944.

Grunfeld, Frederic V. *Rodin: A Biography.* New York: 1987.

Hone, Joseph. *The Life of Henry Tonks.* London: 1939.

Lampert, Catherine. *Rodin: Sculpture & Drawings.* London: 1986.

Lawton, Frederick. *The Life and Work of Auguste Rodin.* London: 1907.

Leppman, Wolfgang. *Rilke, A Life.* New York: 1984.

Leslie, Anita. *Rodin: Immortal Peasant.* London: 1937.

Ludovici, Anthony. *Personal Reminiscences of Auguste Rodin.* Philadelphia: 1926.

Maigrot, Jean-Louis. *La mort et les hommes en Haute-Marne au XIXe siècle: la morbidité en Haute Marne au XIXe siècle.* Langres: 1987.

Nicolson, Benedict. "Rodin and Lady Sackville," *Burlington Magazine* 112 (January–June 1970).

Nostitz, Helene von. *Dialogues with Rodin.* Trans. H. L. Ripperger. New York: 1931.

Ojetti, Ugo. *As They Seemed to Me.* Trans. Henry Furst. London: 1928.

Pinet, Hélène. *Rodin et ses modèles.* Paris: 1990.

Rilke, Rainer Maria. *Auguste Rodin.* Berlin: 1903.

———. *The Letters of Rainer Maria Rilke, 1892–1910.* Trans. Jane Bannard Greene and M. D. Herter Norton. New York: 1945.

Rodin, Auguste. *Correspondance de Rodin.* 5 vols. Paris: 1985–92.

Roe, Sue. *Gwen John: A Painter's Life.* New York: 2001.

Thiolier, Hubert. *Jeanne Bardey et Rodin.* Lyon: 1990.

Tirel (Martin), Marcelle. *The Last Years of Rodin.* Trans. R. Francis; preface by Judith Cladel. New York: 1925.

INDEX